SPAIN
A
HISTORY
IN
ART

spain

cisco Goya owes a large debt to the great painters brought to Spain by the Bourbon kings to decorate their palaces. All this, however, does not make "The Meninas" of Velázquez, the "St. Sebastian" of Berruguete or Goya's frescoes at the monastery of San Antonio de la Florida any less Spanish.

From the Spanish character stem the unique features that allow us at a glance to say that a building, a sculpture or a painting is Spanish. One reason for this is the very profusion of Spanish art. In spite of a century and a half of civil wars and of methodical looting by art dealers, there is still a vast wealth of art scattered all over the peninsula, reaching out to the most remote and inaccessible places. This abundance, hard to explain for a poor country, can be traced to the profoundly religious nature of the Spanish people. Even before they were Catholics or when they lived under non-Christian occupations, Spaniards believed in worshiping God with the utmost splendor—hence the overwhelming artistic treasures found in Spanish churches and monasteries. The cathedrals of Toledo, Burgos and Sevilla, and the monasteries of Guadalupe and El Escorial have unrivaled collections of paintings, sculpture and all types of decorative art. The Spanish people have an anti-economic concept of life. Often their external trappings of opulence conceal a sober and austere way of life. Such is the case with noblemen all over Spain who may live poorly in houses marked with heraldic stones and in rooms decorated with fine carpets and tapestries.

Spanish religious art is found not only in the churches but also in the old mansions. It is worthwhile noting that this pious art is at the same time deeply realistic and reflects historical events, for religion and history are closely intertwined in the fabric of Spain. The art of the "Golden Age" (1550–1660) in particular, with fidelity rarely surpassed, succeeded in mirroring the world in which the artist lived. It has been said of some Spanish painters (Velázquez, Zurbarán) that they were incapable of visualizing heaven or, when mythology was their theme, of creating an Olympus; that they merely pictured what they saw. The Italians, on the other hand, based their mystical themes on archetypes of impossible beauty. Realism is deeply ingrained in the Spanish soul, and it turns up also in Spanish literature, which has no peer in evoking life. Cervantes is as realistic in *Rinconete and Cortadillo,* or Quevedo in *La Vida del Buscón,* as Velázquez is

in the painting "Los Borrachos."

Spanish art, like the Spanish people, is more intuitive than studied and painstaking. It has spontaneity and admirable ease, but it rarely achieves correct interpretations, which may demand long and tedious preparation. The Spanish people love color, movement and life, and this is reflected in their art. It is enlightening to compare side by side a Spanish work of art with a contemporary one of the same school done in another country. Let us, for example, place a 15th-century Flemish picture next to another showing Dutch influence but painted in Castilla or Andalucía. In the former, everything is exquisiteness and masterful skill—one can see in it many years of training, long hours of concentration and work to achieve an exact image. Quality emanates from the fabrics, the metals or the ceramics portrayed; there is a devoted attention to the smallest details of the landscape. The Spanish picture, on the other hand, will not be quite right, as if done hurriedly, with an easy technique. But within it lies something which the northern artists have not been able to capture—life. The same thing happens if next to a Goya we hang another painting done by a contemporary Englishman—Reynolds, for instance.

A typical case is the 17th-century painter Francisco de Zurbarán (1598–1662), who was born in rural Extremadura and became famous as an artist for the monastic orders. He was forced to paint fast, because important commissions poured in on him not only from all over Spain but also from Spanish America. Yet his white monks have such luminosity, such strength and vitality as to make them dangerous and overpowering competitors in any museum. It has been said that in an art gallery the only *living* things are El Greco, Velázquez, Zurbarán and Goya; the rest are nothing but marvelous wax figures.

These qualities of energy and movement are characteristic of the baroque, which colors the soul of Spain throughout its history. The baroque was not just a light that flickered momentarily at a particular time in European culture—toward the end of the 16th century; it is a "constant" phenomenon, with specific qualities, which appears in the final stage of all cultures. Baroque characteristics are found in all Spanish art, except for the brief and barren academic periods. One of these characteristics is the ability to portray pathos and pain. Never has human anguish in the face of death or martyrdom

been expressed so poignantly as in the Christs, Mater Dolorosas and martyrs painted or carved in Spanish works of art. We have already pointed to the persistence in Spain of another baroque signpost—a realism that seeks truth in all its crudeness, showing decrepitude and ugliness, taking delight in emphasizing abnormalities and shortcomings, as do Velázquez with his dwarfs, Ribera with his "Bearded Woman," Carreño with his portraits of a monstrously fat child, and Goya with his black painting and his "Caprichos." The baroque fondness for excessive sumptuousness is often reflected in Spanish monuments.

Some of the unique features that distinguish the Spanish school of painting from other great European schools are determined by geography and history. An anarchic distribution of mountain ranges divides Spain into a series of regions completely different in climate, products and geographical features. The Iberian peninsula is like a small continent where one can find the most diverse terrain and talk with people of different races. There seem to be no similarities between rainy, wooded, mountainous Galicia, whose people are of Celtic stock with some traces of Germanic blood, and the dry and austere Castilian plateau, or the verdant river banks of Andalucía and Valencia, where Arab influences are still strong. To such diverse geographical and ethnical groupings correspond different schools, each with well-defined characteristics. But at the same time the Iberian peninsula is a natural entity, with no less well-defined characteristics. Over a great part of its history it has been politically united under different governments (Roman Empire, Visigothic, Hapsburg and Bourbon monarchies). Often the various races of the Iberian peninsula have joined in action fired by the same ideals—reconquering Spain from the Arabs, defending the Catholic faith or resisting Napoleon. Thus, the art of the various regions has the Spanish spirit as a common background. Only an expert can tell whether a particular painting belongs to the Madrid, Valencia or Sevilla school, but anyone can tell at a glance that it is a *Spanish* painting.

Geography also determined the history of Spain. The Iberian peninsula, located south of the Pyrenees, is separated from Africa by a small stretch of sea. Mountains separate and the sea unites—that is why the African influence in Spain has persisted since prehistoric times. The Mediterranean coast is wide

and Oriental cultural currents constantly converged into Spanish ports—hence the cultural duality of Spain. It has always had elites that wanted to be attuned to Europe; and the great European currents—Greek and Roman, Romanesque and Gothic, the Renaissance—found in the Iberian peninsula a brilliant provincial echo. But Spain is not entirely European. At the bottom of its soul there is something that is not European—its detachment from the contingent and the ephemeral, with a consequent preoccupation with the problems of eternity. The most significant event in Spanish history occurred in the year 711: the inexplicably quick occupation of the Iberian peninsula by an avalanche of Moslems—Arabs, Syrians, and Berbers from North Africa. For eight centuries Spain, or part of it, no longer depended culturally on such European metropolises as Rome, Florence and Paris, but rather on Damascus and Bagdad, from which it now took its philosophy, art, and, above all, its sense of life. At the Spanish end of Europe the most refined Moslem culture flourished, with monuments such as the Mosque at Córdoba—the most beautiful in the whole of Islam—and the Alhambra at Granada. In the 10th century, under the Omayyad caliphs, Córdoba was the most important city in the West.

It is logical that this brilliant civilization should have impressed the leaders of the small kingdoms then emerging in the north of the peninsula, as well as the Christians who had kept their religion and customs under Moslem domination. In the 11th century, as the caliphate began to decline and fall, the roughhewn conquerors from the Christian kingdoms let themselves be influenced by the culture of the conquered. Hence the mixture, unique in Europe, of Moslem and Christian arts—the Mozarab style, which was the art of the Christians under Moslem domination, and the Mudéjar style, the art of the Moors under Christian domination.

Spain has always been a country of surprises. One of them was its rapid emergence as a European power after having been somewhat forgotten at the western end of Europe. Now the Low Countries, a large part of Italy, and some French provinces became a part of the vast monarchy of the Spanish Hapsburgs. The discovery and conquest of Mexico and Peru brought to the Iberian peninsula a river of gold, which Spanish religiousness and the love of the sumptuous soon turned into magnificent buildings with great accumulations of paintings, sculp-

ture and precious objects. A large number of foreign artists came to Spain, while many a Spaniard was drawn to Italy by the fame of the Italian schools of art. The influence of the Italian mannerism, of Venetian painting, of the great school of baroque realism as well as the ostentatious Dutch baroque, is evident in 16th- and 17th-century Spanish art; yet it is not strong enough to obliterate the powerful Spanish personality. El Escorial, that great monastery founded by Felipe II, is based in its entirety on the Vignola system of construction; and although it has other European artistic influences, it could have been built only in Spain. It is one of the most representative monuments of a period of Spanish life and culture. The Spanish milieu was so powerful that it absorbed even the foreign artists who settled in Spain. Thus, Domenico Teotocopulo (El Greco), who was born in Crete and trained as an artist in Venice and Rome, became the foremost exponent of Spanish artistic ideals after living only a few years in Toledo. Furthermore, nothing could be more Spanish than the polychrome wood sculptures of the 16th and 17th centuries, yet many foreigners played a role in the early development of this art: Felipe Bigarny and Juan de Juni, from Burgundy, and Jacobo Florentin, known as "L'Indaco Vecchio," a native of Florence. Without Caravaggio, as we have already noted, and without the great Venetians, one cannot explain the highest pinnacle in Spanish painting—Diego de Silva Velázquez.

Only for one century did Spain seem to abdicate voluntarily its peculiar qualities in order to submit to international patterns of culture. After the Peace of Utrecht, which brought on the dismemberment of the Spanish empire in Europe, the Spaniards seemed to acquire a defeatist complex. The most sophisticated minorities allowed that the defeat was a just one, since the conqueror's culture was superior. This defeatism coincided with the establishment of a French dynasty in Spain—at the peak of Louis XIV's reign in France—and with the renewal of relations between the Spanish court and Italy. The official art became totally French and Italian, and the royal palaces at Madrid and San Ildefonso, for example, could just as easily have been built in Sweden, Italy or southern Germany. To decorate the palaces and churches the Spanish court imported painters and sculptors from all Europe—the Frenchmen Houasse, Van Loo and Ranc, to say nothing of the architect-sculptor Carlier and a whole team of

sculptors who worked at La Granja palace: the Italians Giaquinto, Amigoni, the Tiepolos and many more; the Bohemian Mengs. The Spaniards found these artists, educated in the rigid tenets of the French Academy, totally aseptic. The Spanish spirit continued to beat under the layers of official art and suddenly exploded in the person of Francisco de Goya, who is perhaps the artist in whom the Spanish genius has had its greatest universal projection.

Spanish art of the 19th century is unfairly ignored by most historians, and its greatest figures are totally unknown beyond the Iberian peninsula. Spain, however, has never lacked great painters, even in times of economic ruin and civil war. While watching the success of lesser artists in more fortunate lands, these Spanish painters and sculptors accomplished their historical mission with enthusiasm and decorum even in a difficult period when the government was incapable of great undertakings and the patronage of the Church and the nobility had dried up. Some of these artists, like Federico de Madrazo, Carlos Luis de Rivera and the Catalan "Nazarenes," faithfully followed European trends. Others, the better ones, adhered to the tradition of Velázquez, Goya or Murillo—and among them were Alenza, Eugenio Lucas Padilla, Esquivel and Fortuny. The realism which triumphed over romanticism in literature and art in the last third of the 19th century struck a sympathetic chord in the Spanish temperament and produced a number of painters—such as Rosales and Casado del Alisal, Pinazo and Domingo Márquez—who, although unknown outside Spain, painted much better than their successful colleagues across the Pyrenees.

Under King Alfonso XIII, who reigned from 1902 to 1931, Spain enjoyed a prosperous cultural period. The paintings of Sorolla, Zuloaga and Sert sold at top prices in the art markets of the world.

And finally, in the 20th century, as in the "Golden Age" of the 17th, Spanish artists joined the world's rushing stream of modern painting and contributed to it a glorious tradition and a vigorous and passionate temperament. It will not be possible to write a definitive history of art in this century without mentioning some Spanish names—Picasso, Gris, Miró, among the painters; Gargallo, Hugué and Ferrán among the sculptors. Picasso shares only with Raphael the distinction of having held for over half a century the foremost place in world painting. — JUAN DE CONTRERAS, the Marquis de Lozoya

INTRODUCTION TO THE HISTORY OF SPAIN

What makes the Spaniard unique within Western civilization? Why is Spain so different from other European countries?

Some people look for a simple geographic answer. But the fact is that its geography has not changed that much since the days when Spain, as so many other European lands, was but a piece in the grand imperial mosaic put together by Rome. This common background persisted for several centuries as northern European tribes—Visigoths, Ostrogoths, Franks—overran southern Europe and established themselves there.

What really made the difference was the arrival in Spain of the Arabs early in the 8th century. From that moment on, Spain's development took on a distinctive character. While it is true that the Arabs also reached up into France, they were soon thrown back. In Spain it was a different story. The Moslems conquered much of the Iberian peninsula and stayed on for nearly eight centuries.

Small Christian nuclei in northern Spain resisted the Moslem invaders from the beginning. Over the centuries these rugged groups grew into powerful Christian kingdoms that pushed the infidel ever southward. During this prolonged struggle, Spain served as an advance post for Christianity, a religious frontier. The main performers on this medieval stage were the monk and the warrior—the man who prayed and the man who fought; the man who reflected upon death and the man who faced it on the battlefield. The victory achieved after nearly 800 years of effort gave the Spaniard a feeling of superiority, which was reinforced by medieval chroniclers who were quick to remind them that their country had once given great emperors to Rome.

In that long contest Spain put ideological values ahead of purely material interests. Rivers were more often used as moats behind which to fight raiders than as trade routes. Cities sprang up not because of economics but because of strategic imperatives. Such was the case of Segovia; and it was as a guardian of the mountain passes that Madrid had its humble beginnings. This also explains why the Spanish landscape often has a warlike appearance. Any knoll, any mountain pass, any meadow, was a good place to build a fortress-castle.

When the Catholic Sovereigns ended the war of reconquest from the Moslems, the *Reconquista,* and stood on the Moorish towers of the Alhambra at Granada, they once more turned their eyes southward, as Spaniards had done for so many centuries. This time there was only the sea. But that very same year Spanish ships under Columbus succeeded in crossing the great Dark Sea. It was as though Spain, having run out of land to reconquer, had been forced to look beyond the ocean for new lands in which to continue its feats of valor. In a broad sense, the *Reconquista* grew into the discovery, conquest and colonization of the New World.

It was at this moment that the concept of manifest destiny—so easy to take hold in any country at the height of its power—sank deep into the Spanish conscience. The Spaniard felt he had a godly mission to carry out, and this was to make it possible for him to withstand bitter defeats in later years. When the Castilian Cortes met after the disaster of the Invincible Armada, someone advised the king to abandon his ambitious foreign policy, which had forced Spain to fight against half of Europe. "If they want to ruin themselves, let them," the adviser added spitefully. To have followed this counsel would have amounted to striking the flag that had led Spain on a universal mission. But at that same Cortes another ringing voice was heard. Recommending that the fight be carried on, a representative from Murcia said: "If what we are doing is defending the cause of God—as I am sure we are—then we must not give it up as impossible, for He will discover new Indies for us, as He discovered the Catholic Sovereigns when we needed them."

Defeats such as that of the Armada in 1588 were considered God's fair punishment for the sins of Spanish society. Therefore this society must purify

itself—without stopping its expansion abroad—so that "the nations of this Europe of ours may once again flourish in Christianity." To the deep sense of mission there was now added a burning desire to re-establish religious unity in Europe.

But for one long century before that, from the beginning of the internal restoration undertaken by Fernando and Isabel until the larval stage of the defeatist generation of 1588, Spain had shown a dynamic drive seldom paralleled in history. The Spaniard felt his hour had arrived. He received vast influences from Renaissance currents, both from Italy and the Low Countries. But the fact that he rode on horseback through the lands of the New World was to place him ahead even of Renaissance ideas and to fill him with a proud spirit of progress. New wonders—never even imagined by the ancient Greeks and Romans—came daily before his eyes, and he was impelled to incorporate them into his way of life. For this the teachings of the ancients were of little use. In the words of a Spaniard of the time, the physical features and the customs observed in the new lands "showed how wrong the ancients were in their writings about these areas…"

The enormous task of incorporating the New World into Western civilization was carried out by the Spaniards in an incredibly short time. This can only be explained in terms of their eventful medieval past. To the experience gained in the struggle against the Moslems they soon added the discovery and colonization of the Canary Islands. This was a small-scale prelude for the venture into the New World, involving overseas action, clashing with primitive cultures, preaching of the Gospel and creation of new Castillas. Eventually, not only was the New World brought into the fold of Western civilization, but European life was radically changed as a result. Europe entered into a dynamic period of conquest and assimilation for which Spain had shown the way.

Yet the Spain of the 16th century, though still preserving its great ideals, evolved slowly. The hidalgos who fought under Charles V in Europe and under Cortés in America were men of action, fond of reading books on chivalry. Under Felipe II they were replaced by a new breed more inclined to discourse than to action. While it is true that the most valuable works of the Spanish baroque, both in literature and in the arts, were created after the Armada's defeat, this did not prevent Spanish society from being afflicted by a dangerous dichotomy.

It was then that the underlying lack of internal unity became apparent. This could be attributed largely to a deficiency of adequate organs to bring about the political union of the two former kingdoms of Castilla and Aragón. The difficulties were compounded because the Catholic Monarchy, in addition to the biological creation of an overseas Spanish empire, went on to build a supranational state with vast ramifications in Central Europe.

Indeed, at the beginning of the 16th century, the Catholic Sovereigns succeeded in making a modern state out of Castilla by controlling the nobility, insuring the loyalty of the Cortes and establishing new institutions or reviving some old ones. But they failed to persuade the crown of Aragón to integrate its different customs and traditions with those of Castilla. Only in the field of religion were they able to spread a mantle that covered all of the Spanish speaking people.

It is difficult to explain why Aragón, which had displayed tremendous energies in the early Middle Ages, now flinched from the enterprises undertaken by the Catholic Sovereigns. Had its will been weakened by the establishment of the Castilian dynasty of the Trastamaras? Was it because of the civil wars and social upheavals of the 15th century? At any rate, the disproportionate forces—both in territory and in population—between Castilla and Aragón at the time of the marriage of Isabel to Fernando resulted in a fierce Castilian arrogance and in a cold indifference, born of deep resentment, on the part of the Aragonese, Catalans and Valencians.

The only thing achieved by the marriage was to extend the outer covering of Spanish unity without having really formed an inner structure. There followed a rapid territorial expansion, which brought the supranational Monarchy into being. From the very beginning, Castilla played the leading role in it. After expanding its eastern border to the Mediterranean, it found it convenient to embrace the policies of the dynastic Hapsburgs and Bourbons, who in turn often proclaimed their preferences for Castilla. But these preferences had a serious and unavoidable result: they inhibited the subjects of the crown of Aragón even in the things at which they were most competent—sailing and commercial enterprises. For hundreds of years these subjects were not allowed to sail to or to trade with the New World. All traffic moved through specific ports in southern Spain. Into this vacuum stepped the sailors and merchants of Genoa and Antwerp.

In short, there was always a latent internal weakness that was to become acute at every great national crisis. But at the inception of the Catholic Monarchy Castilla had such vitality that, even without the support of Aragón, it was able to extend its supremacy over a large part of Europe. It had two natural directions of expansion: toward the Western Mediterranean or toward the lands of the New World. In both it was to hold a strong position, reinforced by an awareness of its mission—to contain the Turks in the Mediterranean and to spread Christianity across the Atlantic.

Under Charles V, in the early 16th century, Spanish foreign policy underwent a marked shift. Other than Spanish interests came into play. There was talk of an empire with reference to Germanic lands—the Holy Roman Empire—at a time when Castilla was building its own infinitely larger empire across the Atlantic Ocean. As a result of the new policies of the Hapsburgs, the powerful old *tercios,* or infantry regiments, were going to be used far away from their bases. The gold from the Indies was to be squandered in a labyrinth of European religious wars. The conquest of Algiers would take second place to the defense of Vienna; the continued union with the Low Countries would take preference over a greater control of Aragón.

Spain not only exhausted its soldiers but also its economy. After the disaster of the Armada and the debacle of Rocroi, the treasury was ruined, the land depopulated, the cities devastated.

It is not surprising that, having failed in its attempt to Hispanize Europe, Spain would be the object of a campaign by Europe to make it more European. This historical task fell to the Bourbons. To reform, to renovate, to reorganize—these became the new slogans. What started as the work of a foreign king and of foreign ministers soon became the enthusiastic labor of Spanish kings such as Fernando VI and Carlos III, supported by Spanish ministers. The country's primary need was the reconstruction of its social edifice. It was time to re-examine the old structures with a critical spirit. Spain faced the arduous task of reconciling modernism with tradition. This was the period of the enlightened despots, when the destinies of the nation were placed in diligent and intelligent hands, with remarkable results.

Yet everything could be upset if an inept king occupied the Spanish throne. That was exactly what happened with the crowning of Carlos IV, who, in addition to internal problems, had to face the international consequences of the French Revolution and of Napoleon's ambitions. A series of mistakes was to bring on the French invasion of Spain, and the subsequent war of independence. This soon depleted the resources slowly accumulated by good administrators in the 18th century. As a tragic follow-up, incompetent leadership was to bring about the disintegration of the overseas empire.

As the 19th century advanced, Spain was reduced almost to its old territory. The Treaty of Westphalia, in the middle of the 17th century, had ended Spanish supremacy over Europe; early in the 18th century, the Treaty of Utrecht deprived Spain of its possessions in Flanders and Italy; our War of Independence brought the pruning down to the very trunk of the tree. Deep ideological differences between liberal and conservative viewpoints came to the surface under Fernando VII. There was no agreement on how to cure the country's ills. Many Spaniards looked back to the old political formulas that had existed during the country's finest hours. Others felt that the most urgent task was to bring Spain up to date in accordance with the liberal systems—both political and economic—adopted by Western European countries

A grave dilemma arose. The traditionalists seemed to remove themselves from modern reality; the liberals appeared to want to cut Spain's roots in the past. These opposing views launched the country into a series of *pronunciamientos* and civil wars, at a time when the rest of the Western world was prospering under the industrial revolution.

In 1898, the Spanish monarchy, shocked by the loss of Cuba, Puerto Rico and the Philippines, began to stir. Spaniards looked eagerly through every window of knowledge and explored every avenue of literary and artistic creation in a serious effort to join the scientific progress all along the line. The monarchy gave way to a dictatorship and later to a republic. Neither proved to be a durable solution. Spain's dilemma of reconciling the past with the present, as a prerequisite for facing the future with confidence, was to remain largely unsolved. Yet, for all these weeds of dissension, the Spaniard knew he carried within himself, ready to flower in the most difficult circumstances, a seed of greatness.

MANUEL FERNANDEZ ALVAREZ
University of Salamanca

20,000–1000 B.C.
PREHISTORY

Who were the ancestors of the modern Spanish people? The realistic, polychrome cave paintings of northern Spain and the rock art of the Levantine region—two different expressions by two different hunter people. The impressive dolmens of the megalithic culture. The early influence from North Africa, a beginning of the complex fusion which would eventually produce that unique mixture, the Spaniard.

HISTORICAL CHRONOLOGY		ART CHRONOLOGY
B.C.		
20,000–8000	HIGH PALEOLITHIC *(latter part of Stone Age)* *Aurignac Period* *Solutré Period*	*Cantabrian cave art in southern France and northern Spain (Covalonas, Las Pasiegas, Peña de Candamo). Early batons. El Castillo cave. Abstract designs, perhaps an early form of picture-writing.*
	La Madeleine Period	*Altamira cave. Multicolored, life-size paintings of animals. Portable art.*
5000	MESOLITHIC *(Middle Stone Age)*	*Levantine rock art. At La Gasulla, El Mortero, Barranco de Valltorta.*
2000	NEOLITHIC *(New Stone Age)*	*Man begins to leave caves, but keeps them for burial and religious purposes. Beginning of agriculture and husbandry. Rich ceramic culture.*
1800	ENEOLITHIC *(between New Stone Age and Bronze Age)*	*Beginning of megalithic culture. Dolmen group at Antequera. Sketchy rock art at La Graja and Letreros caves.*
1200 on	*Balearic megaliths*	Talayots, navetas *and* taulas.

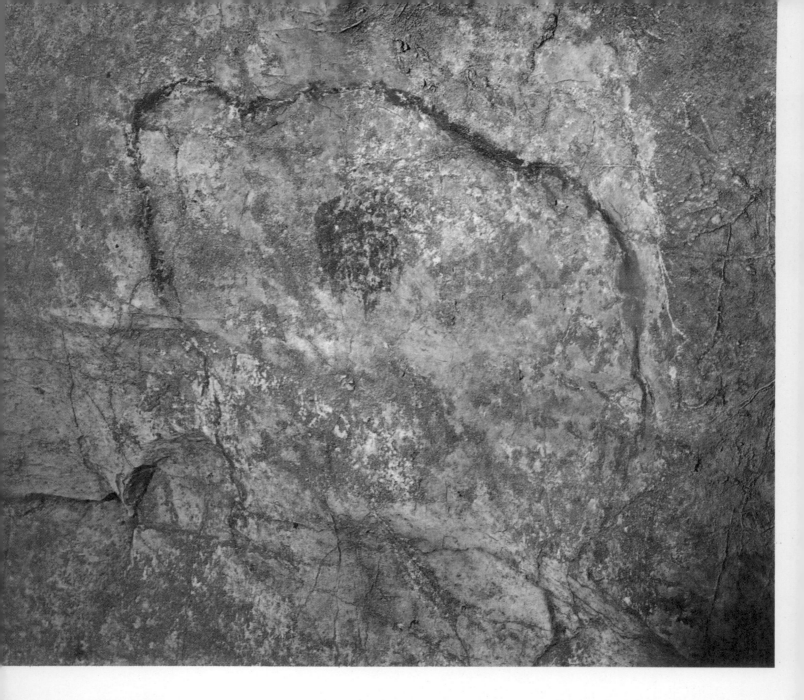

A huge elephant, with red spot that may indicate the vulnerable heart, was painted on a cave wall some 15,000 years ago.

In the Beginning— Hunters and Artists

The earliest known artists of the Iberian peninsula left behind an astonishingly vivid record of their primitive culture.

They were cave dwellers and skilled hunters whose art depicted mostly the large beasts they hunted. When the last enormous glaciers spread a killing cold over Europe, these mysterious people of the early Stone Age vanished from the northern slopes of the Pyrenees. Whether they died out completely or moved into the warmer south ahead of the advancing masses of ice no one knows for sure. But before fading out—somewhere between 8,000 and 20,000 years ago—they managed to create colorful and unique images and to decorate their cave world with art forms never surpassed and rarely equaled by man.

A tall, long-boned people with well-formed brows, they have come to be known as the Cro-Magnon race. They replaced the low-browed, stoop-shouldered, short-limbed Neanderthals who preceded them in the region. The advent of the Cro-Magnons, who greatly resembled the people living in northern Spain today, marked the remote beginning of modern man.

Hunting big game called for cooperation within the tribe. Ways were devised to trap and kill animals twenty times a man's weight and bulk. Sharp flint

One of 44 life-size hands, 35 left and 9 right, the earliest representation of man in Iberia, appears near entrance to cave

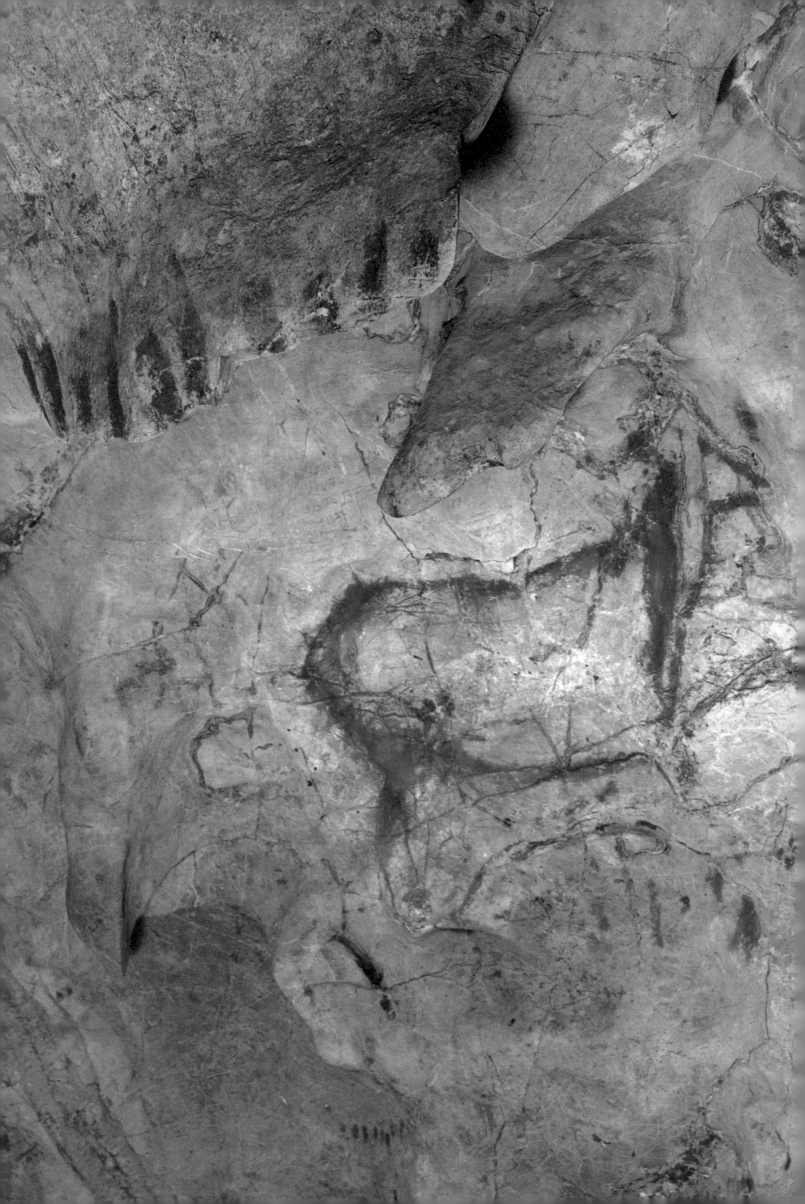

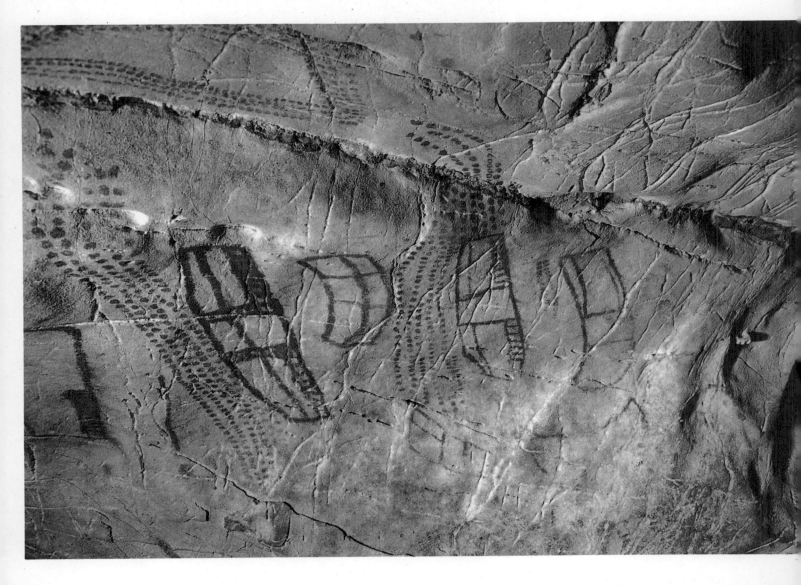

points tipped spears of varied sizes. Spear slings, fashioned out of antlers and carved with heads of animals or birds, were used to hurl short hunting shafts. The ancient elephant, musk ox, bison, horse and mountain goat supplied food, clothing, ornaments and weapons; they were also instruments of magic and objects of a rudimentary form of religion. The hunt, with all its mystique, its rewards and perils, elations and fears, was their way of life.

Here, then, was an aware and relatively affluent society (based on an abundance of game and a knowledge of the techniques for killing it) that, perhaps for the first time in the vast panorama of the human race, was in a position to produce intricate works of art. For its painters, sculptors and etchers were most likely supplied with a portion of the food gathered by the tribe, allowing them the time necessary to portray in dramatic images the very animals that gave them life.

Native mountain goat in red ocher is superimposed on an earlier drawing. Foreground may be decorated to create depth.

Within their caves fires were kept, skins were scraped for clothing and, in the deeper recesses, striking galleries of animal pictures were painted or etched in the rock. To the primitive artists who created these images and to their fellow tribesmen who were allowed to see them, the way through the dark passages, lit only by flickering pine torches, must have seemed like a descent into a subterranean world of departed animal and human spirits—or perhaps the route by which their spirit ancestors came up to earth. Certainly the chambers in which the great drawings were done had both a magical and a religious significance.

The dead were often buried within the caves. A belief in afterlife seems a reasonable deduction, for these men buried tools, weapons and food to sustain the spirit on its dark journey.

At El Castillo, one of the important caves, prehistoric artists created an abstract design that re-

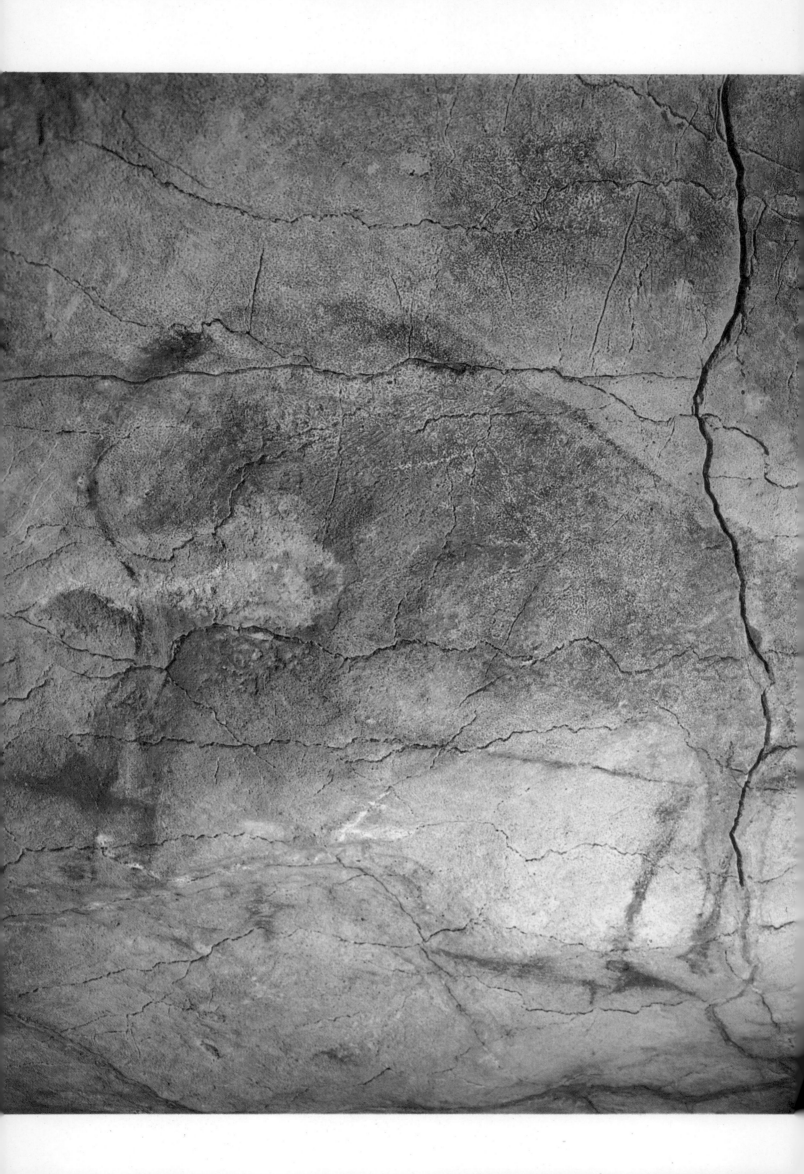

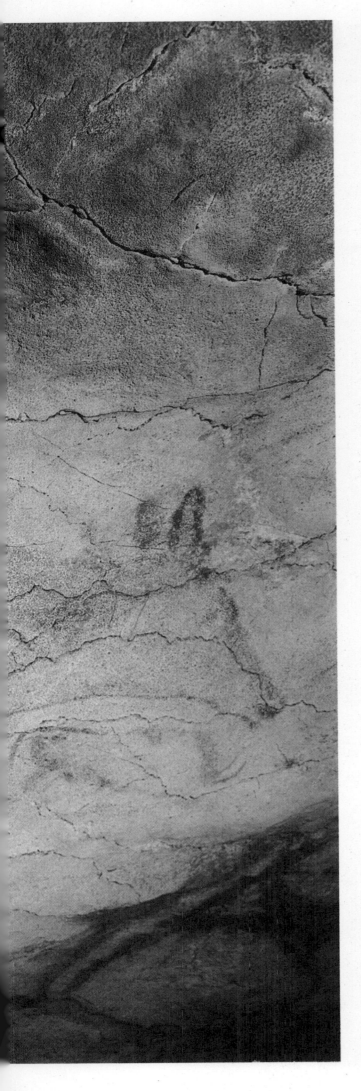

sembles the pattern of animal feet leading across the cave wall and down into a crevice. Below, other designs are painted in red ocher. These images, so far undeciphered, may be an early form of symbolic or picture writing.

Three major regions contain most of the caves in which these men of the north created their great works of art. Two are in southern France and the third extends along the Cantabrian coast of Spain, from Asturias to the Pyrenees. The most important paintings in France are located in the southwest, primarily in the departments of Dordogne, Corrèze and Vienne. Farther south, the second French region is on the border of the Pyrenees, in the Ariège and Haute Garonne departments. While other examples of outstanding cave paintings exist in both France and Spain—the most notable in Spain being in the provinces of Guadalajara, Madrid, Valencia and Málaga—none are so magnificent as those in the north of the Iberian peninsula.

There the murals show the fleetness, the power and the flowing movements of bison, deer and horses. Bison are portrayed in relief wherever the artist, pondering and choosing carefully, has taken a natural protuberance in the rock and has painted the animal in the semiround. Realistic scenes depict deer feeding, bison and musk ox standing, lying or crouching. A strong feeling that the spirits of these animals live on pervades the cave gallery.

It seems incredible that most of the techniques used by artists throughout the centuries were already known to the prehistoric craftsmen of this Cantabrian culture. Engravings, drawings, bas-reliefs and paintings (both flat and three-dimensional) were all in their comprehensive catalogue of skills. To achieve brilliant, permanent colors, raw ochers were prepared from oxides of iron to produce hues ranging from brown to red and then graded down to orange and yellow. These colors were finely ground in a mortar and the resulting powder was carefully stored in holders made of bones, shells and human skulls.

Outlines of human hands found on the walls of the Cueva del Castillo are the earliest recognizable images made by the men of the north. Two types of hand images have been found. One was made by holding the hand against the cave wall and blowing or scattering paint around the thumb and fingers. The hand thus acted as a stencil, with the result that each finger was represented as a blank area outlined

A magnificent deer, over 7 feet long, is painted on the sloping vault of the Altamira cave. A bison crouches below.

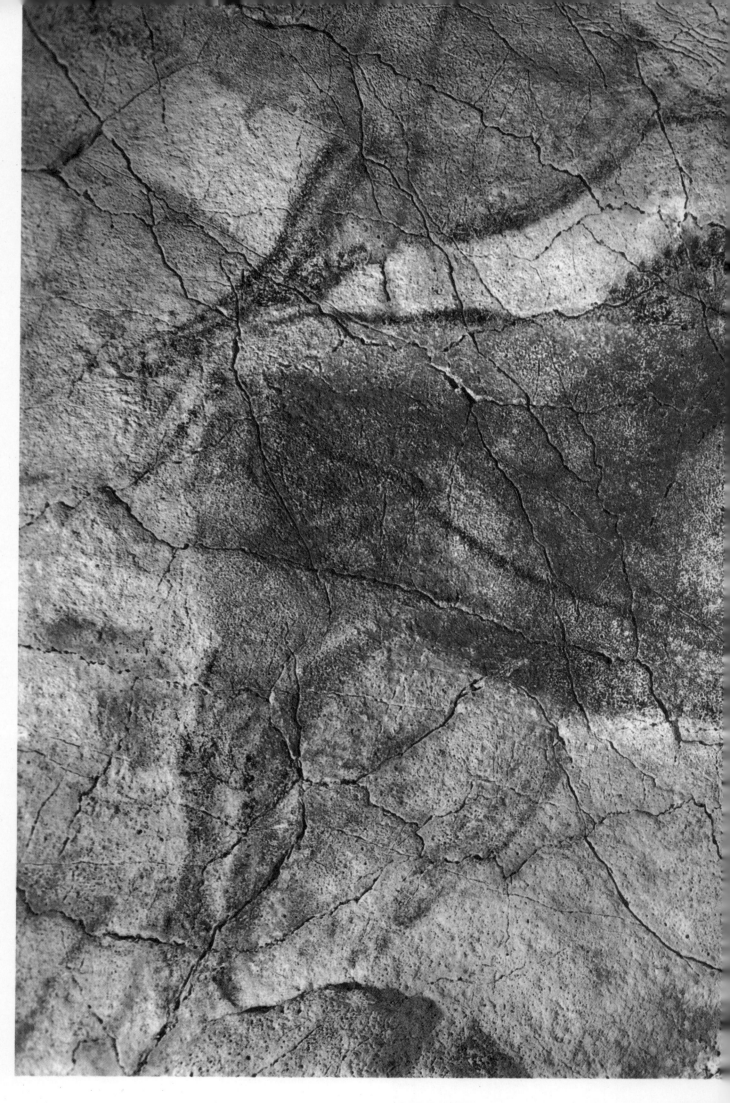

*Great bison like this one are painted in various attitudes in
the extensive picture gallery of Altamira. Twenty-five animals—*

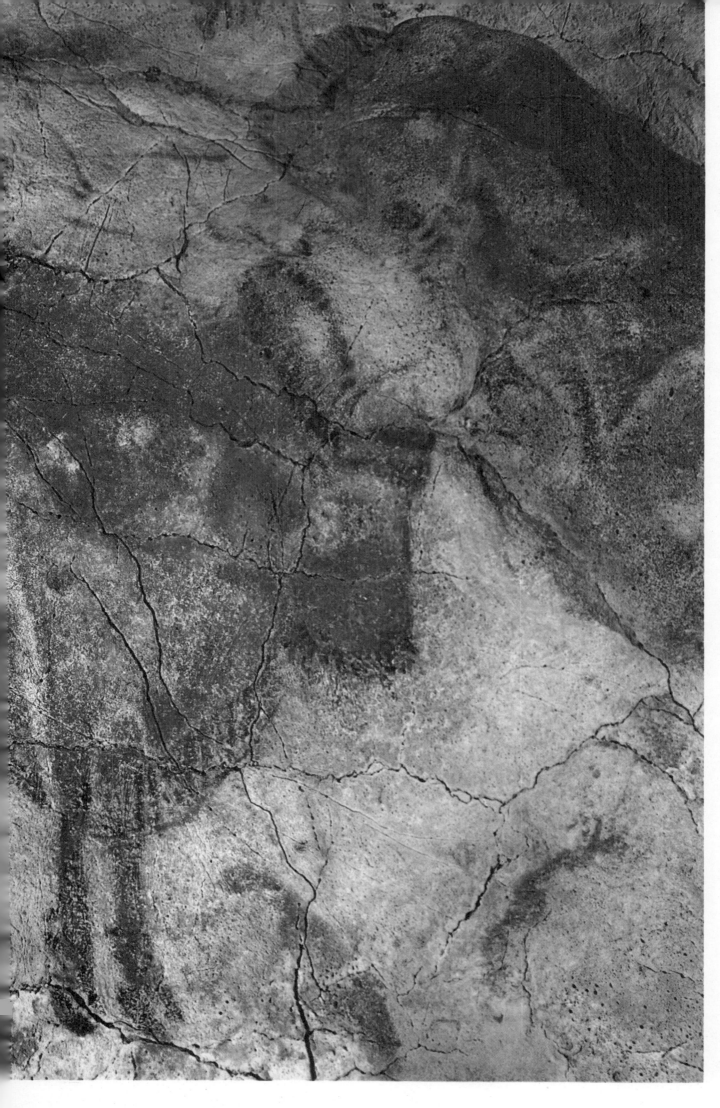

horses, goats, deer, bulls and bison—illumine the
alls and ceiling of this greatest natural museum of Iberian art.

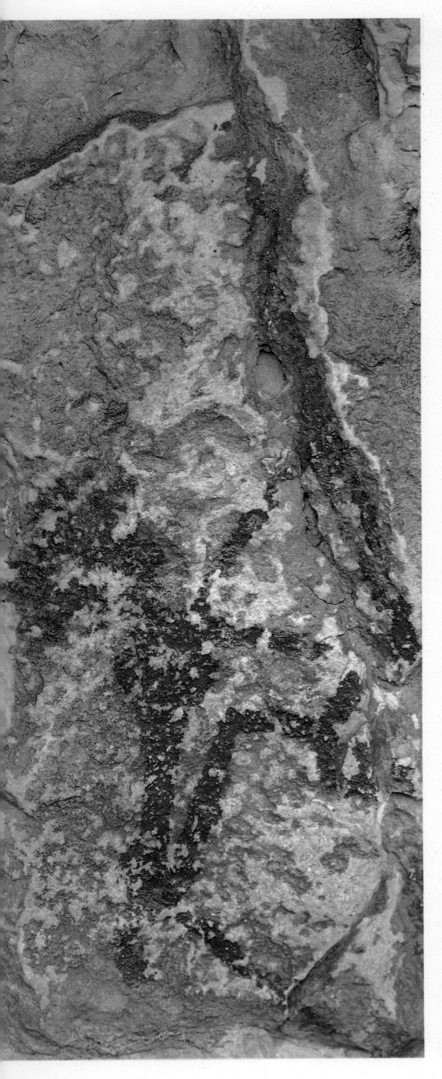

in red. A second type was created by covering the hand with pigment and pressing it against the surface so as to leave a solid-color imprint. It is an easy temptation to conjecture that these handprints, often found near the entrance to the cave, may have identified a priest or chief or tribe, or were perhaps intended to signal some especial content or function.

Outline drawings, usually in black, but sometimes in red, came somewhat later than the hand sketches. Early outlines of musk ox, bison and mountain goat show a simple but effective style. Much "portable" or household art has been uncovered. Meant to be placed in cave dwellings or rock shelters, it was fashioned from pieces of rock, bones or antlers, and sensitively etched with images of animal heads, fish (sometimes with crosshatching to denote fishnets) and birds.

These tentative gropings finally exploded into a procession of superlative paintings of animal figures on a life-size scale. Upon viewing these brilliant multicolored works one feels that they are hyperrealistic, that in addition to showing the animals as they looked when alive (or dead), they are infused with a quality of permanence. The paintings, especially those of Altamira, make it plain that these artists were highly imaginative technicians as well. Their style and perspective are amazing not only for their time but for any time.

The main picture gallery at Altamira, where the walls and the entire ceiling are covered with paintings, must have required many men working for many years. It is difficult to understand how they managed to get into position to work on the almost inaccessible ceiling areas where they produced such incredibly detailed work. Their labors can only be compared to those of Michelangelo on the Sistine Chapel ceiling. Their efforts seem even more startling when one remembers that the interiors of the caves were pitch-dark except for dim islands of light provided by flickering torches.

The Cantabrians, while the first to produce a pictorial record of prehistoric times, were not the only ones to do so. As glaciers formed and waters receded, a land bridge rose between North Africa and southern Spain. It is believed that across this bridge a second group of people, dating back an estimated 6,000 to 10,000 years, trekked into the Iberian peninsula. Their record is painted and carved on precipitous rock outcroppings and cave entrances throughout southern and eastern Spain, particularly

On a sheer, almost inaccessible, cliffside, a prehistoric man climbs a vine in this example of rock art of the southeast.

in the region known as the Spanish Levant.

Like the tribes of the north, they emphasized the hunt in their paintings. But their art reflected in some respects a more evolved civilization. They made drawings showing men and women in attitudes and at chores that heralded the dawn of agriculture, the domestication of animals—hence, the beginning of husbandry—and the securing of food from difficult sources, as by robbing beehives. Their pictures were drawn almost exclusively outside the caves, usually on a sheer cliff wall with a rock overhang. Perhaps to save these images from the ravages of man or the elements, they were executed in almost inaccessible areas on the underside of the rock shelf. As with the paintings in the vaults of northern caves, it is hard to see how these Levantine artists got into the positions necessary to draw their effective, though much more sketchy, scenes.

The people of the south seemed more concerned than those of the north with human activities and the relationship between human beings and animals. There are many scenes of men pursuing animals, and some of animals pursuing men. In what looks like a religious ceremony, men stand in a circle while women, clothed only in skirts, parade in the center.

They emphasized the sex of both men and women, and in their sketches of nude running figures the male sex organs are usually exaggerated. When clothed, men are shown wearing short breeches similar to those worn in some parts of Spain today. Women wore skirts reaching to the knee. From the waist up they are shown nude, and all have heavy, pendulous breasts.

Levantine art spreads over six major areas and, although each area is distinctive, they have one thing in common: the paintings are located on a hazardous cliffside and the drawings are invariably difficult to reach.

During the latter part of the Stone Age, prehistoric man turned increasingly from hunter to tiller of the land, fisherman and keeper of herds. He moved out of the caves, which he still preserved as places of burial and worship. Tribes that had formerly lived in complete isolation now began to form communities along the seashores and rivers, and learned to navigate. Contact between tribes. brought a beginning of commerce, but also led to rivalries and wars and, as a by-product, to improved ways of trading and fighting. Man discovered the use of metals.

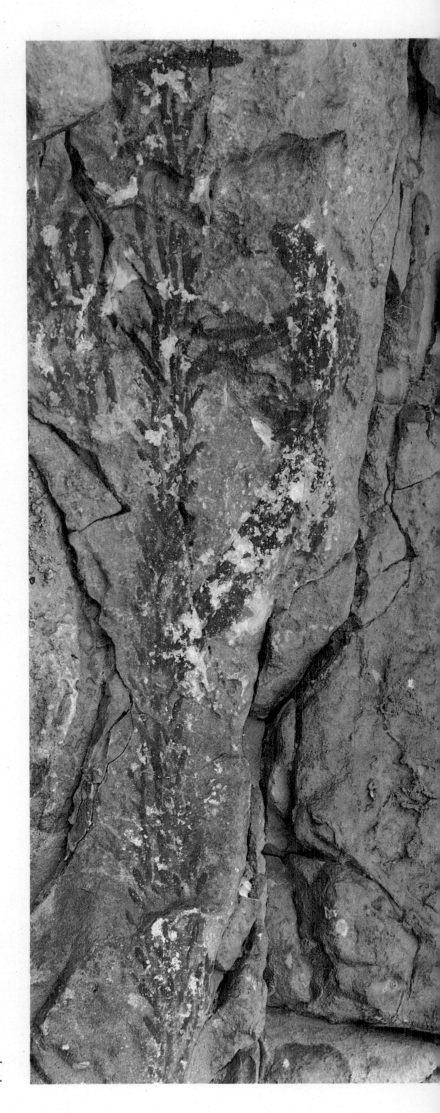

A woman climbs a leafy tree, possibly to a tree shelter.
This drawing is in the Teruel region, also known as the Levant.

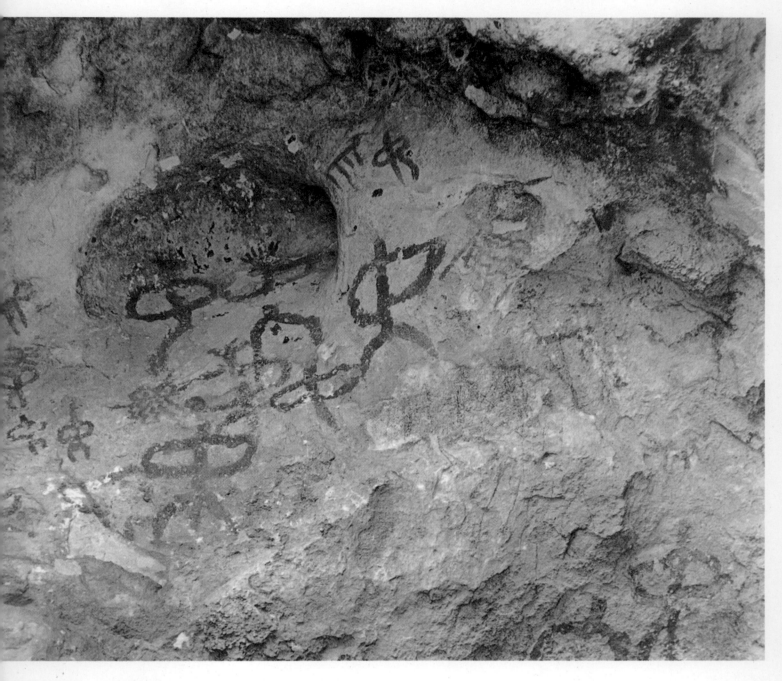

Late rock art in the Cueva de la Graja near Jaén shows semiabstract schematic figures in a variety of postures.

Art in this transitional time reflected an increasingly utilitarian frame of mind. Neolithic man was more potter than painter, more architect than sculptor. In contrast with the realistic art of the Cantabrian cave dwellers, his paintings were highly schematic and stylized. Intellectual elaboration and geometric pattern superseded the direct representation of keenly perceived subject matter. Still, this stylized art shows the same mastery of movement and rhythm.

Once out of the caves, the Neolithic people of the Iberian peninsula began to build stone huts, to be used either as living quarters or as funeral chambers and monuments. Among the most important of these was the *dolmen,* a structure made up of

a few large stones topped by a horizontal slab. The crude shelter thus formed had an entranceway and, inside, stone rooms set in a circle with a narrow passageway. When used as a tomb, the Iberians placed inside it the bodies of their dead, and sometimes made etchings of crude human figures on the stone blocks in the dark interiors.

Another interesting structure was the *menhir,* a crude stone obelisk used to commemorate great events. From the etchings found on some of these structures it has been surmised that they were also used as objects of worship and as funeral steles. A circle of menhirs formed a *cromlech.*

These early architectural works, known collectively as *megaliths* (giant stones), while common in

A group of archers at Alacón (Teruel) lift their arms as a sign of victory or perhaps in the ecstasy of a hunting ritual.

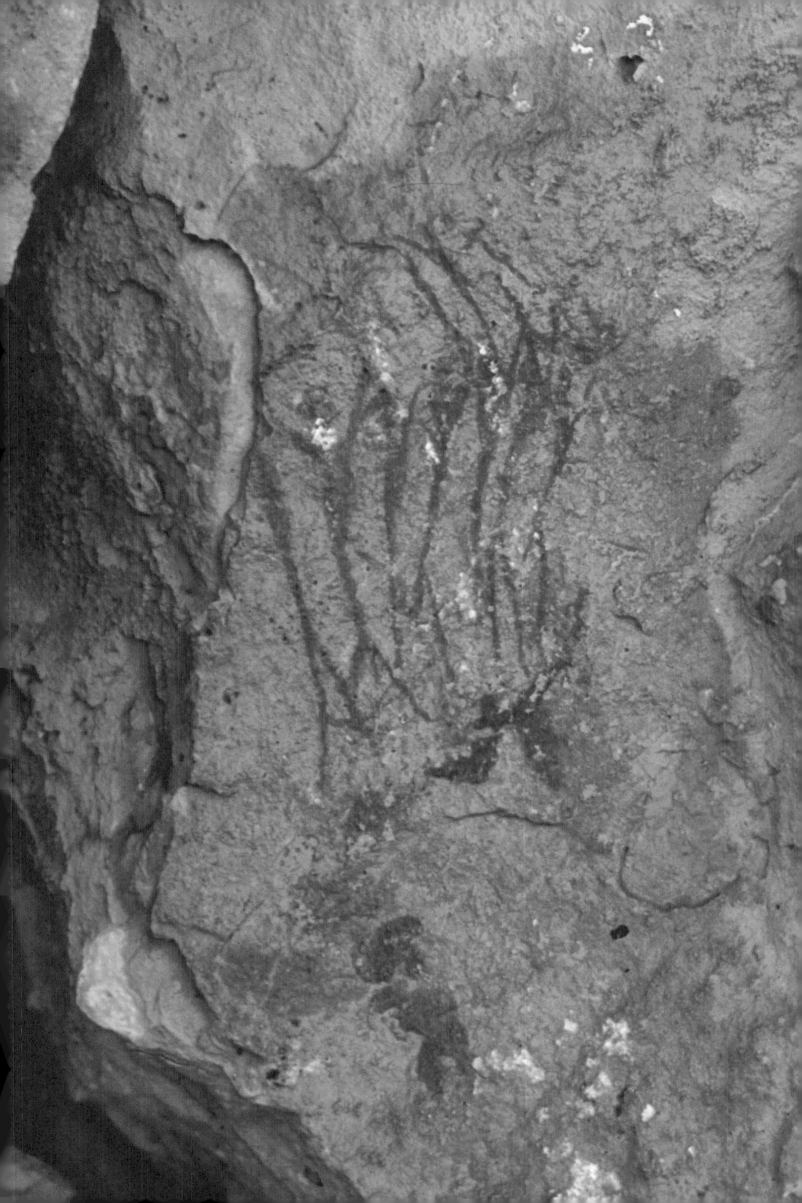

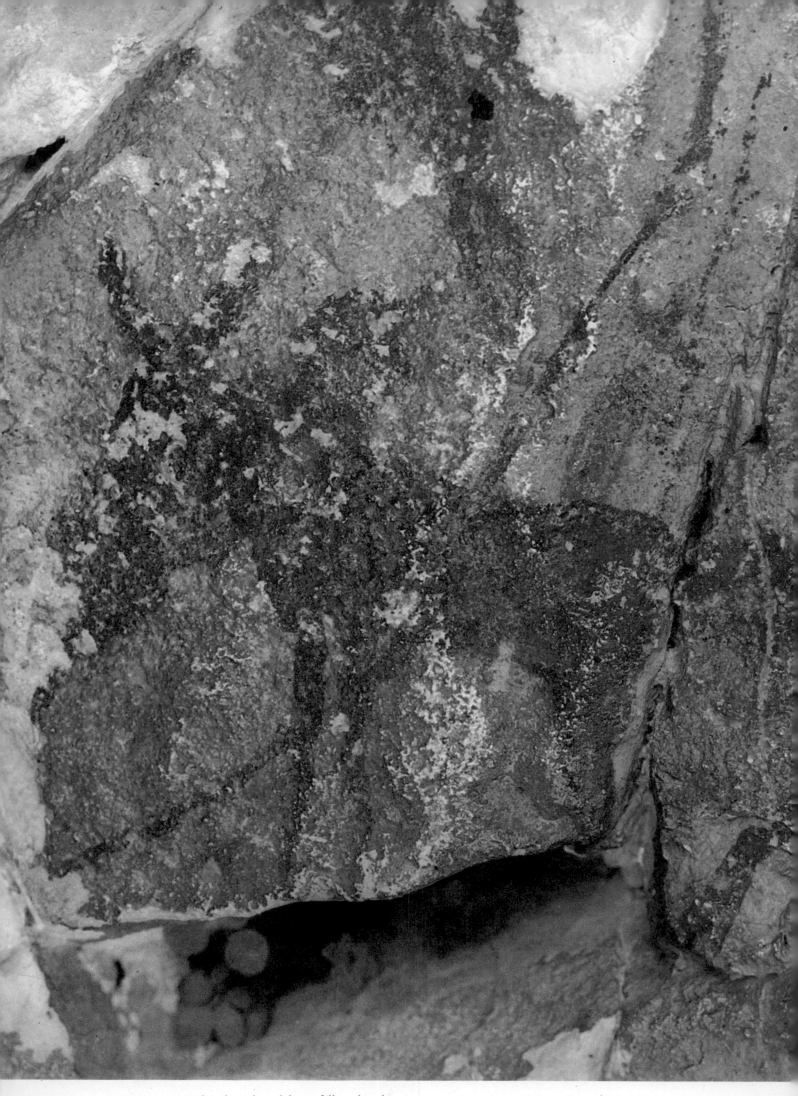

A deer (note horns) being followed or driven,
may be the earliest evidence of domestication of animals in Iberia.

At bottom, a man is skinning or butchering an animal he has killed. The man above is running toward the scene.

the Iberian peninsula are also to be found elsewhere. In fact, their very names are of Breton origin, and one of the most famous examples of megalithic art is Stonehenge, in England, where a group of concentric blocks of stone (menhirs) are arranged around a dolmen that faces east. It is believed to have been a temple of sun worshipers; recent investigations seem to indicate that this arrangement had definite astronomical uses and may have allowed Neolithic man to compute the time, the seasons and the cycles.

Beginning with the first use of metals, between 3000 and 2500 B.C., it became possible to date subsequent cultures more accurately. Metal tools, weapons and household utensils give a rough chronology of human development. Yet, the dividing line between late prehistoric and early historic men is anything but clearcut, since they both lived under similar conditions, used similar tools and painted similar pictures. By the time written history dawned, the occupants of the Iberian peninsula had some impressive achievements to their name, particularly in the field of art. These had taken long millennia to bring about; now the changes were to come at a

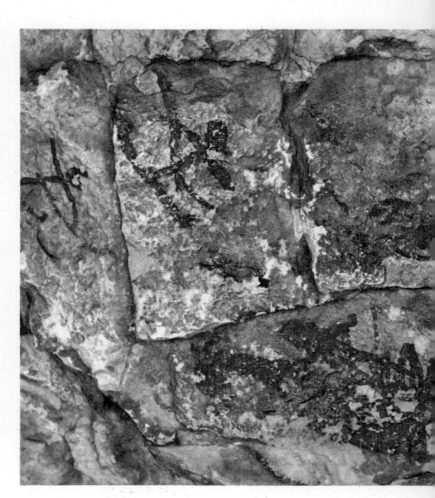

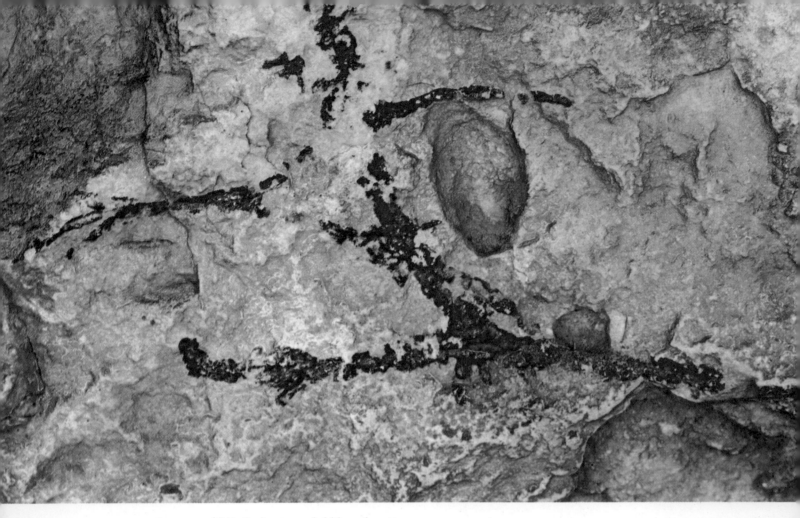

Running at full tilt, legs extended like a dancer's, a nude warrior with bow in hand is seen on the wall at La Casulla.

quickened pace. But a great many of the basic ingredients that went into making Iberian man had already been developed and, to an extent, fixed.

Such were the players rehearsing for the drama of history. The stage on which this great adventure was to unfold has changed little geologically since the last ice age. The northern coast of the Iberian peninsula, birthplace of the cave painters, is full of coves and rolling hills. To the east, the great bulwark of the Pyrenees rises to separate Iberia from the rest of Europe. Today the peninsula is divided into Spain and Portugal, with Spain covering four fifths of it, or some 190,000 miles out of a total of about 225,000. Spain alone is twice as large as Great Britain, one third larger than Italy, and almost the same size as France. It is a country physically isolated by mountains and seas. Within its confines it affords as great contrasts in terrain and temperature as can be found anywhere in the world. Snowy peaks rise even higher than the Alps to look down on sun-drenched valleys rich in forests. From the north the sloping country slowly changes to great arid plains, which turn into moonlike deserts as one reaches farther south. The center of the peninsula is one vast, level tableland, but even this is broken by high peaks; mountains are always visible in the distance.

Cutting through the central plateau are deep canyons and gorges rivaling any in the New or Old Worlds. The Mediterranean area, where the Levantine prehistoric art flourished, has a more benign climate. There native or transplanted cork, bay, olives, oranges, lemons, figs and dates grow along the coast and into the hills beyond.

Because of the extreme climatic contrasts—from tropical through temperate to arctic—the variety of flowers and plants found in the Iberian peninsula is greater than in any single area of similar size in the world. And the mineral wealth—ranging from coal to copper, gold, silver, iron, mercury and lead—though greatly depleted in the last millennium, is still considerable. Recently the known reserves have been increased with the finding of the largest deposits of uranium in Europe.

But as recorded history began, the mineral deposits of the peninsula had been hardly scratched by the first users of metals. News of these riches traveled on ships to the far corners of the Mediterranean and—together with the alluring image of Iberia as the farthest land to the west of the then known world—was to attract successive waves of merchants, invaders and colonizers, who would further shape and reshape the Spanish character.

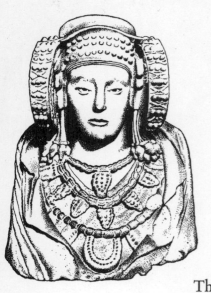

1600 B.C.–A.D. 711
ANCIENT SPAIN

The Iberian peninsula receives the political, economic and cultural influences of a series of powerful Mediterranean civilizations—Phoenicians, Greeks, Carthaginians—culminating in the Roman conquest. Celts intermingle with Iberians to first resist the Latin invaders and later become Roman subjects. As the strength of Rome wanes, the Visigoths enter from the north to dominate the Roman and indigenous cultures.

HISTORICAL CHRONOLOGY		ART CHRONOLOGY	
B.C.		**B.C.**	
pre-16th c.	Iberians are settled in the peninsula.	pre-16th c.	Iberian ceramics; falcata sword, diadems, buckles, bracelets and rings.
11th c.	Phoenician trading post at Gadir (Cádiz).	10th–15th c.	Phoenician hypogeia; sarcophagus in the shape of a human figure at Punta de la Vaca (Cádiz). Gold belt and other treasures.
10th c.	First Celtic penetration.		
6th c.	Greeks establish colonies.		
6th–3rd c.	Arrival of Carthaginians. Celts and Iberians merge to become Celtiberians.	6th c.	Celtic decorations for war chariots and horse harnesses using gold, coral or enamel inlays. Gold collars. Stone statues of animals called Toros de Guisando. Greek vases of alabaster at Ampurias; bronze statuettes.
219	Carthaginians begin Second Punic War. Hannibal crosses Alps into Italy.		
218	First Roman army arrives in Spain.		
205	Romans drive out Carthaginians.		
2nd c. B.C.– A.D. 1st c.	Conquest by Romans. Destruction of Numantium (Numancia) 133 B.C.	6th–3rd c.	Iberian sculpture, including famous Lady of Elche and Bicha de Balazote, from Cerro de Los Santos, which show Greek influence. Carthaginian sarcophagus at Cádiz; ceramics and coins.
A.D.			
end of 1st c., start of 2nd c.	Christianity is preached in Spain.		
1st c.– start of 5th c.	Rule by Romans.	2nd c. B.C.– A.D. 5th c.	Roman temples, amphitheaters, theaters, aqueducts, statues, mosaics, painted vases, gold objects of art. At Mérida, Tarragona, Sagunto, Itálica, Segovia, Alcántara.
400	First Council of Toledo.		
409	Germanic tribes enter Spain.	**A.D.**	
414	Visigoths conquer other Germanic tribes.	414–710	Visigothic church of San Juan de Baños, Palencia, with horseshoe arches and rough capitals; votive crowns, crosses, jewelry and coins from the Guarrazar treasure found near Toledo.
587	Conversion of King Recared.		
710	King Roderick sets stage for Moslem invasion of Spain.		

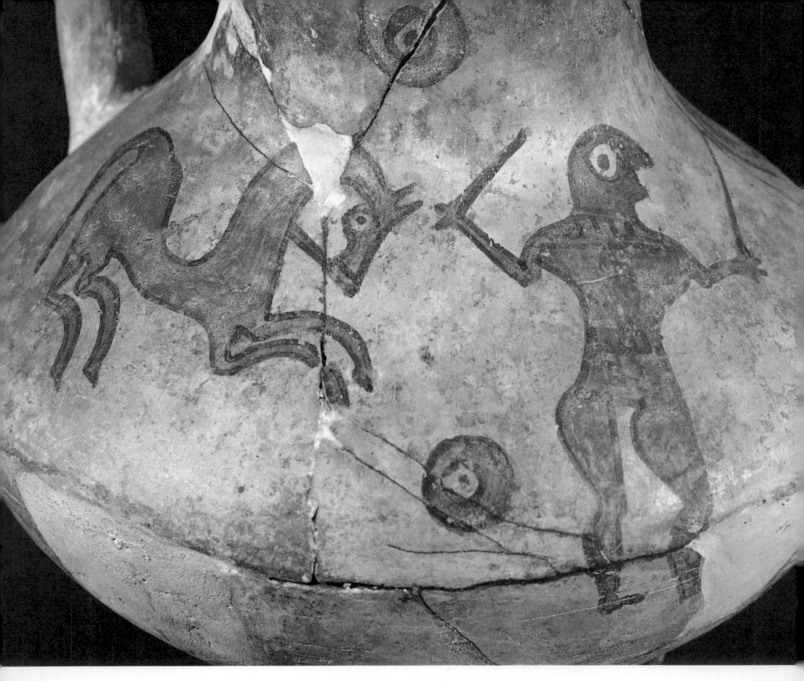

Carrying a whip and a short sword, the Celtiberian on this vase may be a trainer of horses or a cavalryman.

The Roots of Spain

The Greek geographer Strabo, who wrote in Rome shortly before the birth of Christ, referred to the Spanish peninsula as Iberia. In a revealing sentence in his *Physical Geography* he observed: "If the extent of the Atlantic Ocean were not an obstacle, we might easily pass by sea from Iberia to India." This obstacle, 1492 years later, turned out to be not so much the Atlantic Ocean as the New World.

The country had at least two other names. The Greeks referred to it as Hesperia (from *hesperos*, west)

and the Carthaginians called it Spania ("land of rabbits"). But the name Iberia probably derives from a Celtic word meaning river, for a center of Iberian culture was located in the green valley of the Ebro River.

In the centuries before Christ, when the ancient historians made mention of the Phoenician, Greek and Carthaginian penetrations into the peninsula, they described a people with a distinct appearance and language. These Iberians, they wrote, were small but sturdy, broad-shouldered and olive-skinned. They were alert and learned quickly from their contacts with the Mediterranean world.

First appearing in southern and eastern Spain, the Iberians are believed to have come from Africa crossing over a land bridge then in existence. Another theory has them coming in a seaborne mi-

gration, using small craft to cross the Mediterranean.

They worshiped the sun, the moon and a god of war called Neto. Their special ceremonies were held on the occasion of the full moon; one early historian records that an Iberian tribe stopped fighting in the midst of battle because of a lunar eclipse. Rivers, springs and mountain peaks were included in their pantheon of deities. Religious rites were performed in natural sanctuaries located in wooded groves and in grottoes. Roman historians noted that the Iberians of the south offered human sacrifices and that their priests made predictions after observing the flight of birds or the direction of flames in the wind. But then the Greeks and Romans also made human sacrifices and their priests observed the same natural signs as portents of the future.

We know that the Iberians were farmers and that they domesticated animals for food, clothing and transportation, as evidenced by the remains of stockades located within their walled villages. Short breeches and belted tunics were woven from hemp and flax, and some styles reflecting the wearing apparel of these ancient dwellers can be seen in modified form even today in southern Spain.

They went into battle with the *espada falcata* (forged sword), which later became famous throughout the Roman Empire. It was designed for both slashing and thrusting. In this efficient weapon the blade was sharpened to a fine point and the cutting edge ran across the entire front and down one third of the back. Pommels were usually decorated with a bird or a horse's head. The *espada falcata* was valued for its temper, and the forging of these weapons was perhaps the earliest of Iberian industries.

Into the peninsula, from the east, came the Celtic invaders, who first fought the Iberians and later became integrated with them in a new culture—the Celtiberian. A vigorous race of warriors migrating from the Danube basin, the Celts first spread south from Austria and Bavaria, over the Alps and into Rome, which they attacked and sacked 400 years before Christ. Rome bought them off with land and gold, and they went on westward. A major Celtic base was founded at Massilia, a strategic harbor which had previously been occupied by the Greeks on the Mediterranean where the city of Marseilles now stands.

In contrast with the Iberians, the Celts were a medium-to-tall, often fair, usually blue-eyed people. Early Greeks referred to them as Keltoi, and the

Greek writer Herodotus recorded the diffusion of the Celts over much of the Iberian peninsula. Here a great Celtic expansion took place in the 5th and 4th centuries B.C. After penetrating deeply into the eastern region they continued to push west into the central plateau. They had a great advantage over the Iberians for they were great horsemen. This mobility made them almost invincible. By force of arms they finally succeeded in extending their influence as far as the Atlantic coast of Iberia.

Their reputation as fierce and unconquerable warriors preceded them. Wearing gold collars around their necks, golden amulets, horned helmets and sandals, their early leaders went naked into battle with their troops. Riding out before his men, the chief of the Celts would hurl a challenge at his enemy. He would first identify himself, tell how strong his ancestors had been and how invincible his army was; only then would the battle be joined. This vocal challenge became part of the Iberian battle ritual and, hundreds of years later, El Cid, champion of Christianity against the Moors, stood out before his army and exclaimed: *"Feridlos, caballeros, por amor del Criador! Yo soy Ruy Díaz, el Cid de Bivar Campeador!"* ("Thrust, my horsemen, for the love of the Creator! I am Ruy Díaz of Bivar, the chief, the brave one!"). Celtic warriors carried lightweight swords of iron and short spears that could be hurled at the enemy, plus a jeweled dagger for hand-to-hand combat. Two-wheeled war chariots were used to break the enemy ranks. Well-trained battle horses carried the cavalry forward.

Modern-looking bust of an Iberian woman shows arm- and waistbands and painted breasts or breastplates.

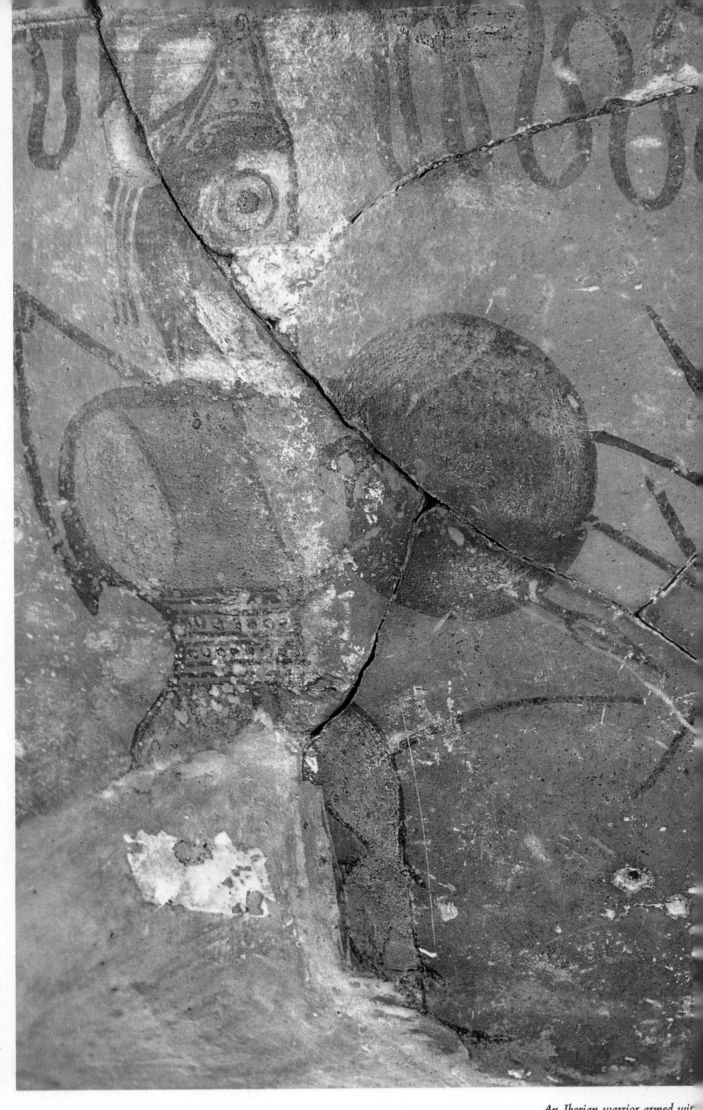

An Iberian warrior armed wit
spear and shield prepares to do battle against a Celtiberian (o

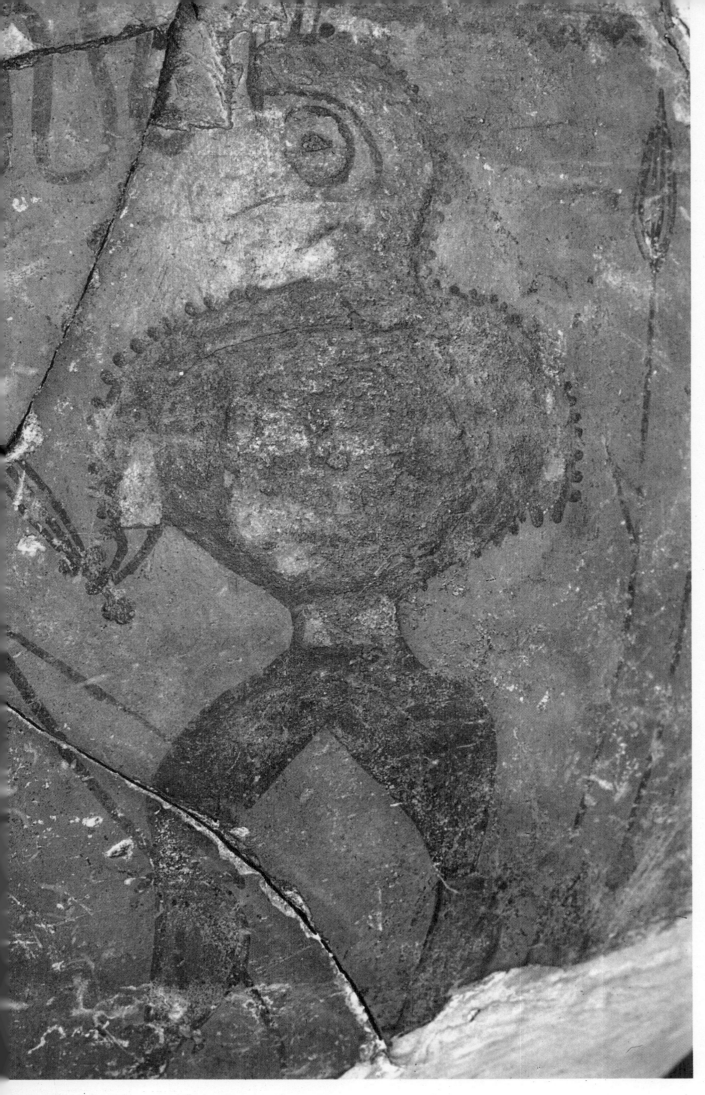

Celt) who has the falcata (short sword) and elaborate helmet
typical of the times on this vase fashioned in the 4th century B.C.

Trappings for horses and chariots were intricately decorated, sometimes with gold, coral or enamel.

After conquering the central plateau, they worked their way into the mountains of the north. Evidence that they were cattle raisers can be found in numerous representations of domestic animals, pigs, bulls and boars, all carved in granite.

The merging of Celts and Iberians into a distinctive Celtiberian culture took place over the next 300 years. This blending may have been hastened by important similarities in their rites of worship for, like the Iberians, the Celts were devotees of nature. The sun and the moon, water and fire, were their gods, and rites were held in wooded groves exposed to the elements. There was one important difference—they had priests who came from a clerical nobility known as Druids.

The Celts brought a well-defined culture with a distinctive language. Many place names and other words that survive in Spain can be traced to Celtic roots that also went into making other words in Gaelic and Welsh. One example, among many to be found throughout Spain, is Galicia, the northeastern region they once occupied. Another word of Gaelic origin still used is *cerveza* (beer).

Prior to entering the Iberian peninsula, the Celts had spread throughout France, where they were known as Gauls. They remained dominant there until the Romans finally had their revenge for the earlier sacking of Rome. In the 1st century B.C. the Roman general Julius Caesar defeated them and occupied Gaul.

As early as the 5th century B.C. the Celts had swept over England, Wales and part of Ireland. That the emotional reflexes of the present-day Spaniards and present-day Celts show similarities—both quick to anger, romantic rather than realistic, intent upon guarding their personal honor, having a ready wit, and subject to extremes of great gaiety and abject depression—may be due in part to their highly diluted but common ancestry.

Whether moved by a common method of worship, or by a need for the agricultural and stock-raising skills of the Celts—or even by the basic requirement of defending themselves against other invaders—the fact is that the Celts and Iberians progressed and prospered together.

Soon walled towns, complete with stone fortresses, were changing the appearance of the sea-coast and the countryside. Inside the town, straight

In an ancient war canoe, one warrior brandishes a bow. The scene may show early invaders along the Mediterranean coast.

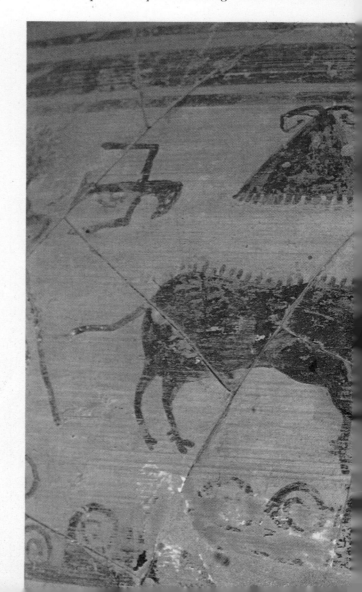

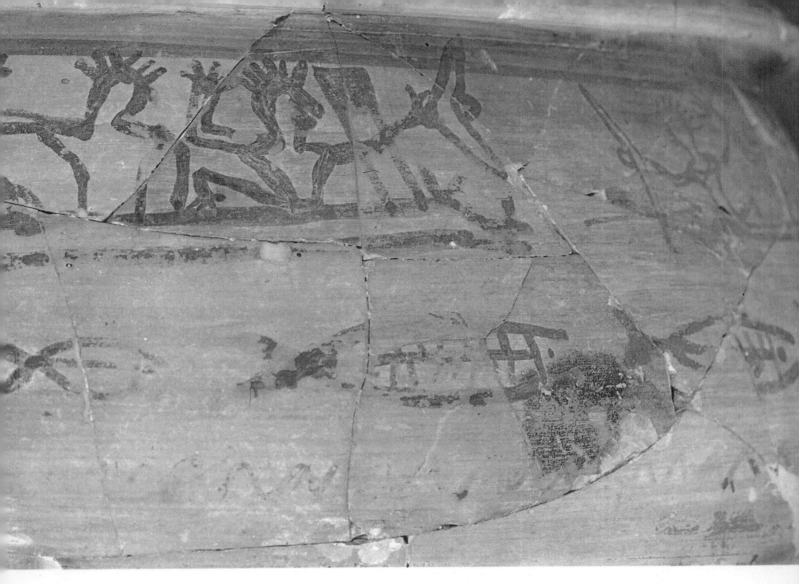

A priest of a bull cult, or a bull train-
er, appears on this Iberian clay vessel of the pre-Roman period.

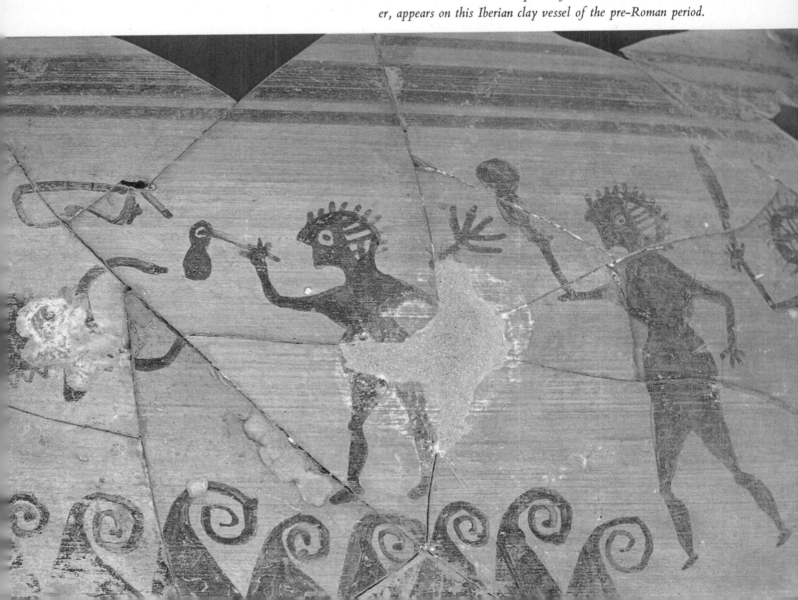

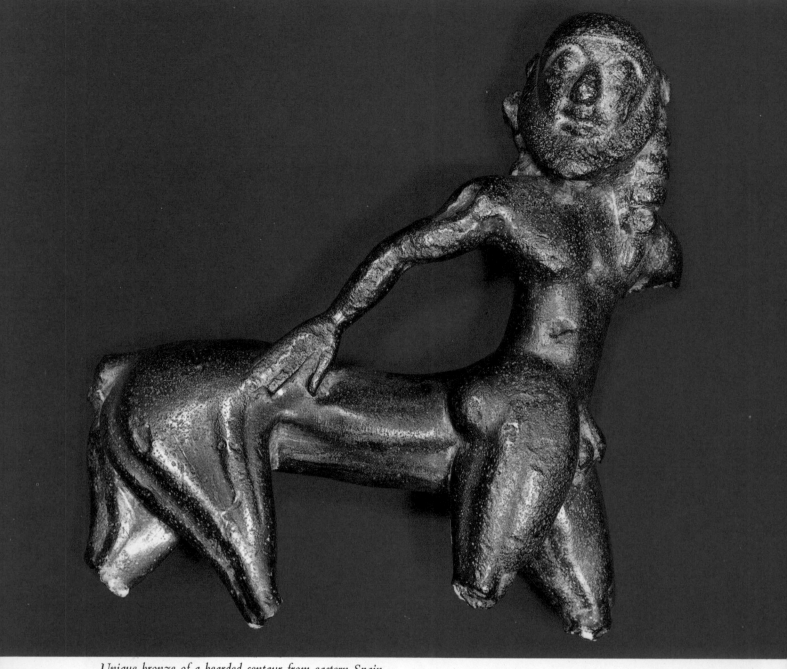

Unique bronze of a bearded centaur from eastern Spain. Dating from the 6th century B.C., *it shows strong Greek influence.*

streets flanked by stone sidewalks led from fortress to fortress. These ancient communities were said to have populations of 5000 to 10,000 persons. One of them, Numancia (Soria), later became so prosperous that both Carthaginians and Romans coveted it and fought for it.

Nevertheless, the first of the older Mediterranean civilizations to penetrate the Iberian peninsula was that of the Phoenicians—an ancient maritime people who had extended their trading areas throughout the Mediterranean, up to the Scilly Islands off the coast of England, and perhaps to the Baltic Sea. On the southwestern coast they founded the trading post of Gadir, which was to become

famous as Cádiz, an excellent seaport and the oldest continuously inhabited city in Spain. Phoenician merchants, undoubtedly including Greeks and Hebrews who had settled in Phoenicia, imported timber, iron and resins, and in turn exported carved ivory, embroideries and objects of gold and bronze created by their talented artists. But the most important contribution the Phoenicians made to ancient Spain was their alphabet, which consisted of 22 letters representing sounds. With this important tool, dating back to the 13th century B.C., recorded history began in Spain.

The Phoenicians may also have contributed to the art of bull-baiting in Spain. Their connections

Wrapped gracefully from head to toe in her mant. this charming portrait of an Iberian woman is of the 3rd centur

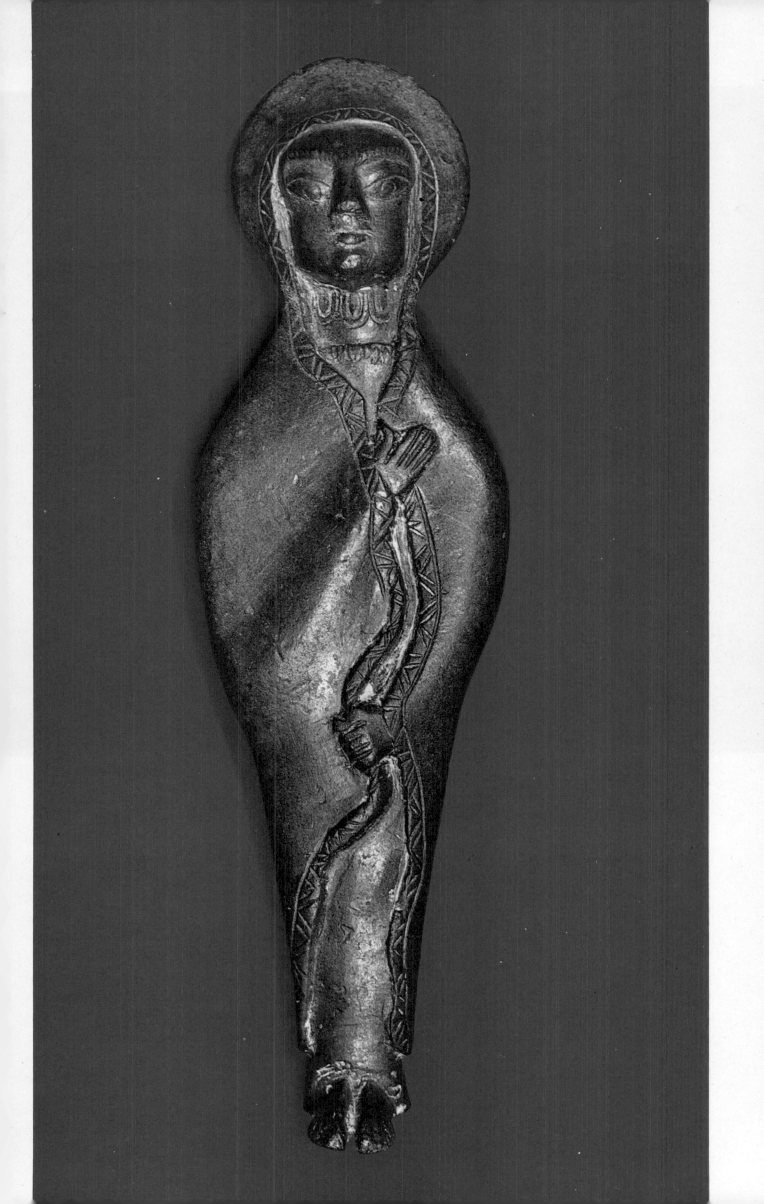

with merchants in Crete, where bull-dancing and bull-baiting had a long tradition, may account for the early figures of man and bull on Celtiberian pottery. The Celts, however, already had a bull god and domesticated bulls. No doubt the Phoenicians were familiar with legends, and possibly facts, about the kingdom of Minos and the palace at Knossos, which seems to have been the center of the cult of the bull in the ancient world.

The Phoenicians left little of their culture, being traders rather than colonizers, and their influence on the Spanish peninsula was transient. Nevertheless, their economic impact must have been considerable and it probably attracted the next wave, made up of colonists.

These were the Greeks, who founded permanent colonies and had an important cultural influence on Iberia. Some of these colonies have been identified. Excavations at Ampurias (originally Emporium), on the northeastern coast, have revealed a fortified town with remains of Greek houses and a shrine to Aesculapius, the god of medecine.

The newcomers exploited the mineral wealth of the peninsula and, in return, brought olive trees and planted grapevines. Even more important, they brought to their colonies an advanced culture, including the philosophical and mathematical works of Pythagoras and the Homeric epics of the Iliad and the Odyssey. Apparently, by the time of the Greek colonization the people of the Iberian peninsula had developed a culture of their own that was ready to absorb the gifts brought by the Greeks, for their art forms advanced rapidly.

Much sculpture of this period shows Greek influence, especially those objects found in the province of Murcia, which was the center of a large Greek settlement. The art of the colonies in Spain paralleled the peak of sculpture and vase painting in Greece, and this is clearly reflected in the ceramics and figurines of the Iberian peninsula. Perhaps the best known piece of Iberian sculpture, the strong and strangely beautiful "Lady of Elche," shows definite Greek traits. Yet there is nothing in Greece like it—the Lady is distinctly Iberian.

After a few hundred years, the Greek colonies had either been absorbed into the peninsular life or were decimated by the next invasion.

This came dramatically in the year 236 B.C. when

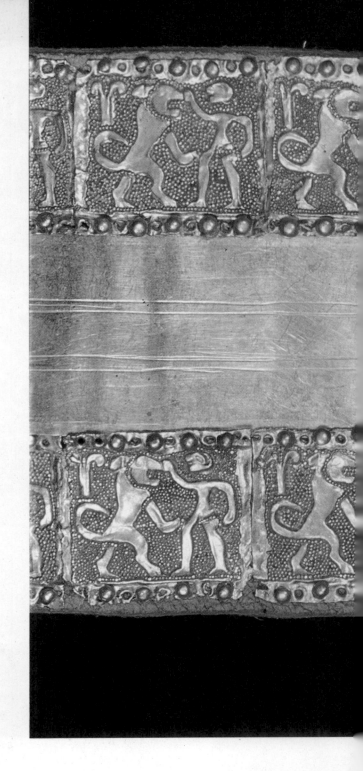

the Carthaginians, led by Hamilcar, his son-in-law Hasdrubal, and his son Hannibal, a child of nine years, arrived with a disciplined army and a powerful herd of African elephants trained in warfare.

Using the human and material resources of Iberia—including the extensive iron mines and the sword forges—Hamilcar built a huge army. With it he planned to attack Rome and change the fortunes of Carthage, which had suffered at the hands of the Romans during the First Punic War, a bitter campaign for the possession of Sicily. But putting together his Celtiberian-African army proved a difficult task. The Celtiberians resisted and Hamilcar

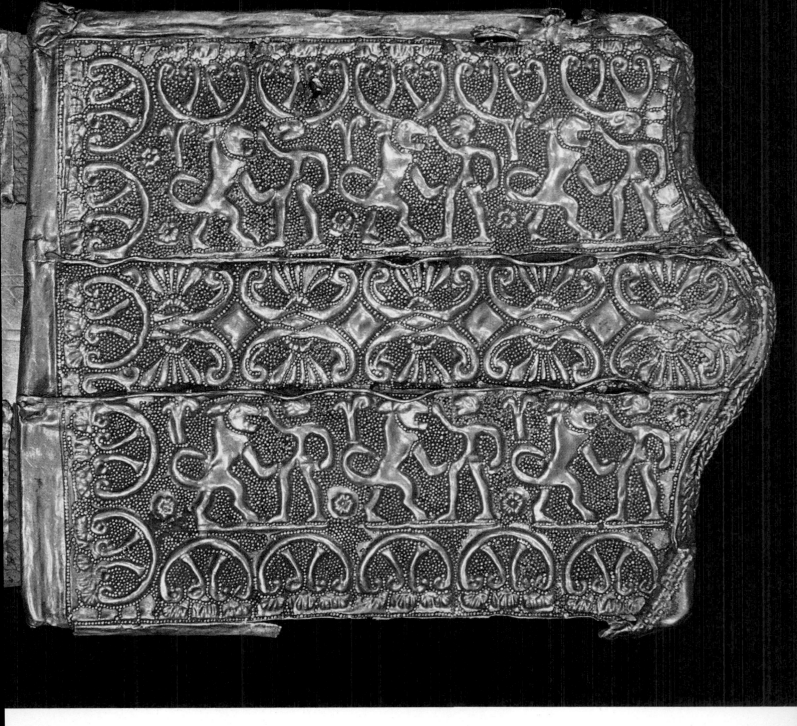

This Phoenician gold belt, with four relief motifs of a man fighting a lion, is ranked among ancient Spain's treasures.

was killed before he could lead his legions and elephants on to Rome. His son Hannibal was 26 years old when he took command of the army. His first move was to attack the fortress city of Saguntum, a Roman protectorate near the present city of Valencia, on the eastern shores of Spain. The occupation of this prosperous city provided a fiery opening for the Second Punic War. Leaving his brother-in-law Hasdrubal in command of Carthaginian forces in Spain, young Hannibal now set forth on his famous march across the Alps, with some 28,000 Celtiberian and African soldiers. He won a series of important victories, but Rome itself held out. Rome had hoped to fight the Carthaginians in Spain, and to this end sent a military expedition against Hasdrubal's army at a time when this general was absent from the peninsula, having been called away to Africa to subdue a revolt in the Carthaginian colonies. The Roman army in Spain enjoyed a brief period of victory, until Hasdrubal returned and routed it. For eleven years he built up his own army, and finally, when called by Hannibal to come to his assistance, Hasdrubal went into Italy. There his men were defeated and he was killed before the two Carthaginian armies could meet.

In Iberia, Rome had intelligently maintained a

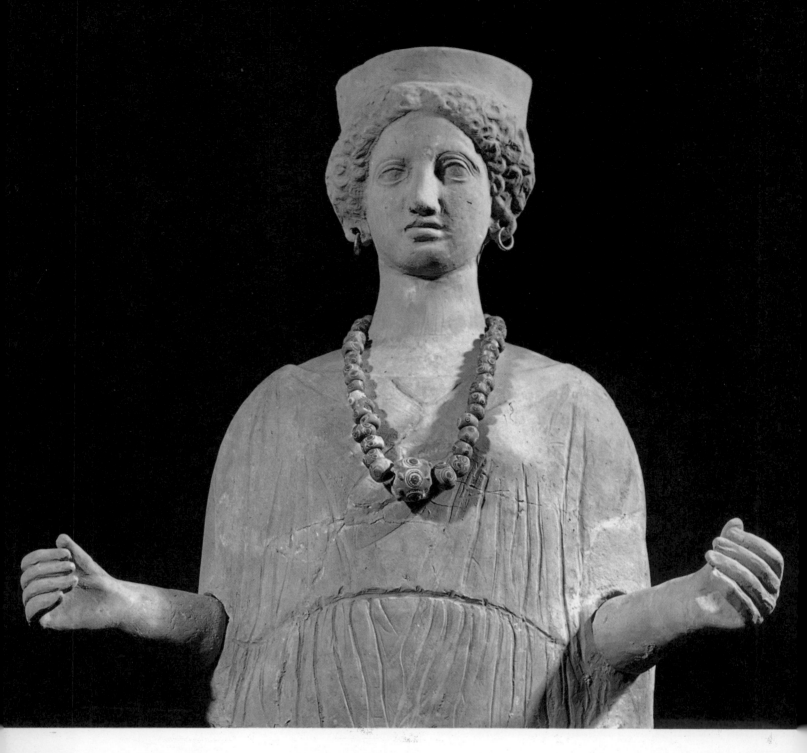

This Carthaginian sculpture, which looks like the figure of a priestess wearing necklace and earrings, comes from the island of Ibiza.

small army, which now seized the leading enemy stronghold of New Carthage (today's Cartagena). Thus began the destruction of Carthaginian strength. The Roman general Scipio was primarily responsible for the victory, and, following his success in Spain, he was given a larger army and a fleet with which to attack Carthage. With the final defeat of Hannibal and his armies, all Carthaginian possessions in Spain became provinces of Rome.

The Celtiberians, however, were in no mood to change masters. The Carthaginians had at no time occupied more than a small portion of the country, while the Celtiberians had developed cities and

provinces that were largely self-governing. One of the most important Iberian provinces, called by the Romans Lusitania, became a center of the resistance. Viriathus, the first in a long line of Iberian heroes, fought a series of victorious battles against the Roman legions. The city of Numancia (Soria) was besieged by the Romans but held out for many months. After setting fire to the town, most of the citizens killed themselves rather than surrender. Viriathus was assassinated by a group of his own leaders who had accepted money and high offices from the Romans. This ended the last effective resistance to Roman control, except for a few pockets

that continued to hold out in the Cantabrian mountains and were never fully controlled. After 200 years of Roman invasions, Spain finally became an important part of the expanding Roman Empire.

To Iberia Rome brought the highest civilization then known to Europe, and it was very high indeed. For Rome had absorbed much that was great in Greece and, by the time Christ was born, could offer Iberia the advantages and benefits of Roman law, engineering, family unit organization and city planning. Romanization meant farm-to-market roads and bridges to crisscross the fertile valleys and provide access to the rich mineral deposits. Aqueducts were built to carry water to the well-planned cities; effective sewerage systems were dug, and luxurious public baths constructed.

Roman law brought a new concept of government, for in spite of the many abuses and tyrannical dictators, it developed certain democratic aspects. Over the centuries, as government in Iberia reflected the changing mores of Rome, the Iberian legal system came to embrace the idea of equality of all men before the law, instead of having one law for slaves, another for freemen and a third for citizens.

But the greatest factor in Iberian cultural and economic prosperity was the expansion of the Roman world itself. The Roman Empire grew to encompass North Africa (including Egypt and the Arab world), all of the European mainland (except Germany), and England and Wales. This expansion had a direct bearing on the development of the Iberian peninsula. Silver and lead flowed in a steady stream from the mines of Almería and Cartagena (a contemporary historian wrote that 40,000 slaves worked the mines at Cartagena); copper came from Huelva, iron from Galicia and gold from the valley of the Sil River in the province of Lugo. After mining in importance came agriculture—and wine, grain, wool, hand-loomed textiles, sheep, cattle. Iberian-bred Arabian horses went out to the markets of Europe and Asia. In great demand throughout the Roman Empire were Iberian swords, spears and knives from Turiaso, Bílbilis and Toledo.

In exchange for all this, tools, pottery, spices, silks, embroideries and jewelry came into the Mediterranean ports of Saguntum, Gades (old Gadir) and from there northward up the Guadalquivir River, to Sevilla and Mérida, and from the cities fanning out over the hills, mesas and mountains.

But by far the most valuable import was the

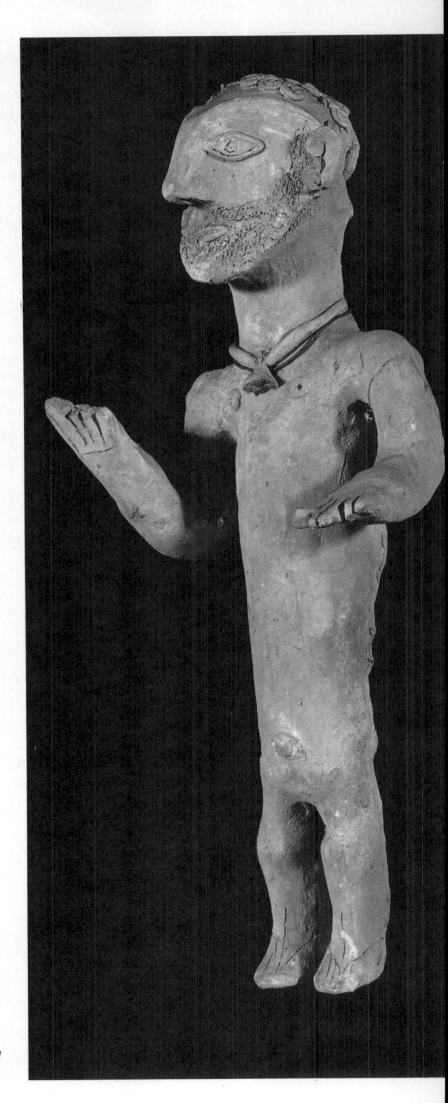

Bearded, short-legged man is Carthaginian, and
was created of terra cotta between the 5th and 2nd centuries B.C.

culture of Imperial Rome. Between the 1st and 5th centuries A.D., Iberia was a central part of the greatest empire on earth. The pervading influence of Roman philosophy, laws and arts changed ancient Spain from a semicivilized, unorganized nation with little written language and a culture limited to sporadic contacts with the Mediterranean world into a well-organized country with a well-educated citizenry that spoke and wrote Latin and was in constant touch with the world of that time.

This economic and cultural evolution started in the 1st century B.C. with the advent of the emperor Augustus Octavian. During his regime, the north and northwest provinces, home of the warlike Celts, were attacked and, with great losses of men, finally subdued. These Cantabrian wars raged for six years in the rugged northwest provinces of Santander and Asturias. So fiercely did the mountain people fight that Augustus himself had to come from Rome to lead his legions. In the midst of the Roman offensive he became ill and was forced to return to Rome. His chief deputy, Agrippa, pursued the war with vigor and finally vanquished the rebellious Celtiberians on the Astura (Esla) River in the year 20 B.C. Yet these fiercely independent people were to continue sporadic revolts. Unlike most of the peninsula, they never became completely Romanized.

In these first hundred years of Roman domination, from Augustus to the Antonines, art forms borrowed by the Romans from Greece were dominant in vases, sculpture and architecture. Most, however, were influenced by the Iberians who, as they had done with the creations of the early Greek colonists, gave them a fresh, distinctive appearance.

In the first hundred years after the birth of Christ his teachings did not gain a strong foothold in Iberia. There were local persecutions of the Jews and of the new unorthodox Hebrew sects led by Christ and his disciples in Rome, but no great influence was felt throughout the Empire. It was believed by later generations that Saint James the Less (considered by many Spaniards of the Middle Ages to have been the brother of Christ) preached the Gospel in the peninsula. If he did, there is no record that he made a journey there. (At a later date, Saint James, or Santiago, was accepted as the patron saint of Spain.) More likely, but still unproven and unprovable, is the belief held by some Spaniards that Saint Paul, Christ's tireless missionary, traveled to and preached in Spain, but details of his journeys are carefully recorded in the Bible and, based on that evidence, Rome would seem to be the closest he ever came to the Iberian coast.

Hispano-Roman writers born in Iberia and writing there and in Rome did not delve into Christianity during the 1st century. Séneca the Elder, who was born in Córdoba and lived out his life in Iberia, except for two visits to Rome, wrote ten volumes called *Controversie,* in which he discussed oratorical styles. Deeply interested in the law, he also wrote *The Imaginary History of 74 Legal Cases* which projected the theory and practice of Roman law.

It was his son Séneca the Younger, also born in Córdoba, who had the greater sway. Leaving Iberia as a youth, he studied Stoic philosophy in Rome. To some critics his writings seem to reflect the Iberian temperament. Teaching that the goal of life was not pleasure but responsibility, Stoicism carries within it the idea of destiny. It teaches that man should not complain of his lot but bear his burdens with silence and fortitude; under intolerable conditions, suicide is allowable. Whether or not this philosophy typified the Iberian character, it certainly did not originate there but in Rome. Séneca was tutor to Nero when the emperor-to-be was a child of eleven years. After his pupil became emperor, he accused Séneca of plotting his death and forced him to kill himself. Séneca complied with dignity and, while cutting his veins, told his sorrowful wife to moderate her grief by finding honorable consolation and living out her life usefully.

But the Sénecas were not the only great literary figures produced by the Iberian peninsula. Indeed it would seem that, during this first century, Iberia produced most of the great literary men of the Roman Empire: Quintilian from the province of Logroño, Lucan from Córdoba (grandson of Séneca the Elder and nephew of the Younger) and Martial from Bílbilis.

The greatest influence on his times and on future generations was attained by educator-author-lawyer Quintilian. He was the first government-paid teacher in European history, as a result of being appointed public professor of rhetoric by the emperor Vespian. His major work was *Institutio Oratoria* (The Education of the Orator). Although cast in the form of lessons in oratory (considered the most important mark of an educated Roman), the twelve volumes written by Quintilian embodied the most

Finely etched figures on Greek-Iberian vase found in Iberian necropolis near Granada. Many such vases were made in Iberia.

advanced thought on education and criticism. Among these books are treatises on memory and delivery, style, creativity, and how to arouse laughter. He believed in teaching the very young, thus projecting the idea of a kindergarten. He pointed out that rules are made to be broken, but that attention to literary discipline molds character. A sincere man of high principles, he felt that corporal punishment was not conducive to learning, and in one of his published speeches, now regrettably lost, he defended a man accused of killing his wife. His influence lasted into the Renaissance and Restoration periods.

A poem in praise of Quintilian was written by Martial, a sharp-witted Aragonese who was his contemporary. Born in Bílbilis (today's Calatayud), Martial wrote that the town of his birth would someday boast of him. He moved to Rome as a young man of 24, but returned to Iberia in his later years and wrote his last works there. Perhaps the most Iberian of the Iberian-Roman authors, he had a quick and mordant wit. When he first came to Rome, he sought out his countrymen Séneca and Lucan, but later drifted away from them.

The Romans loved his epigrams, of which he wrote book after book. In the most familiar he writes, *"Sera nimis vita est crastina vive hodie"* ("Live today—tomorrow will be too late"), and again, "The hours die and are charged against us," or "No man is quick enough to completely enjoy life."

He was clever in getting what he wanted from the Roman rulers. Although he had no children, he was given the citizenship rights of a father of three; by writing flattering dedications, he managed to

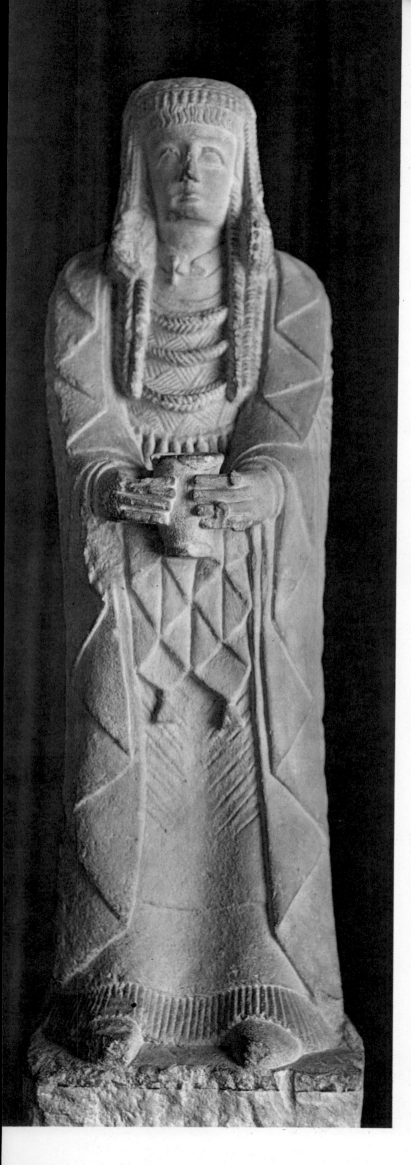

extract a good living from his patrons. This, however, was the custom with all poets of the day and has persisted into modern times.

Martial's forte was humor and especially the surprise ending; puns and parodies enlivened his works: "If you believe Acerra stinks of yesterday's wine, you are mistaken. He always drinks until morning," he wrote. Pliny the Younger said that Martial was a man of ability, discernment and warmth, whose writing was witty, sharp but good-natured. He was a noted pornographer, but he lived in a time when pornography was common; he once wrote that some of his writing was licentious but that his private life was decent, which was more than many of his patrons could say.

When he retired to Iberia he returned to his native village and there he wrote of the enjoyment of nature and the rural life. His work shows a great love for the beauty of nature; he writes that he was never so happy as when he stopped wearing the toga and returned to his hearth: "Give me a healthy native-born servant, a wife who is no prude, my nights blessed by sleep and my days without litigation."

The fifth important Iberian-born writer of the first century was Lucan, born in Córdoba. He was a man of courage who, like Séneca, stuck to his beliefs and, also like the Stoic philosopher, was forced to commit suicide by Nero after participating in a plot to assassinate the tyrannical emperor.

Lucan wrote poems on history and politics with a strong, driving force and a magnificent command of the Latin language.

The fact that these Iberian-born authors were great men of literature at a time when Rome was a strong power speaks well for the availability of education in their land and the pride taken in excelling in Latin, the pride in speaking well. Rhetoric is still so highly respected in Spain that one of the greatest compliments one can pay to a Spaniard of today is to praise his use of his language.

Two great emperors, both born in Iberia, led the Roman Empire to further heights in the 2nd century. Trajan was born in the province of Bética and

Iberian priestess making an offering has the facial features that still persist in many women of the Spanish Levant.

Heavily mitered "Lady of Elche" is the masterpiece of 5th century Iberian art. Her red lips indicate use of cosmetics.

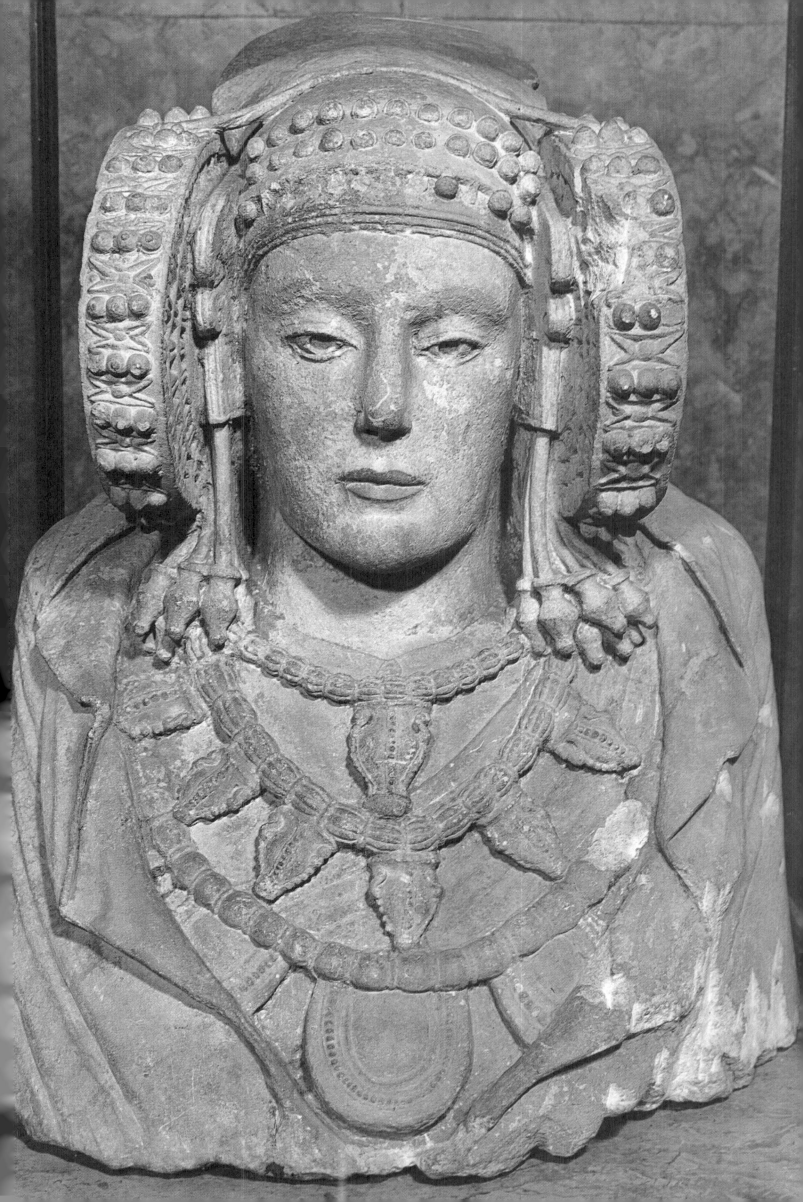

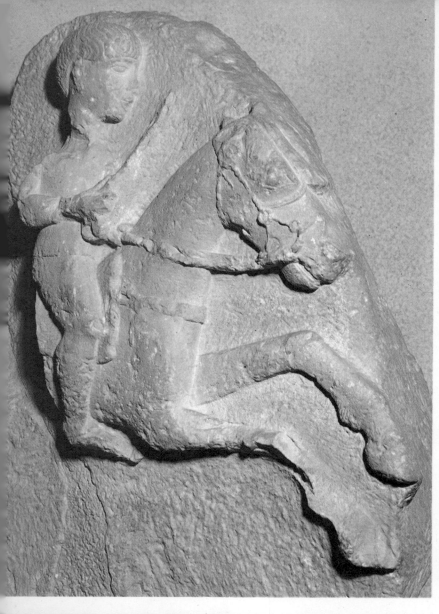

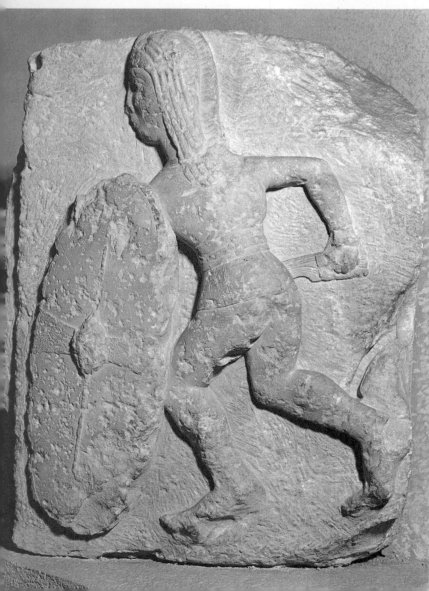

went to Rome to become emperor from A.D. 9
to 117, the period of Rome's greatest expansion
A great general, an efficient administrator and per
haps the most liberal of the Roman emperors, Traja
created a circle of Roman domination with th
Mediterranean as its center. To an already larg
empire he added northern England, Romani
Arabia, Mesopotamia and Armenia.

With Trajan's accession to the throne, Iberi
gained in prestige. He made numerous journey
back to his homeland and caused the ports there t
be greatly enlarged to meet the increase in trad

A just and humane leader, he tolerated both th
Christian and Jewish religions but was powerless
stop local persecution in various parts of the Empir
He refused to employ informers and kept to th
letter of the Roman law.

To succeed him he appointed his adopted so
and countryman, Hadrian. He could hardly hav
made a better choice. A brilliant scholar with
prodigious memory, Hadrian was a man of man
interests. His keen preoccupation with architectur
brought about the construction of a series of mag
nificent buildings and bridges in Rome and in th
peninsula. He was an efficient general, a compete
diplomat and a superior administrator.

Hadrian often journeyed to Iberia. There I
improved the mines and built amphitheaters, b
during his regime the system of *coloni,* which boun
tenant farmers to the soil, was inaugurated. Th
system has been called the beginning of feudalisr

In matters of religion he could be called liber:
The Jewish religion was respected and its patriarc
were left in charge of the affairs of their church. Lil
his adoptive father, Trajan, he tolerated Christianit

His aim was to consolidate the Roman Empi
rather than to extend it. This he achieved with gre
efficiency, making it an almost impregnable fortre
Many of the emperors who followed him we
corrupt, yet the colonial administration that he bu
in Iberia, Gaul and other outposts continued
function effectively.

Like Trajan before him, Hadrian adopted
young nobleman, Antoninus, whom he named l
successor. As Emperor Antoninus Pius, the latt
continued Hadrian's program of consolidation a
implemented it by building the Antonine Wa

Roman invaders, each with his espada falcata *(short
sword) drawn for battle. The infantryman also carries a shield.*

Marcus Aurelius, a man of great literary gifts and a profound philosopher, succeeded Antoninus as emperor. A series of crises, both at home and abroad forced this scholarly man to spend most of his life as a general. Marcus Aurelius nonetheless had time to exert a great influence on his era, primarily through his brilliant exposition of Stoic philosophy. He governed with constant concern for the welfare of his people and not for the extension of the Empire or his own aggrandizement.

Over the next century the fortunes of Iberia were to follow closely the rise and fall of succeeding regimes in Rome. But life was not easy for those Hispano-Romans who could not obtain Roman citizenship. Even in the best of times for Iberia, the residents *(incolae)* and transients *(hospites)* and only a small portion of the elite citizen class ever achieved

affluence. The Roman rulers were slow to grant civil rights and full citizenship. It was only after the rule of the Gaelic-born Emperor Caracalla in the early part of the 3rd century A. D. that all freemen in Iberia were accorded full citizenship. Because the Christian church had prospered in the latter part of the 2nd century in Spain, citizenship gave many Christians an opportunity to further the cause of Catholicism.

The great poet and hymn writer, Prudentius, who was a native of Hispania—as the Romans called Iberia—had a phenomenal impact upon the evolution of Christianity in Rome and in his homeland. Of all the early poets he is perhaps the most Iberian in his manner of thinking and style of exposition. In his great eulogy of the martyrs he spares no bloody detail: bones are cracked, breasts cut off, tongues ripped out; yet the martyrs win each battle

against their torturers. His work is a chronicle of Stoic suffering. His hymns, many of them about the lives and deaths of the martyrs, were widely sung throughout the Christian world. His detailed word-pictures served as models for many painters of the realistic school that flourished from the 5th century onward. In the magnificent but gory paintings of the beheading of Saint Vincent and amputation of the breasts of Saint Eulalia, one can hear the words reflected in form and color that were written by this greatest of Roman Christian poets.

But Christians in Hispania suffered a similar treatment as in other Roman regions. Under tolerant emperors they prospered, while under oppressive rulers, such as the emperor Diocletian, they were tortured, killed or driven underground. His persecutions instigated local uprisings and resulted in the martyrdom (and ultimate canonization) of the youthful Saint Eulalia of Mérida, Saint Vincent of Saguntum, Saint Severons of Barcelona and the wholesale slaughter of the eighteen martyrs of Caesaraugustus (Zaragoza), who refused to pay homage to the galaxy of Roman gods and their representative, the emperor.

The continuous harassment, oppression and massacre of Christians did not abate until the emperor Constantine prohibited their persecution and granted the new faith equal legal rights with the established state religion. Then he went further, restoring to the Christians much church and community property previously confiscated.

Christianity received great impetus in Iberia during Constantine's reign. And, although he was not converted until he was on his deathbed, he can be considered among the founders of the Catholic Church. He was profoundly influenced by the Hispanic Bishop Hosius (from the Greek meaning "saint") of Córdoba, who became his trusted aide and ecclesiastical advisor. When the Christian church was threatened by Arianism, it was Bishop Hosius whom the emperor selected to represent the Roman Empire and the orthodox viewpoint at the first ecumenical council held at Nicaea (Nice). There Bishop Hosius became a key figure who greatly influenced the decision to clarify the beliefs of the church and establish the Catholic creed. He was instrumental in stopping, at least temporarily, the spread of the Arian heresy, which took its name from a little-known bishop, Arian, and created a deep schism in Christianity. Devout followers of

the Arian doctrine believed in a separation of Christ and God. To them, Christ was a divine prophet but also a man who had a beginning and an end, a creature born of woman who had been changed from nothing to something and who would continue to change. The orthodox church insisted that Christ was one and indivisible with God, human but simultaneously divine, and unchangeable; that he was the incarnation of God, and that they were one and the same. If this were not so, argued the orthodox church, Christ would be just a minor god, and belief by man in more than one god was heresy. In spite of the fight of Hosius of Córdoba, Arianism continued to be a problem throughout the reign of Constantine. It was to become a bigger problem in Iberia more than 100 years later.

ERIDANVS

FRIDANVS
ISPVMIVS
PELOPS
IVCXVR

Hispano-Roman charioteers drive their plunging horses across this huge mosaic of a circus scene uncovered in Barcelona.

Between the reign of Constantine and the Iberian-born emperor Theodosius, a series of disasters befell the Roman Empire. Their effects were felt in Hispania. The actual dissolution of the Roman Empire was hastened by the election and appointment of a series of inefficient and tyrannical emperors. The legal system became seriously undermined, there was rampant inflation, and the plague raged throughout Italy. Revolts became common in the colonial Empire. But the most fatal blow was the collapse of *"the limes,"* the seemingly impregnable line of border defenses manned by the hitherto dependable Roman soldiers. These defenses were first breached by the Persians, who attacked from the east. From the north Visigoths and Ostrogoths, Germanic tribes, poured into the Empire.

Under Theodosius, last of the Roman emperors to be born in Iberia, a degree of stability was achieved. He made treaties with the Gothic tribes and employed many of them as mercenaries in his armies. But his most important contribution to Iberia was to make Christianity the state religion. He also gave orders that there were to be no pagans admitted to the ranks of the Roman army. Only 250 years before, Emperor Clesus had prohibited Christians from serving in the army. Persecutions were now reversed and the death penalty meted out to all heretics.

It was Theodosius' son and successor, Honorius, who made allies of the Germanic invaders and resettled many of the tribes within the Empire. This policy was later to lead to the occupation of Iberia

by the Visigoths.

A large group was relocated in Aquitania (southern Gaul) and along the Iberian border. At about this time a wave of Vandals, Suevi and Alans, seminomadic German tribes, poured into Iberia from the north. Rome was far too immersed in its own problems to defend the peninsula. Within the next 50 years, treaties were made with the Visigoths, who were being pushed south from Aquitania by the fast-forming Frankish nation under its first king, Clovis. Under his inspired leadership, the strength of the Visigoths was broken and they were forced into Hispania. Clovis, who became a Christian convert, is considered the founder of the nation which was to become the kingdom of France.

Hispania had taken its vitality from the Celts and Iberians, and its cultural roots from the Phoenicians and Greeks. But the form and structure of its civilization and the development of its language came from the Romans. On this secure foundation, the Visigoths tried, unsuccessfully, to build an Iberian-Germanic society.

Making a treaty with Rome, the Visigoths agreed to protect Iberia from the Vandals, Suevi and Alans. By the time they reached Hispania in force in the year 480, they were a people of considerable culture. Originating in the Scandinavian countries and in northern Germany, they had been exposed to Phoenician, Greek and, more recently, Roman civilization. It was a Visigoth, Ulfilas, who translated the Bible into the Gothic language. By the time of their migration into Spain, the great majority had embraced Christianity; but they were Arians and hence remained outside the province of the rapidly developing Catholic Church. Their conquest of Iberia was slow and costly for, in addition to fighting the Vandals, Alans and Suevi, they were forced to fight certain Roman factions and the ever rebellious Celtiberians. This latter group, inaccessible in their Cantabrian mountain homes, held out for over 150 years. Considering that the Visigoth kingdom in Hispania lasted only 200 years, this means that the people of the northwest were never absorbed by the invaders.

Yet the Visigoths pursued a policy of cooperation with Iberian leaders. They also asked for help from the emperor Justinian of Constantinople, whose Byzantine Empire was at the height of its glory. Justinian sent troops to occupy much of southern Spain. This transfer of Byzantine power had considerable cultural impact on Iberia.

The Visigoths themselves contributed little in the field of art. They seemed content to live with the Roman art they had inherited and the Byzantine influence they had borrowed. There is hardly any evidence of originality, except in the structure and design of the magnificent jeweled crowns worn by their nobility.

In religious matters, during the early years of their occupation they remained strictly faithful to the Arian heresy. The Hispano-Roman Celtiberians seem to have been equally strict in their Catholicism. There was undoubtedly some spilling over of belief on both sides, but the national policy remained Arian even after the rebellion of Prince Hermenegild against his father, King Leovigild. The prince

A farmer gathers wheat, one of Roman Iberia's biggest crops, in this section of a mosaic depicting the four seasons.

had been converted to Catholicism and, with a group of Catholic followers, started a revolt. It was crushed by his father, and Hermenegild, as leader of an armed revolt against the king, was executed. Many prominent Catholics within the Visigothic government sided with the king against his rebellious son. The Visigothic state being considered all-powerful, Hermenegild was treated as any rebel of the times would have been. But because Catholicism was the faith of many people in the peninsula, his death strengthened the Catholic cause. His brother, King Recared, who succeeded Leovigild on the Visigoth throne, was converted to orthodox Christianity, in part from personal conviction, but probably also for reasons of state.

This removed the barrier between church and state. Catholicism now was the state religion, and ecclesiastical power became dominant over the king and government.

The greatest scholar of the Visigoths was Isidore, Archbishop of Seville. He is believed to be of Byzantine-Iberian origin. He supported the conversions of both Hermenegild (although he did not support his rebellion against his father) and Recared. His *Etymologies* (Origins) was a compilation of knowledge of the cultural and political history of the peninsula. It was used for advanced studies not only in Visigothic Spain but well into the Middle Ages.

Not quite so overwhelming as the works of Isidore, but destined to have a more lasting influence on the institutions of Hispania, was the revision of the Roman legal codes by the able Visigoth king Receswinth. The new code, based upon Germanic law, was called *Liber Judiciorum*. It replaced many of the traditional Roman laws with more realistic and more liberal concepts.

The base of the Visigoth monarchy never spread out enough to encompass all of the peninsula. Nor did the Visigoths try to integrate with the local population. Instead they made every effort to continue their racial purity, even to the extent of forbidding Visigoths to marry Hispano-Romans. Ascension to the throne was by election, and only Visigoth nobles were considered; no other groups were allowed a voice. This elective system led to the formation of bitterly partisan factions and, in turn, to coercion and to the frequent assassination of leaders. The Visigoths isolated the large colony of Jews that had long been resident in Spain. Many of them were enslaved, Jewish possessions were confiscated and the luckier members of the Jewish community were exiled. This persecution occurred during the latter part of the 7th century; at this time a law was passed by the Sixth Council of Toledo which stated that no one would be tolerated in the Visigoth kingdom who was not a Catholic.

The monarchy began to crumble, but it enjoyed a brief revival under King Wamba, a strong-willed leader of high principles. Aware of a threatened invasion by the Arabs from the south, Wamba carefully prepared for it. When the invasion came he was ready, and he inflicted a decisive defeat upon the Moslems. After Wamba, his sons and other nobles contended for the throne, confusing and dividing the kingdom. They were caught completely unprepared for the second Moslem onslaught.

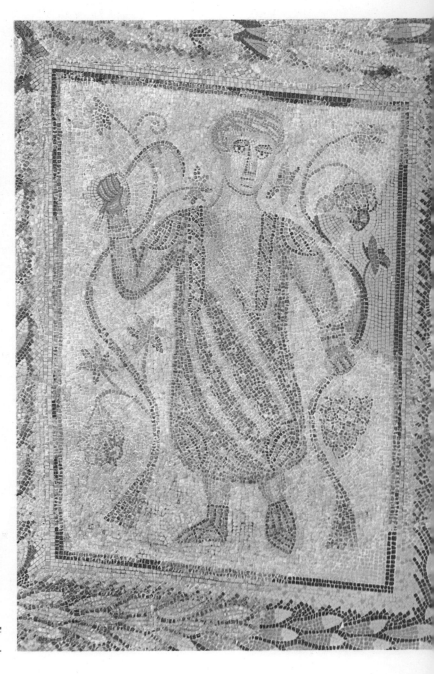

Wine was a major product, and this farmer tends the grapes. The mosaic is still in perfect condition after 1976 years.

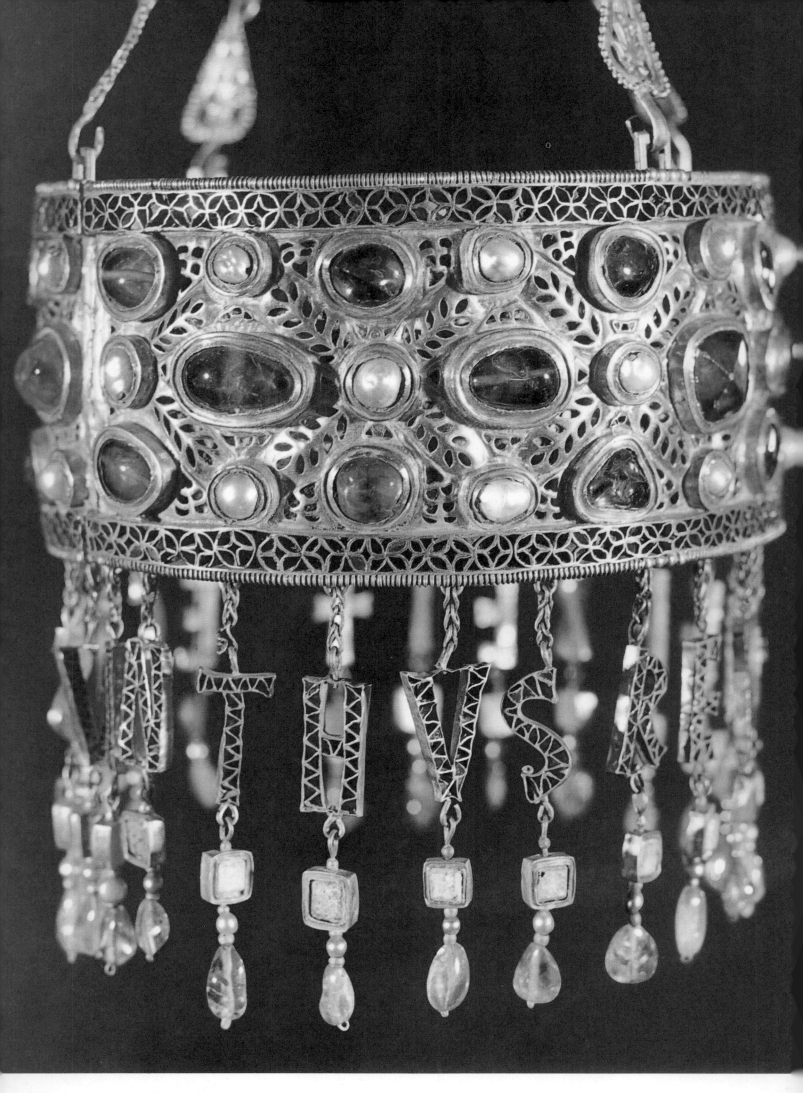

Brilliance of the Visigothic court is reflected in this
magnificent gem-studded crown of the 7th-century King Suintila.

711–1469
MOSLEM AND CHRISTIAN SPAIN

Fired by their newly organized religion, the Moslems invade Spain. Nuclei of resistance are formed in the north, where new Christian kingdoms emerge amidst internal disputes. Over nearly eight centuries, a paradox of perpetual war and peaceful coexistence marks the relations between Christians and Moslems. During this long struggle, the Romanesque, Mozarabic, Mudéjar and Gothic arts develop.

HISTORICAL CHRONOLOGY		ART CHRONOLOGY	
711	Moslems from Africa conquer most of Visigothic Spain.	786	Mosque of Córdoba.
718	In the north, the Christians under Pelayo begin war of reconquest.	888	Pre-Romanesque monastery of Ripoll.
756	Abdu-r-Rahman I establishes emirate of Córdoba, independent of Damascus.	10th c.	Extension of Mozarabic-style art to Christian kingdoms.
mid-9th c.	Kings of Asturias advance through León.	926	Miniatures in codex Beato de Magio.
901	Sancho Garcés I becomes king of Navarra.	936	Palaces at Medina Azzahara.
929	Abdu-r-Rahman III proclaims the caliphate of Córdoba.	999	Completion of Mosque of Córdoba.
961	Castilla becomes independent kingdom.	11th c.	Romanesque art along the pilgrims' road to Santiago de Compostela.
1031	Caliphate of Córdoba breaks up into kingdoms called taifas.	1000	Catalán Bibles. Paintings in Tarrasa.
1037	Castilla and León united under Fernando I.	1047–1081	Arab palace of Aljafería at Zaragoza.
1086	The Almorávides invade Spain.	1075	Romanesque cathedral at Santiago de Compostela.
1094	El Cid conquers Valencia.	1198	Completion of the Giralda tower at Sevilla. Appearance of Mudéjar art.
1137	Aragón and Cataluña form kingdom.	12th and	Catalán Romanesque frescoes and
1442	Conquest of Naples by Alfonso V.	13th c.	tempera paintings.
1143	Portugal becomes independent.	13th c.	History by Alfonso X, Las Siete Partidas. Poems, illustrations of the Cantigas and Book of Games.
1157	Last separation of Castilla and León.		
1212	The Almohades are defeated.	1238	Construction of the Alhambra in Granada and the synagogue of Santa María la Blanca in Toledo.
1230–1247	León and Castilla reunited.		
1238	Moorish kingdom of Granada.		
1340	Alfonso XI defeats new Moslem invaders.	14th c.	Mudéjar towers of Teruel.
1369	Enrique of Trastamara kills Pedro the Cruel; founds Trastamara line.	15th c.	Beginning of Gothic cathedral of Sevilla. Mudéjar Alcazar of Sevilla.

Moslems invaded Spain in 711. Harsh angularities of a 13th-century miniature indicate bitterness of fighting.

The Moslems Invade

The invasion of Spain came across the eight-and-a-half-mile channel that separates Africa from Europe where the Pillars of Hercules once stood. A small force of 12,000 Arabs, Berbers and Syrians led by a Berber chief, Tarik, landed without opposition in the year 711. The rock where the landing was effected still bears his name—Jebel-al-Tarik, or Gibraltar (mount of Tarik). Shortly after the successful landing on that rocky prominence, he began to build fortifications, some of which still exist.

Legend and some historical evidence indicate that the Arabs were welcomed by at least a portion of the badly divided Visigothic kingdom. For as Tarik advanced, the confused Visigothic army did not consolidate against the invaders. Some elements rallied around Roderick, the elected king, but he was defeated and his army completely dispersed. An early legend tells that his horse was found after the battle, but there was no trace of the king. Soon after Tarik's advance, his chief, Musa, who was governor

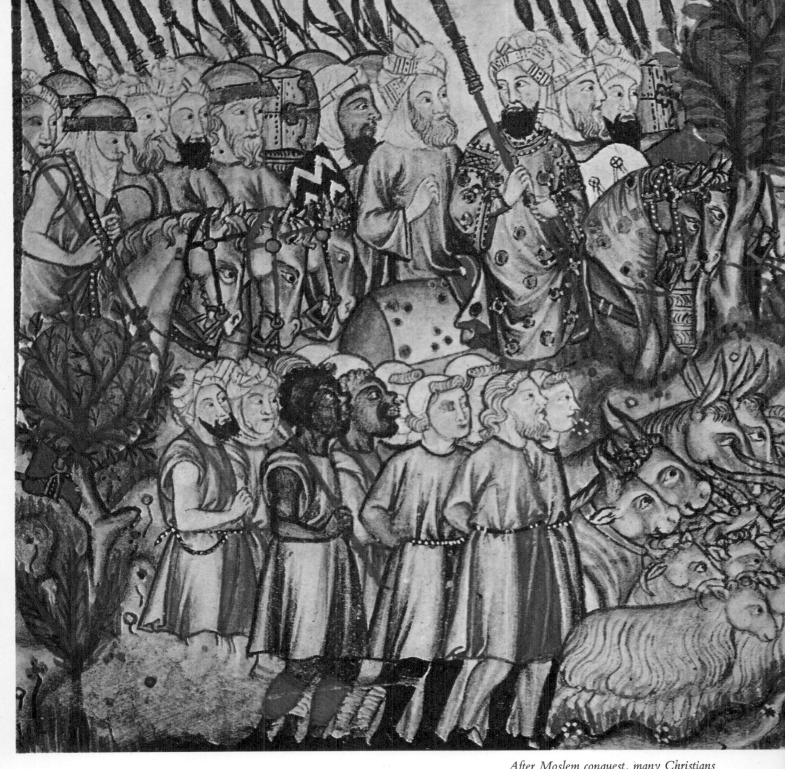

After Moslem conquest, many Christians
were herded off into slavery along with all their livestock.

of Moslem Africa, joined him with a larger body of men. Before their combined forces, one region of the peninsula after another capitulated almost without a struggle. Only the city of Mérida, originally settled by Celtiberians and later by Roman garrisons, put up a strong opposition and continued to fight on during the early days of the Islamic conquest, but its defenders were overwhelmed.

Musa placed Iberia under the sovereignty of the caliph of Damascus. But neither he nor Tarik were responsible for the easy conquest. The man who laid the groundwork for the invasion, supplied its impetus, and made the rules which would govern both conqueror and conquered was born in Mecca

143 years earlier. While working as a caravan leader and shopkeeper, he gathered a loyal group of relatives and friends and in the year A.D. 616, less than a century before the greatest expansion of the Arab world, he announced a new religion. It was called Islam, and he, Mohammed, was its prophet.

It is impossible to understand the invasion of Iberia or its subjugation without some knowledge of Mohammedanism. The prophet based his new faith upon Jewish and Christian beliefs, many of which he incorporated into the new religion. But there were important differences, and some of these were largely responsible for the rapid expansion of the Arab world after his faith was accepted.

He gave his followers a religion distinctively their own, one they could fight for with assurance of being rewarded both on earth and in paradise, whereas Christianity only offered rewards in the hereafter. Unbelievers were to be conquered rather than converted, and then forced to pay tribute to support the true believers. Powerful angels from paradise would appear to fight alongside the faithful. Upon death in battle, there would be no waiting; the true believer would go directly to paradise, there to enjoy, to an even higher degree than on earth, all the worldly pleasures.

Mohammedanism had an electrifying effect upon the Arabs, leading to their immediate unification. Tribes that had lived as unorganized nomads now fought successfully against the great nations of Syria, Iraq, Mesopotamia, Egypt and Iran. With only the light cavalry of desert tribesmen, carrying supplies by camel, disciplined by five daily devotions, they rode on to victory after victory in the name of Allah.

The principles of the prophet were carried out in the conquest of Iberia. Women, he had taught, were an important part of the plunder; he subscribed to the custom of the victorious leader's taking the wife or daughter of the vanquished as concubine or wife. Therefore, Abd-er-Aziz I, son of Musa the Conqueror, took the Christian widow of the missing King Roderick as a wife. In their advance across the peninsula the Arabs exacted tribute from kings, nobles and minor rulers; later they allowed them to retain and govern their holdings with little interference, provided they kept the peace and paid the taxes. As had long been Islamic policy, Christians and Jews were allowed to continue to practice their own religions for both theological and practical reasons. From the theological viewpoint, non-Arab converts would always be suspect. The economics were simple. Someone had to support the Moslems, and tribute could not be collected from the faithful, only from the unbelievers.

There was some opposition. Isolated cities held out against paying tribute and typical Celtiberian guerrilla bands harassed the invaders. But there was no central resistance, and within seven years followers of the prophet were in loose control of all Spain, except for the same regions of resistance in the Cantabrian mountains that had stood their ground against the Romans and Visigoths.

One group who welcomed the Arabs were the Jews, and it is even possible that they helped pave the way for the invasion. They certainly supported it, and with good reason, for they had often suffered under the Visigoths. The Arabs offered them freedom of worship and freedom to elect local leaders to enforce their own laws. The talents of the Jews as emissaries, physicians and teachers were used by the invaders, who treated them as allies. Many Jews held high office and made important contributions to the culture of Islamic Spain.

To save money by avoiding the head and land tax, to escape slavery, to gain higher office, or from sheer religious conviction, a great many Christians were converted to Mohammedanism over the succeeding years. They were called *Muladíes* by the Moslems but *Renegados* by the Christians. They should not be confused with the *Mozárabes,* who remained Christian and paid tribute for that privilege. The Christian church, although allowed to exist, came under considerable pressure from the Moslems. Its bishops were appointed or selected by the invaders. Its finances were carefully scrutinized and its properties sometimes confiscated. Like other existing institutions, it was used by the conquerors. As long as the church could control its congregations, the Arabs were satisfied to let the conquered peoples take care of their own problems.

The Arabs had more than enough problems to solve among themselves. In addition to the Berbers and Syrians, there were at least two important Moslem sects of Arabian stock—the Sunnites and the Shiites—which were in basic disagreement over theological issues. The Berbers, dissatisfied with their share of the spoils, revolted in the year 732, at a time when a large Moslem army was pushing north into the country of the Franks. The Moslems were defeated near Poitiers by Charles Martel. It is doubtful whether it was this encounter that threw them back into Spain. The bloody rebellion of the fanatical Berbers appears to have been a more pressing reason.

Moslems brought few women with them from Africa. Instead, they made wives, concubines or slaves of the Christian women captured in battle. These women are probably in a harem, judging from the revealing character of their dress.

As a serving woman bring
food and wine (which, though prohibited by Islam, was muc

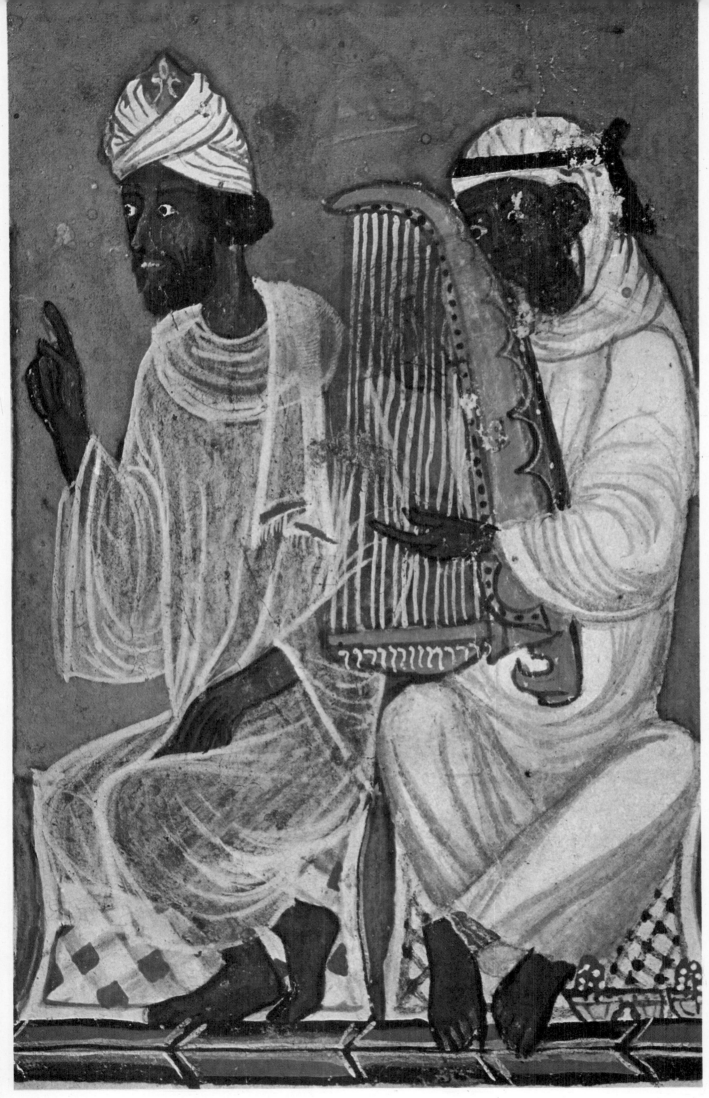

…drunk in Moslem Spain), an attendant strums a medieval harp and
two gentlemen converse in a 13th–century manuscript illustration.

The Berbers were defeated but at the cost of importing a large Syrian army into Iberia. The Syrians felt dissatisfied with the rewards given them by the emir and now turned against him. After a series of savage encounters, which badly decimated both sides, the Syrians were finally awarded the income from a large section of southern land.

Before long, civil war broke out between the Sunnites and the Shiites. The country was thrown into near anarchy when a young man with a background bordering on the miraculous made his way to Iberia from Damascus. Born into the ruling Omayyad family, which controlled the Arab world outside of Spain, Abdu-r-Rahman was about twenty years old when his grandfather, the caliph, was overthrown by the Abbasid sect. The caliph and all of the family, except for young Abdu-r-Rahman and his brother Yahwa, were murdered. The two survivors fled into the desert and made their way across Africa. Unwilling to risk having any Omayyads alive, the Abbasids hunted the young men from village to village throughout the empire. At a river crossing, Yahwa was caught and beheaded. Abdu-r-Rahman had a narrow escape and managed to reach Ceuta, the African city directly across from Gibraltar. From there he made his way to Spain, where he was welcomed by loyal members of the Omayyad clan. Forming a small army (it was said that he rode the only good horse), he fought and defeated the emir Yusuf at Córdoba. Having no banner, the young prince unwound his green turban and attached it to a spear; this was to become the official emblem of the new Omayyad dynasty in Spain. The new dynasty became independent of Damascus and established its capital at Córdoba. Through almost continual warfare Abdu-r-Rahman I brought a degree of unity to the Arab states.

He was the ancestor of Abdu-r-Rahman III, by far the greatest Moslem to rule in Spain. With his impressive administrative ability and military leadership he brought a state of comparative peace to the country. First he consolidated the various kingdoms—which had been allowed to grow increasingly independent—under his central authority. Then he declared Islamic Spain a caliphate, or empire, and himself the first caliph. So powerful did he become that even the Moslem provinces of North Africa fell under his influence.

Spain, under the caliphate, was the richest, most powerful state in all Europe. So again, as they had before in Greek and Roman times, the dwellers of Iberia reaped the advantages of a culture that was at the peak of its development. Into the peninsula came writing paper to replace the more expensive and cumbersome papyrus. Counting devices (including the introduction of the zero sign, which the Arabs had borrowed from India) were useful in the fast-developing economic life. Particular attention was given to irrigation techniques, and large, previously arid sections were made productive. Chroniclers of the times describe Córdoba as having 200,000 houses, 600 mosques and 900 bathhouses, as well as many magnificent public buildings. The great Mosque of Córdoba had already become famous, for it was begun in the reign of Abdu-r-Rahman I. By the time of Abdu-r-Rahman III it had 21 gates and 1293 columns of jasper and porphyry, each one with gilded capitals.

It is said that government revenues in Moslem Spain increased eighteenfold during the 112 years that elapsed between Abdu-r-Rahman I and Abdu-r-Rahman III. In this increasingly affluent society, great impetus was given to the intellectual pursuits. The availability of paper meant a greater production and circulation of books on a variety of subjects—religion, astronomy, law, medicine, philosophy. But the favorite literary form of the period was poetry, most of it meant to be sung. Poets were popular with both the aristocracy and the commoners. Some rulers kept a large staff of poets on the royal payroll; it is said that Almanzor (Al Mansur), a minister who became caliph in fact if not in name, had forty poets in his retinue, for he knew that a well-sung topical verse could make as much mischief as a raiding party. Almanzor was a vigorous leader who, according to legend, became the lover of the caliph's wife. After becoming prime minister, he took over the caliphate from Hisham II and ruled in the name of the displaced monarch. His real name was Mahomet, but he is better known as Almanzor, meaning "Favored of God." He fanatically persecuted the Christians, and in attempting to form a dynasty he contributed to the ultimate downfall of the caliphate. His son Abdul Malik succeeded him but died young, and another son failed to win the support of the generals. Civil war broke out. In 1027 the last of the Omayyads, Hisham III, became caliph, but his reign lasted only four years. It was the end of the caliphate of Córdoba, and Moslem Spain was fragmented into a number of independent, often rival, small kingdoms, called *taifas*.

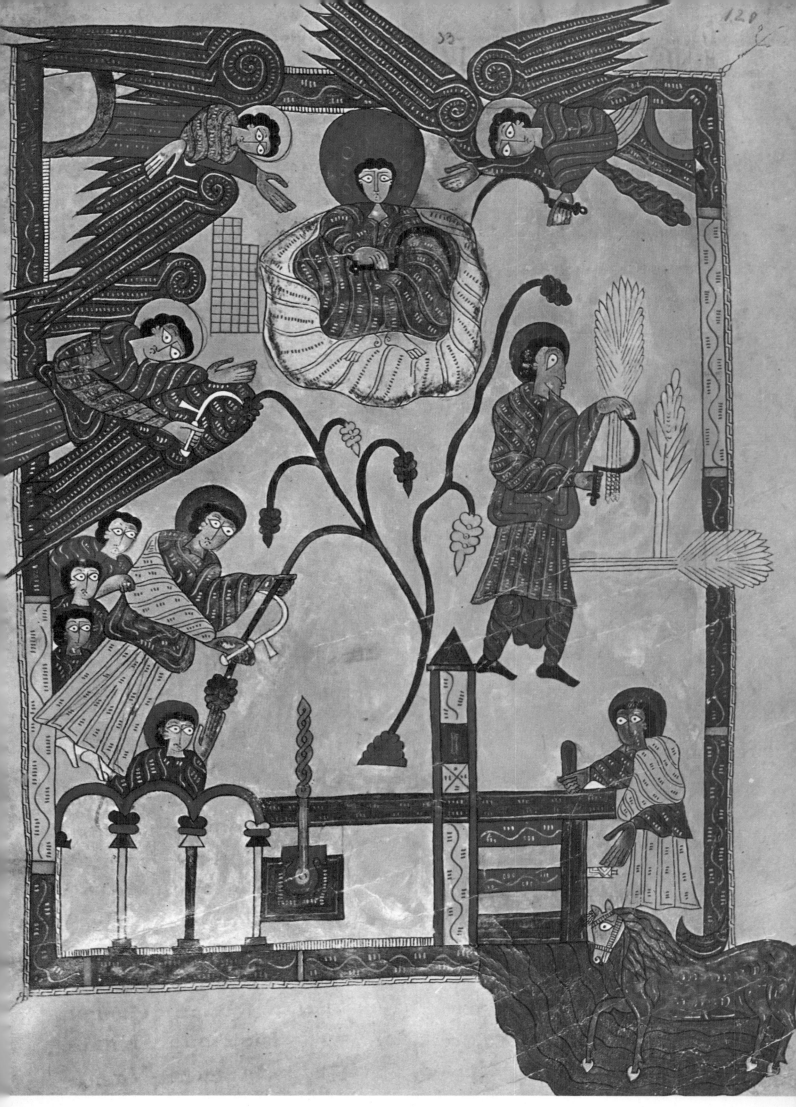

*Early Spanish Christians—assisted by angels—harvest
ripe grain and grapes. Wine flows out of press at lower right.*

65

Miniature shows Moslem fondness for chess and for living outdoors. Player at right seems confident of winning.

The Christians Attack

The disintegration of the Arab empire into separate states marked the beginning of 250 years of pressure by the Christian kings and nobles to retake southern and eastern Spain. Behind an ever-changing frontier the northern Christians mounted an offensive that eventually was to turn into a crusade. In the vanguard marched the men of Castilla, led by King Fernando I, who had brought all northwestern Spain under his rule by conquering the kingdom of León. His son, the audacious Alfonso VI, carried the war deep into enemy territory, pushing south in 1082 all the way to Tarifa, near Gibraltar, where he is quoted as saying: "This is the end of Spanish

earth, and I have walked upon it." Three years later, Alfonso VI added the *taifa* kingdom of Toledo to the expanding Christian empire.

Spain's most adventurous hero, El Cid, belongs to this turbulent period. Born Rodrigo Díaz in the village of Bivar, near the city of Burgos, he was a true soldier of fortune. He first served under Sancho II but, following the latter's assassination, went over to his brother, Alfonso VI. Sent on an important mission to collect tribute due from the king of Sevilla, he was accused of withholding for himself some of the funds and was banished from Castilla. Good fighting men, however, were hard to come by in those days, and soon the sword of El Cid was at the disposal of the Moslem king of Zaragoza. The name Cid, which comes from the Arab "Sidi," meaning "My Lord," was accorded him by his faithful Moslem followers. Whether serving under Christian or Arab banners, El Cid was never defeated in battle. The last great campaign

Armed with bows, lances and swords, Christians the northwest of Spain began fighting back soon after con

of his career was fought in Valencia. Summoned from Zaragoza by the Moslem king of Valencia (who had been made king by Alfonso VI) to put down a rebellion, El Cid answered the call at the head of a small but battle-hardened army. He succeeded in quelling the uprising, but then broke his agreement with the ruler of Zaragoza and remained in Valencia as its virtual ruler. Upon the death of the Moslem king, whom he had kept in protective custody, El Cid proclaimed himself King of Valencia. Over the succeeding years he fought both Christians and Moslems. Following the death of El Cid, his kingdom fell as a result of a brief revival of Moslem strength.

On three occasions, the Moslems asked for aid from Africa to halt the advancing Christians. The Almorávides (Holy Men), a fanatical sect of Berbers who had fought their way up from the Sahara Desert to become rulers of North Africa, twice sent an army to Spain that stayed on to unite and rule the remaining independent *taifas*. But in less than 70 years the new rulers became lax, more interested in pleasure and comfort than in conquest. The next wave of Moslem reinforcements was made up of Almohades (Unitarians) who, like their predecessors, had become rulers of North Africa and were, if anything, more fanatical in their Mohammedanism. They, too, united Moslem Spain, but at great cost. Completely intolerant of other religions and customs, the Almohades were to cause thousands of Jews, Mozarabs and liberal Arabs to flee into Christian territory, which thus gained in manpower, talent and economic resources. Moslem Spain was made a province of an empire that had its capital in Africa.

This precarious Moslem victory did not last. At a time when Europe was aroused with the spirit of the Crusades, King Alfonso VIII of Castilla asked for and received an indulgence from the Pope for all those who would equip themselves and fight the Moslems. He gathered a huge army, led by Castilla but supported by Theobald de Poitiers of Navarra and Jaime I of Aragón. A critical battle, which broke the unity of the Almohades, was fought in the year 1212 at Navas de Tolosa (near Jaén). But it remained for Fernando III of Castilla and León (later made a saint by the church) and King Jaime of Aragón to conquer the Moslems throughout Spain, with the exception of the stronghold of Granada. As important as their sweeping victories were, it was the subsequent treaties between these two kings—settling their respective boundaries and limits of conquest—that resulted in internal peace. Aragón, which had merged with Cataluña, later found an outlet for expansion in the Mediterranean, where it conquered southern Italy, Sicily and Sardinia in addition to the Balearic Islands. In the west, the old territory of Lusitania, which in the beginning of the 12th century had been given away by Alfonso VI as dowry to his illegitimate daughter, Teresa, continued to develop as the separate kingdom of Portugal, ultimately depriving Castilla of some of her best seaports.

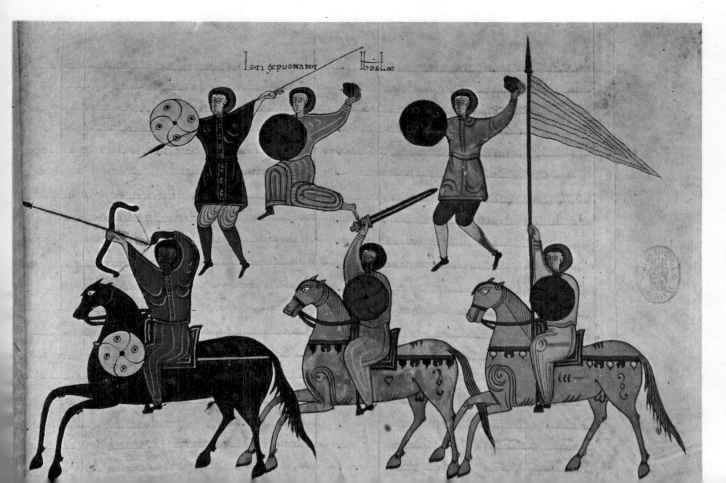

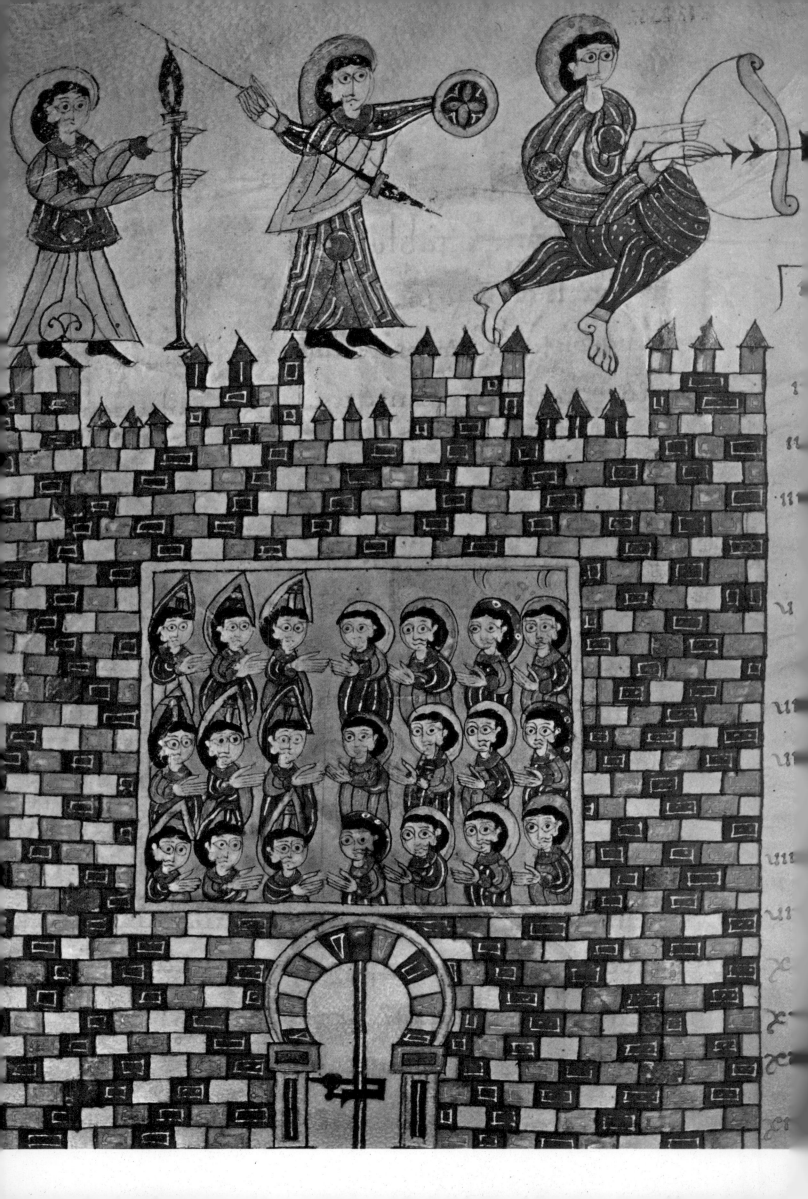

Peace in the Iberian peninsula had been a long time in coming, for the Christian states had been divided and inclined to quarrel among themselves for over 400 years. Yet there was always some opposition to the invaders. It had begun with Pelayo, first of the Christian kings, who won an engagement against the Moslems in the valley of Covadonga in 718, only seven years after the initial Arab invasion of Spain. Pelayo was followed by Alfonso I, known as "the Catholic." Both Pelayo and Alfonso I were kings of Asturias, a region of forbidding mountainous terrain in the northwest.

It was in these mountains that the essential personality of modern Spain was formed by the first true Spaniards, who lived an austere and frugal life in their fastness. They had little to build on, except their independence of spirit and their faith in God. The land they occupied was precipitous and rock-studded, almost devoid of fertile areas. Trading was nearly impossible over the steep and hazardous passes; even if the natural barriers could be overcome, bandits lurked behind every crag. Citizens of the first small Christian states—nobles and peasants alike—led the hard life of frontiersmen. These early kingdoms could hardly be said to have a distinctive culture. Some plain pottery and the remains of a few churches that borrowed from their Visigothic heritage are all they have left us.

Toward the end of the 8th century, during the reign of Alfonso II, two events changed the course of Spanish history. The first was the union of Asturias with Galicia, a region of independent, hard-fighting people of Celtic stock who had retained their individuality through the Roman and Visigothic occupations. Their strength and purpose, added to that of Asturias, gave desperately needed backbone to the budding Christian forces. Of even greater importance was the discovery of the tomb of Saint James, a disciple and, according to some interpretations of the Scriptures, brother of Christ. With Santiago (Saint Yago = Saint James) as their champion the Christians had a formidable spiritual power to oppose Mohammedanism. Belief in Santiago's presence was real, not merely legendary, although later authorities question the possibilities of his earlier preaching on the peninsula, his return to Jerusalem, where he was beheaded, and the magical transportation of his remains to northwestern Spain for burial.

But there was no such doubt on the part of the early Christians, who believed he was fighting alongside them. They needed a champion more powerful than the heavenly angels of the Moslems. Their battle cry became "Santiago Matamoros"—Saint James the Moor-killer. Mounted on a great white horse, wielding his terrible sword, he was believed to work havoc in the enemy ranks.

Santiago brought more than faith to the pioneer Christians. As a result of the finding of his tomb, a church was built in the town of Compostela, which soon became known throughout northern Spain and France. From the year 950, when the French Bishop Gotesculo led a band of devout pilgrims to this shrine, Christians from every part of the world began to converge there to worship before the holy relics. Over the long road to Compostela came the most important spiritual thought of the Middle Ages. This spiritual yet temporal highway carried, in addition to theological concepts, the trade goods, art forms and ideas of the times to the remote Christian states. During the succeeding centuries thousands of Mozarabs found their way to the land of Santiago, bringing with them the gifts of Moslem civilization. The fervent and militant Christian monks of the Benedictine monastery of Cluny, in the heart of France, founded chapels and rest houses along the great route. They worked to reform the clergy—forbidding the sale of church offices and the practice of *barraganía* (keeping of concubines by monks and priests)—and to change the Christian ritual from Mozarab to Roman. By the end of the 12th century the fame of Compostela as a focal point of pilgrimage rivaled that of Rome and even Jerusalem. The adoption of Santiago as the patron saint of Christian Spain, and the Spanish concept of him as both a spiritual and a corporeal figure, seem to provide early evidence of a cultural trait peculiar to Spaniards: unwilling to worship their God and saints from afar, they brought them down to earth. Not only did Santiago ride with them, but their art reflected this need for realism even in their spiritual world. In the Romanesque art of the 11th and 12th centuries, tortured and bleeding Christs, sorrowing Virgins and martyred saints are painted with painful realism and shown subject to the same sufferings as mankind.

In mid-12th century, the military order of the Knights of Santiago was formed. Like the orders of the Knights of Calatrava and of Montesa which preceded it, this institution was both military and religious in character, organized by nobles to serve their sometimes humane, sometimes selfish, purposes.

After driving out Moslems, Christian church-men guarded by armed saints on the ramparts occupy a stronghold.

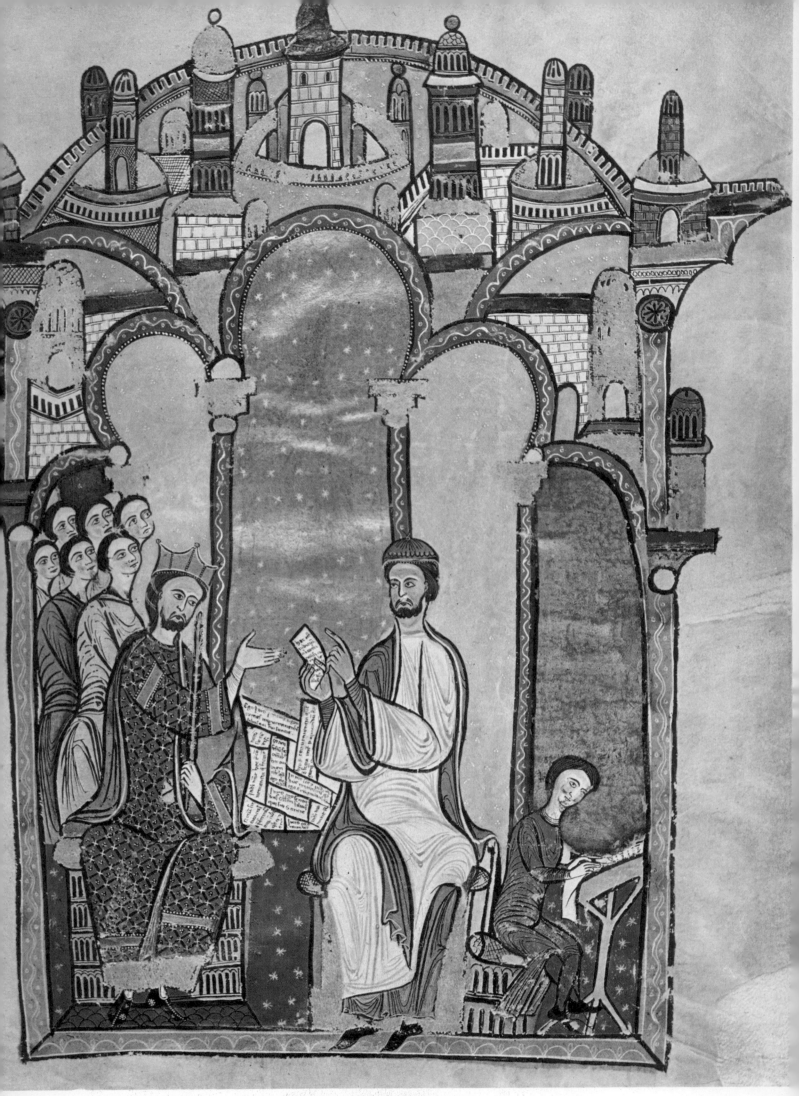

Illustration in 12th–century book of records shows Alfonso II of Aragón, who commissioned work, receiving it from scribe.

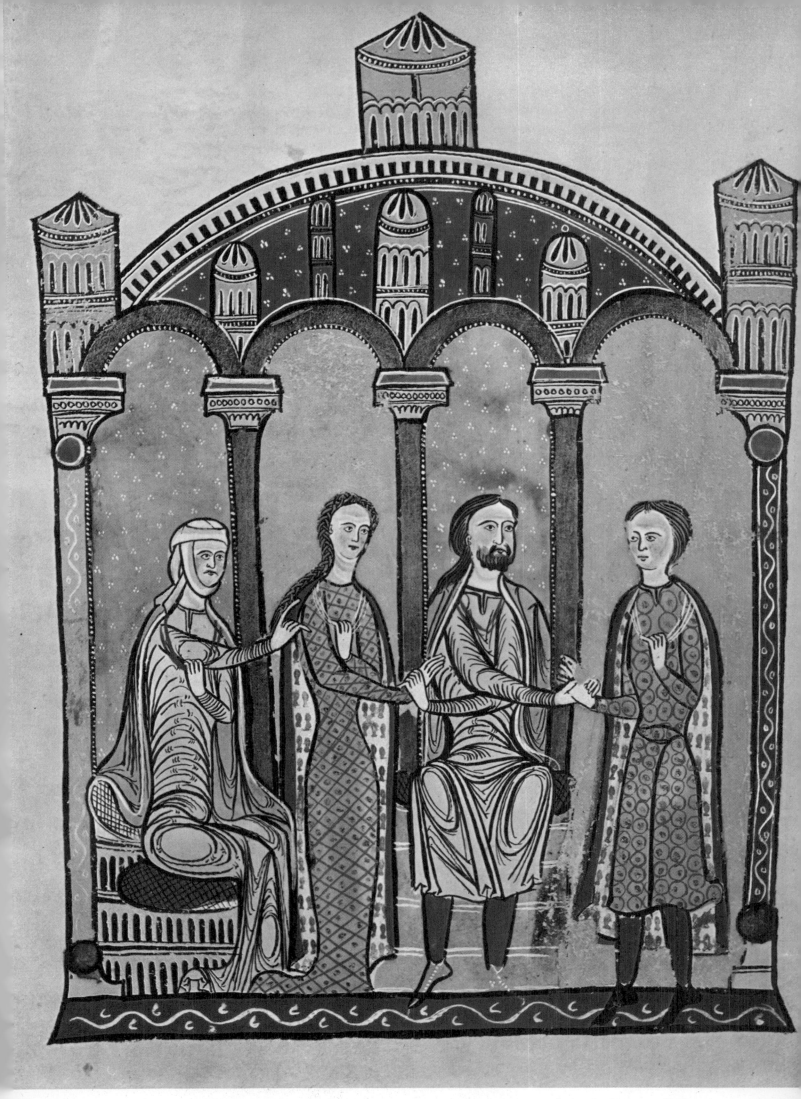

*Same manuscript depicts the Viscount of Béziers
giving his daughter in marriage to the young Count of Rosellón.*

71

The rise of the military orders was foreshadowed by the emergence of the Spanish knights or *caballeros.* Coming up from the ranks of the army, from the lesser nobility and sometimes from the common people, these men, who had managed to equip themselves with horses and fighting gear, offered their services to their king and country. They were to be a contributing factor to the unity of Spain, for the kings used them as a threat against the powerful nobles. This brought about an important balance of power, since the nobles sometimes had at their disposal stronger forces than the rulers.

Two other groups contributed to the stability of the Christian kingdoms: the clergy, sometimes half-soldiers and half-monks, often led into battle by armed bishops; and the *Hermandades,* or "Brotherhoods of Cities." These were organized by independent towns primarily for protection of the highways leading into them. The Hermandades were in effect an interstate police that could and did pursue criminals throughout Spain.

During the long fight to drive the Moslems out, a tendency had evolved in Christian Spain toward the formation of fortified towns, which frequently remained isolated and learned to govern themselves through community assemblies, or town halls. Their independence was occasionally sanctioned by the king, who granted privileges to the towns as a means of gaining their support against the nobles.

From this type of community representation in the affairs of the town, it was but a step to some sort of representation in the affairs of the kingdom. The step was taken by the crown of León at the end of the 12th century with the creation of the first *Cortes,* later to be copied by other Christian kingdoms of the peninsula. In this protoparliament the common people were represented alongside the church and the nobility. The Cortes served two purposes: it acted as a safety valve for the increasingly independent spirit of the Christians, and as a channel for the king to deal at once with the people, the church and the nobility, the three most important elements

of his dominion, without actually relinquishing his authority. For the Cortes was more an advisory than a legislative body. Its members were allowed to vote on how they would share the burden of taxes necessary to maintain the kingdom, to approve budgets and expenditures submitted by the king, to voice complaints and petition the crown for new legislation. But the king had the last word, and his word was law. Yet, though the monarch used the Cortes for his own purposes, he could not fail to be influenced by the deliberations and recommendations of its members. To this extent, Spain experienced democracy much sooner than the rest of Europe. But even this limited democracy was to be extinguished later by absolutist monarchs.

The greatest impact of Moslem civilization upon the Christian states came after they had achieved a degree of stability in the 12th and 13th centuries. Their reaction to that influence was to do much to forge, finally, the character of the modern Spaniard. There occurred at this time a complete turnabout

Painted tile of a minstrel is an early example of Mudéjar art. Mudéjares were Moslems living under Christian rule.

in Moslem-Christian relations. As long as the Christians had been intent only on survival or had been subservient in Moslem-dominated cities, towns and states, they had neither the time nor the will to accept the Oriental-Arabic culture surrounding them. But during their successful wars against the *taifa* states, the situation was reversed. Great numbers of Moslems, known as *mudéjares,* lived as vassals under the Christian kings. They were responsible for great advances in the study of botany and medicine, in techniques of irrigation, in the building of libraries and in the forming of the great school of translators at Toledo, through which a great deal of ancient Greek, Roman, Arabic (and modern Arabic) thought filtered into Spain and all Europe. Moslem literature added a new dimension to Spanish culture. In the field of architecture, by solving the problem of balancing heavy weights on slender columns, the Moslems were able to build such gems as the Alcazar in Sevilla, the Mesquite in Córdoba and the Alhambra in Granada. To the growing Castilian kingdoms they supplied tradesmen.

For the 200 years after the conquest there was an uneasy peace. But the great states of Castilla, León and Aragón continued to prosper and grow stronger. In the year 1369 Enrique of Trastamara, the bastard son of Pedro I, killed his half brother King Pedro the Cruel and proclaimed himself king of Castilla. This event, although casting the shadow of illegiti-

Mounted hunter and hounds pursue deer (or large rabbits) in fresco by a Romanesque master of the 12th century.

73

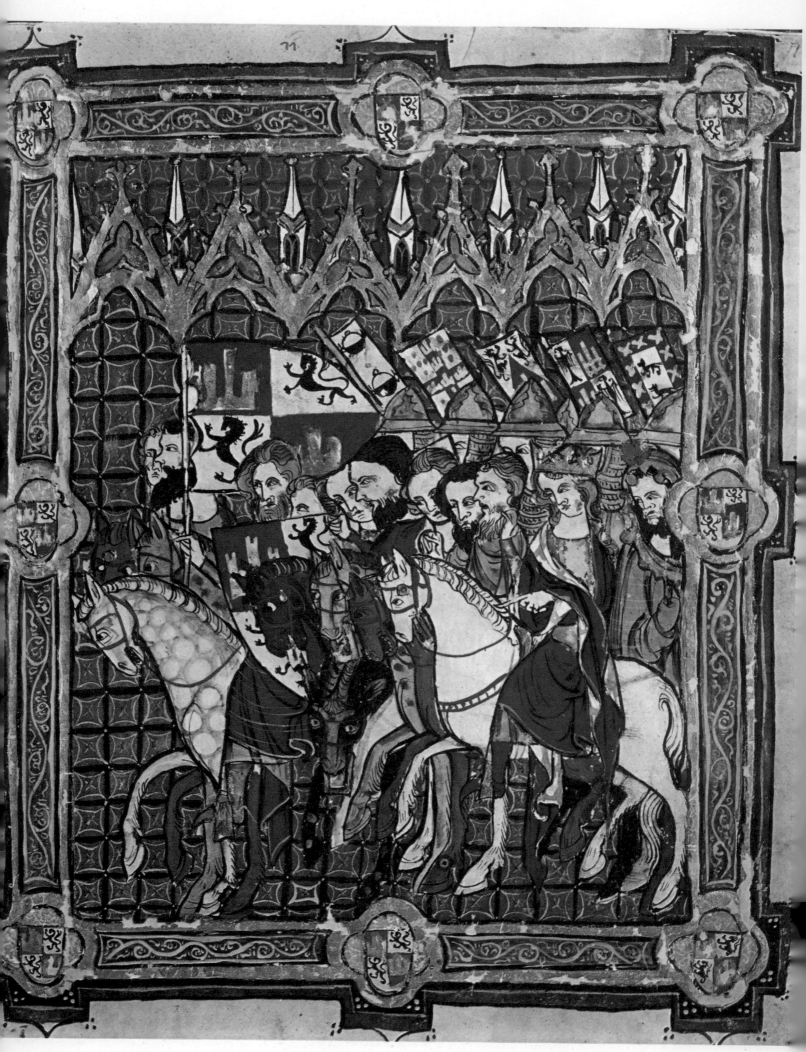

Sidesaddle on a white horse, beneath the
74 banners of Castilla and León, Alfonso VII rides to his coronation.

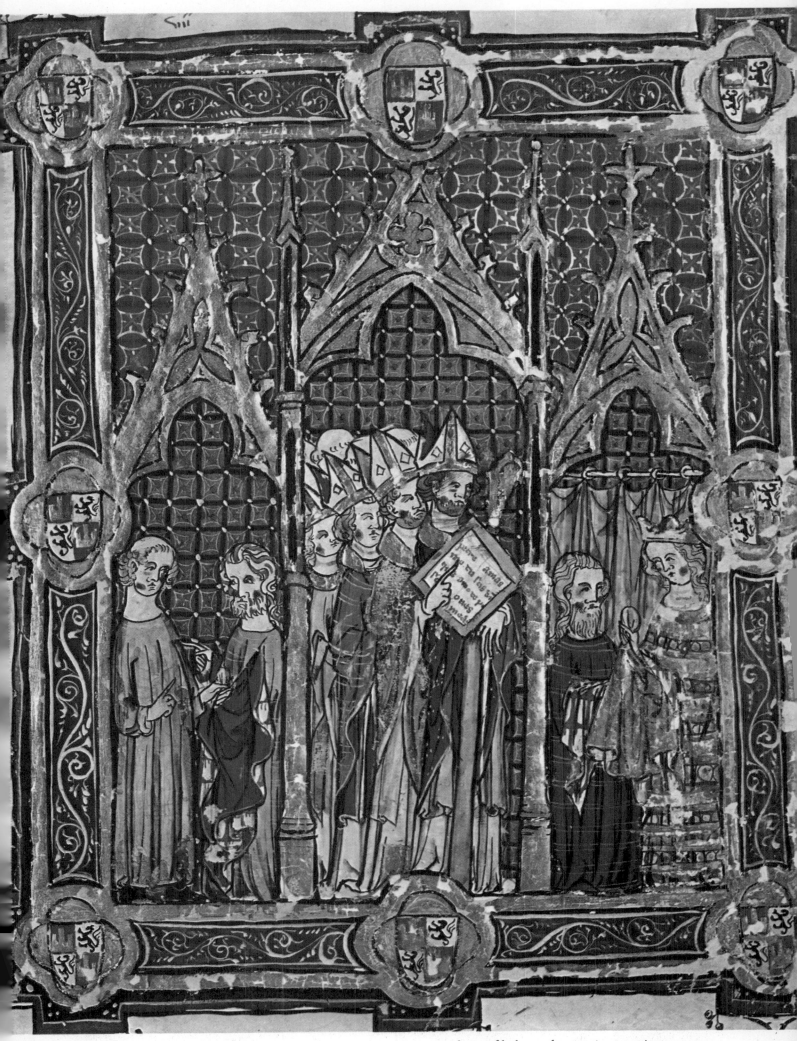

A cluster of bishops takes part in coronation ceremony.
Background shows Moslem influence. From 14th-century codex.

75

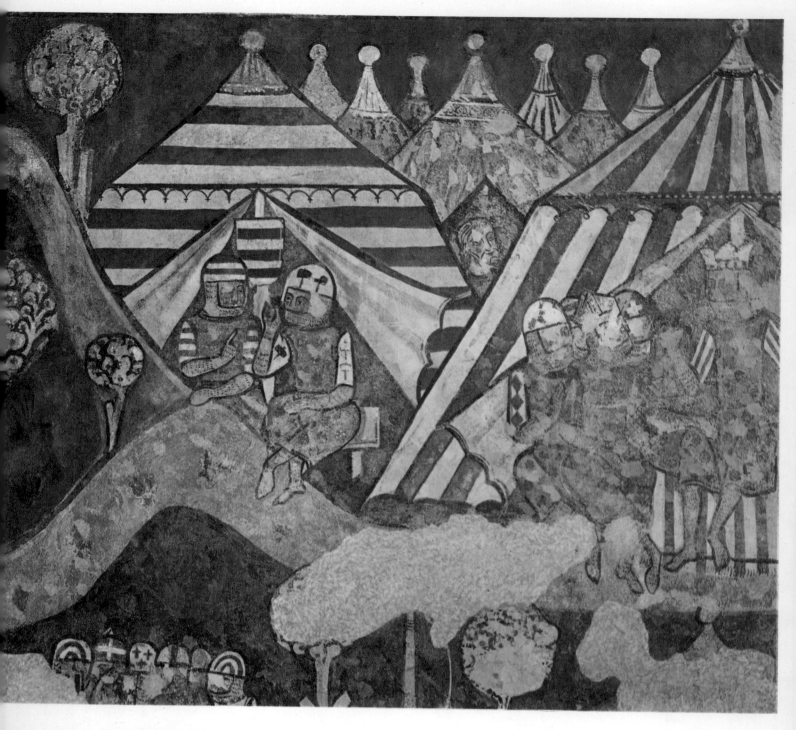

*King Jaime I (right) and his army encamp in Cataluña
before undertaking invasion of the island of Majorca in 1228.*

macy over the throne, was to be of great consequence to the rising fortunes of all Christian Spain. One result was the addition of English blood to Spanish royalty, for Pedro the Cruel had an illegitimate daughter, Constanza, who married John of Gaunt, the Duke of Lancaster. To press the claim of his wife to the throne of Castilla, the Duke landed with an English army. He remained not to fight but to settle the dispute by marrying his daughter to Enrique III, grandson of Enrique of Trastamara.

Among their grandchildren were Enrique IV, King of Castilla, and his sister Isabel. Enrique IV

(who was called the Impotent) had only one daughter, Juana, and she was believed to have been fathered by the court favorite, Beltrán de la Cueva. Juana la Beltraneja, as she was called by those opposed to her succession, was at first accepted as heir to the throne, even by her aunt, Isabel. But after Juana had been twice rejected by the nobles (her father, too, now failed to support her in her claims to the throne), Isabel agreed to accept the throne of Castilla, but only upon the death of her brother. The year was 1469, and Isabel was being courted by young Fernando of Aragón.

*Conquest of Majorca took a year. During the lengthy
siege of the capital city, slings loaded with fireballs were used.*

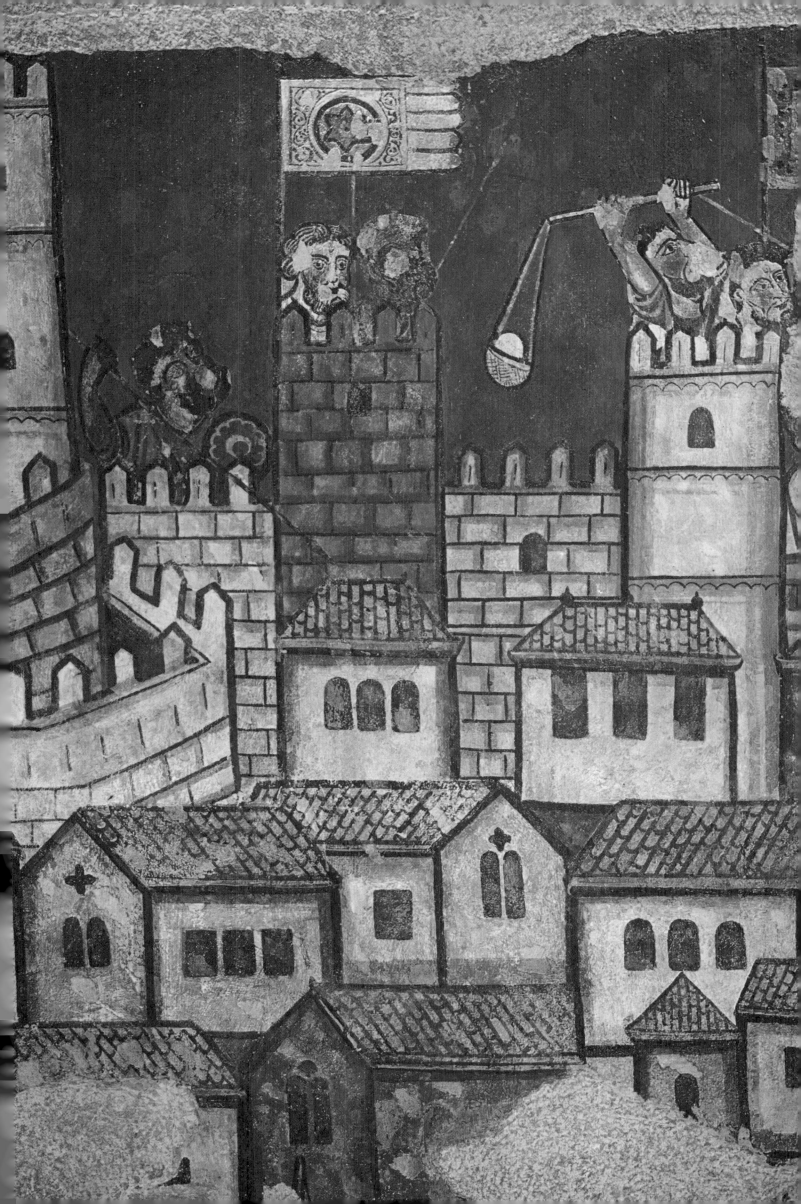

Mining for iron was an early industry. Seated
en hold magnets and indicate star as source of magnetic power.

As farmer watches, his son plows furrow behind
oxen. Before soil was depleted, Spain was a major grain exporter.

Alfonso X
Called "The Wise"

History has bestowed upon Alfonso X, King of Castilla and León, and the son of Fernando III, the title of *El Sabio* (variously translated as "Wise," "Sage," "Learned"), for he was a poet, scientist, legislator, historian and patron of learning.

Alfonso gathered a host of Latin, Arab and Hebrew scholars, who helped him translate and write treatises on astronomy, astrology, medicine, mathematics, physics, chemistry, mining, sports and games. He himself wrote a history of Spain and left unfinished a history of the world. He ferreted out a thousand stories, told them pungently and had them illustrated with magnificent illuminated miniatures.

Alfonso is likewise famous for his *Cantigas,* a superb collection of over 400 poems intended to be sung. In language which goes from the sublime to the earthy and even the bawdy, the king, who called himself the "troubadour of the Virgin Mary," recounted the miracles attributed over the centuries to the mother of Jesus. The richly illuminated manuscripts of the *Cantigas* are the most vivid record the world has of life in the Middle Ages.

As a legislator, Alfonso produced *Las Siete Partidas,* a seven-part code of the varied laws of the time, which were basically of Gothic origin. Into these he discreetly infused important elements of Justinian law and Roman ideas of centralized authority. The *Partidas* define the roles of religion and the church, emperors, kings and noblemen, of justice, marriage and blood relations, contractual obligations, last wills and estates, and penal law.

During Alfonso's reign only the kingdom of Granada remained in the hands of the Arabs. For expanding Christian Spain, this was a period of transition, a time to take stock and try to fuse the patchwork of states into a single nation, as a preliminary step toward the realization of an imperial dream. In a country whose intellectual life had long been stunted by wars, Alfonso X was just the voice to spell out this dream. But a rebellious nobility fought him at every turn and forced him to make humiliating concessions.

The noblemen did not approve of Alfonso's ideas of centralized power, or of his imperial ambitions. Through his mother, Beatriz of Swabia, he had a valid claim to the throne of the Holy Roman Empire. Upon the death of William of Holland, the Holy Roman Empire was left without direct succession. Alfonso submitted his candidacy and although he gained the support of many electors, he was thwarted by the strong opposition of a series of popes. For eighteen years he persevered in his claim to the Empire and spent lavish amounts trying to buy further support. In the process, he depleted the treasury, and as an expedient he devalued the

Alfonso X, El Sabio (The Wise), supervised the compilation of an illustrated history of Spain in the Castilian tongue.

currency, thereby giving rise to the first well-documented inflation in history. Although his unsuccessful bid for the Holy Roman Empire had given him a bad reputation as a politician, Alfonso had managed to make Spain aware of two important instruments required for empire-building, in addition to money and force—a language and a code of laws. In his time, Castilian became the foremost language of the peninsula, and the king used it even in his diplomatic correspondence.

The order of succession he had envisaged in his *Partidas* was to lead to his downfall. It called for the throne to be handed down to his first-born son, Don Fernando de la Cerda, who died on his way to fight the Moslems. Don Fernando's son was then

to become heir to the throne. But this was challenged by Alfonso's second son, Sancho, who now claimed that right for himself and entered into an alliance with some noblemen to fight against his father. In that civil war, Sancho took all but two cities. The King was deposed by the Cortes at Valladolid in 1282, and he died in 1284.

In balance, this man of learning, vision and idealism was a ruler well ahead of his time. Although his *Partidas* proved to be his own undoing, they were the legal fountainhead from which, two centuries later, the Catholic Sovereigns—Fernando and Isabel—were to derive their authority, unify the nation, and begin to realize Alfonso's dream of a vast empire.

Women shopping for luxuries examine silk thread, rugs, brasswork and jewelry. Goods came from as far as the Orient.

Ferias (Fairs)

The absolute necessities of life were available on the feudal estates in the Middle Ages. For the luxuries, however, peasants, tradesmen and nobility traveled to regional *ferias* (fairs). Held on religious feast days, the fairs were planned far in advance. Soldiers patrolled access roads to insure the safety of Christians, Moslems and Jews on their way to the celebration. Sales taxes were temporarily set aside by royal decree, which made the fairs especially popular with merchants.

At the fair women could shop for fine woolens, rich brocades and gold-threaded silks woven on the looms of Moslem Spain, Italy and India. Furs of marten, beaver, fox and sable to keep the rich warm found their way in from the north—from as far away as Russia. Ermine, so expensive it was usually reserved for the robes of royalty, was sometimes

available. To keep the less affluent from the cold there were garments of sheepskin, cat, horse and goat.

In greatest demand, and often in short supply, was honey, the only sweetening available before the process of extracting sugar was discovered. Salt, pepper, ginger and various spices brought highest profits to the traders. These commodities weighed little, great quantities could be carried by caravan or boat, and they sold at high prices.

Cosmetics and perfumes were popular with women of the 13th century. They also bought glassware from Venice, porcelains from France, and jade carvings, chinaware and precious gems that traveled precariously by land and sea from the Orient.

Men bought plows, rakes, tools, armor, swords, lances and daggers. Slaves were an important commodity. They were often exchanged (Moslems for Christians and vice versa) or bought outright. In the predominantly Moslem regions, eunuchs were sold.

The enterprising merchants who gathered these products were most often of Syrian, Genoese, Greek

Most physicians were either Arabs or Jews. Patients of this prosperous practitioner come carrying shopping bags

or Arabic origin, and the majority were of Jewish faith. Multilingual, hardy and adventurous, they traveled from Spain to North Africa, to Egypt through Persia and India and into China. Dangers from bandits and pirates were so great that many shipments changed hands more than once before arriving at the fair.

As trading centers the fairs filled an economic need. As important was the common meetingplace they afforded for the dissemination of ideas. Philosophers, physicians, alchemists and astronomers exchanged news and views. Crowds heard minstrels singing songs of the past and the present. Lyric poetry competed with verses which were sometimes vulgar, often satiric. Jugglers, gymnasts, bear tamers and bullfighters entertained. Dances, masquerades, jousts and tournaments added to the romance and excitement.

It was at the fairs that Christians, Jews and Moslems met in a peaceful environment. Each respective culture was thus more easily absorbed, as were influences from France, Italy and Flanders. Out of the fairs, as out of the fighting, came elements to shape the emerging Spanish nation.

Music of Christians and Moslems

The Moslems brought to Spain their vocal and instrumental arts, which were to leave an indelible exotic imprint on Spanish music. At first the invaders were constrained by the recent teachings of the Koran against wine and music, but as the caliphs of Córdoba gained in power and security, their courts witnessed a great musical flowering. The Moslems were particularly adept at playing stringed instruments, flutes and tambours. Moorish musicians even played alongside Christians in the palaces of Christian kings and nobles.

The invaders had left their women behind, but in Spain they found a rich supply of dancers to grace their harems and festivities. Since Roman times, the girls of Cádiz had been renowned for their seductive dancing and their skill at clicking castanets.

Meanwhile, Christian Spain was also experiencing an outburst of musical creativity, marked by the constant interplay of religious and popular themes.

During the 12th and 13th centuries, popular music flourished in the area in and around Santiago de Compostela. The bands of pilgrims who visited the shrine could find there not only heavenly inspiration but earthly communal singing and dancing. Galician troubadors composed a variety of pastoral, love, humorous and even bawdy poems intended to be sung. They called them *cantigas*. Some were also intended to be danced, as was the case with the *cantigas de vilhao*.

This popular music, born in religious surroundings, could not fail to be influenced by them. Galicians began to write a great number of songs dedicated to the Virgin Mary. Curiously, the best of these nonliturgical poems appeared in Castilla, though the Galician language was used for the texts. They were gathered or written by King

A Moslem and a Christian strum on citterns, a type of [Moslem's eyes seem to have been purposely defaced in pict

Alfonso the Wise and his assistants in the famous *Cantigas de Santa María*.

The *Cantigas* of King Alfonso are also a rich source of illustrations of medieval musical instruments, over 50 of which are pictured.

About the same time that the lyrical *Cantigas* were popular in Galicia—and later in Castilla—a type of epic poem called *cantar de gesta* emerged in Castilla. In song form, it told of the heroic deeds and memorable events of the recent past, so as to lift spirits for the long fight against the Moslems. The best known is the *Poema de Mío Cid,* which recounts the exploits of Rodrigo of Bivar.

From these lyric and epic traditions the 14th and 15th centuries derived the *villancicos* and the

Two court musicians play bagpipes made of goat or sheep-skin in an illustration from the Cantigas (Songs) of Alfonso X.

romances. Some musical historians trace the *villancicos* back to the Galician *cantigas de vilhao*. Like the latter, they were rural song-dances, but some had religious lyrics which made them appropriate for church festivities. In time the religious aspect won over the rural, and today *villancicos* are sung almost exclusively as Christmas carols.

A great composer of *villancicos* was the poet-musician Juan del Encina, who also wrote many *romances,* or ballads. Sung by *juglares,* these ballads were usually commentaries on political events, such as the murder of Pedro the Cruel by Enrique of Trastamara; or else they were frontier songs depicting the last battles of the triumphant Christians against the Moslems.

Cantigas *contains pictures of over 50 different kinds of instruments. Here two flutists play a duet.*

Sporting Life
in the Middle Ages

In the Middle Ages the Iberian peninsula was familiar with a sport closely resembling baseball and similar to the English game of rounders. Ever since ancient times, all sorts of ball games *(pelota)* had been played on Spanish soil, using bare or gloved hands, sticks or bats or, as in modern jai-alai, a basketlike extension of the hand. To the Moslems, ball games had a religious connotation and were part of their fertility rites. It is known that in Spain ball playing extended to the highest levels of society, as evidenced by the fact that the death of King Philip in 1506 has been attributed to the effects of drinking cold water after a hotly fought game of handball.

Yet in the Middle Ages, when the horse was so widely used in warfare, the main sports were mounted competitions—jousts, tourneys, horse races, polo and even bullfighting. Generally the contenders were members of the royalty or nobility, while the common people were vociferous and vicariously excited spectators.

The joust, or personal combat, and the tourney, or group battle, were familiar not only to Spain but to France and England; in the latter countries they usually were fought with blunted lances, the prize perhaps being a smile or a favor from the lady who presided over the event. In Spain, however, many of these meets were held without prior blunting of weapons. Often—when they were not fighting each other in the battlefield—Christians and Moslems participated in joint tourneys. Underneath the pageantry, the joust, the tourney, and the horse race were excellent training and tempering for war. Out of them came also the code of chivalrous, courageous and honorable knighthood, which attained

Twelfth-century baseball has elements of modern game. Batter, pitcher and fielders appear together in this picture.

its romantic apex with the knight-errant and which was to give birth to a whole new genre in literature. Cervantes poked fun at the exploits of Sir Lancelot, Roland and Amadis of Gaul.

Bullfighting was likewise a sport of noblemen in Spain during the Middle Ages. In its various early forms—baiting and bull-hunting—it dated back at least to Iberian times. When the Romans occupied the peninsula, their circuses pitted men against lions, bears and the native bulls *(torus ibericus)*. But bull-fighting on horseback may well have preceded the Romans, for it is claimed that Julius Caesar learned to lance bulls on horseback in Spain, proudly showing off his newly acquired skill when he returned to Rome. Bullfighting continued during the Visigothic monarchy and the reign of the early Christian kings. At the royal wedding, in the 11th century, of King Alfonso VII of León, a bullfight was held—the forerunner of many such celebrations.

The Arabs, always great horsemen, began fighting bulls on horseback soon after their invasion of Spain. In the latter part of the 13th century they held bullfights at the Plaza de Bibarrambla in Granada, and also at La Tabla, a plain near the Alhambra. There is even on record a corrida to celebrate the circumcision of the son of Sultan Mohamet V. Bullfights continued under the Trastamara dynasty and the Catholic Sovereigns, although Queen Isabel herself was not fond of the spectacle. The Hapsburg

kings gave it added importance, particularly Emperor Charles V, who often joined in bullfighting on horseback. His son, Felipe II, also participated in defiance of a Papal bull which attempted to put a stop to the bloody toll of noblemen. Felipe III, Felipe IV and Carlos II were all enthusiastic supporters of the *fiesta nacional,* as it came to be known. With the advent of the first Bourbon king, Felipe V, who had no love for bullfighting, the spectacle entered into a period of decadence. Now the common people, on foot, took over the sport from the mounted noblemen and developed bullfighting into a ritual and an art, in which outstanding *matadores* faced the bull with cape, *muleta* and sword.

Games of dexterity and chance were in great vogue in medieval Spain—chess, backgammon, dice, cards. From its very beginning, the Christian church had looked askance on these games, and canon law in general forbade them, particularly to the clergy. The attitudes of Spanish kings were mixed, however. Alfonso the Wise legislated against them in his famous *Partidas,* but allowed government-supervised gambling houses under a series of ordinances known as the *Ordenamiento de las Tafurerías.* Cards and dice were used, and there were penalties for fraud, including fines and loss of property, plus the cutting off of fingers after three violations of the rules. Enough calamities resulted from these practices so that Alfonso XI, the successor of Alfonso the Wise,

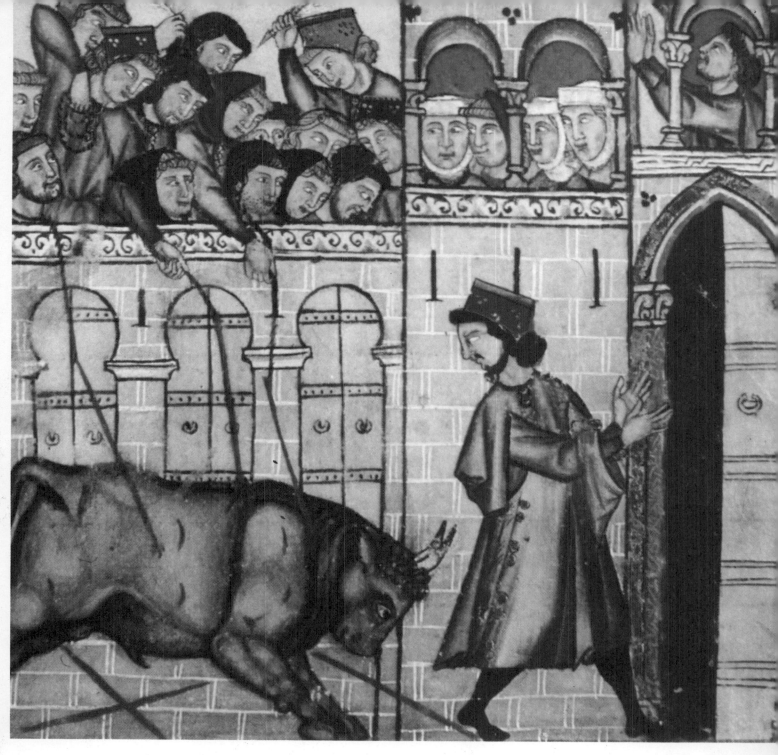

*Entertainments featuring bulls were common by 1250.
In this version, audience participated by throwing banderillas.*

found it necessary to close the gambling establishments. Dice—of disputed origin but believed to have come from Asia—was already popular on its own or as part of other games like backgammon as early as the 11th century.

Chess was reportedly introduced into Spain around the 9th century by the Arabs, who had brought it from Persia. The *shitranch* of the Persians was soon adopted by the court of León with almost the same terminology and rules as are used today. One thing was quite different: Moslems restricted chess pieces to symmetrical abstract shapes and avoided representation of man or animal. Chess was played to perfection by the caliphs of Córdoba,

under whose rule players were classified into five categories, according to their ability, with handicaps allowed to lesser players. Arab players frequently astounded chroniclers by playing blindfolded or without looking at the board, a practice almost unknown in Europe until recent times. One of the greatest chess manuals extant is the *Tratado de Ajedrez* from the *Libro de Juegos* (Book of Games) written under the supervision of Alfonso the Wise in 1270. It contains more than 100 illuminated miniatures and over 100 problems with their solutions. It also gives the rules for *grand chess*, played on a board with 144 (12 × 12) squares instead of the usual 64 (8 × 8).

With an unhappy scowl, loser in a dice game reaches to ~y his debt. Knife on table is presumably to keep game honest.

89

The Hunt

Hunting with falcons was a favorite sport of both the Christian aristocracy and the Moslem rulers in medieval Spain. At lower levels of society, fowling with various types of hunting birds was sometimes a matter of survival. Under the constant Arab raids, the Christians in frontier areas could not do much farming and had to depend on meat on the wing for part of their diet. The art of falconry became highly developed, particularly for hunting wild geese, ducks, partridges and, above all, cranes. There were several species of prized falcons, among them the famous *shudhaniq* from the region of Valencia, and the *lablí,* or *nablí,* from the Andalusian area of Niebla, which together with the falcons of Lisbon were known for their remarkable speed. The birds were trained by covering their heads with a leather hood, strapping their wings so they could not fly away, and keeping them half starved until they learned to obey orders. Once trained, they would be carried to the field, perched on a heavy leather gauntlet worn by the trainer or hunter as a protection against their powerful claws. At a command, the falcon would soar off and swoop down on its prey. In later centuries, as the use of firearms became commonplace, falconry declined and finally disappeared until recent times, when it was again revived, but strictly as a sport.

Then, as now, another popular sport was the *montería,* or hunting with dogs for boar, deer and mountain goat. The Córdoba monarchs indulged in this type of hunting in the mountains of the Sierra Nevada.

Painting of a gentleman hawking, from the Cantigas, *betrays a strong Persian influence. Note the two cowering rabbits.*

Medieval Medicine

The Spanish Moslems brought medicine to what was perhaps its highest peak in the Middle Ages. Long before the conquest of the Iberian peninsula, their Persian and Arabian ancestors had begun translating Greek works on science. By the 10th century, practically all the important Greek tracts on medicine were available in Arabic. At Toledo, two centuries later, many of these same works were to be translated first into vulgar Castilian and then into Latin under the direction of King Alfonso.

Among the most renowned physicians of the Middle Ages were the four giants of medicine at the time of the caliphate of Córdoba. One was Albucasis, who defied tradition and religious teachings in his encyclopedic work *Al Tasrif,* a comprehensive and illustrated account of surgery, repeatedly translated into Latin. Another famous Moslem was Avenzoar, perhaps the greatest clinician of his time. The third, Averroës, was mainly a philosopher, but he also wrote important books on medicine. The fourth was a Jew, Maimonides, who was known all over Europe as a philosopher, Talmudist, hygienist and physician. He later moved to Egypt, where he became physician to Emperor Saladin. The Jews in Spain were great practitioners of medicine, both under the Moslems and in the Christian kingdoms.

At the time of the Moorish kingdom of Granada, two Moslem physicians made original contributions to the understanding of infection. The Black Death had just hit Spain, after having supposedly started in India in 1348 and spread to the Mediterranean. Ibn Khatima, of Almería, pointed out that contact with someone who had contracted the plague could bring on the same symptoms in other persons. Ibn-al-

Medieval artist's conception of a Roman hospital is actually a better picture of what hospital looked like in 12th-century Spain.

Miracle described in the Cantigas *tells of a pregnant Jewish woman who had come to term but could not deliver. A*

Khatib, of Granada, held that infection could be transmitted by clothing and household objects by ships coming from infected places, and by people who carried the disease though they themselves might be immune to it.

Until the Middle Ages, using a knife on the body had been beneath the dignity of physicians, and therefore was left mostly in the hands of barbers and bathkeepers. Surgery consisted mainly of cautery, amputation, opening of abscesses and repairing bone fractures. Among the Arabs and Jews it was used mostly in connection with the sex organs: castration, infibulation and circumcision. The Arabs,

however, made striking progress in eye surgery and developed to a high degree the operation for removal of opaque lenses in cases of cataracts.

Midwifery and gynecology were forbidden to men in medieval times. Physicians were usually called only after the mother and child were already dead. Obstetrical aid was generally denied to women in labor. In cases of abnormal presentation of the fetus, the mother was left to suffer for weeks until she died of exhaustion or complications. No one was allowed to interfere with the position of the fetus—it was believed to be preordained by providence. One of the few operations permitted by the

voice told her to pray for help to the Virgin. She did so, was helped, and in gratitude turned Christian along with her children.

hurch was the Caesarian section, which was re-arded with awe and could be used only to save the hild upon the death of the mother.

In Spain the Moslems instituted an advanced stem of hospitals. At one time Córdoba had ver 50, while Granada, Sevilla and Toledo were ot too far behind in numbers. These hospitals ere of various types, including some for lepers, hom the Moslems were the first to separate (in ance they were usually burned), and for the insane the rest of Europe they were generally chained). he Arabs also developed ambulatory clinics, prison spitals, first-aid stations, army hospitals and field

stations (at a time when elsewhere in Europe the wounded were looked after by their comrades in arms or by the prostitutes that followed in the wake of battle). It was a Moslem practice to admit every-body, regardless of race or circumstance (both free-men and slaves). Much stress was put on running water and baths. The hospitals had separate depart-ments for internal medicine, eye diseases, surgery and orthopedics. Frequently musicians and singers were brought to entertain the sick. Upon leaving the hospital, each patient was given a sum of money to tide him over until such time as he was able to obtain gainful employment.

Conversions of Moslems and Jews

At the beginning of the Moslem occupation Christian institutions were tolerated, so that conversions were not numerous. Yet certain economic and political advantages could accrue to those Christians and Jews who sincerely adopted the faith of the invaders. Intermarriage had much to do with conversion, for the Arabs took wives, concubines and slave girls from the captured territory.

During the invasion by the fanatical Almorávides and the even more fanatical Almohades, conversions were forced to the point where most of the Christian population in the Moslem area was made up of *renegados*. Those who kept the Christian religion (Mozárabes) were killed or compelled to flee to Christian lands. The fate of the Jews was much the same, although in the early days they had been respected members of the Moslem state, with greater rights and privileges than the Christians.

When Christianity spread over most of Spain in the 13th century, it was the Moslem's turn to live in a Christian-dominated society. Mudéjares and Jews were allowed at first to practice their religions and to retain their institutions, but later social, economic and religious pressures were used to force great numbers to convert. These baptized Mohammedans and Jews were called *conversos*. If they secretly kept their religion, they were called *marranos*, a word with the double meaning of "pigs" and "anathema." Moslems and Jews were confined to segregated sections, often walled. To be easily recognizable, they were required to wear distinctive dress—a shoulder strap or hat. They were forbidden to visit public baths or to partake of food or drink with Christians. Finally, throughout the 13th and 14th centuries, Jews and Moslems having sexual relations with Christians were liable to torture, dismemberment or death.

In Cantigas tale, Moslem is converted when he gets image of Virgin as booty, prays to it, sees milk come from its breasts.

Enrique of Trastamara commissioned this lovely painting to mark his victory in a mortal fight with his half brother

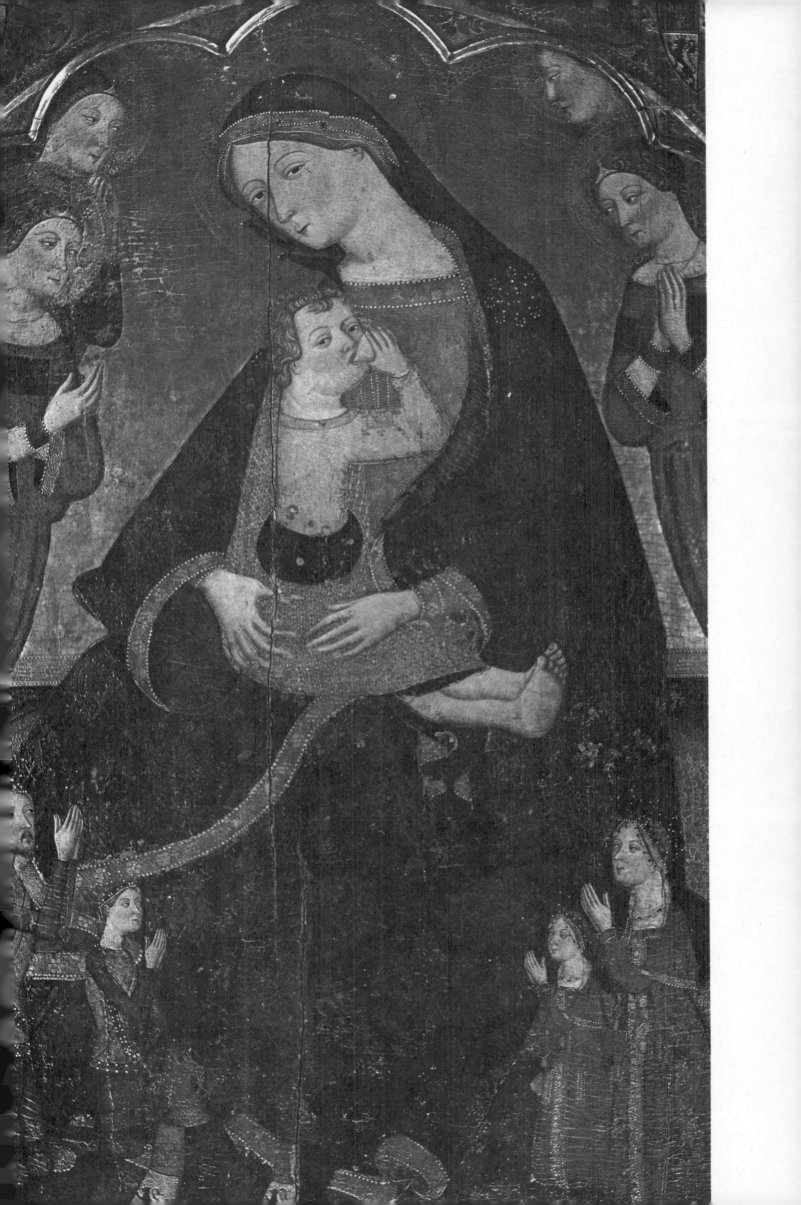

During last flowering of Moslem culture in Spain at end of 15th century, these two Arab chiefs were painted in Granada.

The Crest of Moslem Culture

For over 200 years, the Moslem kingdom of Granada stubbornly held out against the Christians. Its territory had been reduced by the conquest of Murcia and Jaén by Alfonso X (the Wise) and now comprised the provinces of Granada, Málaga, Almería and areas of Sevilla and Córdoba.

It is estimated that this Moorish stronghold had a total population of about three or four million, many of whom were refugee Mudéjares, but the bulk of the Granadian population was made up of

Arabs and Muladíes. The city of Granada itself is said to have had 200,000 inhabitants.

Alfonso X's continuous fights against the nobles of his kingdom, and the split among his children over the rights of succession, gave the Granadians an opportunity for a last attempt to reconquer Spain. For the third time since the original Moslem invasion they called on African help. A strong army of the Benimerines, a new African dynasty that had won over the Almohades, landed at Gibraltar in 1275. But before engaging the Christians they thought they saw an opportunity to take over the rich kingdom of Granada.

This turned out to be more difficult than they had foreseen. The Granadians, who had so far been spared by the Christians through an agreement to pay tribute to the king of Castilla, became fearful of the new invaders and asked for Christian help. This marked the beginning of a series of alternating alliances—with the Benimerines when Christian demands rose too high, with the Christians when the Benimerines became too greedy. Granadians

A Christian lord pledges friendship with a Moslem. But according to Cantigas story, Moslem nevertheless betrayed him.

and Castilians found themselves fighting alongside one another in many a skirmish, and expedient friendships—if not great loyalties—flourished.

In 1340, during the reign of Alfonso XI, the Benimerines and the Granadians once more joined forces for a decisive battle on the banks of the Salado River. They suffered a stunning defeat at the hands of the Christians, who forced the Africans to recross the Strait of Gibraltar.

Granada was again on its own against all Christian Spain. But the Christians fell into new and bitter quarrels among themselves, and the Moorish kingdom continued its lonely course for a century of sporadic fighting against Castilla.

Lonely it may have been, but hardly dull. For Granada was a rich kingdom, and enjoyed a prosperous commercial life. The silk trade with Italy alone made Granada the wealthiest of Spanish cities; Genoese merchants opened shops there, and, as late as the 15th century, Florence was still importing silk from the Moorish kingdom.

During the reign of Mohammed II, Granada had begun to rival Córdoba as a cultural center. Architecture, literature, science, technology and

craftsmanship were developed to a high degree. The latter period of the kingdom was marked by soft and sensuous living, as well as by bloodbaths and political intrigue. The Granadian Moslem was a far cry from the first desert nomads that had spilled over from Africa. In addition to the rich cultural heritage of Arabia, centuries of contact with strong vestiges of Roman and Visigothic civilizations in Spain had left a deep mark. The early African warrior was now, particularly at the princely level, a scholar, a poet, an artist and a sybarite.

The Alhambra, a fortress-palace still standing at Granada, is a fit symbol of this period. Begun under Mohammed II, it is not particularly prepossessing from the outside. Deliberately conceived by the Moslem architects to avoid formal symmetry, its castle-like buildings, surrounded by a thick wall, blend with the hilly surroundings. Adjoining the Alhambra are the beautiful gardens of the Generalife which overlook the city. From the gardens the Moslem sovereigns could watch their armies coming home after battle with the Christians.

Inside the Alhambra and within the Generalife gardens the scene is a Koranic dream come true.

Cult of chivalry swept even Moslem Spain by the 15th century, when this scene of a knight rescuing a maiden was painted.

With imagination and mastery of construction techniques, Moorish architects used heavy materials, such as marble or porphyry, for surfaces that had to withstand friction (floors) or support weights (columns). As the eye traveled upward, the materials grew lighter and lighter. Plaster, stucco and wood were molded into stalactites that resembled the entrance to a desert tent, or were cut out into lacy patterns that seemed to repeat the embroidered veils covering the faces of the women of the harem. Columns fanned out at the top like palm trees. Walls were covered with exquisite glazed tiles, and ceilings were decorated with gold, lapis lazuli or the blue ore azurite.

To give the buildings life, the Moslems planted tall and slender trees like cypress, and stately, fragrant shrubs like myrtle. Orange and jasmine added their scent to courts and patios. Last, there was water. To the North African and the Arab water was precious on two counts: first because he had to use it five times a day for his religious ablutions, and second because it was such a scarce commodity in the desert that he often had to use sand as a substitute in performing those ablutions. The Alhambra

Continuation of previous scene, executed on leather in the Alhambra Palace, shows Moslem knight killing Christian.

was, in this sense, an oasis. There the Moslems found abundant water and used it inspiredly, turning it into a visual and musical treat. The trickling, bubbling, cascading sounds of water were like so many grace notes and arpeggios, in contrast to the long, restful silences of the pools.

No Arab palace is complete without a harem. Women with jet-black hair reaching to their ankles, brilliant white teeth and gleaming skin—attributed to the Moorish fondness for baths—added a voluptuous center of attention to the sensuous atmosphere. There were also blondes and redheads, probably of Celtic and Visigothic ancestry. The women of the harem wore long tunics, pantaloons and Moroccan slippers, in addition to their face veils. Men wore similar attire, except that in war they would line their turbans with an iron cap and add coats of mail to protect their bodies. The harem was guarded by eunuchs, called *eslavos* (Slavs) because they came mostly from eastern Europe.

The Moslem penchant for baths is reflected not only in the Alhambra, but in the existence of public bathing facilities in every town and hamlet. Women used these baths three days a week, and men bathed

poetic pedestal. From the love poems they dedicated to their beloved came recitations and ballads, later spread throughout the peninsula by *juglares,* or troubadours. Arabian poets treated love diversely: to some, love was suffering at the hands of the beloved; to others it was an all-consuming spiritual experience, even though the lovers might never have intimate contact; or again, it was described as a game. The idea of pure love, later to be a part of the lore of chivalry, may well have received its original inspiration from these love verses of Arabic Spain. Among the great Arab poets, two couples stand out: Aben-Zaidn and his lover, Walladah, and King Almotamid and his favorite, Romaiquia. It is hard to say who were the most lyrical, whether the men or the women, in both these cases.

Many Moslem words became commonplace in the languages of the Christian kingdoms. Castilian borrowed a large number of them, for they added a clarity of concept as well as a beauty of sound. Cities were governed by an *alcalde* (mayor) and policed by *alguaciles* (constables). An auction, an *almoneda,* was held in an *almacén* (store). The *albardero* (pack-saddle maker) sold harnesses for *acémilas* (mules) to carry *aceite* (oil) to the *zoco* (marketplace). Almost every word in the Spanish language which starts with the prefix "al" is Arabic; also words ending with "í," like *Marroquí* (Moroccan), *alhelí* (gillyflower), *zahorí* (diviner). Finally, the Moslems managed to leave the name of their god on every Christian lip throughout Spain in the often-used word *Ojalá (wa xa Allah),* which expresses a wish or a hope of something happening.

A long series of Moslem sovereigns had ruled Granada by the time Fernando and Isabel decided to end the centuries of Arab domination. In its last years, Granada was split asunder by Sultan Abul Hassan, whose favorite wife was his cousin Aixa. She bore him a son whom the Spaniards called Boabdil. In one sortie into Christian territory, the Arabs seized as prisoner a beautiful lady, Isabel de Solís (later known as Soraya). When the sultan saw the Christian, he fell in love with her, forsaking Aixa. This gave rise to political factions which Fernando adroitly pitted against each other. The Catholic monarch, whom Machiavelli used as a model in *The Prince* (his treatise on political power), vowed to take Granada (which literally means "pomegranate"), saying: "I intend to pick this pomegranate seed by seed."

there the remaining four days. All necessities were supplied—hot water, soap and towels—but anyone availing himself too freely of them could lose an ear. Note the contrasting attitude of the Christians, who believed bathing weakened men for battle. In 1567 the Christians destroyed all "artificial baths" in Granada, and almost three centuries were to pass before bathing, in any public sense, returned to Spain.

The Moslems were somewhat inconsistent in their attitude toward women. In general they considered women little better than slaves, but once they fell in love with one, they placed her on a

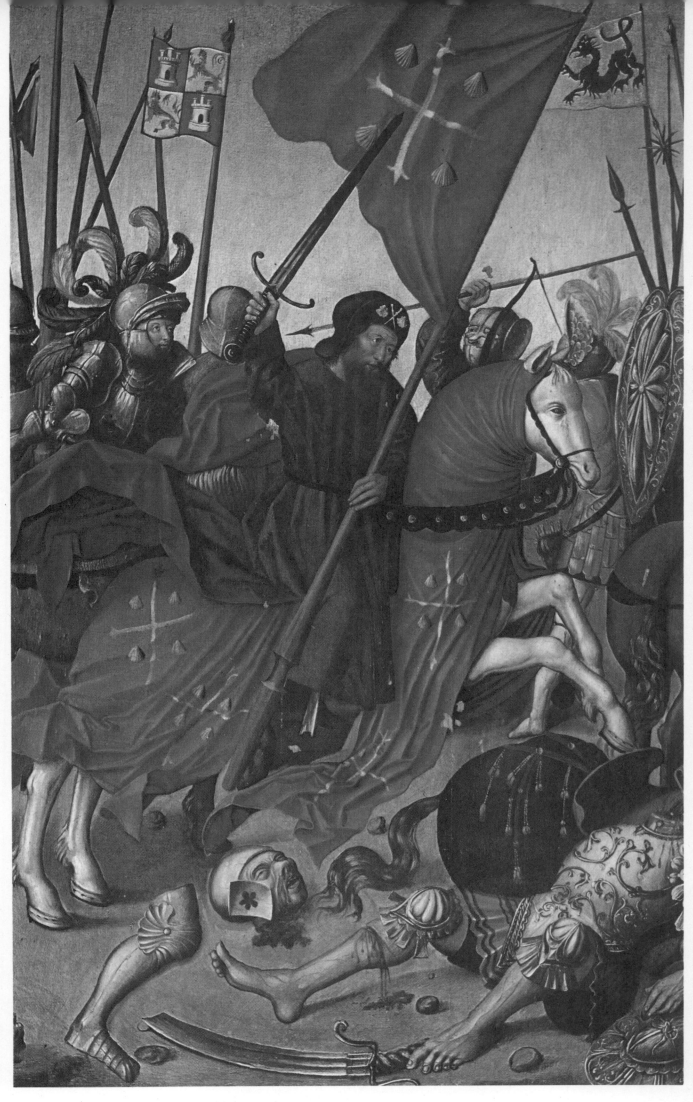

At Granada, the last stage of the reconquest of Spain from
the Moslems, St. James—Santiago—still rode with the Christians.

1469–1516
THE CATHOLIC SOVEREIGNS

An epoch of political and religious unification. Castilla and Aragón are joined together by the marriage of Fernando and Isabel. The Moslems are finally defeated in Granada, the Inquisition is established and the Jews are expelled from Spain. The creation of an empire begins—Naples is conquered and Columbus discovers America. The Italian Renaissance leaves its imprint on the culture of this period, and Fernando de Rojas writes the first modern novel, *La Celestina*.

HISTORICAL CHRONOLOGY	ART CHRONOLOGY
1469 *Isabel of Castilla marries Fernando of Aragón.*	1474 *First printing press in Zaragoza.*
1474 *Isabel becomes Queen of Castilla.*	1475 *Painter Jaime Huguet (Catalán Gothic).*
1476 *Isabel and Fernando defeat the followers of Juana la Beltraneja.*	1476 *Church of San Juan de los Reyes built by Juan Guas in Isabeline style.*
1478 *New Inquisition is established in Spain.*	1486 *Carvings by Gil de Siloé at Burgos and by Pablo Ortiz at Toledo.*
1479 *Fernando becomes King of Aragón.*	1487 *Colegio de Santa Cruz, Valladolid.*
1492 *(January) Surrender of Granada marks the end of Moslem occupation. (March) Jews expelled from Spain. Those who choose to stay must convert to Catholicism. (October) Columbus discovers America under mandate from Catholic Sovereigns.*	1489 *Works of sculptor Rodrigo Alemán.*
	1490 *Bartolomé Bermejo paints his masterwork "La Piedad" for Barcelona Cathedral.*
	1492 *Antonio de Nebrija publishes first grammar of any European language.*
	1492–1540 *Valencia philosopher Luis Vives.*
1494 *Treaty of Tordesillas assigns areas of influence to Spain and Portugal.*	1496 *Cancionero (Song Book) of Juan del Encina.*
1496 *Princess Juana marries Hapsburg Archduke Philip.*	1497 *Fernando de Rojas publishes La Celestina.*
1504 *Queen Isabel dies.*	1498 *Sculptor Philippe Vigarny starts to work in Spain.*
1506 *Philip of Flanders becomes King of Castilla. Dies same year.*	1500 *University of Valencia founded.*
1507 *Cardinal Cisneros becomes regent.*	1504 *Painter Pedro Berruguete.*
1510 *King Fernando becomes administrator of Castilla. Moriscos of Granada are forced to convert.*	1505 *Royal Chapel of Granada by Enrique de Egas.*
	1508 *University of Alcalá de Henares founded.*
1516 *King Fernando dies. Cisneros becomes regent for the second time.*	1517 *Tomb of Catholic Sovereigns by Domenico Fancelli. Publication of polyglot Bible (in Greek, Latin, Hebrew and Chaldean).*

The Spain of Fernando and Isabel

That Isabel of Castilla ever married Fernando of Aragón is remarkable. From the age of 10 on, she had been promised to at least five distinguished suitors besides Fernando: his elder brother, Don Carlos, King Alfonso of Portugal, Pedro de Giron (grand master of the order of the Knights of Calatrava), a younger brother of Edward IV of England, and the Duc de Guienne, brother of Louis XI of France. Inasmuch as Enrique IV, her vacillating and always difficult brother, continued to find suitors for her who seemed to him more desirable than Fernando, it is a tribute to Isabel that she insisted upon marrying the man of her choice.

At the time of the wedding Isabel was a slim nineteen-year-old with reddish-golden hair, a fair skin and blue eyes, perhaps inherited from her English grandmother. She was a plain woman who did not use cosmetics, nor did she wear the elaborate coiffures then in fashion. Fernando was a year younger, a broad-shouldered, athletic youth with a balding forehead. He was known to be an excellent horseman and swordsman.

The nuptials did not mean that either Isabel or Fernando had any official power in their respective kingdoms. Isabel's brother, Enrique IV, still ruled Castilla; and Fernando's father, King Juan, reigned in Aragón. But both had been recognized as heir apparent to their respective thrones, and when they did inherit the two kingdoms, Isabel through the death of Enrique in the year 1474 and Fernando by the death of his father in 1479, Spain finally became united by their marriage. However, the kingdoms of Castilla and Aragón continued as separate entities.

For four-and-a-half years, Isabel was engaged in continuous warfare to maintain her position. Even though the Cortes had confirmed her right to the throne, the followers of Juana la Beltraneja, her niece, together with Alfonso, King of Portugal, continued to make every effort to depose her. They failed, and Juana was forced to give up any right to

Pictorial chart records in Latin the distinguished genealogy of Fernando the Catholic and his wife Isabel.

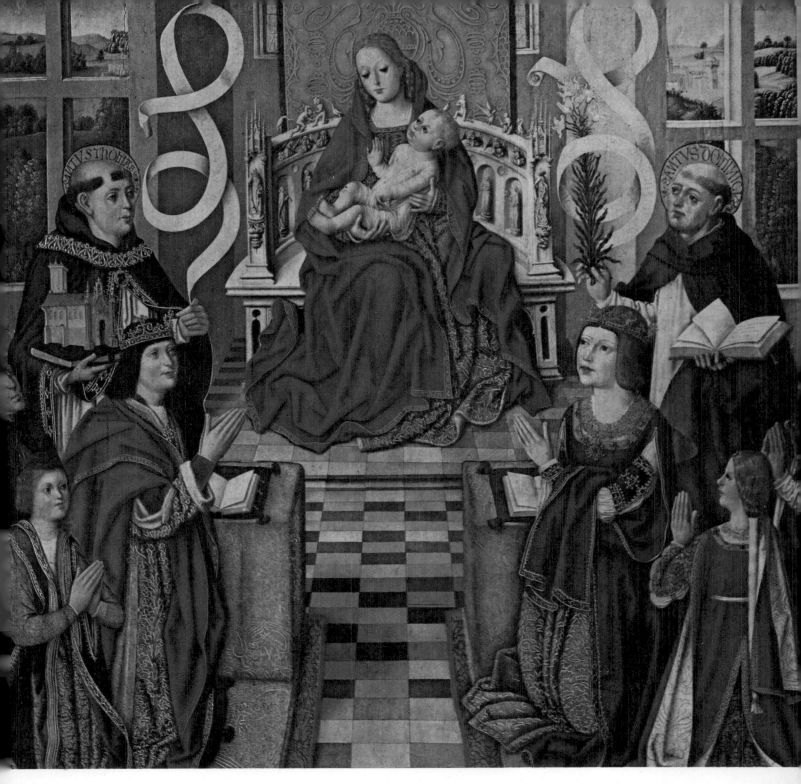

The Catholic Sovereigns kneel reverently before Virgin. Others include the Queen's infamous confessor Torquemada (right).

succession and to retire to a convent in Portugal.

The end of this war of succession did not bring peace to Castilla. The nobles had become very powerful during the anarchical reign of Enrique IV, and some were richer in gold and men than the Crown itself. Within their extensive estates they considered themselves kings and observed only their own laws. Los Reyes Católicos (the Catholic Sovereigns), as Fernando and Isabel were soon to be known, acted quickly against the nobles. They dispatched a small army, led by a soldier, Fernando de Acuña, and a lawyer, López de Chinchilla, to bring order to the northwest provinces. Similar expeditions were sent to other regions. In these enterprises the Catholic Sovereigns were greatly helped by the

church, which did much to finance the expeditions, and by the Santa Hermandad (Holy Brotherhood), the reorganized militant group that performed similar police functions but enjoyed more authority than the earlier brotherhoods.

An important reaction to the power wielded by the nobles came when the Crown made itself head of the great military orders, including Calatrava, Santiago and Alcántara. Next they ordered the destruction of all castles not needed for the defense of the kingdom, and forbade the construction of new ones by the nobility.

By curbing the influence of the nobles, the Catholic Sovereigns indirectly benefited the middle and peasant classes. Isabel further helped the serfs by

107

legislation that emancipated them from the land and spelled the beginning of the end of feudalism. The right of serfs to leave the land of their master and take their cattle and goods with them had earlier become the law of León. Under Isabel it was extended throughout Castilla. Fernando was later to follow her example in Aragón. As the number of Christian serfs diminished, Moslems and slaves took their place. Yet even they were given the right to buy their freedom. A class of freedmen, both Christian and Moslem, evolved, but went on farming as tenants, since over 90 percent of the land was owned by the nobility.

The country prospered under a more efficient tax collection system, a reunited church and state, and the reopening of trade routes along the Mediterranean, especially in Cataluña. In further efforts towards unification and central control, a universal military service was inaugurated, and a fulltime royal army was formed. Law enforcement compelled the nobility to bring their problems into the courts instead of settling them among themselves.

None of these reforms would have been possible without the amazing popularity enjoyed by Isabel. She traveled on horseback throughout the countryside, and became, like Santiago before her, a rallying symbol of Spanish purpose and unity.

One of the reasons for the success of Isabel as Spain's most popular ruler may have been her combination of femininity and piety. For as the Christian forces had advanced down the peninsula, Spain had become a matriarchal country. Nowhere else in Europe were women's rights so well defined or recognized. The underlying reasons for this are difficult to determine, since neither the Roman, Visigothic nor Moorish invasions had brought with them wide acceptance of the rights of women. Yet these rights had been implicit in the early Celtiberian communities, and the advancing Christians spread them in their inroads into Moslem territory. Children carried the surnames of both father and mother. Property could be inherited by the wife upon the death of the husband where there was no brother to succeed him. When a woman of the nobility married, her title went also to her husband. Throughout Spain, the woman was revered as a mother rather than castigated as a delinquent when she had an illegitimate child.

It is interesting that during this same period the cult of the Virgin became paramount in Spain. Christ was most often regarded and represented as a child reigning over his kingdom from the security of his mother's knees or her breast. Shrines to the Virgin at Guadalupe, Antigua, Montserrat and other places were constantly visited by Christian pilgrims. In this matriarchal setting Isabel was revered not only as queen but perhaps as a holy symbol as well. Yet she did not devote herself exclusively to religious affairs. The queen consulted constantly with Fernando on matters of state and accompanied him on most of his trips around the kingdom. She also gave a great deal of attention to her family, but her five children were born in five different regions of Spain—which proves that she was no stay-at-home queen.

The Catholic Sovereigns had a great interest in the arts, notably architecture, which in Spain developed a particularly ornate style known as *plateresque*. The most important building erected during their reign was the cathedral at Sevilla, which harmoniously blended Islamic, Gothic and Renaissance elements. A more specific style, known as "Isabel of Castilla," evolved. It is noted for its simple structural design and for its elaborately ornamental external treatment. One excellent example is the façade of the Colegio de San Gregorio in Valladolid, which presents a huge coat of arms of Castilla and León (see end papers) as its gigantic motif. Other important structures built during the reign of the Catholic Sovereigns include the delightful fairytale Alcázar of Segovia and the ornate Palacio del Infantado in Guadalajara.

Painting was influenced by the Flemish masters who visited Spain in the 15th century, but the Spanish artists retained their national characteristics. Among them were Jaime Huguet, who painted the great altarpieces, and Pedro Berruguete, who reflected in his Renaissance canvases the contemporary life of Castilla.

It was an era of romance and sentiment. Its greatest poem was written by a young man who was killed in battle while serving the queen. He was Jorge Manrique, whose notable work, the *Coplas,* praised his father and reflected upon life and death.

Two literary works of equal importance, yet completely different in content, appeared near the end of the 14th century. One was the *Gramática de la Lengua Castellana,* the first grammar of the Castilian language, written by the humanist scholar Antonio de Nebrija. Published in 1492, it was an indication of the importance of the Castilian language as a unifying force throughout Spain. Within

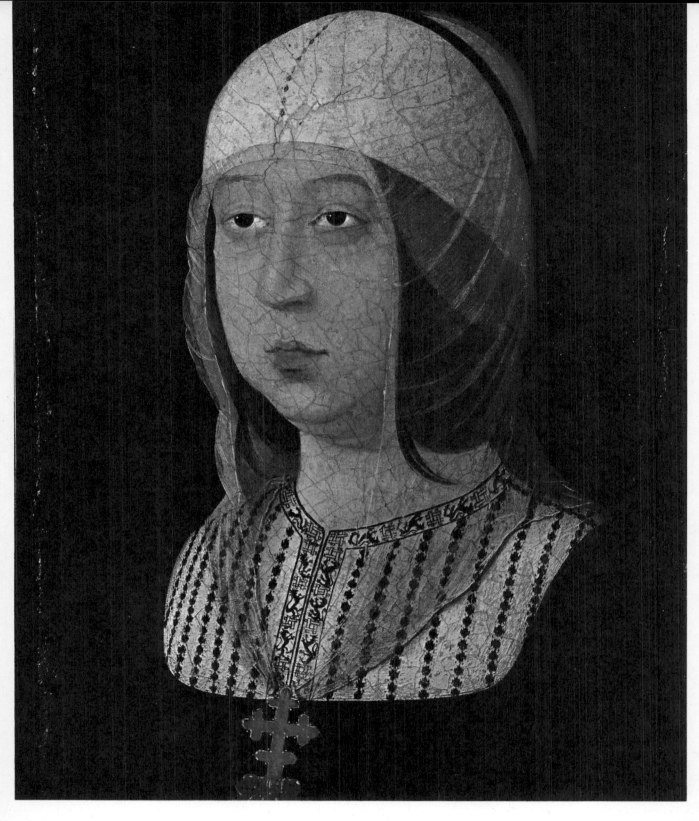

a few years Castilian replaced Galician as the spoken language of Castilla; and although Cataluña continued to speak its own language, even there Castilian was used in literature.

The second great literary work, and the first to contain features of the modern novel, was the *Tragicomedia de Calisto y Melibea,* better known as *La Celestina,* after the name of the book's leading character, one of the most colorful women in all literature. Like Trotaconventos in the *Libro del*

Buen Amor (Book of the Good Love) by Juan Ruiz, the Archpriest of Hita, she is an *alcahueta* (go-between), an ancient and immoral hag, much more charming than her predecessor. With the vivid flow of language that the Spanish are noted for, with wit, spirit and fire, she arranges assignations as she goes from house to house selling cosmetics, practicing as a midwife and herb doctor or purveying love potions. But most of all she sells her wisdom to men and women to pave the way for romance and seduction.

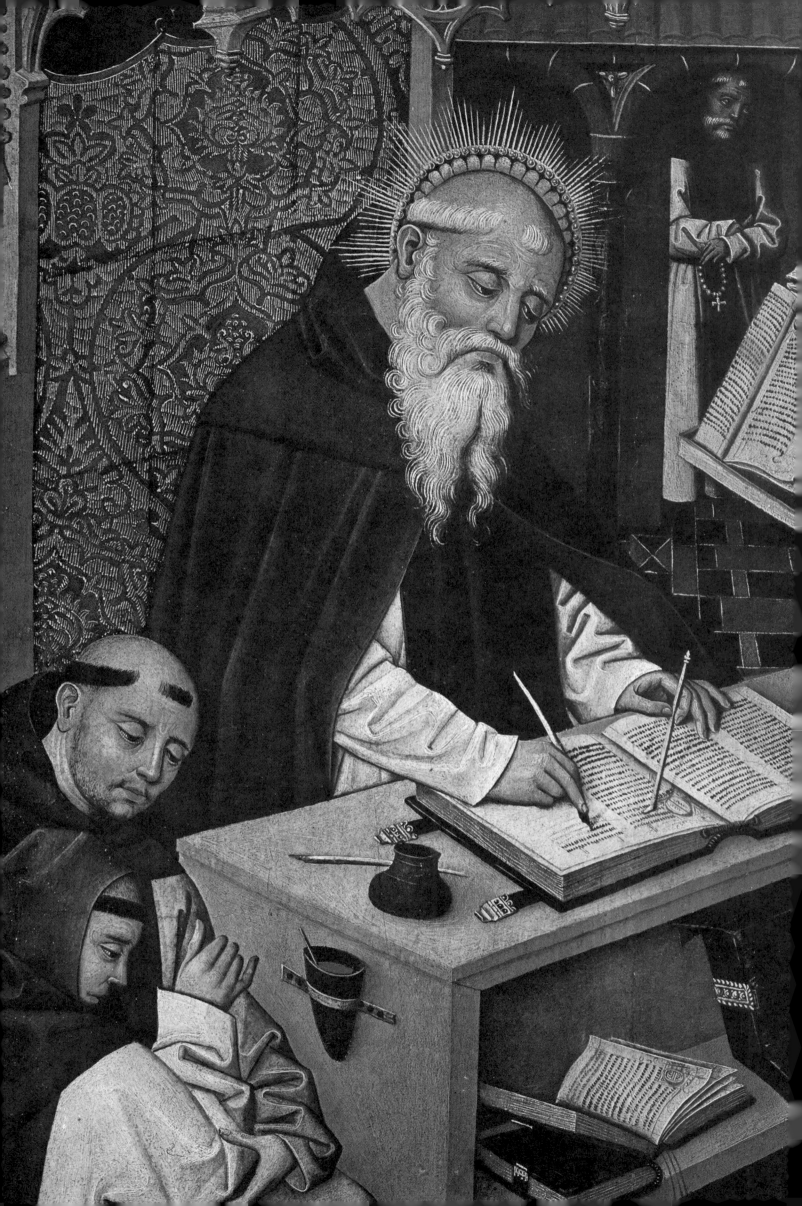

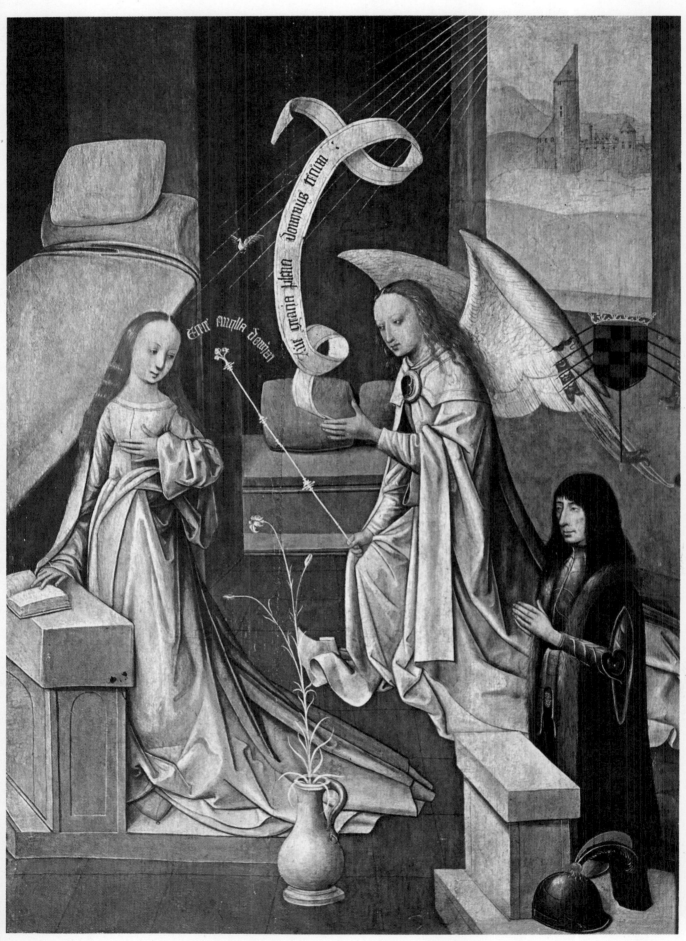

St. Jerónimo is portrayed as a monkish scribe
ying a book in a painting showing strong German influence.

Displaying his religious devotion, the first Duke of
Alba had himself painted as a witness to this Annunciation scene.

The Holy Office
of the Inquisition

To the Catholic Sovereigns unifying Spain meant making it Christian. Several times they seemed to compromise this principle by offering coexistence to Moslems and Jews. But these gestures were invariably rescinded.

What brought about the revival of the Inquisition was not Christian heresy, which was almost nonexistent. The primary targets were rather the Jewish converts who, by their skill and commercial acumen, had amassed considerable fortunes. Suspected by the common people as nonconformists, they could not be allowed to exist at a time when religious conformity was close to fanaticism. Converted Moslems became suspect, perhaps with more reason. The Arab states were still powerful in Africa and had invaded Spain within 150 years.

The use of inquisitors to insure the purity of the faith was not new. It had its origin in the first half of the 13th century when the Spaniard St. Dominic was sent to France by Rome to question the Albigensian heretics. Later the Dominican order that he had founded was placed in charge of the Rome-directed inquisition.

In Spain itself, Aragón saw a brief inquisitional flare-up in the 14th century, but it did not spread to Castilla or León. It remained for Isabel and Fernando to re-create this weapon of Christian intolerance.

When the inquisitors moved into a region, an edict of faith was published commanding Christians who felt themselves guilty of heresy to come forward and confess within a specified length of time. If this was done, they might be pardoned or given small penalties. But there was a provision attached: that they name others who had contributed to their guilt. This led to many accusations against innocent persons whom the confessors wished to injure.

For those who did not come forward but had to be arrested, punishment depended upon the extent of the heresy and the contrition of the accused. It could be a simple penance or it could include confiscation of property, public whipping or galley slavery. Considering the great number of cases tried, the death penalty was relatively infrequent. Only for continuous denial of guilt or persistence in heretical beliefs was the victim burnt.

The *auto de fe,* or act of faith, was a public exhibition held only in major cases and designed to impress the populace. Punishments were not carried out by the Inquisition. Prisoners found guilty were turned over to the civil authorities. The Inquisition was empowered to act in cases involving Christians in bigamy (which brought Moriscos into their net), blasphemy and sodomy, as well as heresy.

The accused was never told the charge against him or who had brought it. He was arrested quietly and kept in solitary confinement during his interrogation by the judges. Confessions were obtained by frightening and confusing the accused, as well as by torture. The Spanish Inquisition did not invent torture, nor did it use most of the elaborate torture devices attributed to it. Contemporary records indicate that only three forms of torture were used, and these under what was said to be adequate medical supervision. They were the hoist *(estrapada),* in which the accused was hung by his wrists with his toes barely touching the ground, or pulled up into the air with weights attached to his feet; the *garrote,* in which bands were placed around various parts of the body and tightened; and the water torture, used only as a last resort. In this latter, the accused was tied head down at an angle on a ladder; while the *bostezo* (yawn), an iron tool, was used to hold the mouth open, a linen strip *(toca)* was forced into the throat and water was dripped down to it. The victim, to keep from strangling, swallowed the cloth. After a certain amount had been swallowed, it was pulled back and the procedure repeated.

Rome protested the violence used by the Spanish Inquisition but was powerless to effect any changes. Perhaps the most exacting task of the Inquisition was the examinations it held and the research done on *limpieza de sangre* (purity of blood). To advance socially or economically at the time of Isabel and Fernando, the ability to trace one's genealogy became increasingly important.

Yet at least a quarter of a million converted Jews survived, and some continued to hold high office. The Jews who did not convert were exiled in 1492.

Two heretics await burning in auto de fe supervise
Inquisition founder Domingo de Guzmán. Chief Inquisitor d

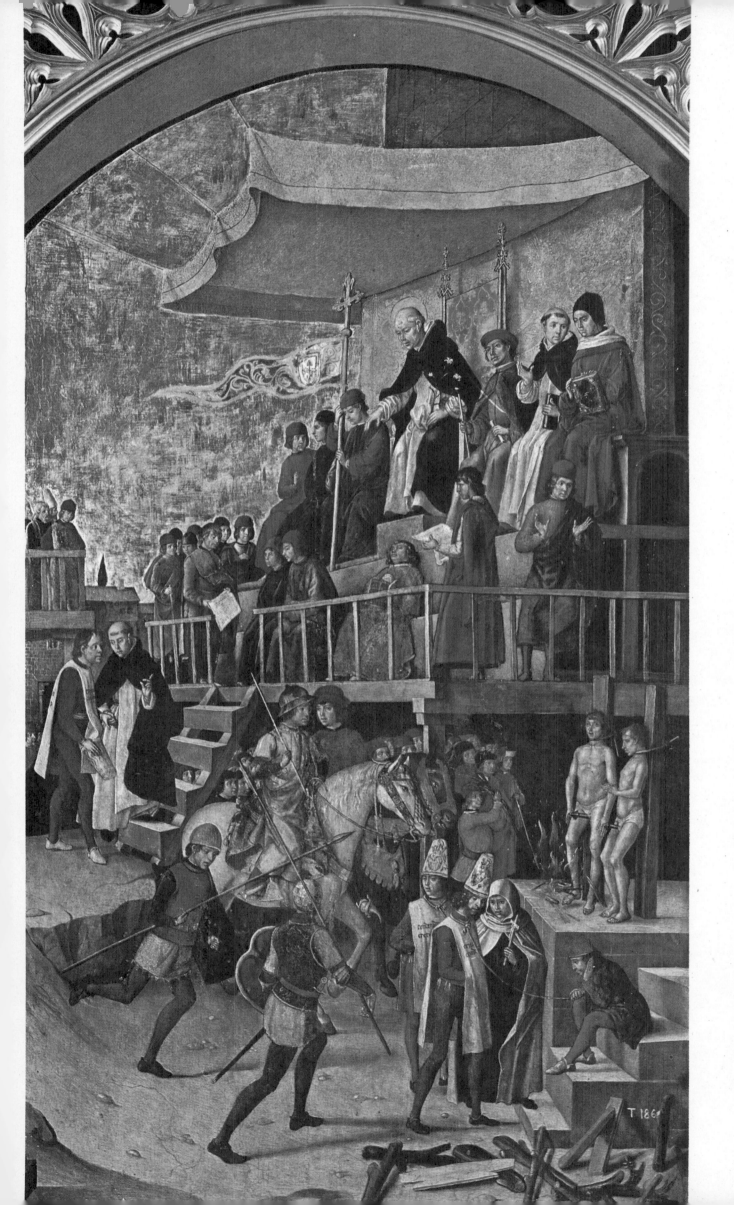

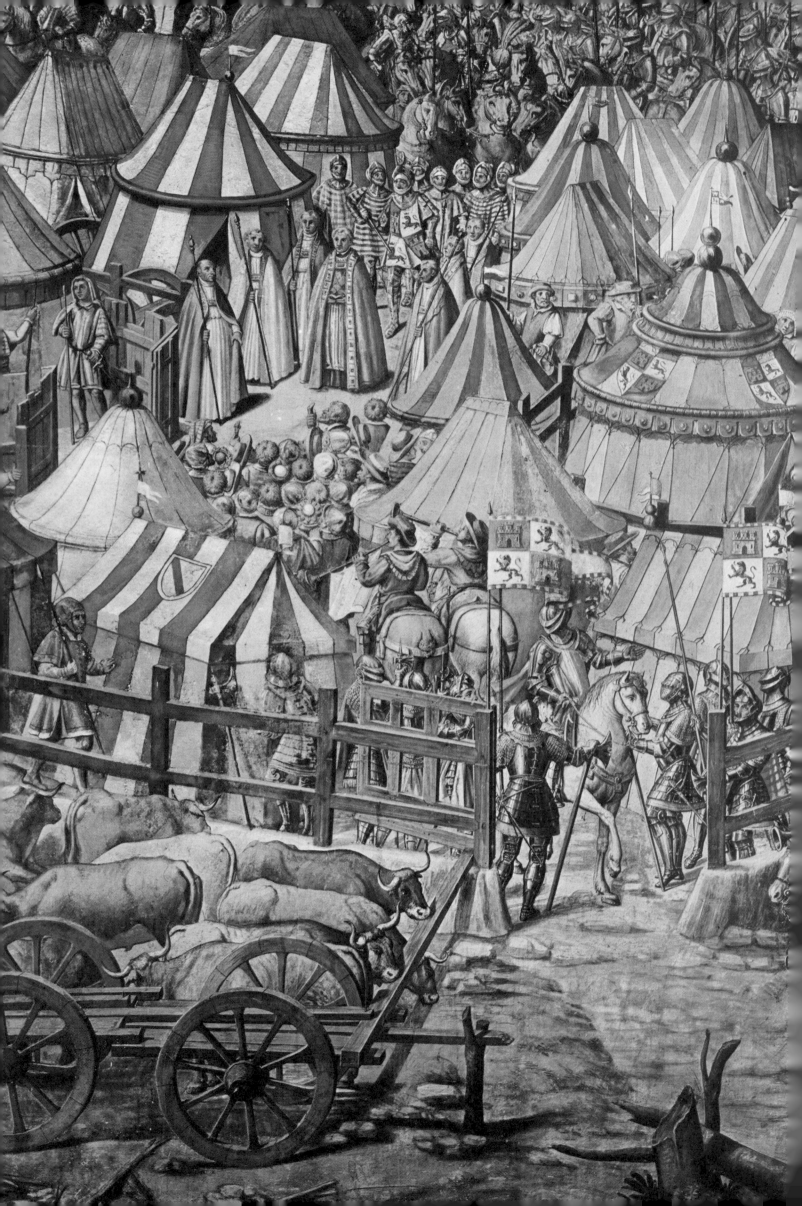

Defeat and Exodus of the Moslems

The two most far-reaching events in the modern history of the Spanish people occurred in the final years of the 15th century. One was the defeat of the last Moslem stronghold on Spanish soil; the other, a petition to the Catholic Sovereigns to subsidize a voyage of discovery presented by one Cristoforo Colombo, known in Spain as Cristóbal Colón.

The final campaigns against the Moors began with minor battles along the periphery of the Moslem kingdom of Granada. The young Moslem leader, Boabdil, had been captured at Lucena in 1485. He was ransomed from the Christians when his mother (who had supported him against his father) returned 400 Christian slaves and agreed to pay an annual tribute in gold. Boabdil willingly agreed to let the troops of the Catholic Sovereigns pass through his lands to attack his father, who still controlled much of the Moslem kingdom.

As the monarchs proceeded with their plans, Columbus, a young sailor, navigator, cartographer and dreamer, sought the support of King João II of Portugal. From his firsthand experiences, his studies

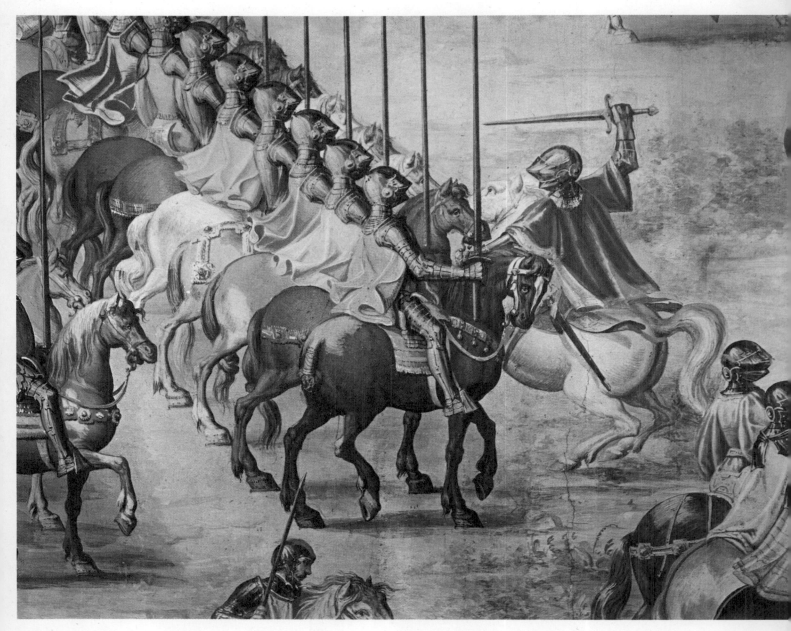

In a fenced 15th-century field camp religious dignitaries conduct services for troops. Cattle for food moved with army.

Brandishing a sword, an officer marshals Christian lancers for an attack. Moslems had a numerical edge but poorer armor.

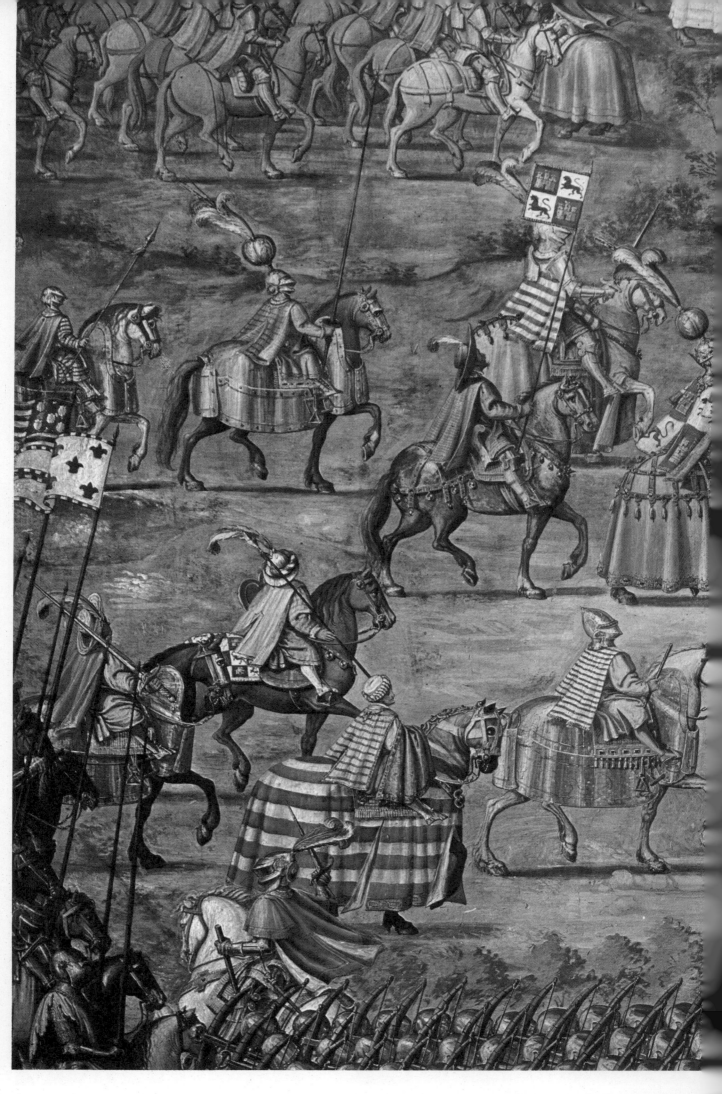

*Dressed in full armor and wearing a cape emblazoned w[ith]
the insignia of Castilla and León, King Juan II rides majes[tically]*

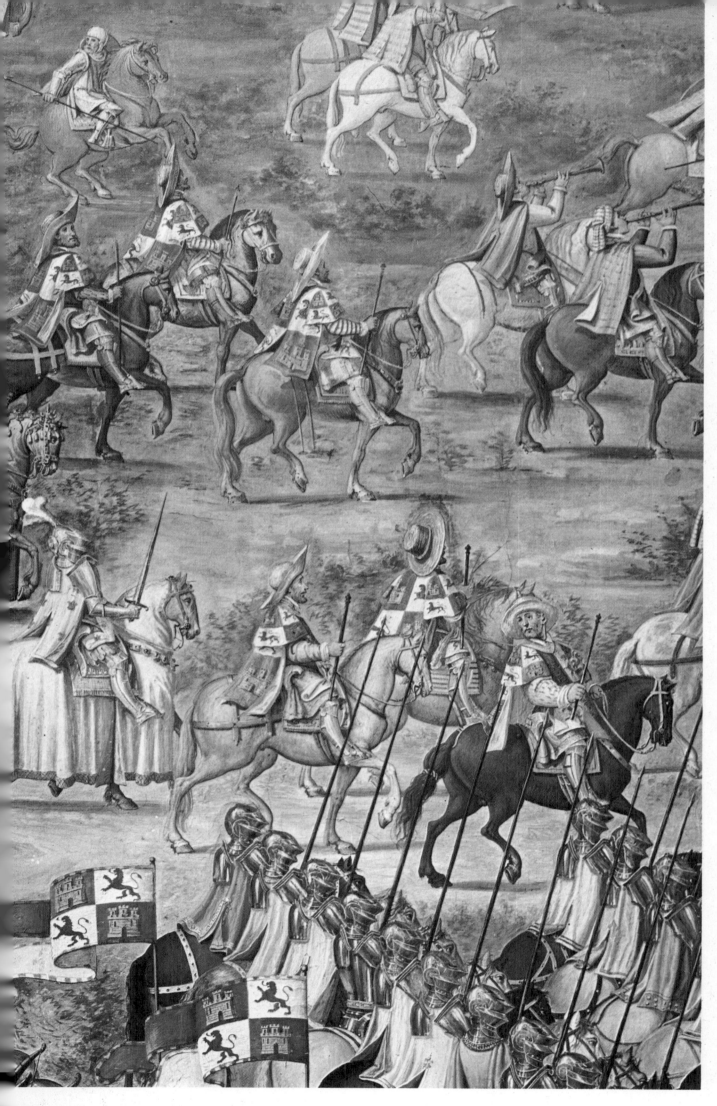

...ly into battle surrounded by his knights. The king carries a
...pter of authority and his horse is "barded" in crimson cloth.

117

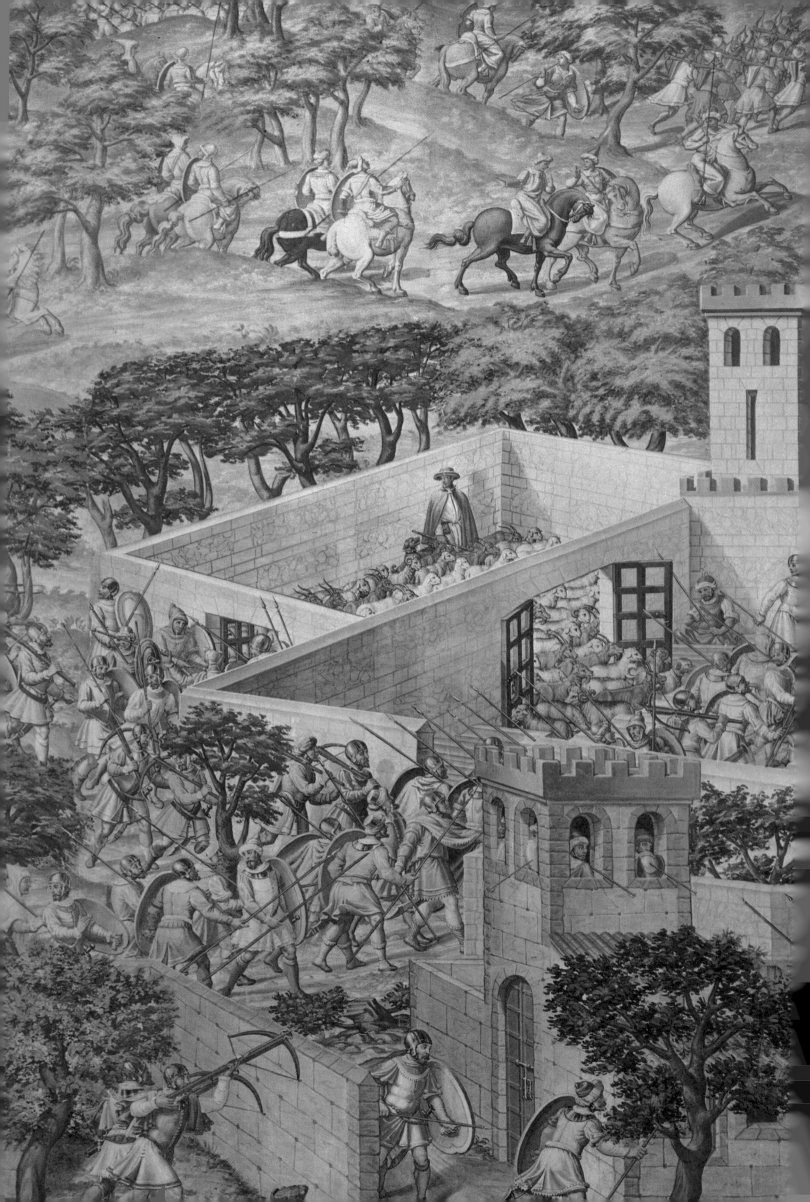

and his maps and charts, he formulated an idea: that the Orient was within sailing distance to the west. It may well have been an idea that occurred to other men, but Columbus was determined to sail the ocean far enough to prove it.

Between new voyages to Africa, England and Italy he continued to solicit the support of the Portuguese king. He made a good marriage to Dona Felipa Moniz Perestrelo of Lisbon. She gave Columbus his first (and only legitimate) son, but died before the child, Diego, was five years old.

When his entreaties to the Portuguese king were turned down, Christopher Columbus gathered his charts and, in the summer of 1485, sailed with his young son from Lisbon to the port of Palos in Spain.

He may have heard about the monastery of La Rábida with its reputation for hospitality, and certainly must have seen its white walls as he sailed up the Rio Tinto, for shortly after landing he knocked at the monastery gate. He was well received, and he left Diego in the care of the priests.

From there he journeyed to Sevilla where he tried to enlist the support of the Dukes of Medina-Sidonia and Medinaceli. The latter was so interested he requested permission from the queen to outfit Columbus and share in the profits of the enterprise.

The court was at Córdoba, 85 miles from Sevilla, and deeply enmeshed in the details of food supply, armaments, and the formation of the first field hospital to be set up in Europe. Yet Isabel was interested in the possibilities of such an expedition and requested that Columbus visit the court to present his plan for exploring the western sea.

Columbus went to Córdoba in January 1486, but by the time he arrived, the court had moved to Madrid. Yet his time was not wasted there. He soon made the acquaintance of Beatriz Enríquez de Arana, an orphan who lived at the home of her cousin Rodrigo Enríquez de Arana. We do not know whether Columbus actually moved in with them, but he and Beatriz had an affair and she bore him a son. They were never married and there is no record of their having been together after the birth of their son, Fernando, in 1488.

The Catholic Sovereigns returned to Córdoba in the spring and took up residence in the Alcázar. They were now ready to consider the proposal of Columbus. The Queen and the discoverer-to-be met for the first time in the early summer of 1486. They had much in common. Both were tall and

Routed by Spanish, Moslems fleeing Battle of Higueruela seek refuge inside a castle along with a shepherd and his flock.

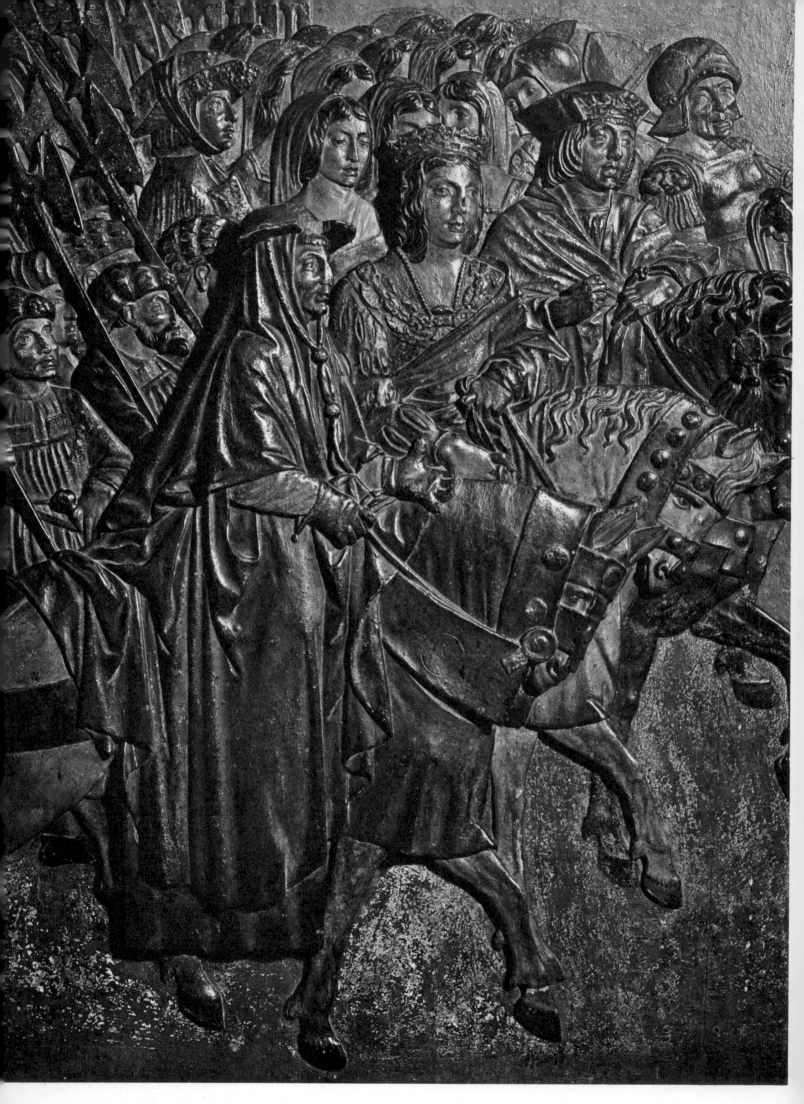

After fall of Granada, the last Moslem stronghold in Spain, Fernando and Isabel enter ruined city to accept surrender.

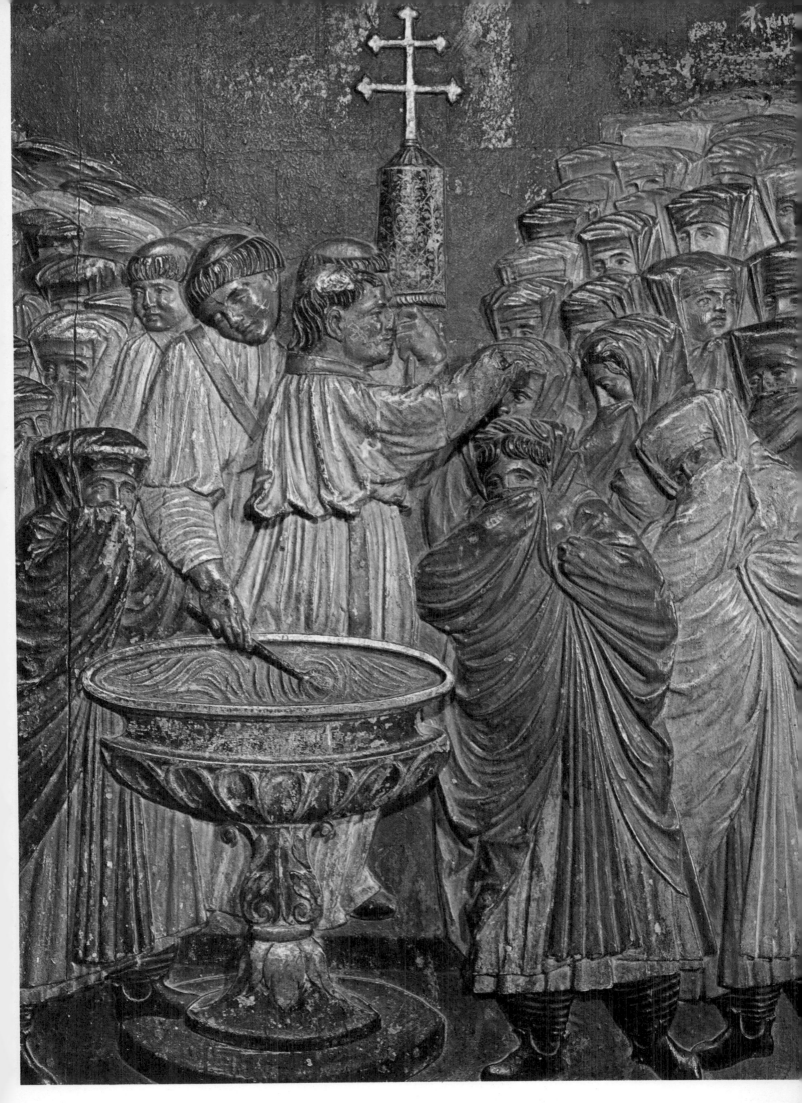

Forced to choose between conversion and expulsion from Spain,
many Moslems, like these women, submitted to Christian baptism.

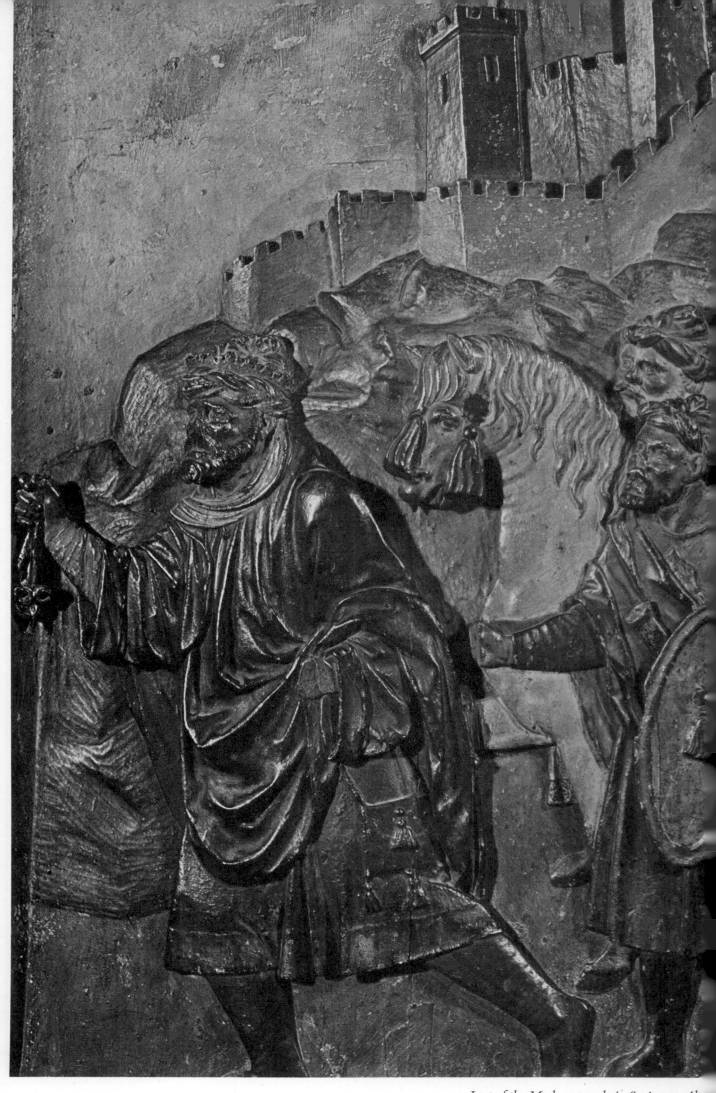

Last of the Moslems to rule in Spain was Ab-
Abdula, also known as Boabdil. After the fall of Granada to th

Christians he was driven into African exile. Here, followed by his horse and a group of retainers in chains, he leaves the Alhambra.

blue-eyed, with reddish hair. Both were practical dreamers of almost the same age. There must have been an immediate interest on the part of the crown, for a committee was appointed to investigate the practicability of the proposed exploration and to make a report. Then the monarchs left for Salamanca. There the committee met, and there Columbus was first put on the royal payroll as a foreigner (*extranjero*) at 12,000 maravedis a year—worth something less than $100 at the time.

The first of the Moslem cities to be attacked, as part of the master plan for surrounding the Moslem stronghold at Granada, was Málaga. Fernando took command of some 12,000 horsemen and 40,000 foot soldiers. The queen in her armor rode among the troops, and Columbus was there either as a participant or as an observer.

The successful siege of Málaga had no effect on the immediate fate of Columbus. The committee continued to meet but issued no final report. The king and queen advised him that they were too involved in the war to consider his plans.

Columbus traveled to Portugal and reapplied to King João for a subsidy. He met with a polite but firm refusal. Because Bartholomeu Dias, the Portuguese navigator, had made the trip around Africa and discovered a perfectly usable route to India, Portugal was perhaps less interested than it had been previously. Bartholomew Colón, the map-making brother of Christopher Columbus, left for London to try to interest Henry VII in the project. Unsuccessful there, he continued on to France.

Meanwhile, the next step in the encirclement of the Moorish kingdom was the siege of the mountain city of Baza, near Jaén. As Fernando and Isabel were holding court at Jaén in the year 1489, Columbus arrived to press his plans for the voyage of discovery. This time he was given an order addressed to local authorities for free board and lodging. The victory of the battle of Baza also settled the fate of Almería, the last important fortified city protecting Granada. It fell without a struggle.

The court was in Sevilla in 1490. It still could not decide whether to accept or reject the proposition made by Columbus. So it did neither, but suggested that he apply again after the Moslems had been finally defeated.

Isabel and Fernando spent the next months in preparation for a final assault on the well-fortified city of Granada. The siege began in the summer of 1491. That same summer Columbus traveled to the monastery of La Rábida to visit his son. There he talked of his plans with Fray Juan Pérez, who had once been confessor to the queen. Pérez was most enthusiastic and felt he could persuade the queen. He wrote a letter to her at Santa Fe. She replied favorably and commanded the friar to visit her. The good friar must have been very convincing for the queen agreed to see Columbus again.

It was early fall and the siege was at its height when Columbus arrived. But again his proposal was put into the hands of a committee. While it was being considered, Granada capitulated. The war against the Moslems was finally over. Terms to the defeated were comparatively liberal. Under the treaty of surrender, the population was to be allowed to continue to practice its religion and to be unmolested throughout Castilla. But in the opinion of Cardinal Cisneros, the treaty was unworkable. When a policy of forced conversion was instituted in violation of it, there was a brief Moslem uprising. The Christians used this as an excuse to void the entire treaty. Conversion or exile was the only choice for the Mudéjares. The converts to Christianity became known as *Moriscos*.

Why the monarchs again decided against Columbus' adventure, no one really knows. The committee may or may not have reported favorably. Columbus' son Fernando, writing later, believed it was because of the high honors and financial arrangements demanded by his father. Regardless of the reason, the proposal was finally turned down and Columbus started back to La Rábida.

Then came a dramatic reversal. Luis de Santángel, a converted Jew who was treasurer to the king, upon learning that Columbus had been dismissed, hurried to see the queen on that same day. He succeeded in convincing her that great benefits would accrue to the crown as a result of the projected voyage of Columbus. Realizing that money was an important consideration, he offered to advance some of it and to find the balance. The queen reconsidered and even offered to pledge her jewels as security for the project, but this proved to be unnecessary.

A messenger was dispatched immediately to recall the navigator. Columbus was found some four miles away, and he returned at once to Santa Fe.

Spain was now ready to embark on a new challenge, one that was destined to make her the most powerful country in the world.

Though many Spanish Jews achieved prominence, harassment by religious authorities was common. All were expelled in 1492.

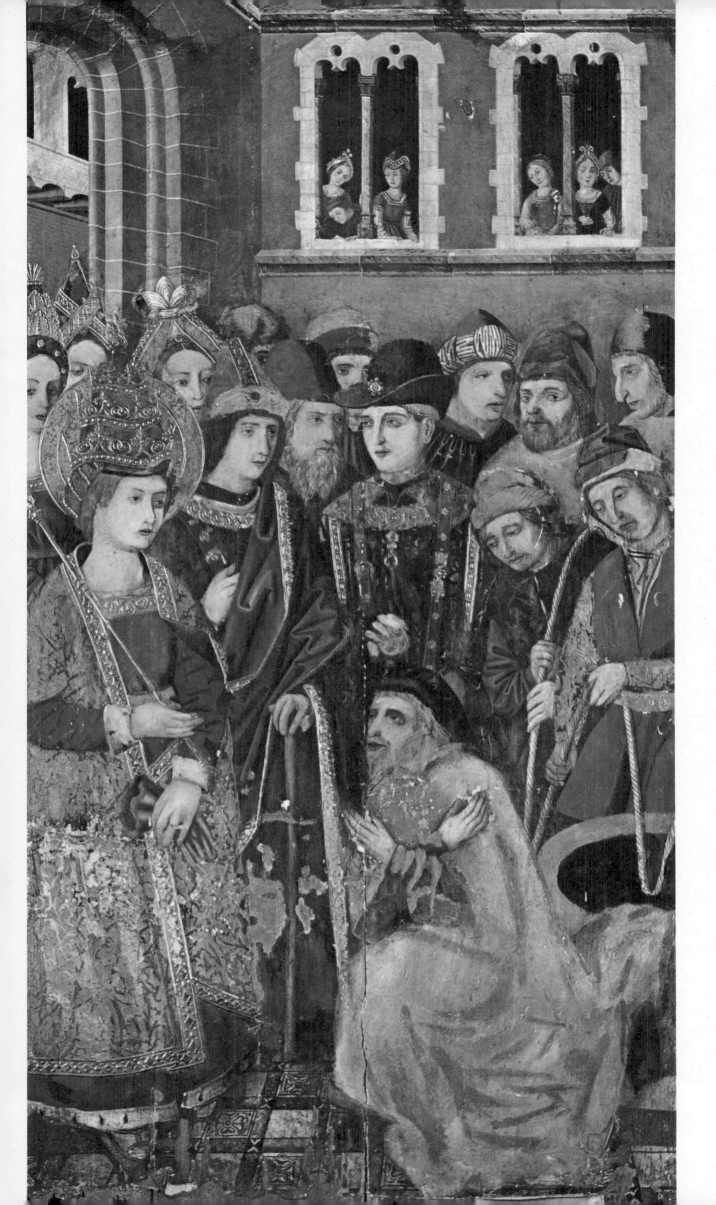

*Carved and painted wooden effigy of Fernando kneels in the
royal chapel of Granada Cathedral, where he was buried in 1516.*

*Backed by relief of Santiago, scourge of the
Moslems, polychrome statue of Isabel overlooks the royal tomb.*

Red-robed Cardinal Jiménez, who became Regent of Spa⟨in⟩
after Fernando's death, leads an army into Africa to attack Moslem⟨s⟩

The Fighting Cardinal

One man rode as an equal with the Catholic Sovereigns. He was Francisco Jiménez de Cisneros, a modest recluse who rose to control the religious life in Spain. He became confessor to the queen, Bishop of Toledo, Primate of Spain, Grand Inquisitor and Prince Regent of the empire.

Humble before God, he never forgot his vows of poverty; ruthless before men, he reformed the clergy, reducing concubinage to a minimum and expelling immoral and ignorant priests. A zealous Christian, he was primarily responsible for the expulsion of the Jews and Moslems. Though he burned many Arabic books—except those on medicine—he was a humanist who influenced the culture of his and future generations. He founded the University of Alcalá de Henares and invited the great thinkers of Europe to work there. Both Old and New Testaments of the Bible were translated into Latin, and the resultant work, known as the Polyglot Bible, was printed on the presses of Jiménez' university.

He led a Spanish army into Africa, where he added Oran, Tripoli and other North African areas to the expanding empire. But he carried the Inquisition with him to Africa and later exported it to the New World. After the death of Philip the Fair, the first Hapsburg king of Spain, and again following the death of Fernando the Catholic in 1516, Cisneros became regent of Spain.

THE NEW WORLD EXPLORED

Prodigious findings with incredible feats of stamina and valor. The discovery of the West Indies is followed by the conquest of Mexico, Peru and Chile, which are rapidly colonized and converted to Christianity. Remarkable expeditions to North America. In a brief space of history the Spaniards explore the New World from Colorado to Patagonia, extract fabulous wealth, establish innumerable missions and universities, and erect splendid examples of Renaissance, baroque and churrigueresque art.

HISTORICAL CHRONOLOGY		ART CHRONOLOGY	
1492–1504	Columbus makes four voyages to the New World.	second half of 16th c.	Cathedrals of Mexico City and Puebla, by Juan Gómez de Mora.
1508–1512	Juan Ponce de León conquers Puerto Rico and discovers Florida.	1521	Pedro de Gante establishes the first art school in Mexico.
1514	Núñez de Balboa discovers Pacific Ocean.	1534–1594	Alonso de Ercilla, Spanish-born poet, writes epic poem La Araucana.
1519	Juan Sebastián del Cano completes circumnavigation of world begun by Magellan.	1536	Bishop Juan de Zumárraga establishes first printing press in Mexico.
1522	Cortés conquers Mexico.	1538	Santo Tomás, first university in the Americas, founded in Santo Domingo.
1524	First missionaries (Franciscans) in Mexico.	1539–1616	Garcilaso de la Vega, son of an Inca princess and a Spaniard, writes of Incan history in Royal Commentaries.
1529–1539	Alvaro Cabeza de Vaca explores territory of Florida to the Gulf of California. Conquest of Peru by Pizarro. Almagro leads expedition to Chile. Gonzalo Jiménez de Quesada conquers Colombia.	1551	Lima University is founded.
1539–1542	Explorations of Hernando de Soto in North America. Francisco de Orellana navigates the Amazon River. Pedro de Valdivia conquers Chile. First importation of African Negro slaves. Francisco Vázquez Coronado explores the Grand Canyon of the Colorado River.	1553	Mexico University is founded, first on North American continent.
		1563	Bernal Díaz del Castillo writes True Story of the Conquest of Mexico.
		1651–1695	Mexican poetess, Sor Juana Inés de la Cruz, one of the greatest lyrical poets.
		1655–1706	Miguel de Santiago, works at San Francisco monastery.
1546	Fray Bartolomé de las Casas publishes his "Declaration on the Rights of the Indians."	1695–1768	Indian (Zapotec) artist Miguel Cabrera.
1680	Code of Leyes de Indias (Indian Laws) published.	1757–1816	Palacio de Minería and completion of Mexico City's Metropolitan Cathedral.
1810	Wars of independence in America.	1778	Academy of Art of San Carlos.

The Search
for India and Gold

After 31 days without sighting land, the 90 men who had accepted the challenge of the uncharted ocean were restless and rebellious. They urged Columbus to turn back, but the Admiral was determined to continue westward. He asked for two more days. At 10 P.M. on the 32nd day out of Palos—October 11, 1492—the bright moonlight illuminated a dark shape looming on the horizon. It was a small island of the Bahamas group. Columbus named it San Salvador, after his Saviour.

From this first landfall he cruised southwest through the Bahamas, then along the coast of Cuba. Before his eyes a marvelous new world unfolded. The people of these islands were attractive and peaceful, so he selected six "Indians," as he called them, to be taught the Spanish language. He planned to stay until spring or even longer. "Truthfully," he

Map by Juan de la Cosa, pilot and cartographer with Columbus, first showed Caribbean islands and New World coast (left).

wrote down, "should I find gold or spices in great quantity, I shall stay until I collect as much as possible ... I am proceeding solely in quest of them." But his voyage was cut short when, on Christmas Eve, the Santa María was wrecked off Hispaniola.

Columbus, undaunted, decided to build a fort; it was called La Navidad and had a walled enclosure and a deep well for storing gold. Thirty-nine men volunteered to stay behind while the Admiral sailed back to Spain with a cargo of gold belts, masks and bracelets; he also carried bright green parrots and, the most important exhibit, ten natives. Crowds

gathered along the road to see the Indians, the gold, the parrots and the Admiral of the Ocean Sea. The Catholic Sovereigns received Columbus with pomp and ceremony in Barcelona. When he approached, they rose and greeted him as an equal.

Columbus made three more voyages to the New World. On his second venture across the Atlantic Ocean he safely guided 17 ships loaded with 1,500 colonists and adventurers. The cargo also included horses, for breeding and for the troops of cavalry, sheep, goats, pigs and cattle; orange and lemon trees, wheat and barley, seeds and grapevines.

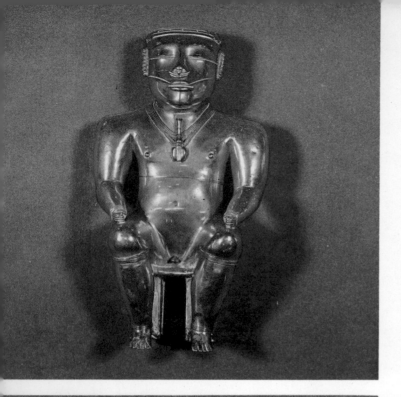

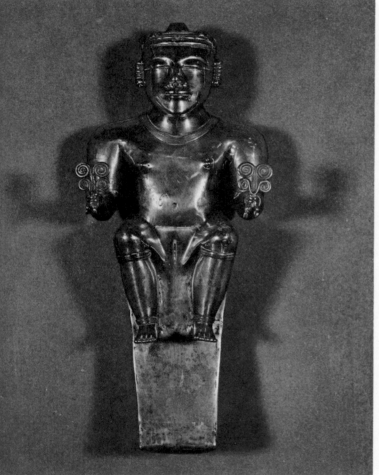

After stopping off at La Navidad and finding that the Indians had killed the fort's garrison, Columbus chose a new site farther east, which he named Isabel. Here the livestock and plants thrived, but not the colonists. A great majority were *hidalgos* who had come in search of gold, but there was relatively little to be found. Some of these men sailed back to Spain, where they spread stories about the inefficiency of Christopher Columbus and his brother Bartholomew, whom the Admiral had left in charge while he continued his explorations.

Over two years passed before Columbus returned to Spain. The new land policies and the expulsion of the Jews had resulted in widespread poverty on the peninsula. The Admiral did not find a happy reception this time, for he was not bringing the shiploads of gold he had promised. Yet the crown finally agreed to a third voyage.

Columbus cruised south, along the equator, but to avoid the unbearable heat and doldrums he turned north in time to make a landfall at Trinidad. Across the channel from this island he came upon the coast of South America. He first took it for another island and named it Isla Santa, but then realized that it was much too large and the river flowing out of it—the Orinoco—too great for an island. "I am convinced this is the mainland," he wrote in his journal. He soon rejoined his brother on Hispaniola, where Bartholomew had founded the city of Santo Domingo. Their combined efforts as administrators were unsuccessful and led to many complaints, until the crown finally sent Francisco de Bobadilla to take over the affairs of the colony. He arrested the two brothers and sent them back to Spain. The king and queen released them and restored the honors—but not the administrative powers—to the Admiral.

On his fourth and last voyage, Columbus discovered the coast of Honduras, but no more riches than before. Returning to Spain, he was not even invited to the court. His queen, Isabel, died three weeks after he landed. Six months later, King Fernando granted him an audience at Segovia. The old sailor was still arguing for his rights, many of which had been abrogated. He followed the court across the country, but his health was now failing him fast. Arthritis had set in so badly that he was forced to give up traveling. On May 20, 1506, Christopher Columbus, Admiral of the Ocean Sea, Viceroy and Governor of the Islands, died an almost forgotten man in the city of Valladolid.

The Spanish melted down most Indian goldwork into bullion. Surviving pieces like these—two gods and a helmet—are rare.

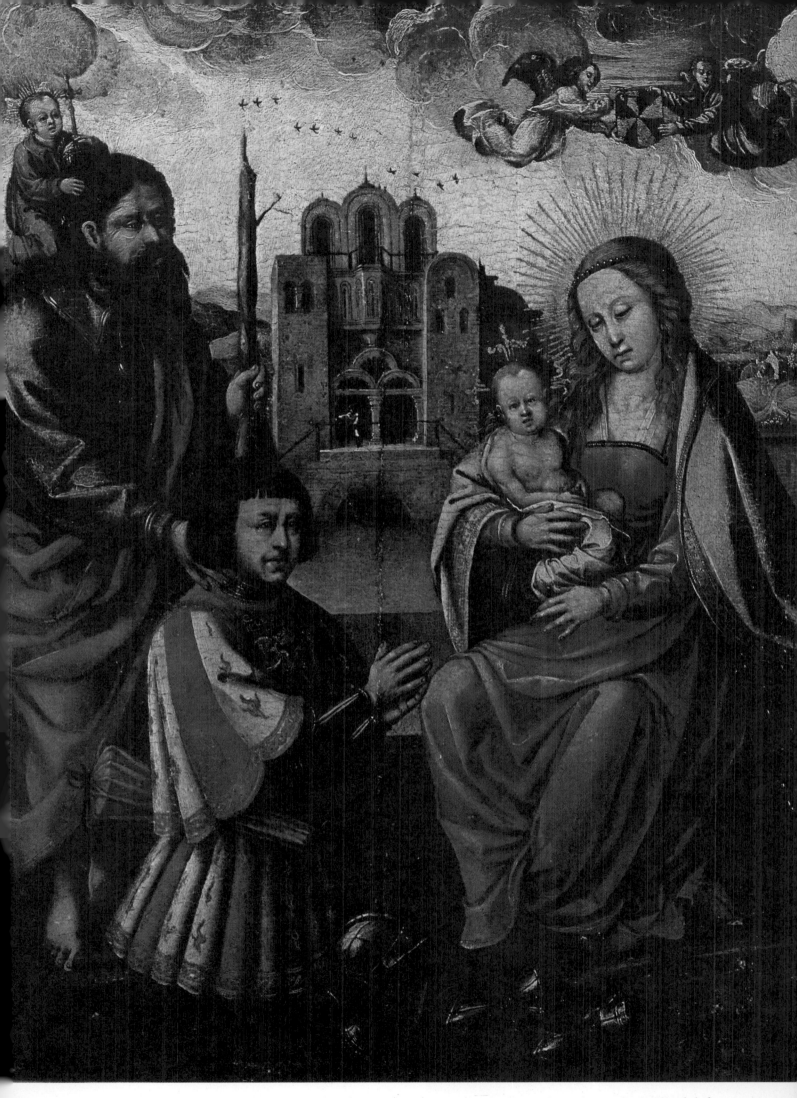

With St. Christopher, Columbus kneels before
Virgin. Nonidealized features may mean explorer sat for portrait.

A contemporary Indian artist recorded his impression of Hernán
Cortés conquering Mexico astride El Morzillo, one of the firs

horses ever seen in the New World. Aztecs developed a system
of pictographic writing before the Conquest, soon forgot it.

Spaniard with a whip manhandles native prisoner in a sketch made by Mexican Indian soon after the Conquest.

The Conquest of the New World

Western Europe had long awaited a short water route to the Orient. Spain, Portugal, France and England were poised and ready to explore the Ocean Sea. As soon as Columbus showed the way, adventurers and explorers, first from Spain and Portugal and later from France and England, swarmed over the islands and then slowly penetrated the mainlands of North and South America.

During the lifetime of Columbus, his Spanish shipmates Vicente Yáñez Pinzón and Juan de la Cosa explored the South American coast together with the Italian humanist and geographer Amerigo Vespucci. The descriptive letters written by Vespucci about the new continent were reproduced throughout Europe. Even before the death of Columbus, the impression prevailed that Amerigo Vespucci had been the first to discover the South American continent, although his voyage was made in 1499, a year after the eventful third crossing of Columbus. A young German geography professor, Martin Waldseemüller, wrote in an appendix to his *Cosmographiae Introductio:* "Now, indeed, as these regions are more widely explored, and another fourth part has been discovered by Americus Vespucius, as may be learned from the following letters, I do not see why one may justly forbid it to be named Amerige—that is, Americ's Land—from Americus, the discoverer, a man of sagacious mind, or America, since both Europe and Asia derived their names from women." Six years later Waldseemüller realized his error and, on a map he published in 1513, substituted the name "Terra Incognita" and noted that this land, with the adjacent islands, had been discovered by Columbus, a Genoese in the service of the king of Castilla. But it was too late. Mapmakers in Germany and Italy had by this time labeled the new continent America, and so it remained.

The Spanish explorers were not concerned with

Another drawing from same notebook shows a Spanish officer conducting an interrogation while dead man lies in the stocks.

names. To them the whole region was known as the West Indies. Their main interest was the acquisition of wealth, preferably in the form of gold. But soon they realized that the gold supply in Hispaniola was limited. After the surface deposits had been depleted and the heirlooms collected, they found that gold was not easy to mine, and so they turned to new horizons. Alonso de Ojeda, a soldier of fortune who had sailed with the Admiral, joined forces with a rich planter to establish colonies on the coast of the newly discovered Panamanian Isthmus. Among the adventurers in this group were Juan de la Cosa, Columbus' mapmaker, who had also sailed with Vespucci. This veteran of many voyages was killed by a poisoned arrow shortly after the party landed.

Two younger men, both destined to play an important role in the history of the Americas, took part in this expedition. They were Francisco Pizarro, an ambitious adventurer who reportedly could neither read nor write, and Vasco Núñez de Balboa, a young planter so anxious to evade his creditors on Hispaniola he had himself nailed up in a cask and shipped out to sea with the Panamanian expedition.

Ojeda's men did not fare well in Panama and might conceivably have been wiped out by the Indians had not Balboa emerged as their new leader. A man of intelligence and determination, Balboa also proved to be a skilled diplomat in dealing with the Indians. After marrying the chief's daughter, he assisted the tribesmen in battles against their tradi-tional enemies. Reorganizing the small army, he gained the confidence of both Indians and Spaniards. Through his relationship with the natives, Balboa learned of a great sea beyond the mountains.

Peter Martyr of Anghera, the most widely read chronicler of this period, describes a dramatic scene that may have led directly to Balboa's decision to search for the sea. The Indians had given some 50 pounds of gold to the Spaniards, who were weighing it and greedily asking where they could find more. A son of the Indian cacique (chief) "knocked the weights from their hands and said, 'I'll shewe you a region flowing with golde where you may satisfy your ravening appetite ... when you are passing over the mountains you shall see another sea where they sail ships as big as yours.'"

Some months later Balboa, in danger of being relieved of his command at Darien by a new governor sent out from Spain, acted on the information he had assembled. Taking 190 of his best men and a large contingent of Indians to help clear the way and carry supplies, he started out on a forced march through a jungle infested with snakes and insects. Oviedo y Valdés, a historian who came to the colony a year later, wrote in his *Historia General:* "And on Tuesday, the twenty-fifth of September of the year one thousand five hundred and thirteen, at ten o'clock in the morning, Captain Vasco Núñez, lead-ing all the rest in the ascent of a certain bare moun-tain, saw from its peak the South Sea, before any

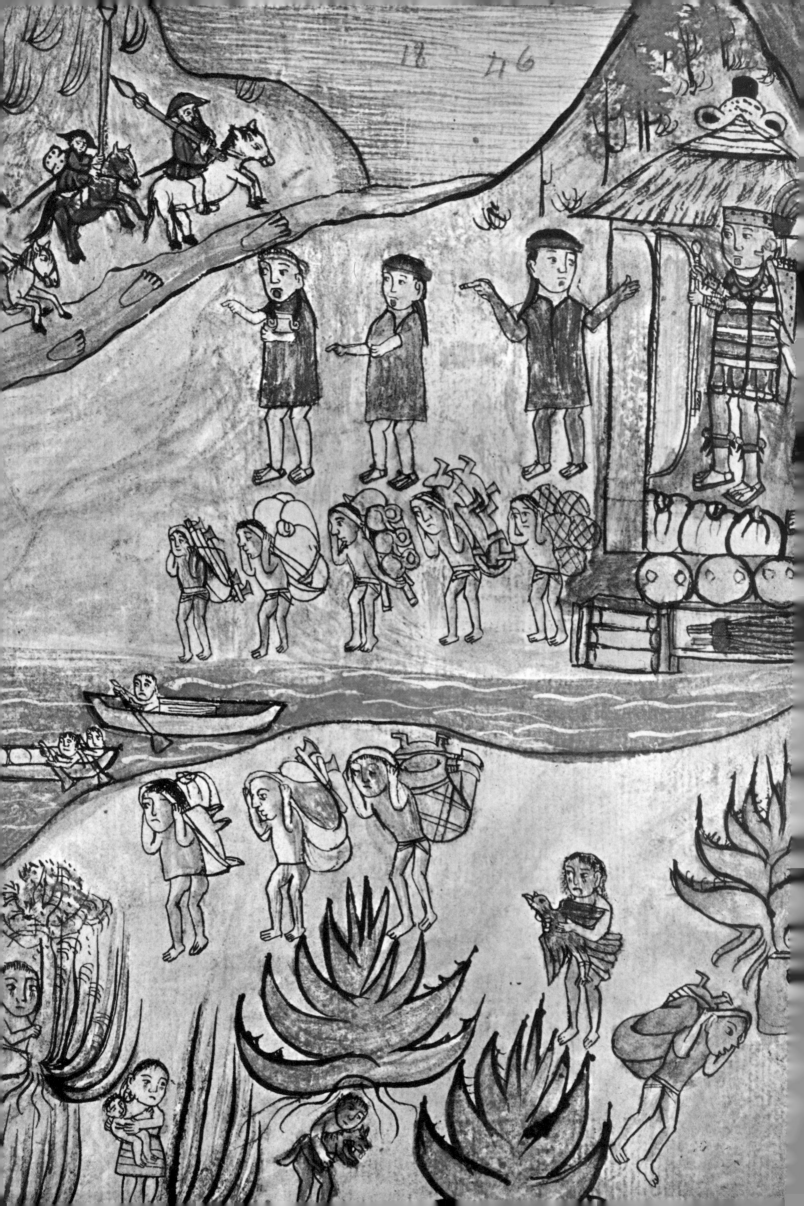

other of his Christian companions. He joyfully turned to his men, raising his hands and eyes to the skies, praising Jesus Christ and his glorious mother the Virgin, Our Lady; then he sank on his knees and gave thanks to God for the favor that had been granted to him … in allowing him to discover that sea and thereby to render such a great service to God and to the Catholic and Most Serene King of Castilla, our lord.... And he ordered them all to kneel and give thanks to God for this grace, and to implore Him to let them discover and see the hoped-for secrets and riches of that sea and coast, for the exaltation and increase of the Christian faith, for the conversion of the Indians … of those southern regions, and for the greater glory and prosperity of the royal throne of Castilla and its princes, both present and to come." This description embodies much of the sentiment of the Spanish explorers concerning the Christian aims of their mission, yet it does not neglect to mention the importance of riches.

Theoretically, the conversion of the Indians was an important reason for the explorations. In fact, the Indians suffered much the same treatment as other conquered people: their possessions were taken, a great majority of them were enslaved and their women considered as the spoils of conquest. As early as his second voyage, while acting as viceroy of Hispaniola, Columbus himself had suggested to the queen that slaves be imported from the islands. Without waiting for her reaction, he dispatched a shipload of slaves, but most of them died either in transit or soon after they arrived in Spain. Some who survived were returned to their country.

The idea of slavery was far from new. Moslem prisoners had been enslaved by the Spaniards during the *Reconquista,* just as Spaniards had been enslaved by the Moslems. Portuguese slave ships had been active in Africa for generations. The Catholic Sovereigns were reluctant to set up a specific slave traffic from the West Indies. All this time, various forms of slavery were being practiced by the natives of the islands themselves.

The problem of obtaining a steady labor supply that could be used in good conscience continued to plague the crown. The Pope had granted the Catholic Sovereigns and their heirs the exclusive right of patronage, as well as the disposition of all ecclesiastical beneficences and the founding and construction of churches in the new world (excepting Brazil, which was assigned to the Portuguese). Spanish policy in the West Indies was like a single body with two heads—one, representing the church, held the interest of Christianity to be supreme; the other, more mundane, longed for riches and power. But in order to let the body live, the two heads were forced to compromise continually. The liberal legislation enacted by the crown to protect and Christianize the Indians was often at odds with the necessity of building a stable and profitable empire.

Three codes were drawn up to deal with the Indians. The first, called *repartimiento,* can be traced to the policies of Columbus. In addition to establishing the relationship between colonists and Indians, it provided for the distribution of food, merchandise and livestock. When the Indians rebelled against the Spaniards, Columbus ordered a new tax or tribute on all Indians over 14. It would consist of a small amount of gold dust or several pounds of cotton, payable every three months. Should the Indians be unable to provide either of these, they

As conquistadores approach, Indians sadly gather up belongings, children, and animals, and flee their village.

Cannibalism, either as ritual or simply for food, was widely practiced among pre-Conquest Mexican Indian tribes.

were allowed to pay with their labor. This supplied the settlers with Indians to work their lands.

Queen Isabel was responsible for the establishment of a similar system—the *encomienda*. When reports reached the queen that Indians were still being enslaved against her wishes, she issued an order legalizing the forced labor of Indians but insisting that they be paid a wage (the exact amount being left to the colonists). To civilize and convert the Indians more easily, they were gathered into villages under a protector, and provided with a school and a priest. The adult Indians were to have houses of their own, with land that could not be taken from them. Indians and Spaniards were encouraged to intermarry. The Indians were to be considered free men.

The *encomienda,* in effect, transferred to the landowners the right that the crown had held over the Indians. As practiced by most holders, it amounted to a form of peonage or slavery. While the Indians were said to be protected by their masters, and in some cases given rudimentary religious instruction,

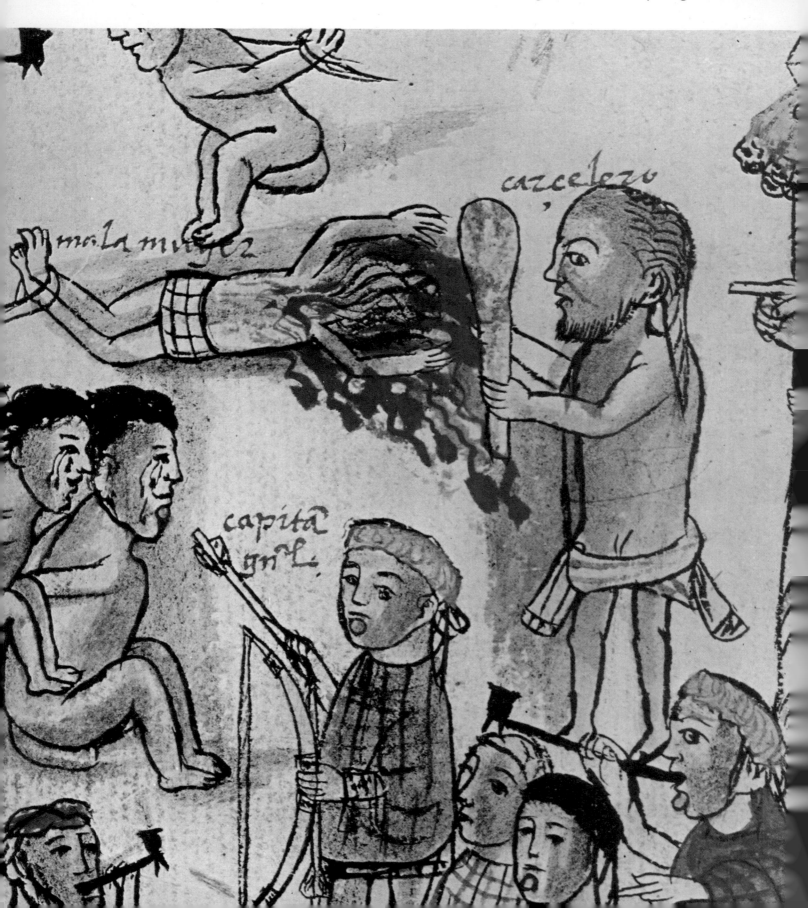

their actual needs were largely ignored. In return for this dubious protection and religious instruction, they were forced to supply the labor necessary to operate the colony. The system was extended, contracted, abolished and renewed time after time.

Among the recipients of an *encomienda* in Cuba was Fray Bartolomé de las Casas. The young priest had come out to the islands in 1502, following his father, who had sailed with Columbus on the second voyage. He lived on the paternal estate on Hispaniola for eight years while taking holy orders. When

Diego de Velázquez began the exploration and colonization of Cuba, Las Casas accompanied him. Soon thereafter he gave up his claim to land and native laborers, in order to spend the rest of his life as a historian, diplomat and missionary, and to champion the cause of the Indians. It was his influence and pressure that moved the crown to redress many of the worst ills visited on the native population.

His angry protests probably led to the adoption of one of the least effective and most frequently flaunted of the major codes: the *requerimiento*. For some time extensive soul-searching had been going on in the West Indies and in Spain. Priests, theologians and lawyers were asking basic questions: Did the Spanish conquerors have the right to claim the land and goods of the Indians? Were the Indians rational human beings? Did they have souls? Or were they subhuman beasts, as shown by their idolatry, cannibalism, nakedness and immorality? These questions were hotly debated, and out of the discussions came the *requerimiento*, an elaborate document compiled by Dr. Juan López de Palacios Rubios. Designed to assuage the conscience of the conquerors and the crown, it began with the Creation; then it reviewed religious history through Roman times; and it finally commanded the Indians to accept the authority of the Pope and the Catholic Sovereigns. Refusal, it explained, would mean enslavement and confiscation of wives and goods.

This lengthy document was to be read to the Indians by an interpreter before their lands could be taken or a battle joined. Oviedo y Valdés, who participated in various encounters, wrote that on one occasion when he and his followers had come upon an Indian village, they found the Indians had fled and left only empty huts. He recounted how he facetiously addressed the governor and his lieutenant: "Sirs, it seems to me that these Indians do not care to hear all this theology, nor do you have anyone who can make them understand it. Your worship had better put this paper away until we have caught an Indian and put him in a cage where he can gradually master its meaning, and the bishop can help to make it clear to him." Later that day, after preparations had been made to surprise the Indians on their return, "...the general...also ordered a bronze cannon of about 200 pounds to be loaded. Two greyhounds, highly praised by their masters, were to be placed on our wings; we were upon the enemy and conducted ourselves like valiant

Under direction of cacique (chief) adorned with heavy gold ornaments, unfortunate Indian captive is clubbed to death.

men. I should have preferred to have the *requerimiento* explained to the Indians first, but no effort was made to do so, apparently because it was considered superfluous or inappropriate."

While Balboa was finding the way to the Great Sea, Ponce de León, a long-time captain in the Spanish army who had participated in the wars against the Moslems and sailed with Columbus on his second voyage, left Hispaniola and conquered the disorganized Indians of Puerto Rico. He served there as governor for a short while. As soon as the island was under control, he requested permission from the crown to seek out the land of Bimini, where Indian legend told of a fountain of waters with remarkable medicinal powers. Sailing west past the islands of the Bahamas, he discovered a new land, which he believed to be a large island; the day being Easter Sunday (Pascua Florida), he named his

discovery Florida. After a coastal exploration, he claimed it for the crown.

Cuba had become a new base for launching campaigns of exploration. Francisco de Córdoba sailed west in 1517 to discover Yucatán and returned after furious fighting to report on its rich Mayan civilization. This led to a second expedition, commanded by Juan de Grijalva, which cruised along the coast of Mexico and brought back information about the even greater riches of the Aztec nation. Governor Diego de Velázquez decided to send a large expedition to conquer Mexico, and selected Hernán Cortés to lead it. At the very last minute, Velázquez had qualms about sending Cortés. He was afraid that the young adventurer might take over the country for himself, rather than put it under the control of the governor of Cuba. He made last-minute efforts to arrest Cortés, but the

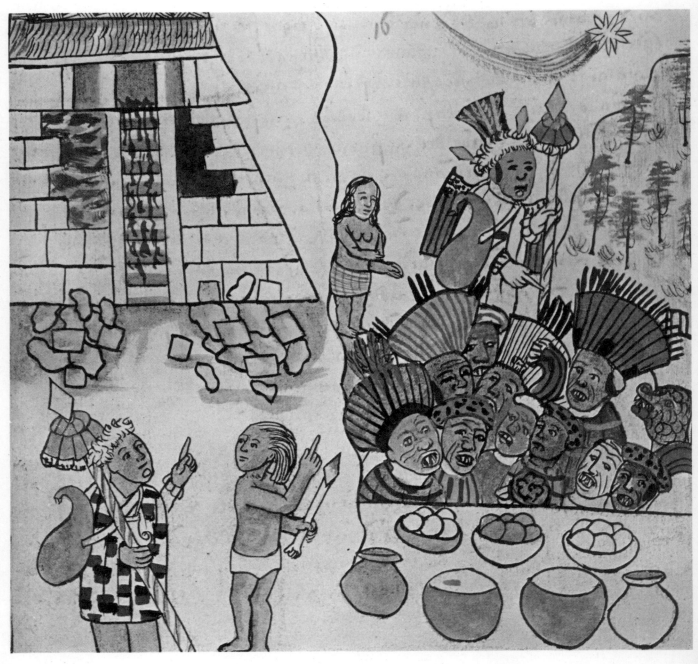

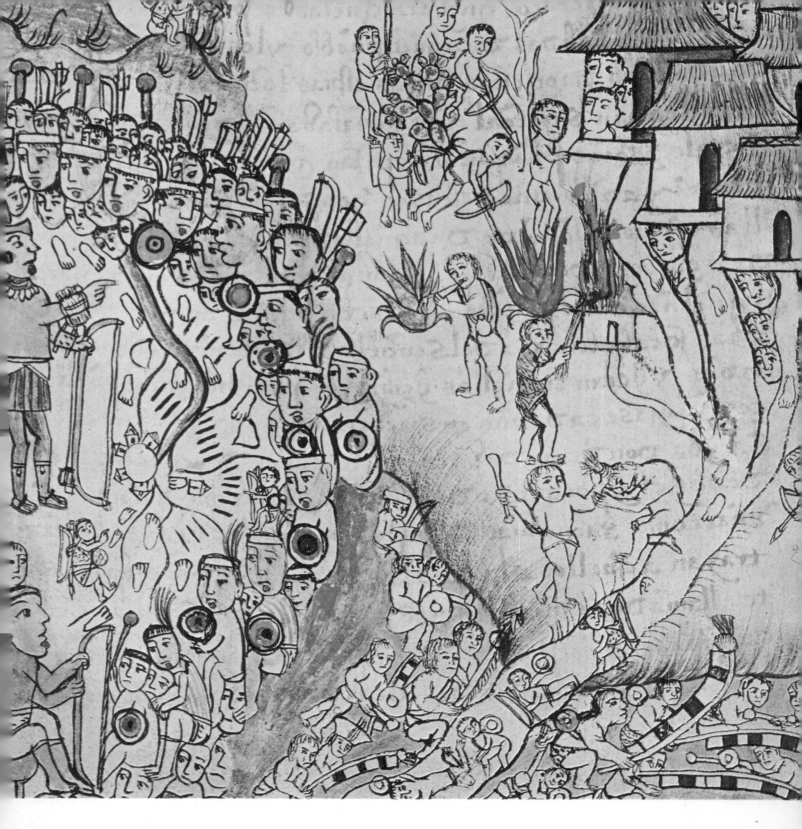

Pictograph from Indian notebook shows cacique rallying his warriors (left) during intertribal fighting at time of Conquest.

plans failed and the expedition, with its 34-year-old leader, sailed from Havana.

The fleet consisted of 11 ships and 608 men. Their fire power included some bronze guns and four small cannons *(falconetes)*. Thirty-two Spaniards manned the crossbows. As important as the armament were 16 horses. From previous experience the Castilians knew how these beasts caused the Indians to panic.

Indian priests consult together after performing a human ~~sacrifi~~ce and dragging body down steps of temple pyramid (left).

The little convoy gathered at the island of Cozumel, where rumor reached Cortés that two previously shipwrecked Spaniards were living among the Indians. The rumor proved true. Jerónimo de Aguilar, who had been ashore eight years, was ransomed from his Indian master and, with his knowledge of the Indian language, became a key figure in the conquest. The other had attained the rank of chief, taken an Indian wife and fathered

Strategic Spanish settlement of Nombre de Dios
on Panama coast was transshipment point for treasure from Peru.

three sons: he refused to leave his adopted people.

The fleet approached the shore of the province of Tabasco at the same place where Grijalva's expedition had landed previously. Cortés tried to placate the warlike Indians who lined the coast by offering them trade. Aguilar did his best to transmit the commander's words, but the Indians insisted they would kill the Spaniards if they came ashore. Cortés deployed one boat to work its way up the river behind his opponents while he took the main force into the water and stormed ashore. The fighting continued for three days, but the superior tactics, armor, artillery and final cavalry charge resulted in complete victory for the invaders.

From this moment on Cortés put to work all his wits, his best diplomatic manner and his skill at warfare; most important, he turned the Indians' own beliefs against them. Learning that their religion promised the return of the great god Quetzalcoatl who had led them to Mexico generations before, and that some of the Indians believed Cortés to be that god, he played the part to the fullest.

After that first battle, the provincial chiefs were summoned to Cortés' presence. But before they arrived, the Spanish commander arranged a demonstration to so terrify them that they would never again oppose the Spaniards. First a mare in heat was brought in and left to stand for some time in the place where the chiefs would be during the audience. Then a small cannon was loaded and aimed above the spot where the Indians would be assembled. When they arrived with protestations of friendship, Cortés listened gravely and replied that the Spaniards, too, wished peace. He explained that, while the Indians deserved to die because of their unprovoked attack, their lives would be spared if they entered into the service of the Spaniards and their king. Should they refuse, the god of fire within the cannon would leap out and kill them. A match was put to the gun and a cannonball whizzed over the heads of the frightened caciques. Then a giant stallion was led in and tied near Cortés. Getting the mare's scent from the area where the Indians stood, the stallion began to rear and paw the ground

Mulatto noble in service of King Felipe III in Ecuador
wears golden jewelry and carries a Spanish pike for portrait.

144

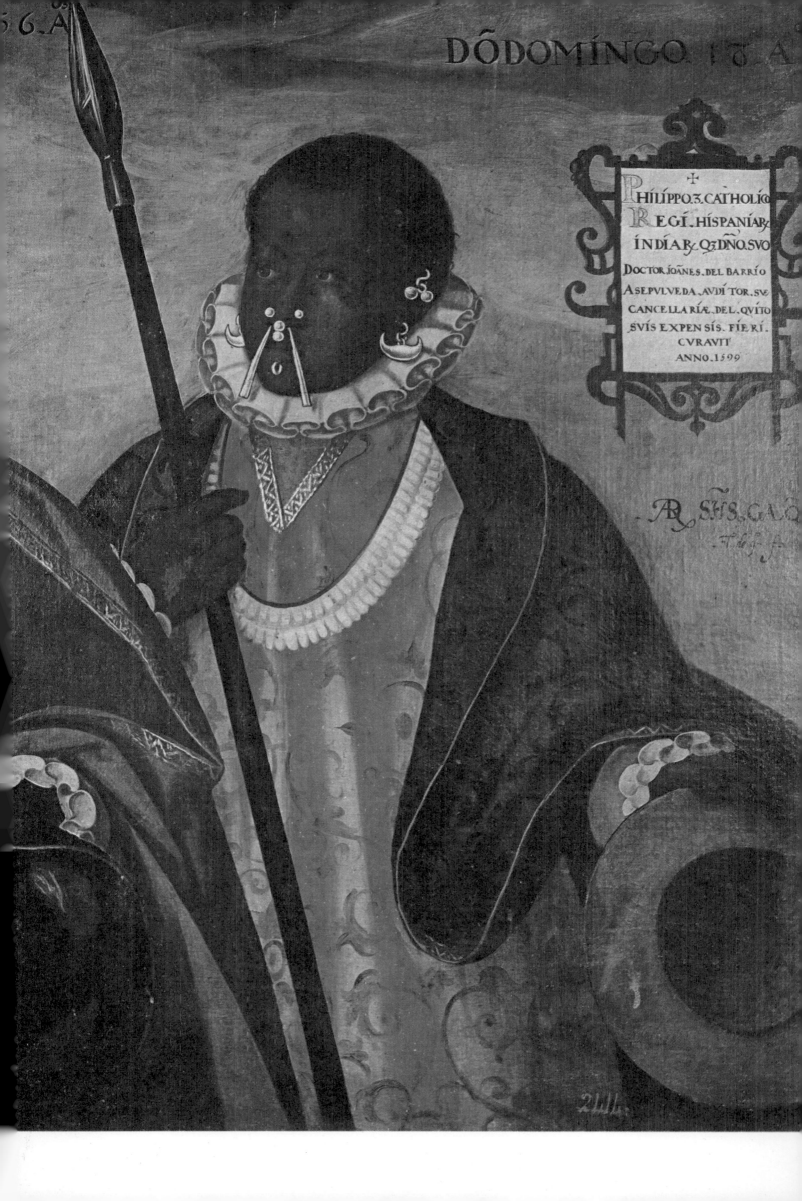

PHILÍPPO. 3. CATHOLICO
REGÍ. HISPANIARᵧ
INDIARᵧ Q₃ DNO. SVO
DOCTOR IOĀNES. DEL BARRÍO
A SEPVLVEDA. AVDITOR. SVE
CANCELLARÍÆ. DEL. QVÍTO
SVÍS EXPENSÍS. FÍERÍ.
CVRAVIT
ANNO. 1599

This colorful if not altogether precise pictorial map,
painted by a Spaniard, shows how plantations and settlements

Río del Catamayo. entra a...
haoamraca.
Catamayo. hazienda del Rey.
Uriguanga chicheros
Cerro Billonaco
saguangoza
Panucato
Billonaco
San christobal.
Piscaja
Rumimiana
Río de matacatos. al N oeste
Loxa
Río de Samora
Mongas
Baller
Caxa numa
Serro de Samora

*sprang up along the waterways in Panama. Note the mule train
and men working in the forests where quinine was discovered.*

147

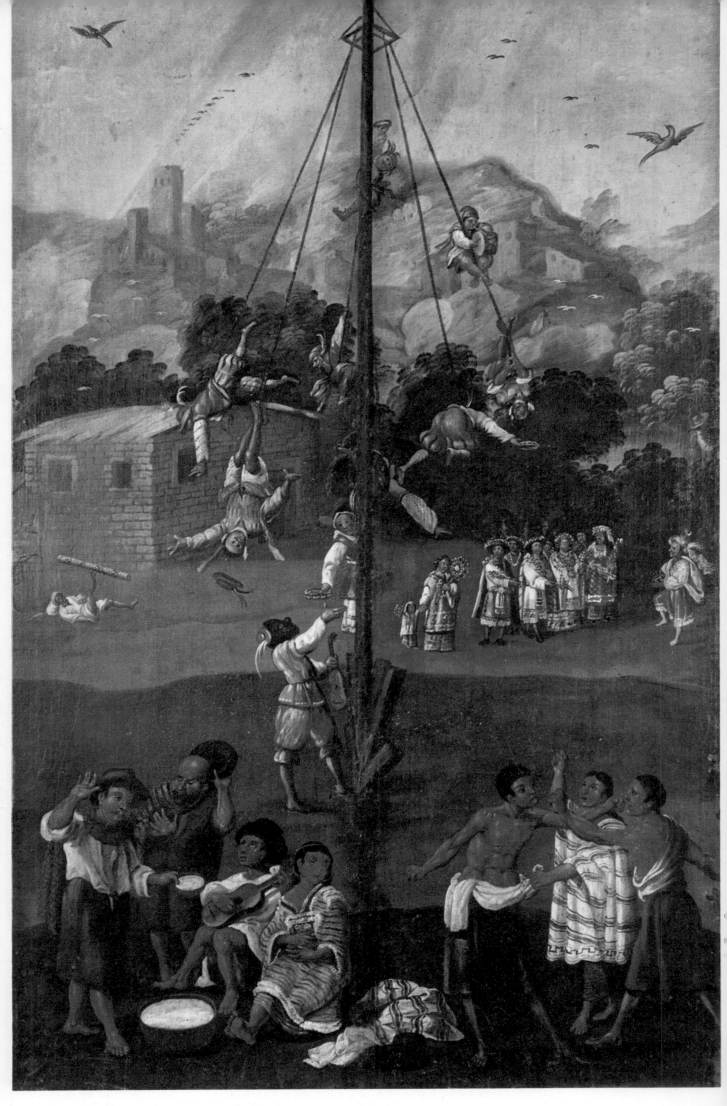

Homesick artist dreamed of castles in Spain as he
recorded village festivities in Mexico about 1650. In center, fire-

works flare, while at left Indians and mestizos in Spanish clothes perform on a high pole—as is still sometimes done in Mexico.

excitedly, tossing his head toward them. After a few minutes of this treatment, Cortés spoke to the horse and then had him taken away, explaining that he had told the horse not to be angry with the Indians, as they had agreed to serve the Spaniards.

Next day the chiefs brought many rich gifts. One that turned out to be of greater value to Cortés than the gold masks and earrings was an attractive and intelligent Indian girl. She was among a group of 20 women given to the Spaniards. Cortés gave Doña Marina, as she was called after she had been baptized, to his companion, Alonso Hernández Puertocarrero. The other women he accepted gracefully and allocated them to his captains. Doña Marina knew the language of the Aztecs as well as her own and served Cortés as a loyal interpreter. When Puertocarrero was sent to Spain four months later, Doña Marina became Cortés' constant companion, and bore him a son.

Learning that the gold gifts came from Mexico—as the country of the Aztecs was called—the Spaniards took their newly acquired women and sailed from Tabasco along the coast to a sheltered harbor which, because the day was Good Friday, they named Vera Cruz (or True Cross). They were 480 miles from the capital of Montezuma, the

First permanent city to be founded in the New World was Santo Domingo. It is now capital of the Dominican Republic.

Solid European stonework of the Viceroy's Palace in Mexico City contrasts with the frail and airy architecture of Indian hut.

Esta es figura de Vn
nopal esta de todo punto cultibado y la cochi
nilla aenſambrado bien yanſi eſtan los
yndios goçando deſu coſecha

powerful hereditary chief of the Aztec nation. Ahead lay the extensive lands of the Tlaxcala Indians.

Before setting out on the long march, Cortés had important matters to resolve. Within his army was a faction loyal to Diego de Velázquez, the governor of Cuba. They believed Velázquez had better access to the king and that their lot might improve if he became governor of this Nueva España (New Spain) rather than Cortés. The great majority of captains were loyal to Cortés. They voted to dispatch a ship to Spain, carrying gold to the king, and bearing Puertocarrero, Cortés' close friend, to plead the latter's case for recognition as governor of the new territory.

To prevent disloyal elements from sailing to Cuba to warn Velázquez, Cortés had the remaining ships destroyed. Now there could be no thought of leaving Mexico before conquering it. Forcing its way across the valleys, jungles and steep slopes, the little army fought some skirmishes and a pitched battle with the Tlaxcalans before learning that these Indians were the traditional tribute-paying enemies of the Aztecs. Once defeated, it was easy to convince them that their best interests would be served by joining the Spaniards.

As the Castilians and their new allies came closer to the Aztec capital of Tenochtitlán, Montezuma was undecided whether to welcome them as the returning white gods their religion had taught them to expect, to bribe them into returning to their own lands, or to fight them. (In time he tried all three courses, but none proved effective.) Emissaries bearing gifts were politely received, but the Spaniards' march continued. At Cholula, an Aztec outpost, the Indians attacked but were no match for the Spaniards. Finally Montezuma came to a decision. He traveled to meet Cortés and welcomed him to the capital. Addressing the Spaniard as a god, he offered him the wealth of the kingdom and put himself at the disposal of the invaders.

The Spaniards moved into the city and marveled at the high stone houses, the canals and causeways, and the affluence of these well-organized people. For a time it seemed as though a bloodless conquest had been achieved. But not for long.

At the instigation of his captains, Cortés boldly kidnaped Montezuma and kept him under guard in the Spanish quarters. He had a reasonable excuse for this as the garrison left at Vera Cruz had been attacked on order from the Aztec emperor. In captivity, Montezuma agreed to swear allegiance to the Spanish king, to bring his country under Spanish control and to release all his stored treasure to the conquerors. But after dividing the treasure, Cortés

Prickly pear was cultivated for sake of cochineal insects which lived on plants. Insects were used to make a red dye.

Colonial cavalryman in Mexico wore quilted cloth armor as protection against arrows. Other arms included pistol, lance.

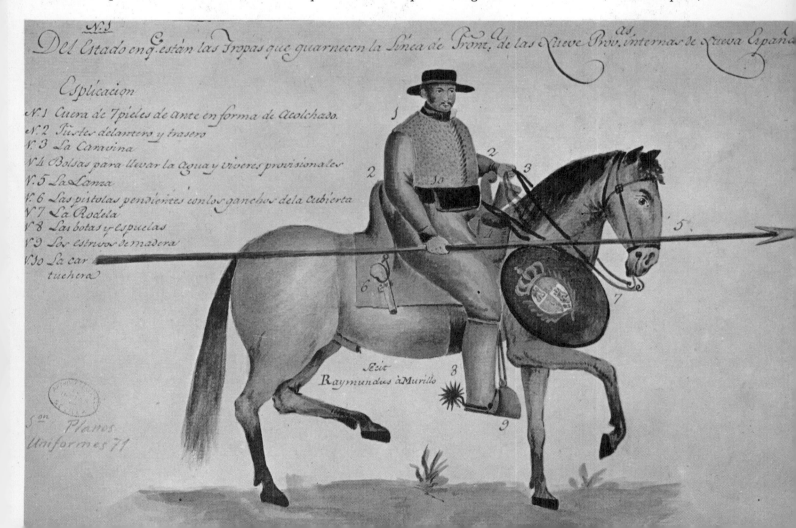

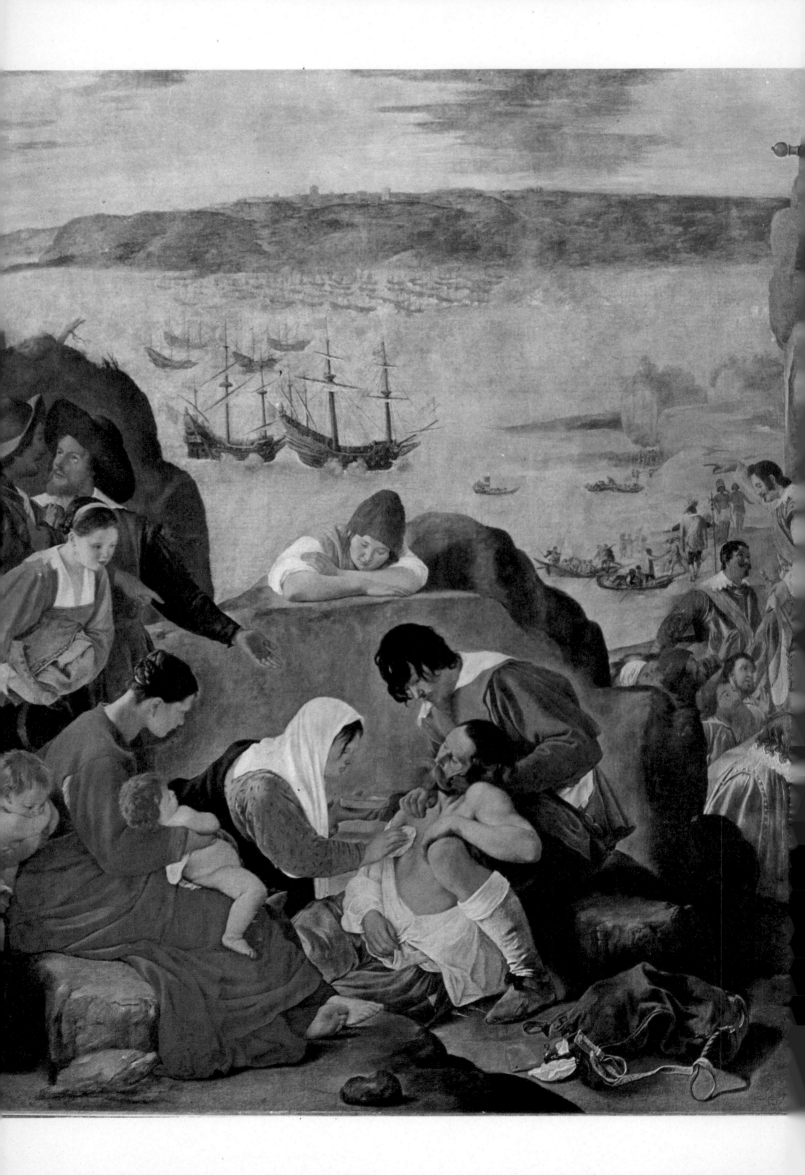

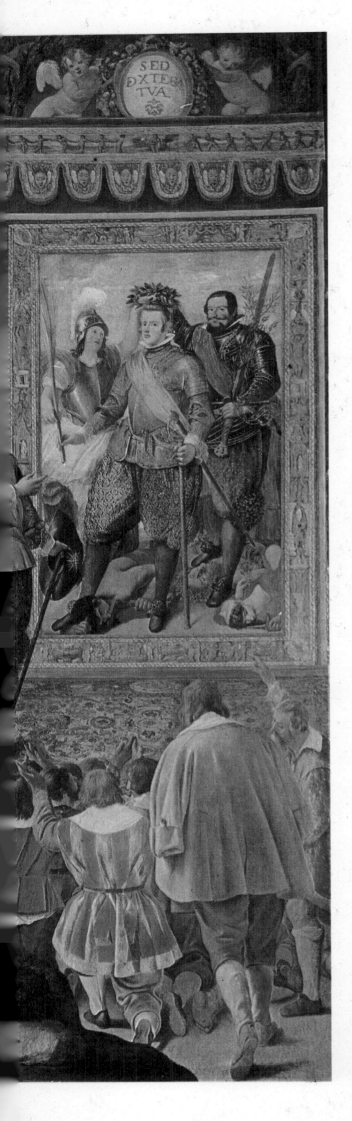

proceeded to destroy the Aztec gods and temples. The Indians became threatening and resentful.

Then word came that Cortés was being attacked from another quarter. A fleet of 18 ships, led by Pánfilo de Narváez and carrying 1,400 soldiers, had arrived at Vera Cruz. Sent from Cuba by Governor Velázquez to take over the conquest from Cortés, they were advancing toward Tenochtitlán. Leaving the capital in the hands of Pedro de Alvarado, Cortés took a contingent of soldiers, raised a small army of Tlaxcalan allies, and surprised the new invaders in a swift night attack. Narváez was captured. His captains were subdued and turned into followers by the eloquent promises of Cortés.

Meanwhile, in the Aztec capital, the Indians were holding their sacred dance festival in honor of the god Uitzilopochtli. For reasons he was never able to explain, Alvarado and his men could not restrain themselves. They fell upon the helpless dancers and massacred them. Now the Indians reneged on their loyalty to Montezuma and, considering only their own survival, elected a new chief. Cortés returned with reinforcements, but it was too late for diplomacy. When the captive Montezuma appeared, supported by Spanish soldiers, to plead with his people, both he and the Spaniards were stoned. Montezuma died a few days later.

The battle raged around the garrison until the Spaniards were forced to fight their way out over the causeway and through the canals.

After ten months spent in reorganizing his forces, Cortés returned to the attack. The siege of Tenochtitlán was long and bloody, although more Aztecs died of hunger and thirst than by the swords and guns of the invaders. When the Spaniards tried to stop the final slaughter, the Tlaxcalans, remembering how their people had been oppressed and sacrificed, killed hundreds more. When the new king, Cuauhtémoc, was captured, Cortés declared the war over; the time was August 1521.

While Cortés had been marching across Mexico, a purposeful Portuguese navigator was following in the footsteps of Columbus. Ferdinand Magellan first tried to interest the Portuguese in his project to discover a western route to the Orient by sailing around the southernmost part of South America, where he expected to find a strait leading to the new Ocean Sea discovered by Balboa. Unsuccessful in his appeals, he took the project to Carlos I of Spain (Holy Roman Emperor Charles V). With the finan-

Symbolic scene celebrates recapture of Bahia in Brazil from Dutch. At right is tapestry of victorious Felipe IV.

155

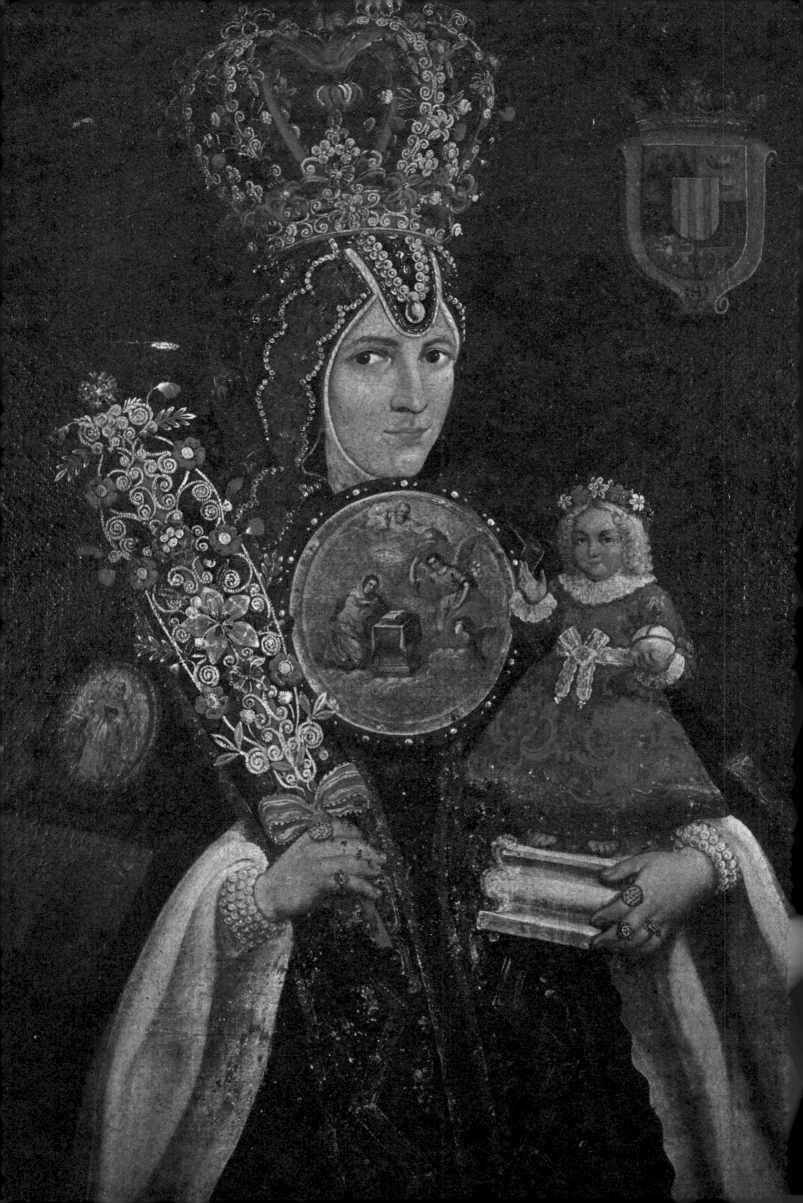

cial aid of Christopher de Haro, a businessman from Antwerp, and the scientific support of Ruy Faleiro, the astronomer, he convinced the king of the importance and feasibility of the voyage. They were granted a patent whereby the trio would receive one twentieth of the profits realized on new discoveries and the right to govern the new lands.

On September 20, 1519, the most hazardous voyage in the history of sailing began. After six months at sea, crossing the Atlantic and cruising along the South American coast, the fleet of five vessels was forced to put in at a spot they called Port St. Julian (latitude 49° south). It was very cold. Magellan's captains urged him to return to Spain. His insistence on continuing the voyage led to mutiny; this he weathered, but not without a battle among the ships. Two of the ringleaders were executed, and two others—one of them a priest—were left ashore when the fleet sailed 4½ months later.

A strait was found on October 18, 1520. During the passage through it, one ship broke away and made its way back to Spain. The other vessels continued on and soon entered the broad and, fortunately, calm waters of the ocean they named Mare Pacificum (Peaceful Sea).

Although they had realized from the beginning that the voyage would be a long one, they were not prepared for the months at sea that followed. Food ran out, and the men were reduced to boiling and eating oxhides that had been bound around the mainyard to prevent mechanical friction. Rats were trapped and devoured. Nineteen men died from starvation, and some 25 or 30 others became ill. For a total of 98 days they sailed from the end of the strait to the Ladrones Islands (Marianas). From there the fleet went on to the Philippines, where Magellan realized—once his Malayan servant succeeded in making himself understood—he had reached Asia. A few weeks later Magellan was killed in a battle with the natives of the island of Mactan, and a Spanish sailor in Magellan's group, Juan Sebastián del Cano, continued the voyage westward, becoming the first to circumnavigate the globe.

Spanish explorers next penetrated the North and South American mainlands. Pedro de Alvarado, Cortés' lieutenant, went on from Mexico to conquer Guatemala. Pánfilo de Narváez obtained a grant from the crown to explore the Gulf Coast from Florida to Mexico. With 600 men he landed in Florida. He made the fatal error of dividing his

Cortés' niece, Sister Joan of the Cross, is elaborately costumed for her entry into convent she founded in Mexico City.

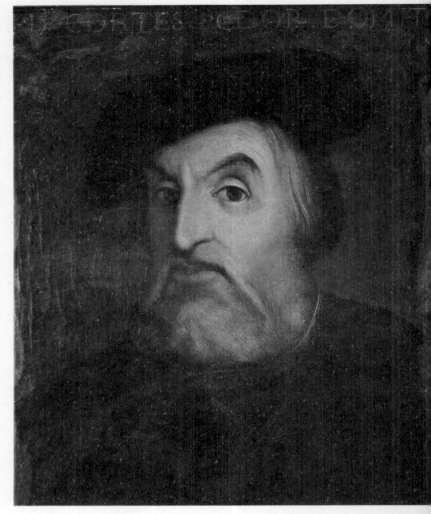

Described as "headstrong in all that had to do with war," Hernán Cortés completed his conquest of Mexico in 1521.

forces, and the land and sea sections of the expedition lost contact. His ships, unable to locate their leader, made for Spain. Within the next eight years, all but four of the men (including Narváez) perished. Only Álvar Núñez de Vaca (one of the captains), two companions and a Negro slave found their way across the southwest to Mexico.

Their tales of the richness of Florida influenced the later expedition of Hernando de Soto, who explored the country from the present state of Florida as far north as the Tennessee border. Returning south to spend the winter, he turned west and discovered the Mississippi. Crossing the broad river, the explorers wintered on its banks. There de Soto died, leaving Luís de Moscoso in charge. At Moscoso's command, de Soto's body was taken out to the middle of the river and lowered overboard.

The survivors constructed boats and floated down the river, making their way along the Gulf Coast to Mexico. In a little over four years they had explored much of the southeastern section of what is today known as the United States. What de Soto

Investors interested in making money in the New World could buy stock like this share issued in 1748 by a Sevilla company.

Columbus introduced tobacco to Europe and it became a profitable New World export. This is a machine for sifting the leaves.

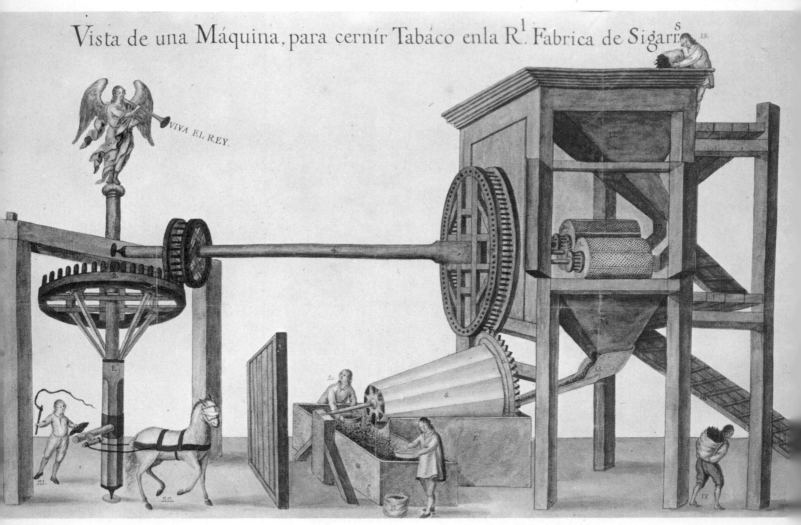

Vista de una Máquina, para cernír Tabáco enla R¹ Fabrica de Sigarrⁱ

did for the southeast, Francisco de Coronado did for the southwest. Marching up from Mexico, he explored as far north as the Grand Canyon of Arizona and east to Kansas—almost close enough to have met with de Soto's forces.

These were the first explorations in depth of the North American continent. No great riches were found; but these expeditions indicate the great energy and amazing resourcefulness of the early Spanish explorers and their followers.

In South America another kind of conquest was taking place. Three bold men—Francisco Pizarro, Diego de Almagro and Fray Hernando de Luque—with 130 foot soldiers, 45 horsemen and a cannon, subdued the Incas in Peru, a larger and richer empire than Mexico. Their pattern for conquest was so similar to Cortés' that Pizarro's men must have been familiar with the sequence of events in Mexico. On a preliminary expedition the wealth of the country was observed. Several Indians were captured and trained as interpreters. Then the trio asked the Spanish crown for rights over the country, should they conquer it. The rights were granted.

Upon landing, they told the Indians they had come in peace. Fortunately for the invaders, the country, recently torn apart by a civil war, was disorganized. The new chief, Atahuallpa, was supremely confident of his power. Even though he had disturbing reports of the great man-beasts with feet of silver (the horsemen), his advisers told him that the guns of the Spaniards were able to fire only twice and that their swords were harmless. Whatever the real reason, Atahuallpa let the invaders approach. He may have been thinking of drawing them into the interior to make their destruction easier. Or, again, there was an Inca legend of a returning god similar to the legend of the Aztecs.

The Spaniards advanced and then asked that the emperor meet with them. When Atahuallpa agreed, Pizarro prepared an ambush. The plan, following Cortés' pattern, was to abduct the king, convince him of the Spaniards' strength and purpose, and then subdue and unite the country through him.

The strategy was completely successful. The emperor came to the rendezvous with an unarmed bodyguard. The Spaniards read the *requerimiento* and a priest tried to explain the meaning of the Bible. When the Inca either dropped or threw down the book, Pizarro gave the order to open fire. Cannon and arquebuses blasted into the defenseless Indians.

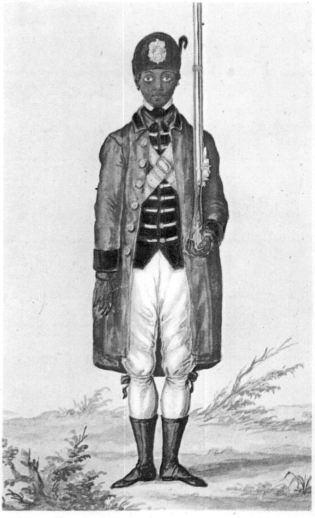

Spanish colonial troops included white and Negro units.
These two sergeants were artillerymen stationed in Puerto Rico.

In the ensuing slaughter, only one Spaniard was injured. Pizarro received a wound in the arm from one of his own men while trying to protect the Indian emperor. He needed him alive.

Spain's achievements in the realm of exploration, colonization and international organization within 50 years of Columbus' first voyage have never been equaled. A new world was opened to commerce; new countries were founded and settled. The culture of Europe was transplanted to Hispaniola, Cuba, Panama, and South America. From Spain came all the essentials of Western civilization: basic foods, produce and animals, law, architecture, music, fashion, medicine and education.

Through the church came much, though not all, of the transplanted culture. The Franciscan, Dominican, Jesuit and other orders built monasteries, missions, hospitals and schools. Magnificent cathedrals were constructed in all the major colonies.

The friars assumed the important task of educating and integrating the Indians into European society. That they succeeded in some countries and failed in others can be attributed, at least in part, to the degree of native development. The Arawaks of Hispaniola, Cuba and Jamaica were a distinctly un-developed people as compared to the Indians of North and South America. There is no question that the friars made efforts toward the integration and education of the Arawaks, but there was little to build on. Unlike the Mayas, Aztecs and Incas, the Arawaks were aborigines living entirely in the Stone Age. They built no truly permanent structures, nor had they anything resembling a written language. It is possible that the gap between the two cultures would have proved too great for their survival even if they had received better treatment from the settlers. European diseases and the European way of life might have brought about their extinction without the introduction of slavery. Certainly the natives were not all massacred or worked to death by the Spaniards, as is the usual impression. In Jamaica, where there were no mines and where the Indians seem to have been reasonably well treated, they had largely disappeared before the 18th century.

To the new colonies the settlers brought their unique quality of Spanishness. Folk songs, dances, jokes, literature, all found their way across the oceans to create a cultural base for what is today called Latin America and for much of the southwestern territory of the United States.

On eve of Spanish-American War, Havana harbor is crowded. War led to loss of Spain's last New World possessions.

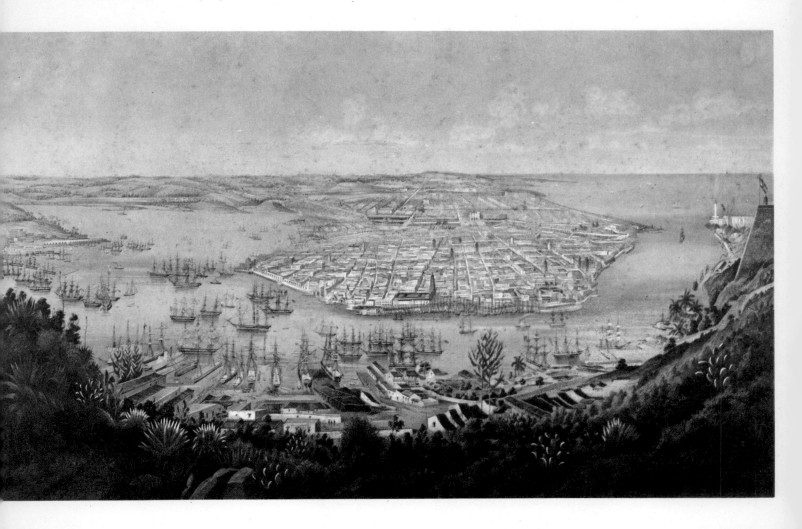

1516–1700
SUPREMACY UNDER THE HAPSBURGS

The Empire extends its power throughout Europe, Africa and America. Charles V unites the Houses of Burgundy, Austria (Hapsburg), Castilla and Aragón. The Armada rules the seas. A golden period of literature and art, during which the greatest heights of creative genius are reached (Lope de Vega, Luis de Góngora, Cervantes, El Greco, Velázquez, Zurbarán), leaves a magnificent record of Spanish and world history.

HISTORICAL CHRONOLOGY		ART CHRONOLOGY	
1517	Carlos I arrives in Spain.	1510	Renaissance style gives way to baroque.
1519	Carlos I of Spain is elected emperor of the Holy Roman Empire under the name of Charles V.	1528	Architect Gil de Siloé works at Granada Cathedral.
1521	The rebellious Comuneros are defeated. Charles V faces Martin Luther at the Diet of Worms.	1530	Architect Pedro Machuca completes Palace of Charles V at Granada.
1525	Defeat of France's Francis I.	1532	Alonso Berruguete works on St. Benito altarpiece at Valladolid.
1547	Protestants lose at Mühlberg.	1566	Lope de Rueda writes popular plays.
1555	Charles V abdicates to Felipe II.	1577	Santa Teresa publishes Moradas.
1557	Victory of Spaniards over French at Saint Quentin.	1563	Monastery of El Escorial is built by Felipe II under two architects, Juan Bautista de Toledo and Juan de Herrera.
1571	Naval victory at Lepanto.	1577–1614	El Greco in Spain.
1588	Defeat of the Armada Invencible.	1605	Cervantes publishes first part of Don Quixote. Playwright Lope de Vega publishes his "Famous Comedies."
1598	Felipe II dies; Felipe III succeeds him.		
1609	Expulsion of the Moriscos.		
1621	Felipe IV inherits the throne.	1625–1681	Plays of Pedro Calderón de la Barca.
1640	Portugal secedes from Spain.	1627	First published works of poet Luis de Góngora, author of Soledades (Solitudes).
1643	Spanish infantry defeated by French artillery at Rocroi.		
1648	In the peace of Westphalia, Holy Roman Empire comes to terms with its enemies.	1632–1639	Tirso de Molina (Gabriel Téllez), playwright, introduces the character of Don Juan in his El Burlador de Sevilla.
1700	Carlos II, last Hapsburg king of Spain, dies, after willing throne to the first Bourbon, Philip of Anjou, known in Spain as Felipe V.	1638	Francisco de Zurbarán paints at the Cartusian Monastery of Jérez de la Frontera.
		1656	Diego Velázquez paints "Las Meninas."

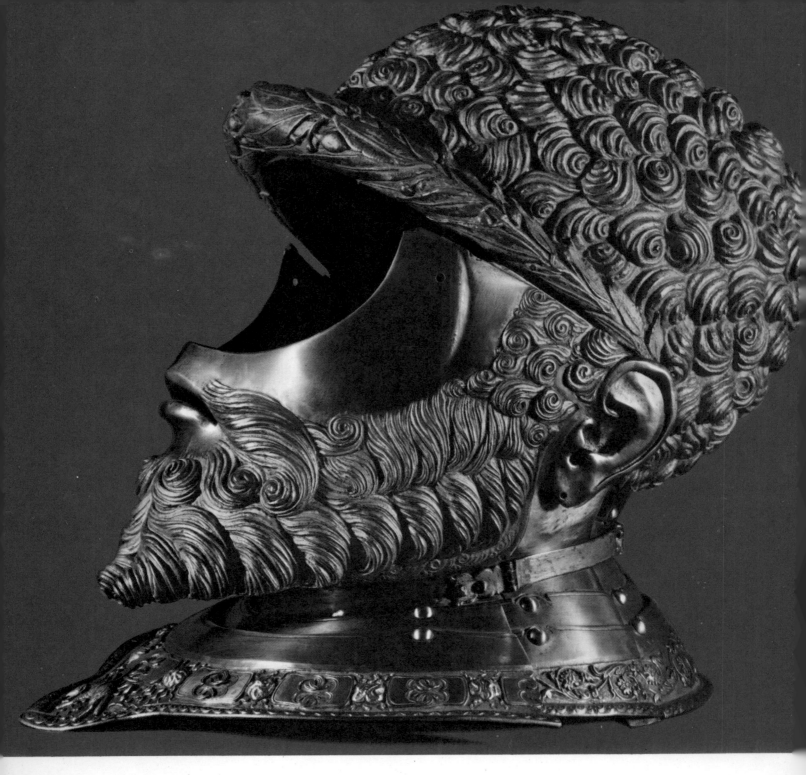

Splendid helmet, with curled beard and laurel wreath, had features of Carlos I and was worn by him in battle.

The Age of Expansion

While adventurers, explorers, priests and coloni[s]ts were creating a Spanish empire in the New Worl[d] Castilla awaited a new king. He was to be Charles [V,] known as Carlos I of Spain, and would come to t[he] throne at the age of 17 through the following dr[a]matic incidents.

Queen Isabel did not leave her kingdom of Castilla and León to her husband, Fernando, but to her daughter Juana (known as *La Loca,* the Madwoman) and her descendants. After Isabel's death Fernando remained king of Aragón and still wielded great influence in Castilla, although reduced from king to regent until Juana and her consort, Philip, called the Handsome, could travel from the Netherlands—his country of birth—to Spain to begin their rule. Hoping to strengthen his position against Juana and Philip, Fernando married Germaine de Foix, niece of Louis XII of France. An additional reason for this marriage was 53-year-old Fernando's hope for an heir who could inherit his kingdom and perhaps lay claim to Castilla as well. As Regent of Castilla he was able to pledge the crown of Navarra to any child he should have by the French princess. A son was born to them but died the very same day, ending Fernando's hopes of a new dynasty.

Fernando did not take kindly to the presence of Juana and her husband, Philip, when they arrived. He fought the succession, but Juana was confirmed by the Cortes as *Reina Propietaria* of Castilla, just as her mother had been 32 years before. Yet Juana and Philip were not to keep control of Castilla away from Fernando for long. Within two years Philip had died of a raging fever, and Juana—the loss of her husband adding to her mental instability—became depressed and irrational. Fernando was made regent again. He conspired to the last possible moment to keep the throne of Spain from falling into the hands of a "foreigner," as he considered his oldest grandson, Charles of Ghent.

Only on his deathbed did he reluctantly agree that Charles, rather than Charles's younger brother Ferdinand (who had been reared in Spain and was a favorite of his grandfather), would become heir to his throne of Aragón, Valencia and Cataluña, and his possessions of Sardinia, Sicily and Naples. From Isabel, his maternal grandmother (through his mother, Juana, whose insanity kept her from ruling), Charles acquired Castilla, León, Navarra and all the Spanish possessions in the New World. Later, from

his paternal grandfather, Maximilian, he inherited Austria, the Tirol and parts of Germany. From his father, Philip the Handsome, he received Flanders, Holland, Luxembourg, Franche-Comté and a claim on the duchy of Burgundy, which had been taken by France from his ancestor Charles the Bold, a claim he never forgot.

All these inheritances did not come at once. At the age of 15, Charles was given the title of Duke of Burgundy. In 1516, two months after the death of his grandfather, Fernando, he was proclaimed King of Castilla and Aragón in Brussels. Meanwhile, Spain was being ruled by the competent and trustworthy Cardinal Jiménez de Cisneros as regent.

The young king arrived in Spain on September 8, 1517. Forty ships carried his Flemish court and a few Spanish advisers, including Francisco de los Cobos, who had traveled to the Netherlands to join him. A tall, awkward boy of 17 with a prominent jaw,

Matching lightweight round shield was meant for fighting at close quarters on foot. Lion's head is surrounded by griffins.

Charles spoke no Castilian and showed little knowledge of the country he was to rule.

First the high noblemen of Spain, then the hidalgos, and finally even the peasantry became alarmed as Charles awarded high offices to his foreign counselors. Adrian of Utrecht became Bishop of Tortosa; later, as Pope Adrian VI, he was to be helpful to Charles. The King's guardian and adviser, Guillaume de Croy (Sieur de Chièvres), received extraordinary concessions, as did others in the foreign entourage.

The Cortes convened at Valladolid, and the king was urged to add more Castilian advisers to his service and to learn Spanish—as well as to observe the laws of Castilla. He agreed in principle, and the Cortes granted his request for a subsidy. The foreign court moved across the rugged countryside to Aragón. There the Cortes was even more obstructive and deliberated for many months before recognizing Charles as King Carlos I, and then only jointly with his mother, Juana, who was harmlessly insane with occasional rational periods. Juana lived on in Tordesillas for the next 37 years.

While Charles was in Barcelona he learned that his grandfather, the Emperor Maximilian, had died, leaving him in an ideal position to be elected Holy Roman Emperor. His advisers moved quickly to secure his claim. Huge sums of money were borrowed

to bribe the electors. Political and economic pressures were used. Soon Carlos I of Spain had become Charles V of the Holy Roman Empire.

In Spain, the election of their king to Emperor was received with mixed feelings. Charles had barely arrived and was already leaving. Their fear of being governed by an absentee king seemed justified. When, on the eve of his departure for the coronation in Germany, the new king requested the Cortes to pledge a second subsidy, some of the townships refused. After his departure, a revolt broke out in Segovia.

The aims of the *Comuneros,* as the rebels became known, were simple: less foreign interference in Spain, fewer foreigners in the Spanish court, and no

draining of the Spanish treasury for foreign adventures. The greater part of the nobility waited out the rebellion. Many towns set up their own governments in opposition to the regency of Adrian of Utrecht, whom Charles had left behind to rule.

Many of these grievances were justified, and the revolt spread through most of central Spain. A critical point was reached when the rebels captured Tordesillas and held a memorable audience with Queen Juana. She was rational during the audience, but refused to sign any document approving the rebel cause—just as she had refused to sign a statement, previously submitted by the government, condemning it. To quell the revolt, Charles sent dispatches naming two Spaniards—Admiral Fadríquez and Constable Iñigo de Velasco—as joint governors with Adrian of Utrecht. Together they assembled an army. The king's forces defeated the *Comuneros* at Villalar, where rebel leaders Juan de Padilla, Juan Bravo and Francisco Maldonado were beheaded.

Another insurrection started in Valencia in the aftermath of an epidemic of the plague. The townspeople armed themselves and formed brotherhoods known as *Germanías* to march against the landowners. The revolt quickly spread to neighboring regions. It was brought under control by authorities only after thousands had been killed.

On the first of many journeys, the Emperor stayed away two years. During this brief period he set the course of the empire. At the Diet of Worms he faced Martin Luther, who had published his edicts demanding the reformation of the Catholic Church on the same day that young Charles first landed in Spain. At Worms he listened to Luther and made some effort toward compromise, for Charles, too, felt that certain reforms were necessary. Unable to come to an agreement, he published an edict banning Lutheranism in the empire.

Charles then turned to the difficult problem of France's ambitions in Italy. His conflict with France had begun even before he had received the title of Emperor of the Holy Roman Empire, which France's able leader, Francis I, coveted for himself. Realizing the danger to France of being surrounded by the powerful and ambitious Charles and his empire, Francis I went on the offensive. He attacked Navarra during the revolts of the *Comuneros* and

Preceded by young heir Felipe, Carlos I (Charles V) rides dappled stallion to review troops before expedition to Tunis in 1535.

165

Carlos I married Isabel, daughter of King Manuel of Portugal. Their portrait by Titian survives only in this Rubens copy.

Germanías. But the French army was quickly driven out of Spain.

This was only a minor diversion. France occupied the duchy of Milan. Charles, shortly after becoming King of Spain, had signed the Treaty of Noyon, which returned Milan to France. But while in Germany, Charles had second thoughts about giving up strategic Milan, and dispatched an army to add this duchy to the empire.

Then Charles moved on to England. His visit to Henry VIII resulted in an alliance and a secret pact—to conquer and dismember France. Two great armies were to be raised, each led by its king. After France was subdued, Charles planned to take back his beloved duchy of Burgundy, among other territories. As part of the agreement, the Emperor, then 22 years old, was affianced to his cousin, Mary Tudor, the 6-year-old daughter of Henry VIII and Catherine of Aragón. Although the conquest of France never took place and Charles did not marry Mary Tudor (he did arrange for her marriage to his son, Felipe II), the alliance between England and Charles's empire continued throughout his reign.

All Spain rejoiced when, at the age of 26, Charles married Isabel, the daughter of the King of Portugal. The feeling that they had a king and queen of their own persisted, even though Charles was to spend most of his remaining years outside of Spain. Isabel, a majestic and intelligent woman, remained as his regent. She was popular and deeply loved.

The children of Charles and Isabel—Felipe, María and Juana—were all born in Spain. The Emperor seems to have been a devoted, if often absent, husband. Unlike many of the kings of his time, he had only two love affairs. The first liaison was with Johanna van der Gheenst, when he was 22. The child of this union was Margaret of Austria. Seven years after the death of Queen Isabel, Charles had a brief affair with Barbara Blomberg of Regensburg. They had a son, who was reared in Spain; he was to become the Spanish hero Don Juan of Austria.

While Charles was in Spain, the French army in Italy was defeated and Francis I, the French king, was captured by the Spaniards. He was brought to Madrid under heavy guard. There he signed a treaty relinquishing all claims to Milan and awarding

In 1555 Carlos I formally abdicated in favor of son, Felipe II. Here the king (wearing miter) renounces tit

Charles his long-cherished duchy of Burgundy. Francis did not honor the vows upon his release, claiming he had been coerced while a prisoner.

Charles never visited the largest and potentially richest of all his inherited domains—the vast and expanding New World. He nevertheless became actively engaged in its development, and his entire reign was marked by continuous and serious questioning of the rights and privileges of Spain in the Americas. Heated debates raged through the universities and invaded the court. Bartolomé de las Casas was a frequent visitor to the royal residence. Charles listened to him and revised policies dealing with the treatment of the Indians. Time after time Spain proclaimed the status of Indians as free men.

Spain's most important intellectual stimulation came from the ideas of Erasmus of Flanders, the great scholar and reformer whose works were widely read and discussed. One of his champions was the Inquisitor and General, Alfonso Manrique, Bishop of Sevilla. Others included Chancellor Mercurino di Gattinara and even the Emperor himself. But the Spanish Inquisition allowed of no middle ground, regardless of the highest support, between the orthodox position and any more liberal one. Lutherans and Erasmians were persecuted.

It required little effort by Charles to keep Protestantism out of Spain, but great effort to control it in the northern portion of his empire. In the year 1547 Charles's army defeated the Protestant Schmalkaldic League, and the Emperor hoped to unite his domains under one religion. But the Pope, who was a temporal as well as a spiritual power, feared Charles would take over the leadership of the church. The Emperor could obtain no papal support for a general conference to reconcile the Protestants. In later years, the Pope allied himself with France against Charles; the Emperor's armies sacked Rome and forced Pope Clement VII to take refuge in the Castle of Sant' Angelo.

Charles's first great defeat came from one of his former allies, Maurice of Saxony. This powerful German prince, who had fought alongside him at the Battle of Mühlberg, gathered an efficient Protestant army and made an alliance with France for the purpose of attacking Charles. The surprise attack came while the Emperor was resting at Innsbruck. Only a small force was with him when the Protes-

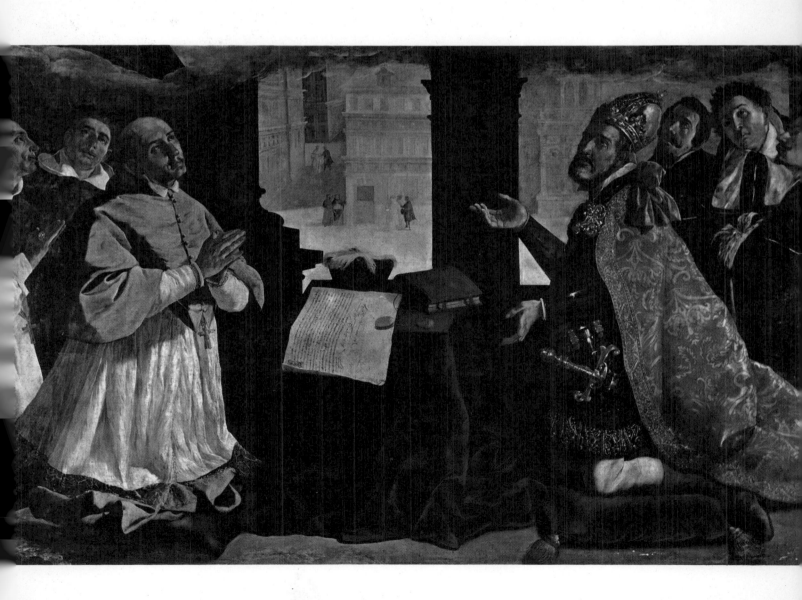

tants and French struck. His outpost garrison was captured and the monarch, with his disorganized court, fled through the night to Villach in Carinthia. The Treaty of Passau followed, allowing the German princes to choose between Lutheranism and Catholicism for themselves and their subjects. The treaty was ratified by the Peace of Augsburg.

If Charles failed in his main ambitions, he nevertheless succeeded in controlling the spread of Protestantism and laid the foundation for the Counter Reformation. He integrated into a single nation a conglomerate people and, for the last time, gave unity to the concept of the Holy Roman Empire.

Francis I subsequently allied himself with the Turks. This almost unbelievable alliance between a Christian king and the most powerful infidel nation shocked all Catholic Europe and brought about a great counteralliance. As a first move, Charles marched on France, almost reaching Paris before the French capitulated and agreed to break off their ties

to the Ottoman Empire and to provide soldiers for the Christian crusade against it.

From the beginning of Charles's reign, the Turks had been a threat. The expulsion of the Moriscos by Fernando and Isabel had placed a hostile group of bitter enemies directly across the Mediterranean from Spain. Pirate raids along the coast damaged Spanish commerce, and the pirates often found cover with those Moriscos still living in Spanish coastal cities.

The Barbarossa brothers appeared on the scene. They were pirates of extraordinary skill who rose to be important officers in the Turkish navy. Reducing Spanish influence all along the North African coast, they succeeded in taking the island fortress at Peñón de Vélez de la Gomera, followed by the capture of Tunis, which was under Spanish protection. Charles equipped a great navy of 600 vessels. In command were the Genoese Andrea Doria, the Duke of Alba and the Knights of Malta; Charles

*Beginning a tradition of royal equestrian portraits followed
by Velázquez and Goya, Titian painted Carlos I at Mühlberg.*

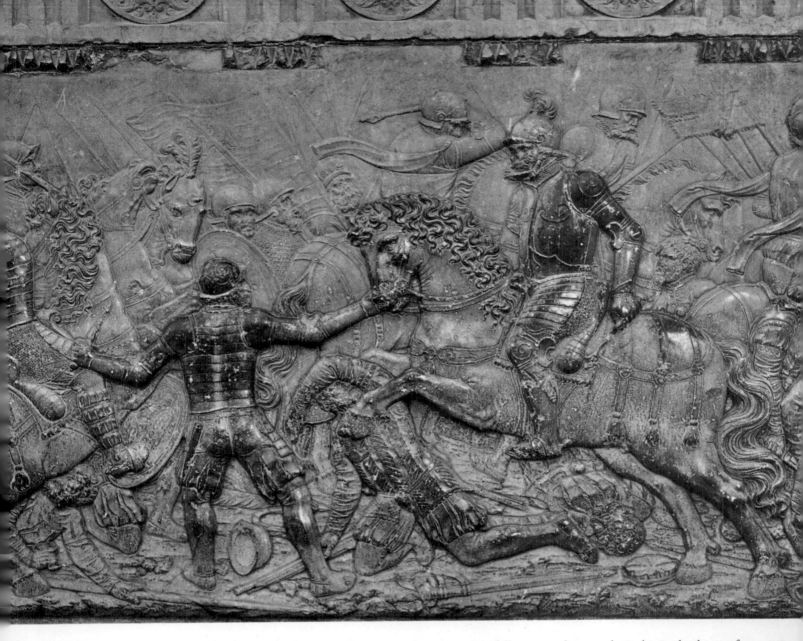

In full armor and mounted, Carlos I rides down a foot soldier in a bas-relief on the front of his palace in Granada.

himself directed the recapture of Tunis. Years later, the Emperor made another massive foray against the Turks in Algiers, but his supply fleet was wrecked and the entire expedition was a failure. It was left for his sons, Felipe II and Don Juan of Austria, to finally defeat the Turks at Lepanto, 13 years after his abdication.

Innovations in poetry, architecture, sculpture and painting marked the era of Charles V. From Italy came the inspiration for new verse forms, including *verso suelto* (blank verse). These new forms were adapted to the Spanish language, and in 1543 a book of the collected verse by Juan Boscán and Garcilaso de la Vega revolutionized the writing of poetry in Spain.

In architecture, Diego de Siloé, Alfonso de Covarrubias and Pedro Machuca dominated the Spanish scene. Their works influenced all of Europe. Machuca produced the outstanding structure of his

Sixteenth-century miniature now in El Escorial displays extent of Hapsburg rule over most countries in Europe.

time, the Renaissance-style royal palace of Charles V, next to the Alhambra in Granada.

The age produced many outstanding sculptors. Bartolomé Ordóñez did the magnificent tomb in Granada's royal chapel. The Frenchman Philip Vigarny created the Burgos Cathedral. He also collaborated with Diego de Siloé and Alonso Berruguete, perhaps the greatest sculptor of them all.

Painting was deeply influenced by the Italian, Dutch and German masters.

Charles was the last of the medieval kings. Like the earlier monarchs, he never had absolute power but governed different states, each with its own background of privileges and institutions. His grandparents, Fernando and Isabel, had united Spain. Charles held it together, strengthened it by building an army, organized the commerce and legislative direction of the New World, expanded the empire and kept foreign armies out of Spain.

During the first part of Felipe II's long reign,
the Spanish empire was at its zenith of power and prosperity.

Enormous tapestry now hanging in El Escorial dates from
time of Felipe II and typifies Renaissance exuberance of period.

Felipe II—
Creator and Destroyer

Prematurely aged by gout, 55-year-old Charles V nonetheless played out the drama of his last days. He arranged the marriage of his son and heir, Felipe II, to Mary I, Queen of England. Through this union Charles hoped to secure the Low Countries and Spain, since England was their only serious threat. Should there be an heir, he would inherit the thrones of England, the Low Countries, Franche-Comté and Burgundy. Don Carlos, Felipe's son by

Manuel Filiberto of Savoy was one of Felipe II's finest generals. He carries baton of rank and wears half-armor.

his first marriage—to Maria of Portugal, who died in childbirth—would inherit Spain and the Mediterranean possessions. If Don Carlos died without an heir, his legacy would revert to the child of Felipe and Mary Tudor. It was a brilliantly conceived plan but it did not work out. The aging Mary failed to produce an heir. She died after four years of marriage.

Meanwhile Charles made his plans for abdication. He waited until the death of his mother in the spring of 1555, and then summoned Felipe to join him in Brussels. Amid elaborate ceremony the now feeble Charles abdicated, leaving the Low Countries to Felipe. It was an inheritance destined to bring about the disintegration of the empire, for no amount of money or of soldiers could stem the rise of Protestantism. The alliance with England then seemed permanent; Mary Tudor was a devout Catholic, and at the time it seemed that the navies of Spain and England could be depended upon to keep secure the possessions of these powerful countries. Germany and Austria were left to Charles's brother Ferdinand and to the latter's son, Maximilian II.

Shortly after, Charles renounced all claims to his dominions in the New World and the Old in favor of Felipe II. Charles had already given the kingdom of Naples and the duchy of Milan to Felipe upon his marriage to Mary Tudor. He transferred Franche-Comté to the son of Henry II of France during a temporary truce in the war between France and Spain.

Charles left behind two famous documents. The first revealed the existence of his natural son who had been reared by a trusted steward. The attractive youngster was 14 when he was taken to the court of his half brother. Felipe received him royally, saw to his education, awarded him rank and recognition. He grew up as Don Juan of Austria, and became a clever and daring leader. He suppressed the Morisco rebellion of 1568–70 in Granada. A year later, at 26, he led 200 galleys, 100 transport ships and 50,000 infantrymen to a great victory over the Turks at Lepanto. After that success, Felipe had trouble in controlling his half brother, who wanted to pursue the Turks to Constantinople, take the city and revive the Byzantine Empire. He also suggested that Spain invade England. Felipe did not agree.

Unusual fresco shows three types of weapons—sw lances and arquebuses—all in use during Battle of St. Que

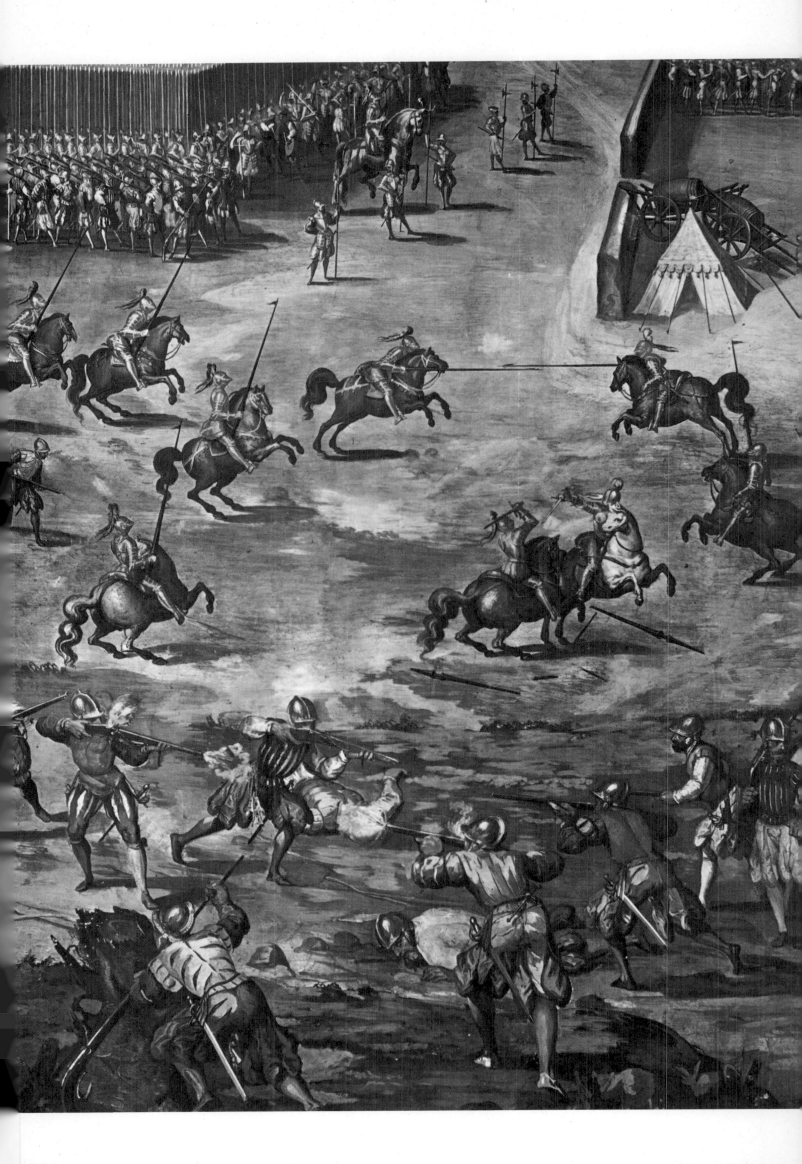

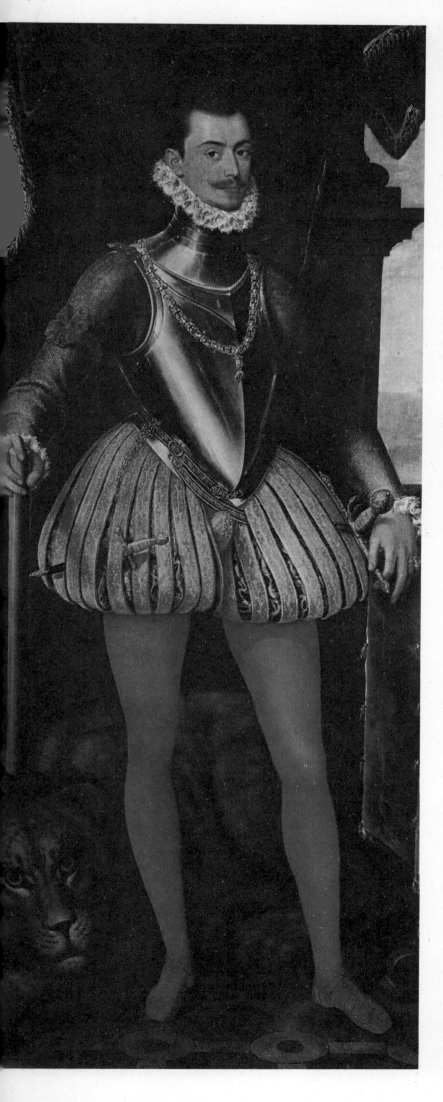

Charles's second document contained a request that a worthy tomb be erected for his remains—a project which occupied Felipe II for 23 years. The result was the magnificent structure called El Escorial, a perfect example of Christian Spanish architecture. Dominated by geometric structural elements, the lines are precise, the decorations austere. It has a solidity and resoluteness that is as firm as Felipe's own Christian convictions. Built as a palace, monastery, cathedral and tomb, it expresses the final realism in Spanish architecture. Felipe himself selected the architect, Juan Bautista de Toledo, then completely unknown. When he died, the talented Juan de Herrera completed the structure.

Inside the somber building, the king built his own modest apartment with a door leading into the chapel. He filled the walls with paintings by Navarrete, Berruguete, Coello, Pantoja, and the master of them all, El Greco.

Ideas as well as art flourished during the 40 year that Felipe ruled Spain. Although the Counte Reformation and the Inquisition silenced som voices, free inquiry and the humanist approach i literature continued. The works of the philosophe Juan Luis Vives (who had been tutor to Mary I were read by increasing numbers. Notable historie emerged: the final works of Bartolomé de las Casa dealt with the New World; the firsthand narrativ of Bernal Díaz, a soldier with Cortés, recorded th conquest of Mexico. But the most distinguishe historian was Juan de Mariana, a Jesuit, who wrot the *Historia General de España*. The Augustinian Fra Luis de León, an outstanding scholar and teacher a the University of Salamanca, although imprisone by the Inquisition for five years, published poetr and prose, as did another great contemporary of hi the Dominican Fray Luis de Granada.

But all the artists, writers, and even the greate army in the world could not solve Spain's an Felipe's supreme problem—the continuing unre generated by the Calvinist uprisings in the Lo Countries. Felipe first considered conciliation an appeasement, as had his father, but decided instea to dispatch the Duke of Alba with a strong Spanis army to crush the northern "heretics." When Ca vinist groups attacked priests and sacked and burne churches, Alba, in return, executed many of the number, and the Inquisition burned others.

In the early days of the Protestant uprising Felipe faced a personal crisis—his son Don Carlo

Considered one of the handsomest men and greatest generals of his time, Don Juan of Austria was the bastard son of Carlos I.

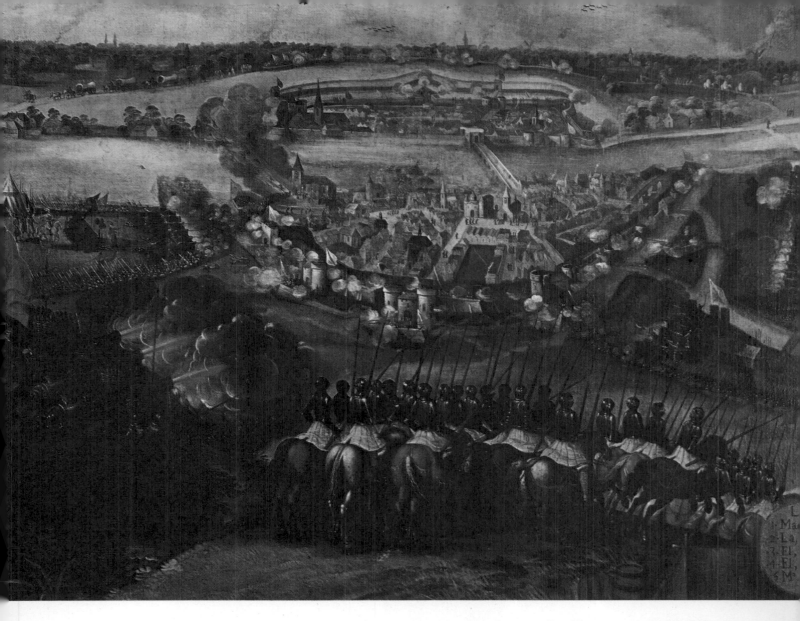

Besieging town during Battle of St. Quentin, Spanish artillery (left) fires as mounted knights prepare to attack French.

bellion against his authority. Never very stable, on Carlos became more irrational as he grew to anhood. Possibly it was his hatred for his father at led him to secret contacts with the Dutch. Felipe d Don Carlos, who was 23 at the time, put under use arrest, where he died in less than a year.

Whether or not Don Carlos was in communicaon with the Dutch, the English certainly were. In dition to giving aid and comfort to Spain's enees in the Low Countries, Drake and Hawkins led glish pirates in attacks on Spanish settlements and ps in the New World and along the Spanish coast. hen Felipe sent a large amount of gold to pay his diers in the Low Countries and the ships sought lter in an English port, the money was confised, or, as Queen Elizabeth said, "borrowed."

Felipe tried to avoid a conflict with England, lizing the potential cost. But he would not give the Low Countries, which were receiving aid m Elizabeth, nor could he tolerate the raids on Spanish coast and the New World settlements,

or the attempts by Raleigh and Gilbert to establish English colonies in Spanish territory. An early invasion of England might have changed things. But Felipe, like Elizabeth, subscribed to a policy of diplomacy and intrigue. When his tactics failed, Felipe obtained the Pope's approval to launch a great invasion fleet, the grand Armada.

Spain had no port in which her ships could rendezvous with the land army from Flanders; she had no shallow draft fleet to protect the barges of the landing force (which was to be led by Don Juan of Austria); and the organizer of the fleet, Admiral Santa Cruz, died shortly before the invasion (leaving a successor who knew nothing of naval warfare). The outcome was almost inevitable: the speedier English ships got windward of the Spanish Invincible Armada, broke it up by sailing fire ships into its midst, and then fought the Spanish ships from a distance with longer-range artillery. The Spaniards gave a good account of themselves, but lost 10,000 men and 66 of their 130 ships.

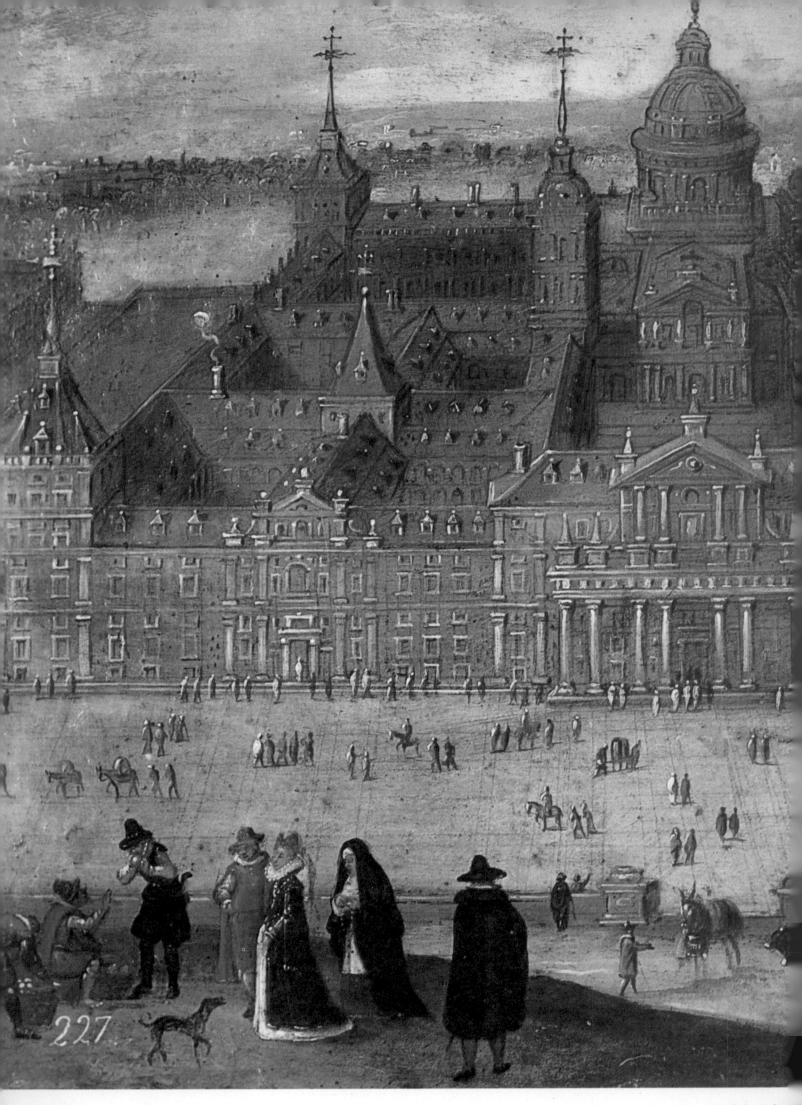

Vast palace of El Escorial was built by Felipe
near Madrid as a memorial and a tomb for his father, Carlo

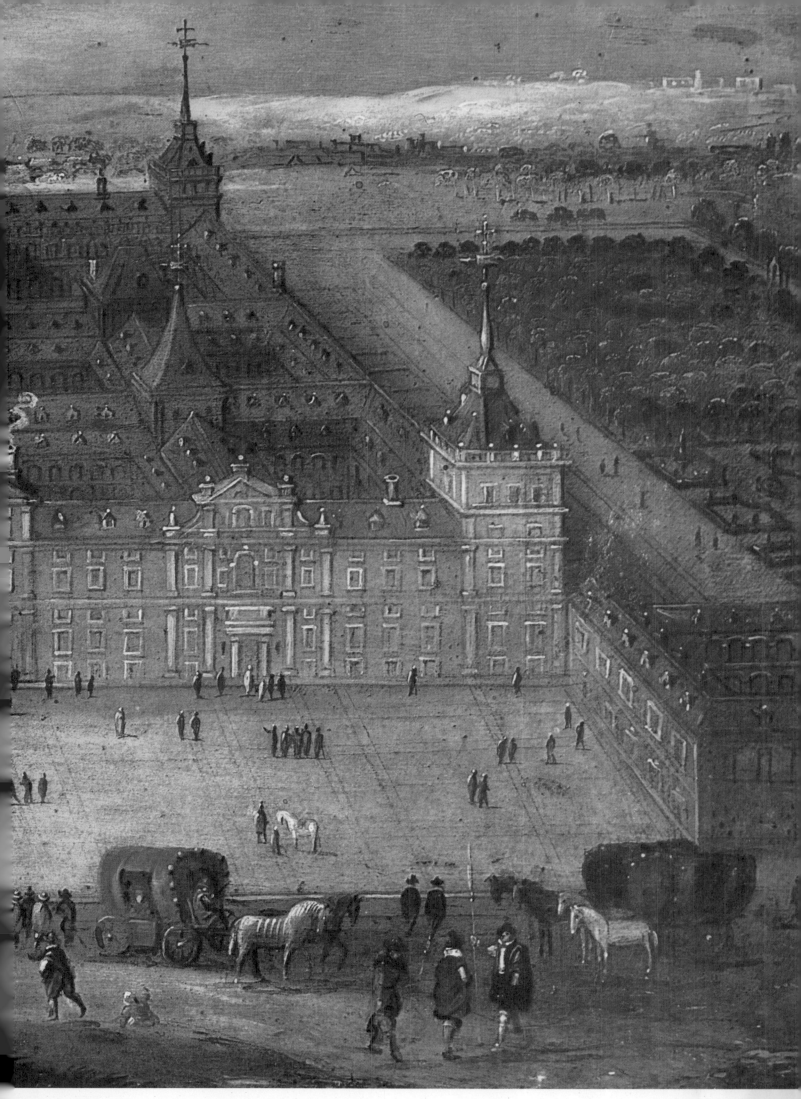

Construction took 21 years, and Felipe spent most of his life
improving it and filling it with treasures, books and paintings.

Soldier of the Cross

In the year 1506, a handsome lad of fifteen, with dark reddish hair, intense brown eyes and a slightly hooked nose, entered the service of the treasurer of Castilla as a page. His name was Iñigo and he was the youngest of thirteen sons of Don Beltrán Yáñez de Oñaz. In the offices of the treasurer, to whom he was related, young Iñigo came in constant contact with Fernando, the elderly Catholic king, and his second wife, the young and radiant Germaine de Foix. Some have said that Iñigo became her lover, but no one really knows. His was the age of chivalry, and we know he composed verses to the queen and wore her colors. At 26, he entered the service of Antonio Manrique de Lara, a distinguished general and viceroy of Navarra.

In a fiercely fought battle with the invading forces of Francis I of France, a cannonball shattered Iñigo's right leg and injured his left. The French captured him and treated his wounds. His left leg refused to heal properly. It was broken and reset, but still a section of bone protruded. A third operation left him with a permanent limp.

For many months Iñigo was unable to walk. To while away the time, the young knight read whatever he could find. The only books available chanced to be *The Life of Christ* and the *Flos Sanctorum (Flowers of the Saints)*. Iñigo reflected upon the glory and selflessness of Christ and the saints, and spent many hours comparing his worldly existence with their spiritual lives. By the time he was able to walk about, Iñigo had made a resolution. He would follow in the path of the saints.

First he made a pilgrimage to a shrine high on an isolated mountain near Barcelona. The former knight revealed the sins of his life in a confession that took three days. He laid aside his sword and dagger, his horse and clothing, and, clad in sackcloth, walked 20 miles to Manresa.

As a begger, eating only bread and water, starving and scourged, he lived in a shallow cave at the

In 1534, Ignacio de Loyola (right) received ...ission from Pope Paul III to establish the Society of Jesus.

edge of town. There he outlined his great book *Ejercicios Espirituales (Spiritual Exercises)*.

He was arrested by the Inquisition for lack of orthodoxy, but was soon released. Journeying to Paris, Flanders and England, he gathered around him such outstanding associates as Francis Xavier, Pierre Lefèvre and Diego Laínez, men who would later help him found the powerful monastic order of Jesuits (Company of Jesus) that was to play an important part in the Counter Reformation.

Iñigo, former page, courtier and knight, was canonized by Pope Gregory XV in 1622 as Saint Ignatius (Ignacio) of Loyola.

Loyola was canonized in 1622. The church once considered him a radical and barred him from preaching for three years.

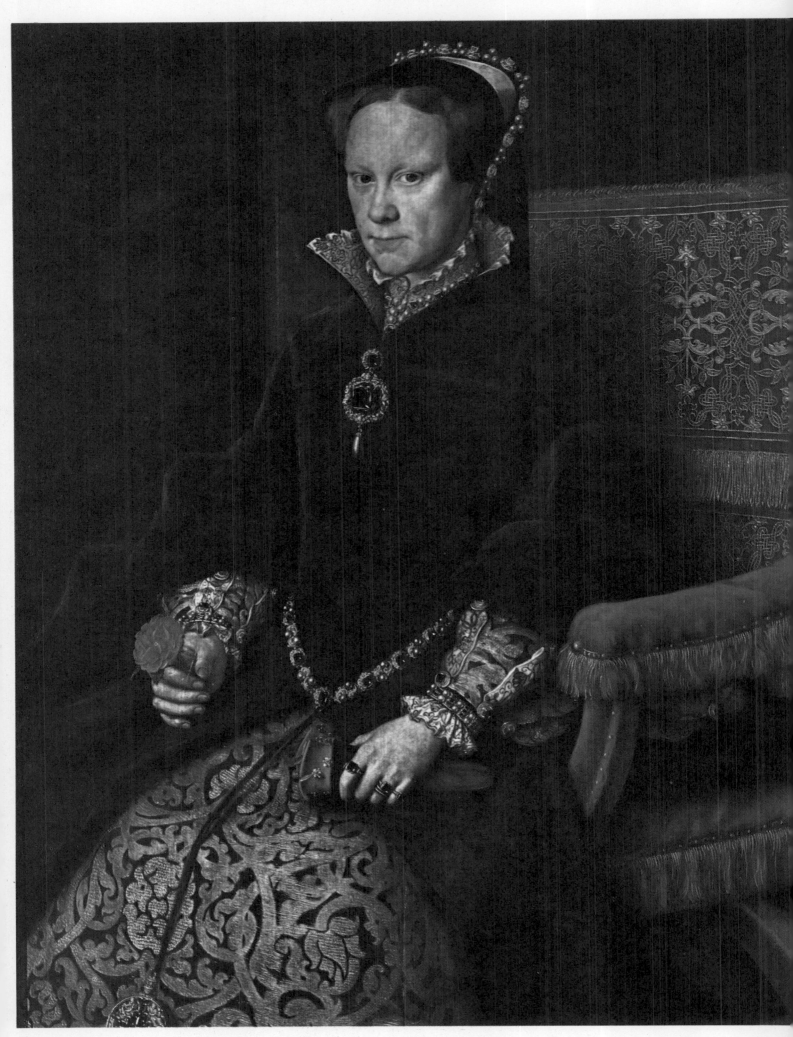

Statuette satirizes Grand Duke of Alba's troubles with *pain's enemies—the Pope, Elizabeth I and the Elector of Saxony.*

Mary Tudor, Queen of England, married Felipe II in 1554. *But she was eleven years his senior and failed to bear him an heir.*

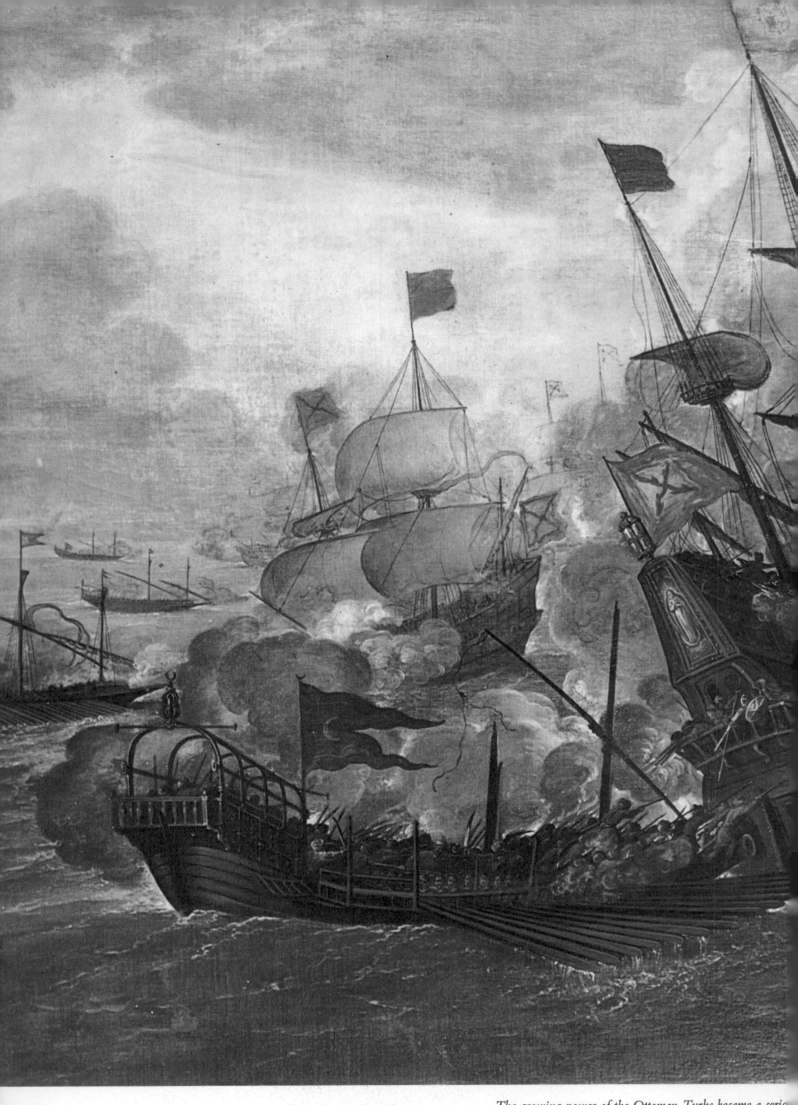

The growing power of the Ottoman Turks became a serio[us]
threat to Western Europe during the 16th century. The Tur[ks]

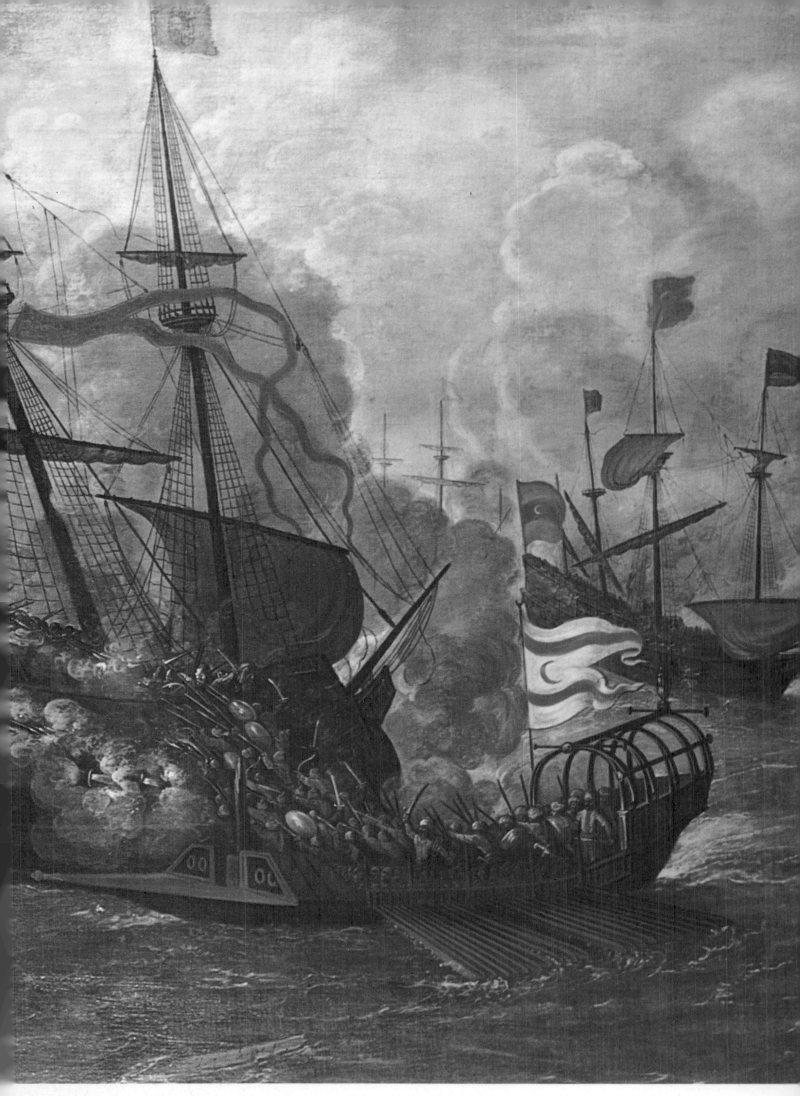

...reyed on shipping and made coastal raids. A series of land ...d sea battles culminated in the Christian victory of Lepanto.

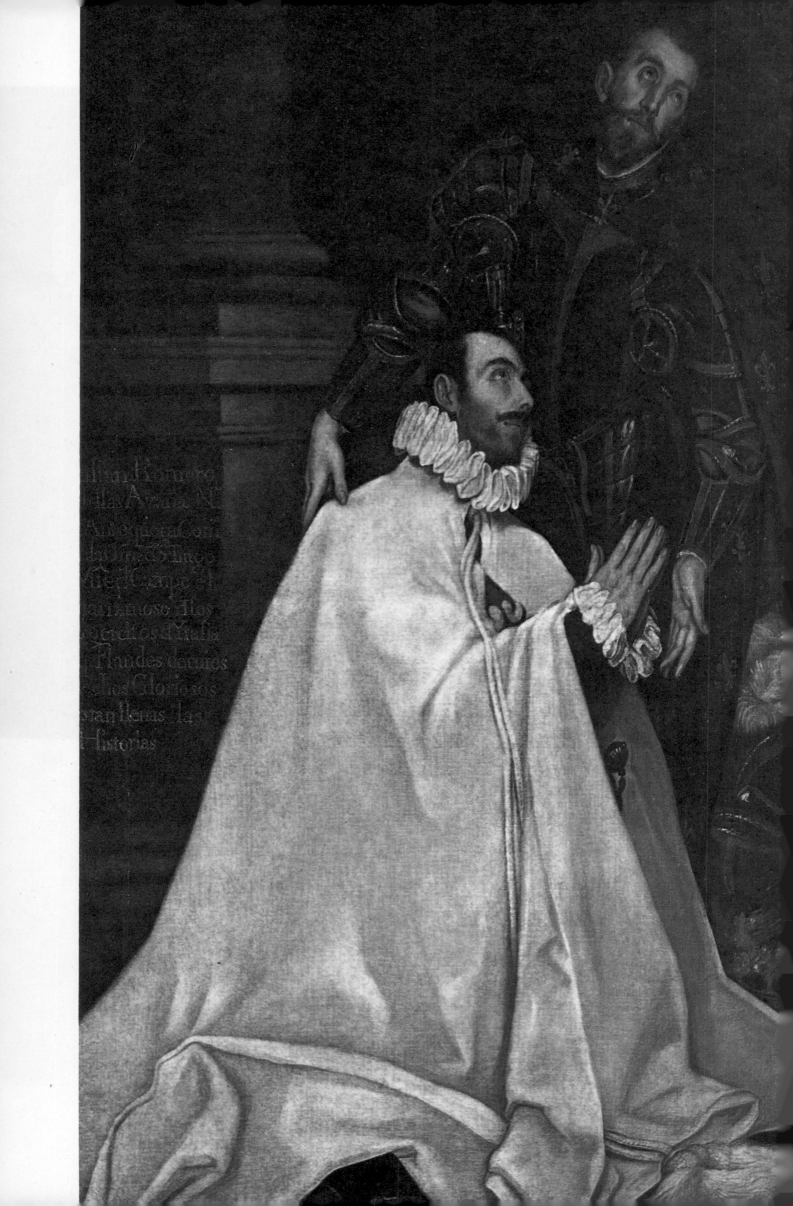

The Spanish Images of El Greco

Spain's first great painter was a genius born in Crete in 1541 when that island was under Venetian rule. His name was Domenico Teotocopulo, but posterity remembers him as El Greco (The Greek).

While still a young man, Domenico went to Venice to study with Titian, and then to Rome where he worked with Tintoretto. Possibly Tintoretto introduced him to the painting of Michelangelo, who had died only six years before. El Greco liked the sculptural quality of Michelangelo's frescoes, but was unimpressed with his use of color.

After a few years in Rome, he traveled to Spain, where Felipe II was preparing to decorate the recently completed palace-monastery at El Escorial. El Greco knew the Spanish king was a great admirer of Titian, who had been court painter to Felipe's father, and he sent the monarch a picture in the "Italian manner," all soft gold and amber. Felipe was so pleased that he commissioned a large canvas for a chapel in El Escorial. The second picture, done in harsh blues and yellows, so upset the king that he had it removed to a less conspicuous spot. This effectively crushed Domenico's hopes of becoming a court painter.

El Greco settled in Toledo, and shortly thereafter Doña Jerónima de las Cuevas bore his son. The painter found an invigorating intellectual milieu in Toledo. He associated with clerics, jurists, bards—including a baroque poet from Córdoba named Góngora—writers and freethinking humanists. He even acted as an interpreter for the Inquisition, in an effort to help accused members of the small Greek colony in the city.

Domenico spent most of his time working profitably and continuously. He drew, painted, and even tried his hand at sculpture, the last without much success. El Greco produced landscapes like his famous "View of Toledo," penetrating portraits such

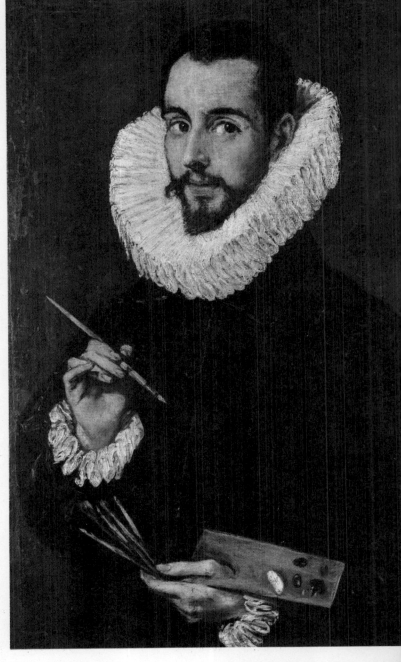

El Greco's bastard son Jorge, whose mother was a young Toledo woman named Jerónima de las Cuevas, was also a painter.

as the one of the Grand Inquisitor Cardinal Don Fernando Niño de Guevara, and mystical visions which paralleled those of his writing contemporaries Saint Teresa and Saint John. In seeking to depict the union of the soul with heaven he sometimes followed the Spanish tradition of bringing heavenly figures down to earth, as in his famous painting "The Burial of Count Orgaz." But more often his elongated, spiraling bodies soared to heaven. El Greco was particularly deft at bringing his portrait subjects to life through their expressive eyes and hands. The 20th-century poet-philosopher Miguel de Unamuno called them "winged hands."

El Greco painted Julián Romero kneeling before his patron saint, Louis of France—portrait of an ideal Spanish hidalgo.

Saint Teresa de Jesús

Under Charles V and Felipe II Spain bore the brunt of Catholic Europe's defense against the inroads of reform-bent Protestants. Spaniards were well aware of the need for reform within the church; years before Luther, Cardinal Jiménez de Cisneros had undertaken to make drastic changes in the practices of the religious orders in the Iberian peninsula. At the Council of Trent, called to reaffirm Catholic dogma, to deal with the Protestant threat, and to initiate Catholicism's own reform, the words and deeds of two Spanish religious figures exerted great influence—Saint Ignatius of Loyola (see page 180) and Santa Teresa de Jesús.

Teresa was born in Ávila in 1515. As a child, she had read avidly the stories of the Christian martyrs. At 18 she left home and entered a Carmelite convent. One day, as she entered the oratory, she was struck by the figure of a wounded Christ being readied for a procession. Bursting into tears, she fell at the feet of the figure and, as she recounted, "felt every worldly emotion die within myself." She went into an ecstatic trance during which she had visions which were to recur often afterward, and the sisters of the convent believed her to be possessed by the devil. Teresa appealed to her confessor and was put under a course of discipline. Thus occupied, another trance came upon her wherein she heard a voice tell her she was not to have any further dialogue with men, but only with angels.

In an autobiography and in several other books she wrote on the subject of mystical experience, Teresa described in simple but powerful language the union of the soul with its heavenly bridegroom: "like two candlelights merging." Or, looking forward to the final reunion with her Creator: *"Me muero porque no muero"* (I am dying to die). At a time when Spanish literature had entered the mundane, realistic world of the picaresque novel—exemplified by Diego Hurtado de Mendoza's *Lazarillo de Tormes* and Mateo Alemán's *Guzmán de Alfarache*—Teresa lifted the soul to new planes of superrealism. In this task she was superbly aided by the works of her protégé, the great lyric poet Saint John of the Cross (San Juan de la Cruz).

Notwithstanding the mystical flights of her mind, Teresa was a woman with feet firmly planted on the ground. On seeing the Protestant "heresy" advance in Europe, the Castilian nun reflected on her own impressions of the order of Carmelites and came to the conclusion that the woes of the Catholic church were caused by relaxation of discipline. Her views were opposed strongly by the prioress of the convent. Teresa secretly founded a reformed order which she called the *Descalzas* (barefoot) to contrast with the relaxed parent body, the *Calzadas* (shod). Her nuns did not actually go barefoot; they wore rope sandals. But they slept on a pile of straw, ate no meat, remained strictly cloistered, and lived on alms, their order having no regular endowment.

What Teresa did for the Carmelite nuns, Saint John of the Cross, following her example, did for the friars. Together they founded new orders all over Spain, including two convents at Alba under the patronage of the famous Duke. Their efforts aroused the suspicions and hostility of the older convent, which finally secured a bull from Gregory XIII prohibiting further extension of reformed orders. Teresa fought fiercely for her nuns and was even jailed for two years in Toledo, while Saint John of the Cross was twice kidnaped and imprisoned. Teresa was accused of misconduct and several times denounced to the Inquisition, very likely by zealots who were aware that her grandfather had been a converted Jew. The Inquisition banned one of her books, and she herself was saved only by the intervention of King Felipe II. She died on a tour of the Alba convents on September 29, 1582.

It was said that an odor of violets and a fragrant oil emitted from the place where she was buried. When the tomb was opened months later, her flesh was still uncorrupted. One of her hands, cut off by a fervent monk, was found to work miracles. The order was convinced their founder had been a saint, and, in 1622, the great nun, poetess and writer was canonized by Gregory IV.

Serene St. Teresa, usually portrayed in a state of religious ...tasy, founded the Descalzas (barefoot) order of Carmelite nuns.

Union with Portugal

The union of Portugal with the Spanish empire was perhaps the greatest achievement of Felipe II. The joining of the entire Iberian peninsula under Spanish leadership had long been his aim. In the year 1578 the Portuguese King Sebastian died without issue; Felipe clearly realized that this was an excellent opportunity to try for his objective. Only one serious contender barred his way: Antonio, Prior of Crato, an illegitimate son of King Manuel. But he had neither the resources nor the following of the Spanish king.

The take-over was prefaced by an announcement from Felipe that Portugal would remain a separate political entity with complete autonomy over its internal affairs. The Portuguese Cortes were to retain their authority, and foreigners would not be allowed to hold office. In case the Portuguese might offer resistance, Felipe moved an army, under the Duke of Alba, to the Portuguese border. When the Cortes accepted his kingship, he began to hope he would achieve the union without bloodshed. Even the elderly Cardinal Henry, who acted for a time as regent, was persuaded to favor the candidacy of Felipe for the throne. But some of Antonio's followers resisted, and Felipe found it necessary to use the army. A short battle followed and Antonio's supporters melted away.

Because Felipe kept his word to the Cortes, the annexation was entirely successful. The economic crisis in which Portugal had found herself was solved by the influx of Spanish silver. Merchants and townspeople supported the policies introduced by Felipe. The 25 articles of concession that had been agreed upon between the crown and the Cortes were scrupulously followed. Customs barriers between the two nations were abolished, but Portugal was allowed to keep its own currency.

The navy controlled by the Spanish empire was now the greatest in the world. It held sway over nearly all the fast-growing Christian world outside Europe. Brazil, Asia and Africa could now be opened to trade from Portugal.

Both the Spanish and the Portuguese merchants were quick to take advantage of the new freedom of markets. Goods were landed at Buenos Aires to be transferred to the Rio de la Plata and then carried overland to Peru and Chile. Lisbon and Oporto joined Sevilla and Cádiz as world trading centers from which goods from Holland, England and France were received and transhipped in Portuguese and Spanish vessels to the New World.

But the most profitable enterprise was the revival of the *asientos,* or licenses, to Portuguese traders to supply Negro slaves for the Spanish settlements. The granting of such licenses had been abandoned, but when the need for agricultural and mine workers became acute in the last quarter of the 16th century, the *asiento* was revived. Licenses were awarded to the Portuguese because they had established a highly efficient slave-procurement system in their African possessions. Later, as the need for *piezas de Indias* (young, healthy Negroes seven hands [*palmos*] tall) continued over the years, such contracts were issued to Dutch, French and English commercial companies.

Possibilities for expansion of trade were endless. If energy and money had not been drained off into profitless wars against the Protestants, the coalition of Spain and Portugal could have brought permanent economic stability to the peninsula.

In bringing Portugal into the empire, Felipe II faced the same problem that had plagued his father: trying to be in two places at the same time. After accepting him, the Portuguese wanted him to remain in Portugal, rule from their country, and make it the center of the empire. The king remained for two years in Lisbon, leaving Cardinal Granvelle, who had served under his father, as head of the government in Spain. As Granvelle's policies fell into disfavor, the king was forced to leave Lisbon and return to Madrid. He left his nephew, Archduke Alberto, as governor.

The union of Spain and Portugal continued for 60 years. It was finally broken in 1640 when the Portuguese revolted and gained independence under the Duke of Braganza, who was proclaimed John IV.

Felipe II completed his conquest of Portugal seizing the Azores in 1582. A great sea fight preceded the landi

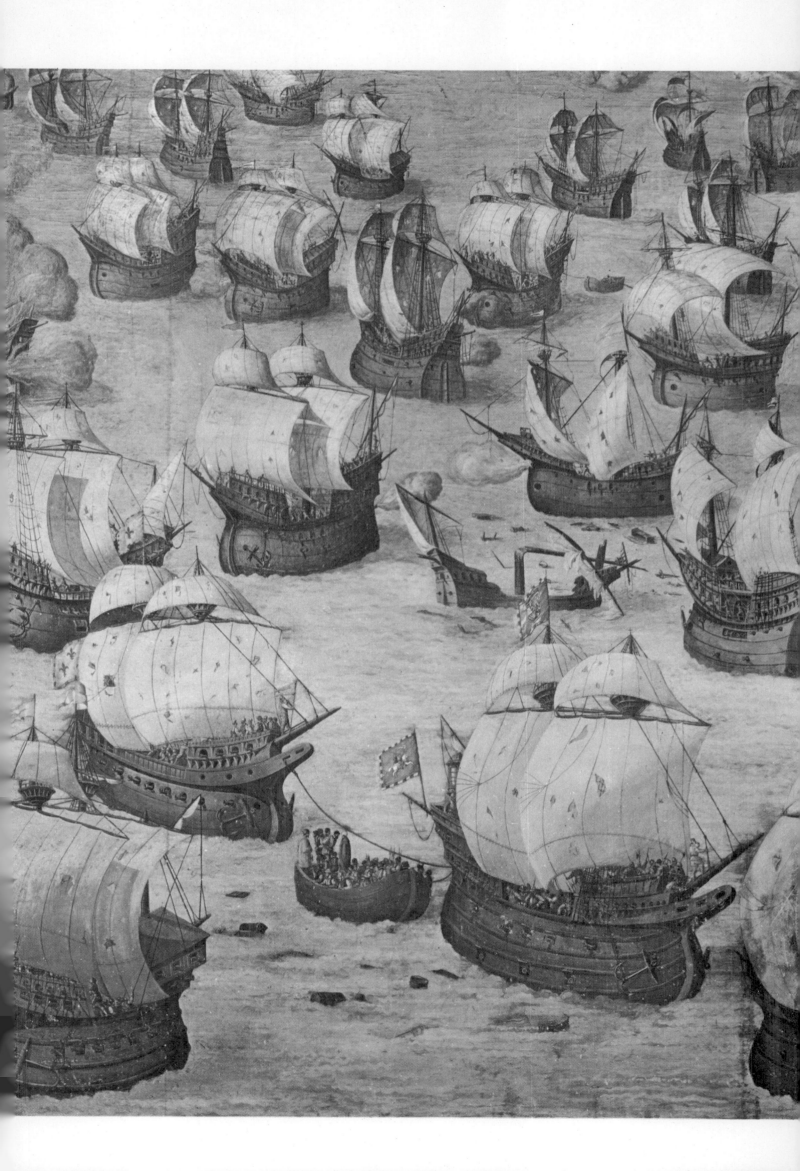

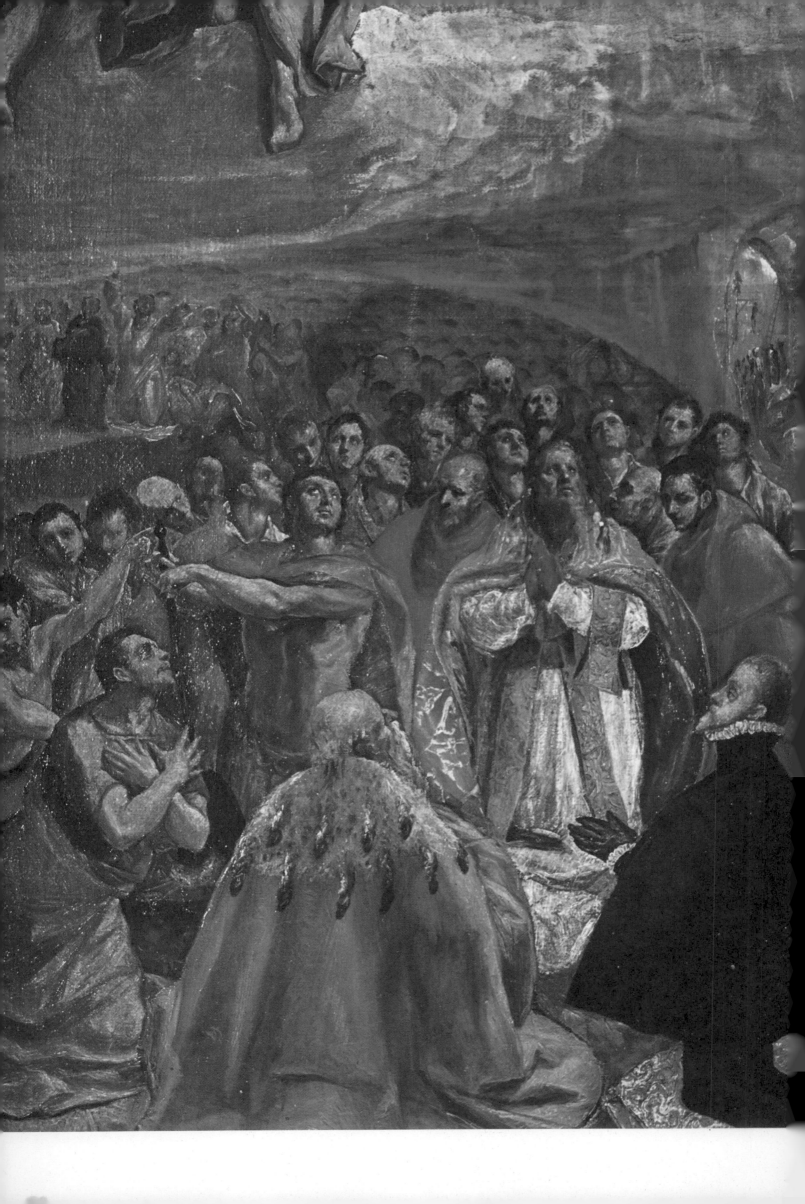

The King Who Lived with Death

Felipe II was always a king, never merely a man. From childhood he was educated in the craft of kingship. As a youth he wrote to his father on behalf of his subjects-to-be, complaining that taxes were so high that the common people were in misery. With his inheritance of the throne came written instructions from his father, which he scrupulously observed: to resist making decisions in anger, to listen to his counselors, never to offend the Inquisition, to see justice done to his subjects, and, above all, to keep God always before him.

As he grew older, his purpose became even more clearly defined. He viewed himself as keeper of the honor and the Christian soul of Europe. In his mind, whenever the church was threatened by heresy, Spain and all of Europe were in grave danger. He was interested in the welfare of his subjects, but in a way that was purely Spanish—their honor and faith were far more important than their physical survival.

He had the medieval kings' concept of justice. Fully convinced that his power and his kingdom came from God, he was compelled, as God's representative, to favor justice for his people. When told that there was some doubt about a decision for or against him at a council, he said, "If there is doubt, the verdict must always be against me." He believed and affirmed that the people were not created for the sake of the prince but the prince for the people.

Wed at age 16 to Maria of Portugal, he became a widower two years later when she died in childbirth, leaving him a mentally unstable heir, Don Carlos. He embarked, at the age of 27, upon a loveless union of political convenience with Mary I of England, in compliance with his father's wish. Their barren marriage lasted only four years. At the

Black-gowned Felipe II prays in a detail from El Greco painting. King first rejected, then came to enjoy artist's work.

age of 32 he married Elizabeth of Valois, eld
daughter of the King of France. She bore him t
daughters, Isabel Clara Eugenia and Catalina. T
was the happiest time of his life. He became a d
voted father and husband, and took great joy in t
limited family life that his busy schedule allow
him. But, after less than ten years of marriage,
beloved Elizabeth died. He was again a widow
his only son, Don Carlos, was dead, and there
no male heir to the throne of Spain. Two ye
later, at 43, he married his cousin, Anne of Austr
She bore him five children; four died in childho
Only Felipe III survived as heir to the throne. An

Despite dropsy and gout, Felipe II ruled actively
until his death in 1598, soon after this portrait was finished.

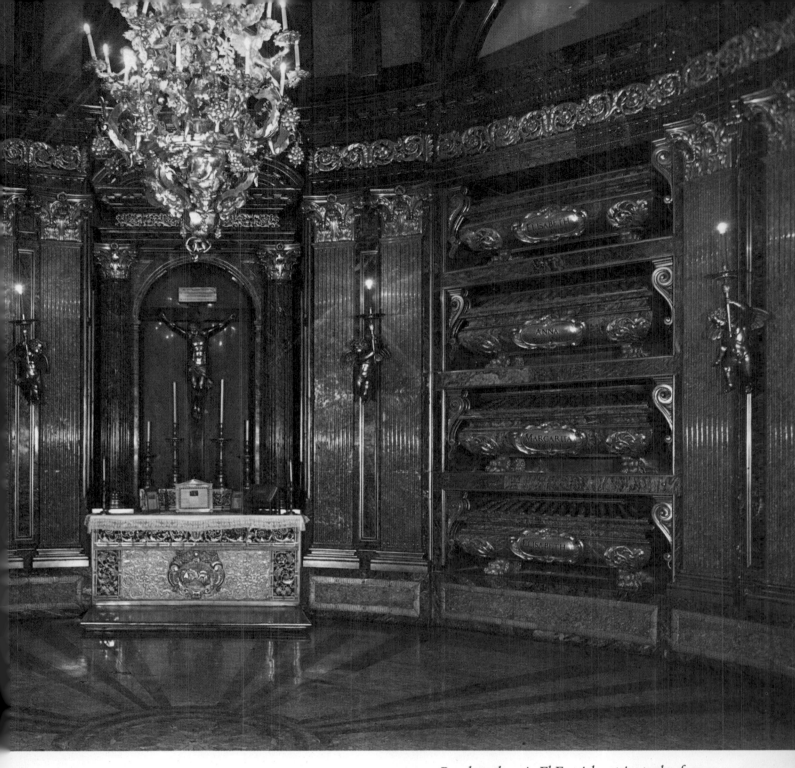

*Royal pantheon in El Escorial contains tombs of many
Spanish kings and queens, and still has room for future monarchs.*

oo, died after ten years of marriage, and, at 53,
elipe became a widower for the fourth time.

For the next eighteen years, he lived alone with
is two affectionate daughters. Prince Felipe grew
p in his father's shadow. While he was still young,
is father showed solicitude and concern, but later
here was little rapport between them.

Felipe II strove for tranquility, but his mental
nergy made inaction difficult. As he grew older,
e became aloof from the world and withdrew
ore and more to the cold, severe yet magnificent
scorial. There he liked to stroll through miles of
orridors and look out into the vivid sunshine from

hundreds of doors; he spent hours in his spacious
and well-stocked library, or in viewing his collec-
tion of fine Spanish and Italian paintings. His plain
apartment contained one large room with two win-
dows, which he used as an office, and a smaller
adjoining room—little more than a cell—within
which was a canopied bed, a commode, a few small
religious paintings and a crucifix.

During his last years he became deeply pre-
occupied with death. He spent hours kneeling in
quiet meditation. Like the saints, he lived an austere,
solitary life. Work became his main activity. For
Felipe hoped to leave Spain a heritage—not that of

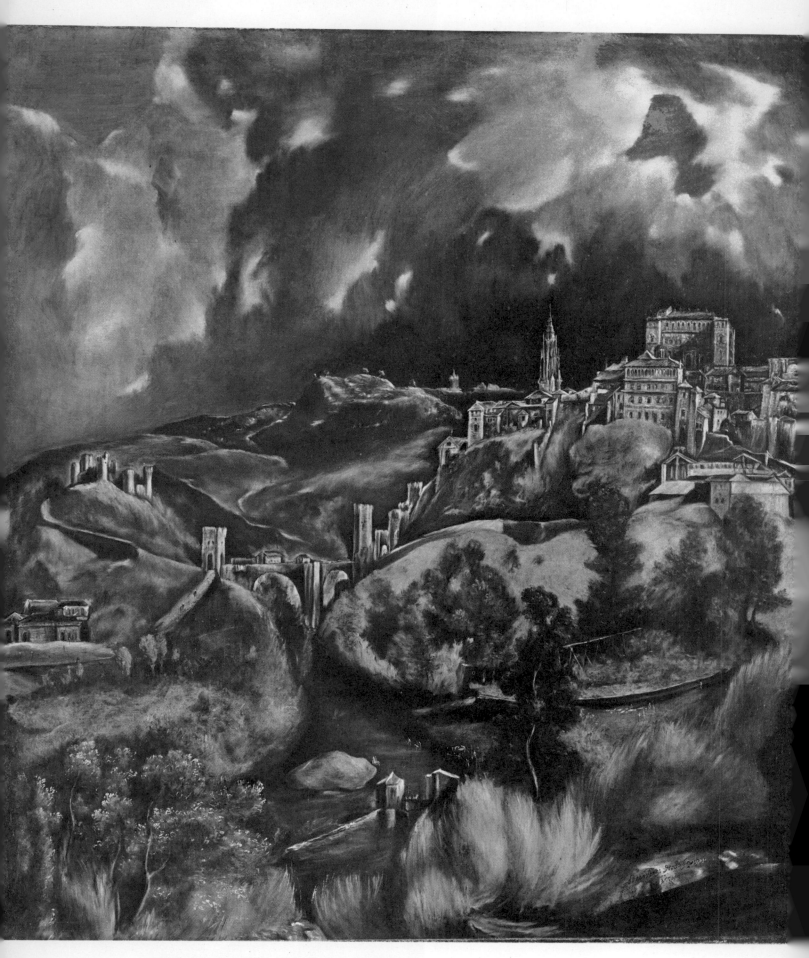

One of the greatest of all Spanish paintings is El Greco's
"View of Toledo." It is also one of the first true landscapes.

his son, in whom he had little confidence, but a working empire with a future.

With this in mind, he tried in those last years to establish order as best he could. In their last adventure against France, Spanish forces had occupied Paris to bar Henry of Navarre, then a Protestant, from the throne of France; they attempted to place Felipe's elder daughter, Isabel Clara Eugenia, on the throne instead. But Henry was converted to Catholicism and was confirmed as King Henry IV. Felipe revoked his declaration of war against France. The resulting Treaty of Vervins, establishing peace between the two countries, was signed only five months before Felipe's death.

At the same time, Felipe endeavored to solve the knotty problem of the Low Countries by giving them a semiautonomous status. He installed his nephew Alberto, who had married Isabel Clara Eugenia, as ruler. The Low Countries were finally separated from Spain, on condition that they revert to Spain should there be no heir.

The Spanish monarch succeeded in solving the political-agricultural problem which had given rise to a rebellion in Aragón. Large estates encompassing hundreds of towns and thousands of peasants were acquired by the crown from independent feudalistic landlords. Some of the *fueros* (traditional privileges) of the Aragonese nobility were curtailed, but the vast majority of the citizens benefited.

Felipe outlived all the eminent men who had served him: Cardinal Antoine Perrenot de Granvelle, Don Juan of Austria, the Duke of Alba and Alessandro Farnese, all of whom had loyally led his armies in the Netherlands and France. They served him well but he mistrusted them because of their power and large following. History and his father had taught him that a strong aristocracy could endanger the crown as well as its subjects.

His last days were spent in great pain from gout, asthma and an ulcerated skin. He did not complain; he worked up to the end, which came on September 13, 1598. Just seven days earlier, an immense new country had been added to his empire. One hundred and thirty Spanish families, traveling in 83 wagons and driving 7,000 head of cattle, had crossed the Rio Grande into "New Mexico." They laid claim to the new land and began its colonization. Within the next century this new conquest would expand to include all the land west of the Mississippi River and northward to California.

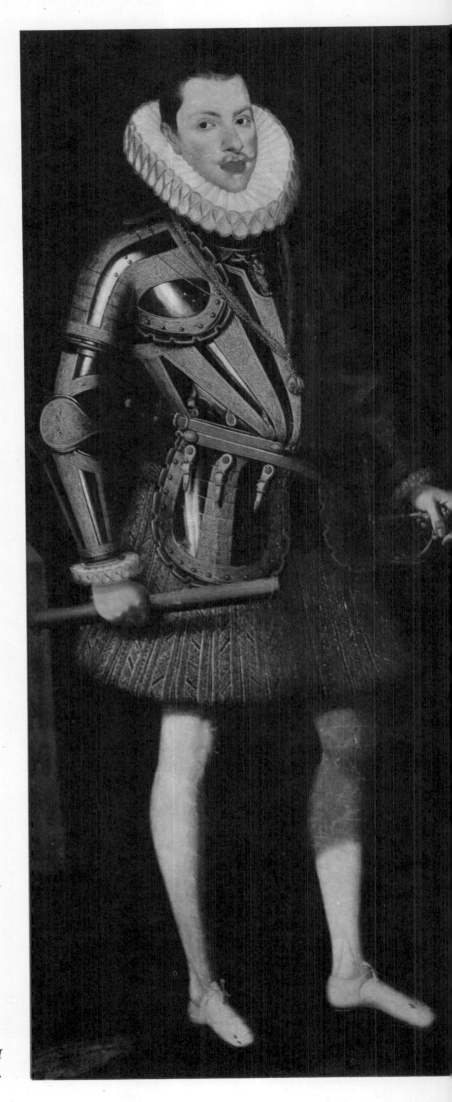

A weak king compared with his father, Felipe II; Felipe III was interested in science and invited Galileo to visit Spain.

Don Quixote
and Sancho Panza

The early 17th century was greatly enlivened by two fictional characters: Don Quixote and Sancho Panza. They were the creation of Miguel de Cervantes Saavedra, and appeared in the most widely read novel in the world.

The characteristics of the noble knight, Don Quixote de la Mancha, and his peasant squire, Sancho Panza, have been considered a composite image of the Spanish personality: the first, idealistic, temperamental, reckless; the second, stolid, practical, distrustful. But this is a restricted view. The contrast between the two brought forth an image of man that is not simply Spanish but universal.

Cervantes knew that man must seek beauty, truth and justice. He knew, too, that man must have his Dulcinea—represented in the book by various women, including some who are immoral, selfish or ugly. Yet when treated with respect and affection, Dulcinea conforms to man's image of her.

In the plot, an aging writer of little means goes mad from reading the tales of chivalry which were then so much in vogue. Believing himself to be a knight on a mission to correct the evils of the world, he takes his rusty lance, shield and broken helmet and, mounting his ungainly horse, Rocinante, goes out into the world. After a series of disastrous adventures, he returns to his village. Recovered from his wounds (but just as mad as before), he convinces his peasant friend, Sancho Panza, to travel with him on a series of new adventures.

After a lengthy sequence of encounters with mule skinners, peasants, trollops and windmills—which the mad knight believes are enemy knights, magicians, ladies in distress and giants—he finally becomes disillusioned, returns to his village and dies.

These are the bare bones upon which Cervantes creates his image of a man who, living by his illusions, ruins himself bodily but perhaps saves himself spiritually. The book poses a series of questions: Is it madness to be noble and high-minded? Was there ever any such thing as chivalry? If Don Quixote is a madman with his head in the stars, is Sancho, with his feet on the ground, entirely sane?

It is easy to separate the man Cervantes from his hero Don Quixote. Although the writer's experience may have led toward the ideas expressed in the novel, they are so transmuted as to become universal rather than personal experiences. He knew his characters so well from life that he could replace his own rich adventures with more revealing ones.

Some have said that Cervantes intended his book to be a parable of the political and social age in which he lived, and it is possible to read such meaning into it—for the wars, truces and victories of his day were illusory. At the time Cervantes wrote, the reality was extreme poverty and national bankruptcy. His own life was a mixture of grinding poverty and high adventure. As a youth he fought an illegal duel and, to escape punishment, journeyed to Italy, where he became a soldier. He lost the use of his left hand while serving heroically on Don Juan of Austria's ship, the Marquesa, at the battle of Lepanto. Sailing from Italy to Spain he was captured by the Moslems. He tried to escape many times—in the course of which he became a hero to other captive Christians—before he was ransomed and returned to Spain at age 33. His daughter Isabel was born of an affair with an actress; and he married another actress. He worked gathering supplies for the Armada, and then as a tax collector. Accused of misappropriation of funds, he was imprisoned in the Sevilla jail. Later he had some success as a playwright, but the competition of the young and talented Lope de Vega drove him from the theater.

Cervantes' first real literary success was *Don Quixote de la Mancha,* which he started when he was 56 years old and finished when he was 58. It became the most widely read book in Spain, and even in the New World; it brought him fame but little money. Ten years later, in 1615, the second part of *Don Quixote* appeared and duplicated the success of the first volume. Cervantes died a year later, on April 23, 1616, the same day that Shakespeare died in England.

When this portrait was painted (in 1600), Miguel de Cervante was only a minor author. Five years later Don Quixote appeared

D. Miguel de Ceruantes Saauedra

Iuan de Iauregui Pinxit año 1600.

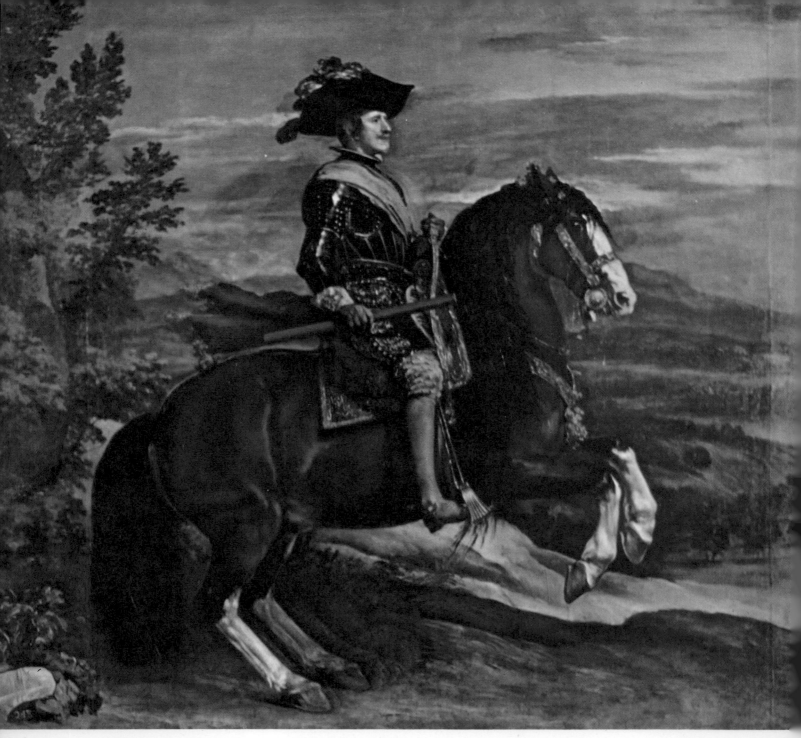

*Velázquez' painting of Felipe IV on horseback shows signs
of revision to provide a more plausible balance for the horse.*

Decline of the
Spanish Empire

A period of 50 years—from 1600 to 1650—marked
the high plateau in Spain's golden age of literature,
painting, sculpture, architecture, poetry and music.
During these years the political power of the Haps-
burg kings declined while that of France, England

and Holland increased. But no other countr
generated as much creative genius.

The beginning of the century was marked by th
emergence of the Spanish theater. From its cruc
beginnings in the works of the actor-writer Lop
de Rueda, it grew into brilliant maturity as th
vitality and ingenuity of Miguel de Cervantes, Lop
de Vega, Tirso de Molina and Pedro Calderón de
Barca chronicled the events and sentiments of th
times. While the easily led Felipe III allowed h
favorite, the Duke of Lerma (and his corrupt asso
ciates), to rule the kingdom, Lope de Vega wro
play after play mirroring the three great themes
the age: war, religion and love. Interwoven in the

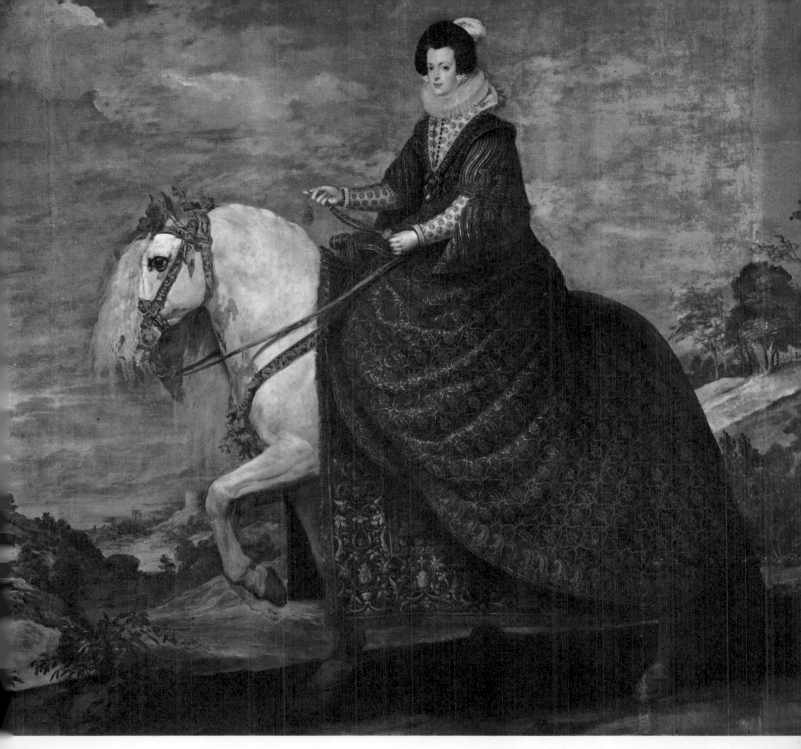

*Matching portrait of Felipe IV's wife, Doña Isabel,
emphasizes the luxurious drapery of her gold-embroidered skirt.*

emes was a constant thread of intrigue. Lope took
s characters from the court and the Cortes and the
bility, from the departing and returning colo-
sts, the galley slaves, the feudal lords and their
bjects. The romance and reality of war were fa-
liar to him, for he had sailed in the *Armada In-
ncible* and his brother had been killed beside him.

Most often Lope de Vega wrote of love, a sub-
t he knew well. After an affair with a married
oman (who left him), he wrote scandalous verses
d was forced to exile in Italy. Upon returning to
ain he became happily involved with a wife and
mistress, and had a son by each within the same
ar. Even after entering the priesthood, in his 50s,

he fathered two children by Marta de Nevares San-
toyo. His experiences made him sympathetic in his
treatment of women. Their character, individuality
and wit come through clearly in his plays.

Never was there so prolific a playwright; he
wrote 2,000 plays. His primary fame rests upon his
fertile imagination. He created no lasting characters
nor did his plays contain an overall philosophy. At a
time when the king and the court preferred enter-
tainment to participation in world affairs, Lope
helped fill that need. He was always entertaining,
rarely profound.

It remained for a contemporary of his to give
life to the third great character in Spanish literature

(Cervantes had introduced Don Quixote and Sancho Panza). A Mercedarian friar, Gabriel Téllez, under the pseudonym of Tirso de Molina, created Don Juan—the embodiment of Spanish honor and daring, the symbol of masculinity and, like Sancho and Don Quixote, a universal personality.

In his play *El Burlador de Sevilla* (The Deceiver of Sevilla), Tirso de Molina did not present Don Juan as a great lover, but rather as a monumental joker. Later versions have made him more appealing, but in the original play he was cast as a practical joker who considered the seduction of women the supreme jest. It was a time when women were secluded, when their fathers and brothers conspired to keep them away from the wiles of men. A true battle between the sexes was being waged. If the woman triumphed, she won marriage and children. If the man was the victor, he got away with sexual satisfaction without responsibility. Don Juan fought the battle of the sexes like a diplomat and a soldier, and, up until the end of the play, he won.

The story is that of a young nobleman who tricks and seduces a duchess. Forced to flee, he is shipwrecked. He comes under the care of a young fisherwoman whom he promptly seduces by promising marriage. Deserting her, he proceeds to Sevilla,

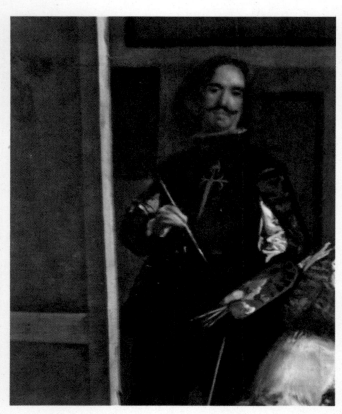

Velázquez inserted this self-portrait in picture painted when he was 57. Cross of Order of Santiago was added after his death.

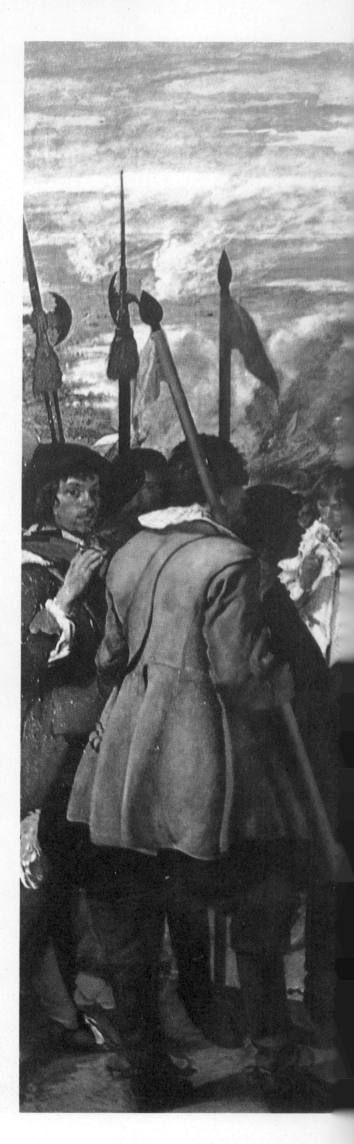

Eight years after event, Velázquez depicted this dramatic version of the Dutch surrender of Breda to the Spanish.

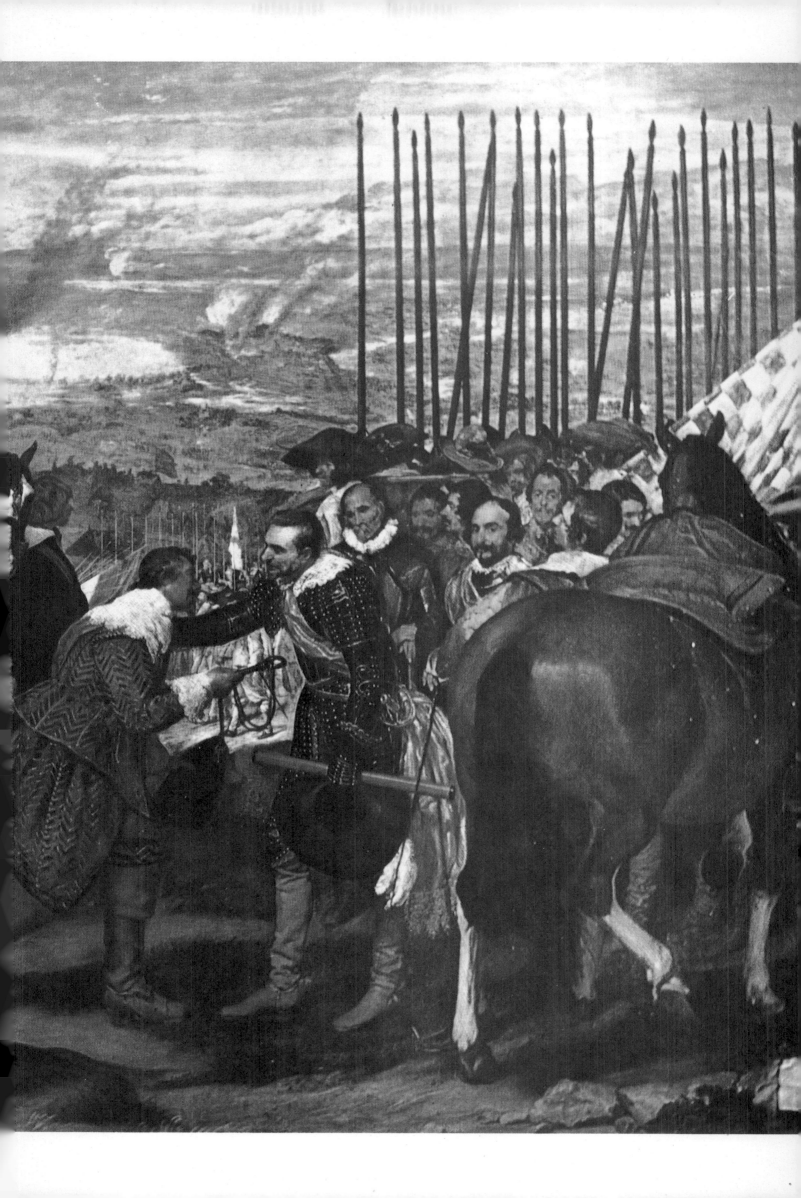

where he compromises another girl. Surprised by her father, the Commander of the Order of Calatrava, Don Juan kills him. He now escapes to a nearby village, where he ingratiates himself at the wedding of a peasant girl. By intimating to the bridegroom that he has already enjoyed the favors of the bride, he forces him to abandon her. Don Juan proceeds to replace him on the wedding night. Forsaking his new conquest, he returns to Sevilla. In the magnificent cathedral, he comes upon the tomb of the man he has killed. With his usual daring, Don Juan tweaks the beard of the statue on the tomb and jokingly invites it to eat with him. That evening the ghost of the Commander dines with Don Juan. As the ghost takes his leave, he invites, or dares, Don Juan to join him for dinner

the next evening at his tomb. Don Juan's sense honor will not allow him to refuse, so he goes the cathedral and dines on the food of the dead wi the ghost of his victim. At the end of the repast, t specter gives him the final dare: he asks him to ta his hand. When Don Juan accepts the challenge, t fires of hell envelop him.

It is a crude but powerful tragedy, the story this practical joker on whom death plays the la joke. But it is also a play that reveals much abo Spanish concepts of honor.

It was the national sense of honor that made t Spain of Felipe IV (who succeeded the we Felipe III in Tirso de Molina's time) continue t wars against the Protestants. While King Felipe hunted, read, wrote poetry and collected paint

The Governor of Cádiz (seated) gives orders for the defense of his city in 1625. The British attackers were badly beaten.

At the command of Felipe IV, Velázquez painted Zaragoza as it looked when the royal party went there in 1648.

and paintings, his favorite (El Privado), Gaspar de Guzmán, Count of Olivares and Duke of Sanlúcar, tried to reorganize the empire. But he fought a losing battle against increased taxation. Of additional concern was the slow drying up of the flow of gold and silver from the New World as a result of piracy and a lack of slave power to work the mines. Nevertheless, his major problem was the increasing commercial warfare waged by the Dutch traders. Continuing economic problems brought an ever-present fear of starvation to the people of Spain. Hunger was a recurring theme in the popular picaresque novels of the day.

The Count-Duke looked back at the reforms that had been recommended on the succession of Felipe III. Now he hoped to put them into practice.

Unfortunately, the resumption of the war against the Netherlands delayed his program. He began by cutting down on pensions, on the number of municipal offices and on the import of foreign goods. Legislation was passed prohibiting brothels, and an effort was made to control the extravagance in the dress of the nobility. The ruff, so prevalent during the reign of Felipe II, was banned. A national bank was envisioned that would extricate the economy from the hands of the foreign bankers. The abolition of the *millones* (taxes on such essentials as meat, sugar, flour) was considered. But not even the energy and ability of the Count-Duke of Olivares could compete with the lethargy of the nobility and the ever increasing expenditures for war. None of the reforms were successfully adopted.

Don Fernando, brother of Felipe IV, was both a cardinal (he received his hat at the age of 10) and Governor of Flanders.

The golden age of literature and art did not lag while the Count-Duke and his ministers struggled to bring about a greater prosperity. Lope de Vega had made the theater popular. Tirso de Molina had created one of its greatest characters. Now Pedro Calderón de la Barca, a playwright of towering talent, made it important. The structure of his plays was more formal, his plots more carefully constructed, than those of Lope de Vega. His themes were often taken from religious motifs and cast in the form of allegories. The Catholicism of his time was implicit in his work. Calderón based one of his most famous plays, *La Vida es Sueño* (Life Is a Dream), on the futility of earthly riches, and he reemphasized the soul. He reflected a rigid code of morality based upon entirely different standards for men and women. Women in his plays were mere possessions; plots were the variety of challenges to male honor.

What Lope de Vega, Tirso de Molina and Calderón de la Barca did for literature, Velázquez, Zurbarán, Murillo, Ribera and Cano did to bring Spanish painting to its greatest glory.

Diego Rodriguez de Silva y Velázquez, the greatest Spanish painter of his time, spent his life in the service of Felipe IV. Unlike other painters, playwrights and poets of his day, he was never touched by scandal nor was his a difficult or violent existence. Through a friend in his native city of Sevilla he met the Count-Duke of Olivares, who introduced him to the 18-year-old king. Felipe IV was as interested in art as he was in literature. The young painter soon began a series of court portraits, which achieved almost immediate success.

The year Velázquez painted his first picture of Felipe IV, the Count-Duke of Olivares presented to the king a memorandum which revealed a great deal about conditions in Spain and in the empire. In it he noted that Aragón, Portugal, the New World and the Netherlands had certain grievances, partly because of taxation, but also because they were rarely in contact with their king. He wanted the laws of the various kingdoms within the Spanish empire modified so that a single set of laws, based on those of Castilla, could prevail. Olivares meant well, and it is possible that had he been successful in welding together the Spanish kingdoms into a united government with a single purpose, Spain might have been able to deal with the forces of England, France and Holland.

Velázquez painted the leading characters of the

Prince Baltasar Carlos, son of Felipe IV, stoutly poses for Velázquez with his small gun and two dogs.

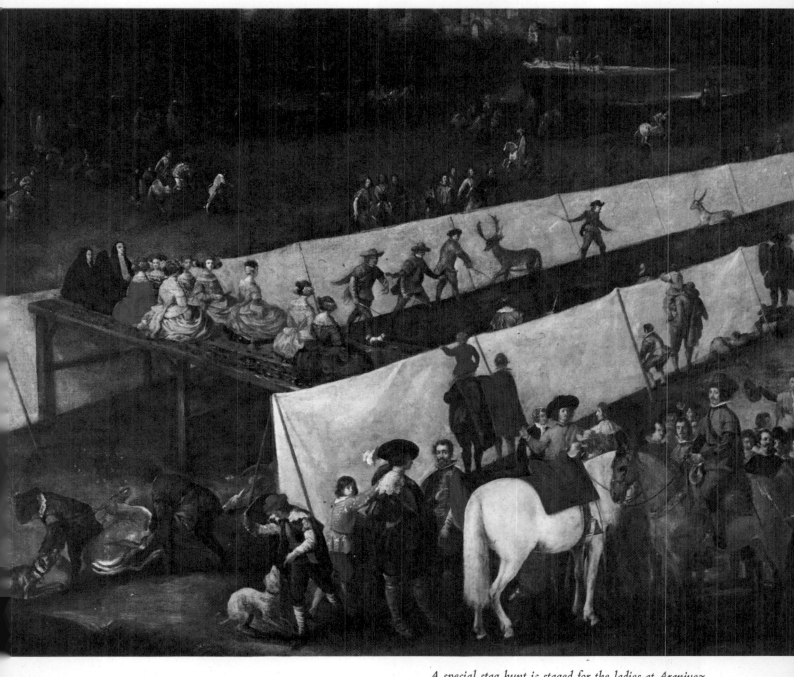

A special stag hunt is staged for the ladies at Aranjuez.
Driven down corridor, beasts are slaughtered beneath platform.

urt during the dramatic events of the period of
sengagement, as Spain lost, one by one, her Euro-
an possessions. Huge canvases, almost life-size,
vealed the king, his queen, Doña Isabel of France,
d the Count-Duke mounted upon spirited horses.
he 6-year-old prince, Baltasar Carlos, posed in
nting costume. A few years later Velázquez im-
rtalized him riding his pony. The painter accom-
nied the royal party on a tragic visit to Zaragoza,
ere the prince contracted smallpox and died a
v days before his 16th birthday.

After the death of his French-born queen, Felipe
rried Mariana, the 15-year-old daughter of his
er, who had been affianced to Prince Baltasar

Carlos. Diego painted the beautiful young queen.

But he was not a typical "court painter." As
chamberlain he had an independent income and
could paint as he pleased. His prodigious output in-
cluded religious paintings, landscapes, and one fe-
male nude—a rarity in his time.

Among Velázquez' best-known paintings are
"Las Hilenderas" (The Spinners) and "Las Meninas"
(Maids of Honor). "Las Meninas" is thought to
have been spontaneously composed by the artist
when the Infanta, her royal playmates and their
dwarfs burst into the studio while the painter was
working on a portrait of their majesties. It reveals
the artist as a sensitive analyst of human nature as

Zurbarán's "The Child Virgin in Ecstasy," painted about 1630, uses a little Spanish girl in contemporary dress as a model.

"Las Meninas," showing Philip IV and wife sitting for Ve̶ quez as children dash in with dwarfs, may be artist's finest w̶

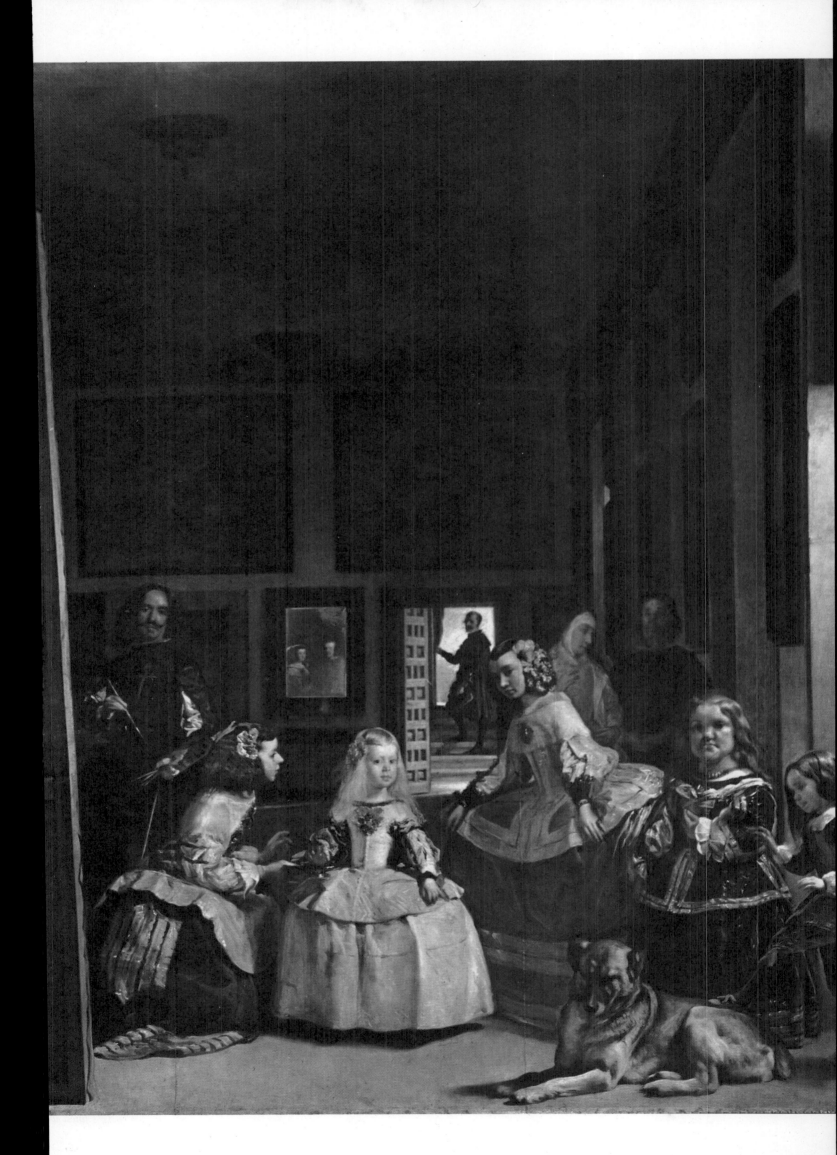

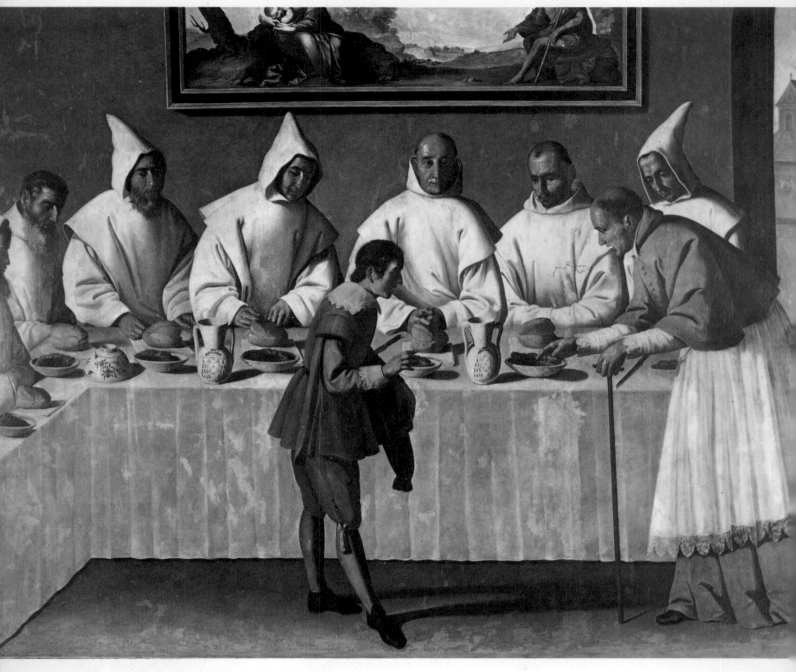

*Zurbarán, a skilled painter much admired by Velázquez,
preferred religious subjects like this "Miracle of St. Hugo."*

well as an exceptional painter of light reflection and spatial relationships.

In addition to playwrights, painters and poets, Spain's golden age produced musicians of world-wide repute, such as Cristobal de Morales and Tomás Luis de Victoria, both great polyphonists and outstanding composers of masses and motets. Antonio de Cabezón and Francisco Salinas wrote and played superb organ music.

Spanish art and literature extended Spanish culture throughout Europe; but the French were far more effective politically under their preeminent strategist Cardinal Richelieu. After arranging al-

liances with the United Provinces and England Richelieu and Louis XIII declared war on Spain Spain enjoyed some early success when the Prince Cardinal Don Fernando, brother of Felipe IV, invaded France from Flanders; but this was followed by the cutting of the supply route from Italy to the Netherlands by the allies and by the Battle of the Downs, in which the new Spanish navy was beaten.

Trying to find money to pursue the war, Olivares put tax pressure on Cataluña and Portugal The Catalans rebelled, and Richelieu was only too happy to provide French protection.

As though the rebellion in Cataluña and the w

against France and England were not enough, a new disaster struck the beleaguered government. Taking advantage of the absence of Portuguese-Spanish troops, which had been moved to Cataluña, the Portuguese, possibly assisted by French money, started an uprising. The acting regent, Princess Margaret, was sent to Spain, the agent of Olivares was executed and the Duke of Braganza, a descendant of Emanuel II, became King João IV. After only o years of unity, the peninsula was again divided.

Fortunately, Valencia and Aragón did not join in the Cataluña revolution, or the peninsula might have been split into three parts. The French had given full military support to the revolution, and the final blows came when the Spanish army was defeated at Montjuich, the fortress hill that overlooks Barcelona, and again at Rocroi.

The peace with France was preceded by a final settlement with the Dutch. After three-quarters of a century of conflict, Spain recognized the independence of the United Provinces.

In Cataluña, peasant, landowner, noble and commoner found no meeting ground under French protection. As the country drifted toward civil war and anarchy, a renewed Spanish army led by Don Juan José of Austria besieged and took Barcelona. A general amnesty was offered and accepted. The king swore to uphold the old laws and liberties. The kingdoms that had been united by Fernando and Isabel came together again.

The peace of the Pyrenees was signed with France in 1659. Velázquez, as chamberlain to the Spanish king, decorated the pavilion in which the meetings were held. France was generous in taking from Spain only Rosellón and part of Cerdaña. The marriage of Felipe's daughter, María Luisa, to Louis XIV was arranged. Spain promised a huge dowry and María Luisa relinquished her claim to the Spanish throne. Neither pledge was kept.

With her European empire gone, Spain might have concentrated on rebuilding her home economy—but she did not. Her hope of a reunited peninsula was too powerful. War with Portugal was resumed; bankruptcy, defeat and the death of Felipe IV followed. His successor, Carlos II, grew up to be a sickly and ineffectual king. Now the French, English, Dutch and Austrians all began campaigns aimed at the dissection of Spain.

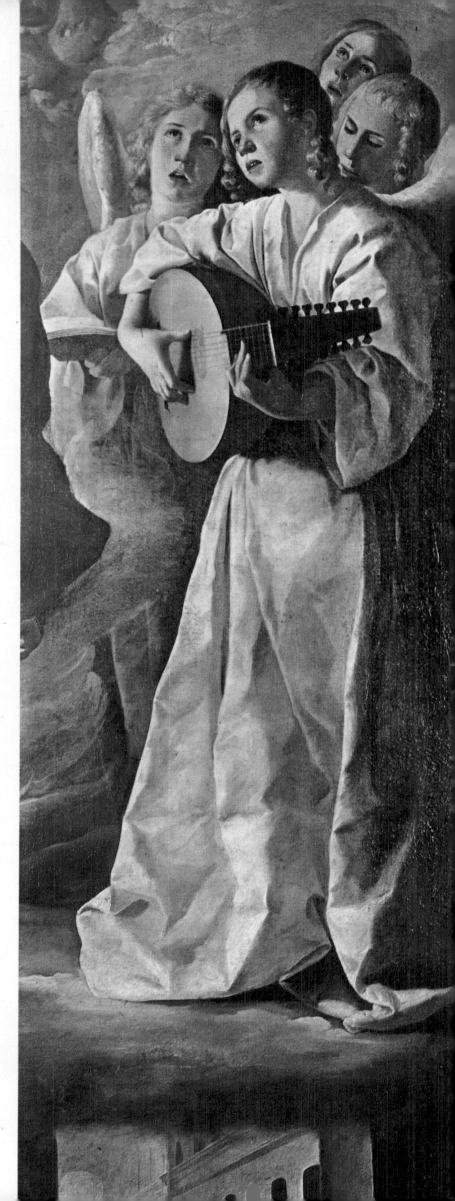

In Spain even angels—as in detail of a work by Zurbarán—played the lute. Instrument later developed into the guitar.

*Smoke of battle dramatically obscures
the sky as cavalry troops execute an ambush in a mountain pass.*

*By mid–17th century, Spain's military heyday in Europe
was ending. Troops straggle away from siege of Aire–sur–la–Lys.*

213

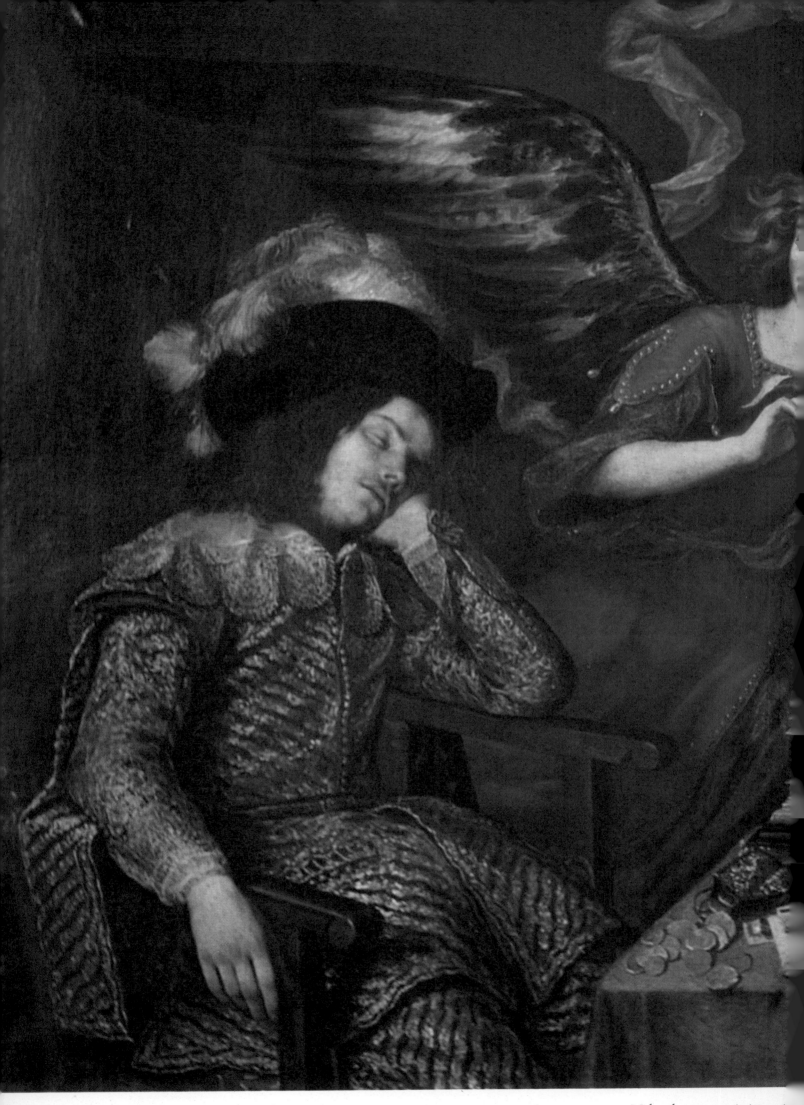

Mid–17th-century painting enti
"Sueño del Caballero" (The Soldier's Dream) allegorizes

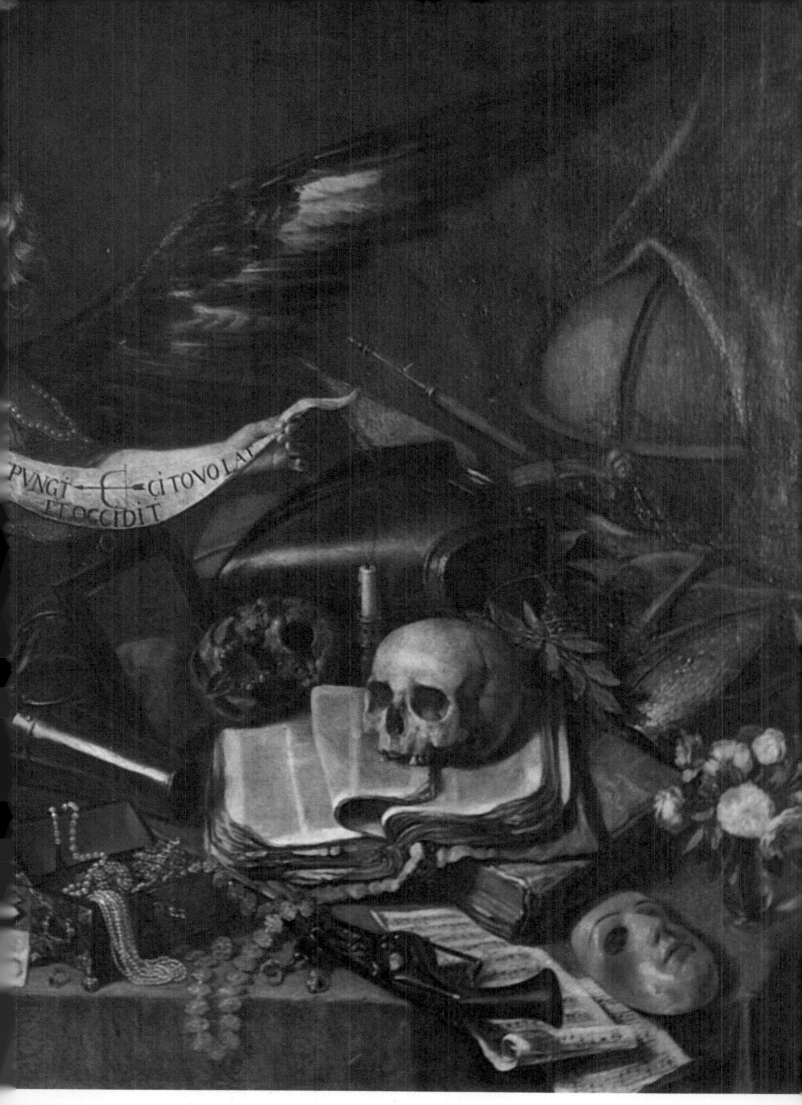

lings of despair and fatalism that swept over Spain as its
pire began to crumble. Heroism is replaced by visions of death.

*The last—and weakest—of the Hapsburg line
to rule Spain was epileptic Carlos II, called "The Bewitched."*

The Last of the Hapsburgs

The Hapsburg legacy to Carlos II was a body and mind both weak and disordered, and a country prostrate before its enemies. Five generations of inbreeding had made the prominent Hapsburg jaw grotesque. Epileptic fits racked his disease-prone body. Superstitious court followers called him Carlos the Bewitched.

But in his short life, Carlos was bedeviled by human greed rather than by supernatural forces. Austrian, English, Dutch and French interests fought over his heritage. His marriage to a French princess was arranged so France might claim an heir, but the queen died barren. A second marriage, to an Austrian princess, was consummated to no avail. Plots to dismember Spain followed. Rather than see Spain fragmented—a threat posed by the coalition of England, Holland and Austria—Carlos defied his Austrian wife and willed his throne to the Bourbon prince, Philip of Anjou.

A time of frequent humiliation and privation. The throne passes to the French house of Bourbon, as Spain loses many of her possessions and her position as a leading power in Europe. The French influence is predominant everywhere in Spain and Spanish America. Economic, administrative and educational reforms are initiated under the rule of enlightened despotism. Far above the generally average and imitative artistic expression towers the awesome genius of Francisco de Goya.

HISTORICAL CHRONOLOGY		ART CHRONOLOGY	
1701	Philip of Anjou is proclaimed King Felipe V of Spain.	1709–1713	José de Churriguera develops a new style called churrigueresco (churrigueresque).
1702–1713	War of Spanish Succession.	1713–1714	Felipe V creates the Royal Academies of Language, History and Fine Arts.
1704	The British take Gibraltar.		
1713	Peace of Utrecht. Spain loses most European possessions.	1720–1757	Padre Antonio Soler writes music for organ, piano and harpsichord at El Escorial.
1759	Carlos III, most capable of the Bourbon rulers, is crowned. Reforms are initiated. War with England.	1786–1839	Father Gerónimo Feyjóo, Spanish essayist, writes social and aesthetic commentary Teatro Crítico Universal.
1765–1778	All Spanish ports opened to commerce with America.	1738–1764	Royal Palace of Madrid is erected as Bourbons react against baroque art.
1783	Second war with England. Spain recovers Minorca.	1757–1800	Traditional art forms and folk music influence musical currents.
1793	War with France over the execution of Louis XVI.	1761–1762	Carlos III summons Mengs and Tiepolo to Madrid.
1797	England attacks Spain and her possessions.	1768	Paintings of Luis Paret y Alcazar.
1805	In the battle of Trafalgar, England defeats the combined naval forces of Spain and France.	1771	Fine example of churrigueresque art, the Transparente, in Toledo's cathedral, by Narciso Tomé.
1808	Madrid rebels against the French occupying forces. The War of Independence starts.	1774	Goya invited by Mengs to paint cartoons for Royal Tapestry Factory.
1812	Cortes of Cádiz approves Constitution.	1763–1828	The works of Goya.
1814	War of Independence ends. Fernando VII returns: absolutism restored.	1786–1791	Sainetes (one-act farces) by Ramón de la Cruz.
1830	Fernando dies, and his widow, María Cristina, acts as regent.	1800	Francisco Bayeu, Goya's brother-in-law, paints "Olympus."

The Influence of France

The imposition of the Bourbon dynasty on Spain brought on a war, yet yielded long-term advantages to the Spanish people. The country was not partitioned among its enemies as it might have been. Many of its institutions remained intact and more important new ones came into being. Once again Spain came under the influence of a nation at a high level of cultural development. Yet it was not as though a foreign ruler had come to Spain. Philip of Anjou's ancestry was as Spanish as it was French. His great grandfather was Felipe II and his mother María Teresa, the daughter of Felipe IV.

As Felipe V, he was proclaimed King of Spain in 1700. Almost immediately he and his young queen, María Luisa of Savoy, were accepted by the great majority of Spaniards. But his succession was opposed by Leopold I of Austria, who questioned the validity of Carlos II's will. Leopold supported his son, the Archduke Charles. Neither had clear title to the throne. María Teresa had renounced all future claims to the crown of Spain upon her marriage to Louis XIV. But her renunciation was voided, according to some authorities, since the huge dowry which was to have accompanied the renunciation was never paid.

The Archduke Charles traced his right to the crown through Margaret, daughter of Felipe IV, and the first wife of Leopold I of Austria, because Margaret had transferred her rights of succession to her husband and his heirs. Charles was the issue of Leopold's second marriage.

War might have been avoided had Louis XIV given assurances to the allied powers that Spain and France would not be joined as a result of the succession. Instead, he wrote formal dispatches recognizing the ultimate rights of Felipe V to the throne of France. Further actions within the first year of Felipe's accession indicated that his plans were for France to be the real power in Spain. As a result Austrian opposition became more militant. Less than a year after Felipe V reached his capital in Madrid, the War of the Spanish Succession began. Great Britain, Austria, Holland and Denmark declared war on France. Soon they were joined by Portugal and Savoy.

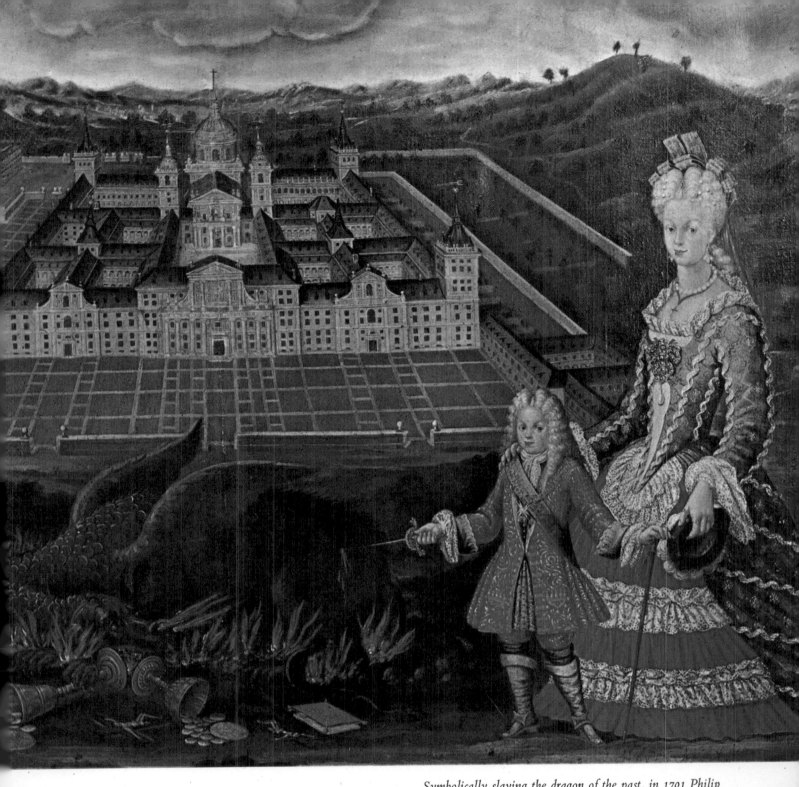

Symbolically slaying the dragon of the past, in 1701 Philip of Anjou (left) became Felipe V, first Bourbon to rule Spain.

Unfortunately for Spain, many of the battles were fought on her soil. Madrid changed hands a number of times. An invasion from Portugal brought the allied armies to the Spanish capital on June 26, 1706. The Archduke Charles was proclaimed king *in absentia*. But the victory was a fleeting one. A joint Castilian and Irish army, led by the English Duke of Berwick, who had come over to the French-Spanish cause, attacked the invaders furiously and drove them to Valencia. Four years later the British-Austrian army again pushed through to Madrid. This time the Archduke was

present, but not for long. Again a Spanish-French army forced the allied troops back to the coast.

Much of Cataluña had supported the allies against Felipe V. Among their reasons was fear that Bourbon absolutism would result in loss of their cherished *fueros* (privileges); another was distrust of the French, who had once occupied their country.

By a strange and ironic twist of fate, the Catalans may have been responsible for Spain's loss of Gibraltar. The allied forces, thinking they had sufficient support, attacked the city of Barcelona. Driven off, they revised their strategy and attacked

219

Combined British and Dutch fleet seized Gibraltar in 1704. Spain often, but unsuccessfully, tried to retake it.

Gibraltar. While the fortress was battered from the sea, English marines were landed. The small garrison was quickly overrun. The Spanish navy counterattacked but the British had firmly entrenched themselves and could not be dislodged.

While the war raged back and forth, its economic effects were felt in the Spanish colonies of the Americas. In the early years of the conflict, no fleets and few individual ships sailed from Spain to the Caribbean. Later on, convoys of Spanish ships navigated under the protection of French warships. Such safeguards became increasingly necessary, for not only were the British and Dutch ready to pounce on any unaccompanied ship, but the waters of the Caribbean were swarming with pirates of all nations. Treasure ships were sometimes captured, but more often they got through.

After twelve years, all the countries involved were exhausted. When King Leopold of Austria died and the Archduke Charles became emperor, there was no further reason for Great Britain and Holland to support his claim to the Spanish throne. A possible Austrian-German-Spanish empire was no more desirable to the allies than a French-Spanish

one. To achieve a balance of power, a series of peace pacts resulted in a settlement at Utrecht. By the terms of this treaty, Felipe V was confirmed as King of Spain, but he was forced to renounce any future claims to the crown of France. Austria received the Spanish Netherlands, Milan, Naples and Sardinia. The island of Sicily went to Savoy, which exchanged it for Sardinia a few years later.

Great Britain benefited most by the war. She kept Gibraltar, which gave her a key fortress at the entrance of the Mediterranean. Minorca, an island off the Catalan coast, was ceded to her. But the most important concessions were commercial rather than territorial. To develop and extend her colonies in the Americas she needed trade with the prosperous Spanish settlements of Puerto Rico, Cuba and Hispaniola. Commerce with these islands had been sporadic and illegal. Under the treaty she received important trading rights. More important, she was granted the *asiento* (labor contract) previously held by the French to supply Negro slaves to the Spanish colonies. This profitable privilege remained in British hands for 36 years until repurchased by Spain for 100,000 pounds.

Only the former Archduke Charles, now emperor of Austria, refused to recognize the sovereignty of Felipe V. The Austrian army fought on until the beleaguered forces of France, under the brilliant General Villars, defeated the emperor's forces at Denain, Landau and Freiburg. The resulting peace left only one dissident faction—the Catalans. Both Austria and Great Britain had promised to preserve Cataluña's traditional rights. But Felipe V would only agree to a general amnesty, granting Catalans the same rights as Castilians. This offer was unacceptable to the separatist-minded Catalans. They did not want integration with Castilla, fearing it would destroy their independence. Their declaration of war led to a year of bitter fighting. The well-organized Castilian army was often outfought by the Catalans' guerilla tactics; but their larger forces prevailed when Barcelona was destroyed in desperate house-to-house combat.

French thought, manners and ideas gained rapid ascendancy at the court of Spain, and spread slowly over the rest of the country. Early in his reign, Felipe came under the influence of the intelligent and attractive Madame Marie Anne de la Trémoille.

Many treasure ships from the Indies fell victim to pirates. This diving device was invented in 18th century for salvage.

This talented lady had been sent to Spain by Louis XIV as an adviser and companion to the young Queen María Luisa of Savoy. But her influence went far beyond her apparent position as lady-in-waiting. Together with Felipe's two French ministers, Jean Orry and Michel Amelot, she extended her interests to politics and economics. This effective trio planned a series of successful financial and administrative reforms. Although originally placed in the court as an agent for the French king, Madame de Trémoille became a loyal subject of Spain and a good friend to its king.

Her charge, María Luisa of Savoy, married to Felipe when she was thirteen, also became a true Spaniard. During the War of Succession she did not hesitate to support her adopted country against her

Plan de la Machina Hidraulica qui sert pour vivre et valier dans L'eau invantée par le S.r Burtel Zeres

221

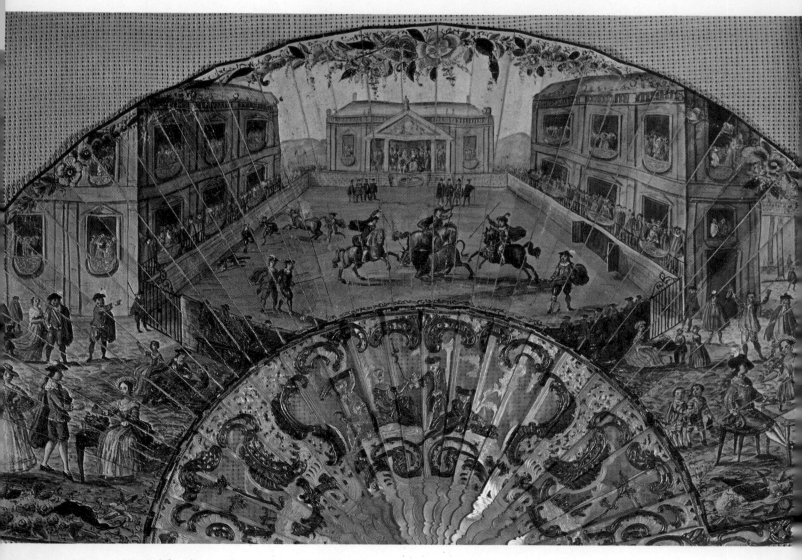

Painted fan shows mixture of French influence (costume)
and traditional amusements (bullfight) in 18th-century Spain.

father, King of Savoy. While Felipe was in the field at the head of his army, María Luisa, acting as regent, earned the love and respect of her subjects.

Her early death, and the second marriage of the king, swept Madame de Trémoille from court and back to France. Felipe now came under the influence of his second wife, Isabel Farnese, daughter of the Duke of Parma. She bore him two sons and spent most of the rest of her life conspiring to obtain kingdoms in Italy for them. She was ultimately successful, but not before wars were fought with Great Britain, France and Italy. Prince Carlos, later known as Carlos III, became King of Naples, while his brother Felipe was established as Duke of Parma.

In his later years Felipe V had prolonged fits of depression. During these periods he retired to his Versailles-like palace of San Idelfonso de la Granja. He abdicated his throne to his eldest son Luis, but was forced to return when Luis I died after less than a year as ruler. The king's last years were enlivened

by the presence of the Italian Farinelli—a *castrate* who became official singer to the king. He was said to be the only person who could bring Felipe out of his melancholy.

In addition to Italian singers and musicians, Italian architects and painters were imported to design and decorate the new buildings that rose in the early days of the Bourbon kings. The preceding century's severe Spanish style gave way to lighter more decorative forms. The Palacio Real, designed by two Italian architects, combined the weight and size of a traditional Spanish fortress with the ornateness of a French palace. Unlike El Escorial, with its austere lines, the royal palace exposed a façade broken by columns and pediments studded with statues. Inside, almost every chamber was treated differently. Some had walls of gold leaf, others of marble, still others, covered with huge tapestries, depicted vistas of the hunt, biblical scenes and allegories. Ceilings showed gods and goddesses, cupids

Elaborate float represents Water, *one of four* Forces, *in allegorical parade at time of coronation of Feli*

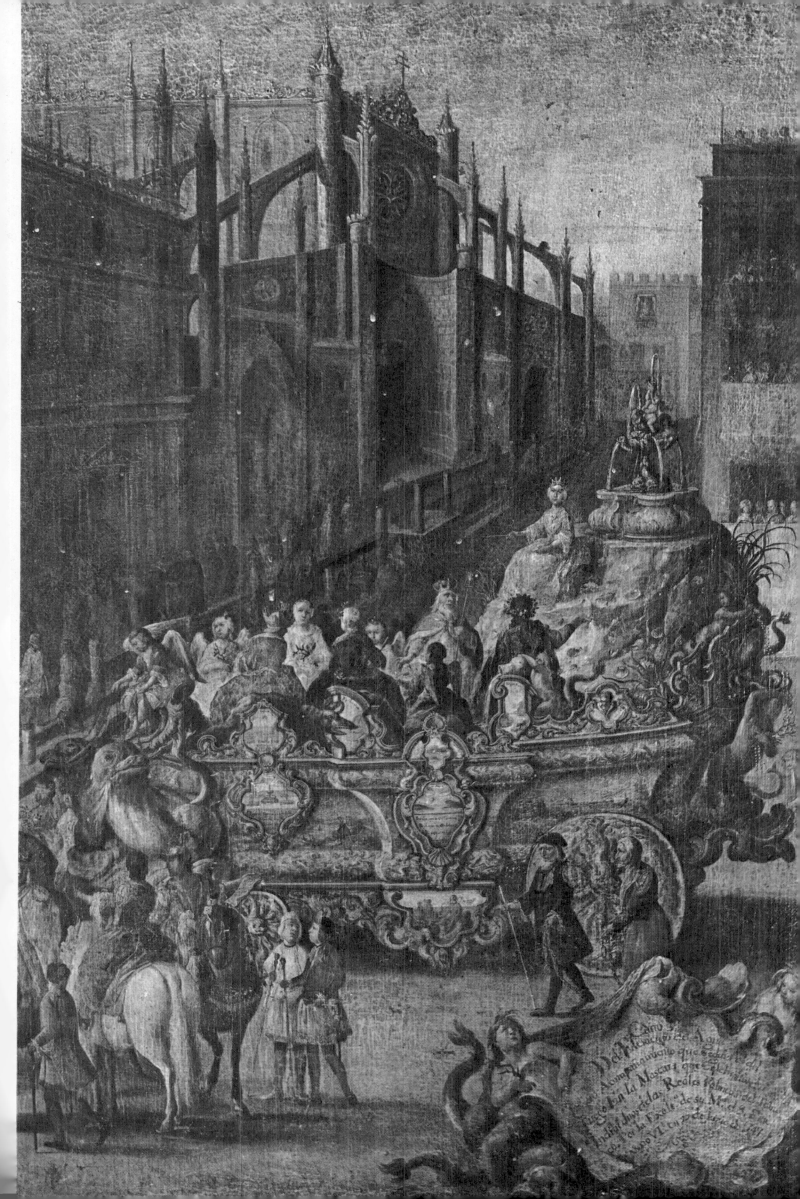

*Although Carlos III considered dancing to be
immoral, masked balls were a favorite form of entertainment*

-century Madrid. *This elegant scene in the Teatro Príncipe*
painted by a Spaniard in the fashionable French manner.

Except for the lady's mantilla and a few other details,
this elegant 18th-century Madrid shop might have been in Paris.

dryads and satyrs, painted by such men as Giovanni Battista, Giaquinto and Tiepolo.

When Felipe V died, Spain was again at war—as it had been for 40 of the 46 years of his reign. Fernando VI was fortunately dedicated to peaceful coexistence with the warring nations around him. Through the good offices of his wife, Maria Barbara de Braganza, daughter of John V of Portugal, a settlement was achieved. During his thirteen-year rule, Fernando took care that the peace was kept.

It was a difficult task. War was still a state policy of Great Britain and most of the countries of Europe. Fernando, nevertheless, kept Spain neutral, even turning down such an attractive offer as the return of Gibraltar and Minorca in return for military aid to the British. This peaceful interlude was desperately needed. The Marqués de la Ensenada and José de Carvajal, the Spanish ministers who replaced the French advisers of Felipe V, took advantage of the

peace to build a base for future progress. Under their direction the country gradually recovered its strength and purpose.

A man of considerable culture, Fernando attracted scholars, artists, craftsmen and especially musicians from Germany, Italy, France and Great Britain. Court life was greatly enlivened by music, for the queen was an accomplished performer on the harpsichord. Her teacher was Domenico Scarlatti, the virtuoso son of Alessandro Scarlatti. Fernando was himself a skillful violinist, and duets, trios and quartets were regular gala affairs at court. Operas, operettas and concerts, elaborately produced and expensively costumed, were scheduled periodically. Fernando's interest in music became known throughout Europe. Frederick of Prussia, a flute player himself, had a royal march composed for the Spanish king and sent it to him with instructions that it should be played upon silver flutes.

Colorful scene in a Madrid park was the ascension of a gl
Montgolfier, a hot-air balloon named after its French inver

Stalls were set up at dawn in Madrid's Plaza de Cebada, then taken down at night, as markets are in Spanish cities to this day.

The peace enjoyed by Spain under Fernando VI had far-reaching effects. It provided a good climate for the reign of Carlos III, one of the truly great kings in Spanish history, and the son of Isabel Farnese. At last Spain profited from the long and costly campaign that had made him King of Naples. For when Fernando VI died childless, and Carlos III became King of Spain, he had behind him 25 years of experience as ruler of Naples. Unlike the latter Hapsburgs or early Bourbons, Carlos III was his own man. He was led by neither women nor court favorites. The government had never before been so well organized as it was under his direction.

Only one local uprising marred his reign in Spain. Although the Jesuits were blamed, the primary instigator of this minor rebellion was the minister of finance, a Sicilian, Leopoldo de Gregorio, Marqués de Squillace. Squillace believed that Spanish citizens' long capes (worn to keep out the cold) and large hats with low brims shading the face (to keep out the sun) were impractical and, even worse, immoral. Men, he felt, could too easily disguise their identities. Believing French styles to be superior, Squillace issued a decree banning the traditional Spanish dress. The new fashion was to be a waist-length cape and a French-type three-cornered hat. A further mistake Squillace made was to impose a tax on olive oil and bread; disorder followed. During the resulting riots, the king was forced to leave Madrid. Members of the palace guard were captured and beaten. In one swift move the king repealed the unpopular "national dress" edict and removed Squillace from the government.

Carlos III's first and most effective reform measure came when he encouraged freedom of inquiry in the universities. He and his minister, the Count

The great Plaza Mayor in Madrid was often used for b fights. But Carlos II disliked the sport and banned it in 1

of Aranda, clearly understood the need for more and better education at every level. New schools were founded and existing ones were expanded. He began by extending the study of the exact sciences. The universities of Salamanca, Alcalá, Sevilla and Madrid revived their schools of mathematics and humanities, while other universities, such as Barcelona, Valencia and Zaragoza, established new departments for the study of sciences. Aristotle was left behind as the new philosophies were examined. Schools of natural history, astronomy, engineering, mechanics, medicine and jurisprudence were established. For the first time in many years, Spain entered the mainstream of European life.

The works of the Frenchmen Diderot, Voltaire, Rousseau, Montesquieu, and the Englishmen Hobbes and Locke found their way into Spain. Highly placed nobles read them, and some—the Duke of Alba and the Count of Aranda, for example—corresponded with the new writers, who nevertheless were not welcomed by the state. Indeed, most of the works of the French and English reformers were prohibited, but their ideas seeped through. Spanish writers were reawakening. Fray Benito Jerónimo Feijóo published his stimulating *Teatro Crítico Universal* and the *Cartas Eruditas y Curiosas*. An important literary event was the publication of *Poesías Castellanas Anteriores al Siglo* XV, which translated into modern Spanish such classics as the poem of *El Cid*, the works of Gonzalo de Berceo, the *Book of Alexander*, and Juan Ruiz's *Book of Good Love*.

Progress was made not only in the fields of education and letters. The public economy was surveyed, and this time reforms were carried out. Communal lands were divided, new agricultural colonies founded. The privileges long afforded to the powerful sheep raisers were curtailed. Privileges and exemptions were given to new industries. New ports were built in the Americas for free trade with Spain. Spanish ports were opened to ships from the Spanish colonies, finally breaking the monopoly held so long by Sevilla and Cádiz.

PLAZA DMADRID

In 1739 fighting br
out between Spain and England, then widened into a gene

...uropean conflict. Here, in an engagement off the Provence coast ... 1744, a tattered Spanish warship sinks a flaming British vessel.

While ladies watch from an open carriage, men on horseback and dogs hunt boars. At right cornered boar is killed.

Carlos III was a devout, practicing Catholic. Yet he saw, as had some of his predecessors, the necessity for both church and state reforms. Believing that censorship by the church could stifle the spirit of inquiry, he took exception to the Spanish Inquisition's publishing a document condemning a book by the French theologian Mesenghi. This was followed by royal orders that no papal bulls could be circulated without first being presented for approval to the king or the royal council. The orders went further—they informed the Inquisition that it could condemn no book without giving the author an opportunity to defend it, and that it should publish only such edicts as were forwarded to it by the king. The conflict between the crown and the Inquisition continued for some time, but most of the latter's power was removed. From the year 1799, no Spanish subject could be arrested by the Inquisition without royal authorization. Methods of trial were modified; secret interrogation and seclusion of the accused were abolished.

While Carlos acted entirely in the interest of his subjects in the case of the Inquisition, his motives are less clear concerning the expulsion of the Jesuit

Duck hunting became a favorite sport for both sex in 19th-century Spain. Note picnic aboard broadbeamed boa

order from Spain. The Jesuits had become so powerful that they were the envy of other Catholic orders. The universities opposed them on grounds that their teaching methods were archaic, and because of their partisanship to papal jurisdiction over the state. In the year that Carlos became King of Spain, the Jesuits were expelled from Portugal; a few years later they were exiled from France.

A special *junta* (council) was formed. Jesuits were charged with responsibility for riots, with teaching subversion, with monopolizing commerce in the Americas, and with intrigues against the crown. It is doubtful that any charge was based on specific evidence. But the Jesuits wielded power and the king and court considered them dangerous.

The king gave the matter long consideration before he signed the decree of expulsion, which also affected the Jesuits in the Spanish colonies. It was carried out secretly and with great haste in Spain. Within a few days, 2,746 Spanish Jesuits were expelled. Carlos sent them to the Papal States, but the Pope, although sympathetic, did not allow them to land. When their boats arrived off Cività Vecchia, the port of Rome, orders were given to keep out of the harbor or be fired upon. They were finally settled in Bologna and Ferrara. Soon the Spanish king, acting in concert with Portugal, France and Naples, succeeded in having the Jesuit order dissolved by the Papal Court.

Although Carlos was intolerant of the Jesuits, he was far less so with regard to Spanish Jews and Gypsies. Laws keeping Jews in segregated quarters and forcing them to wear identifying insignia were revoked. Opportunities to work in trades or to serve in the army or navy were offered them.

The Gypsies—who came from northern India through the Balkans or through Egypt and North Africa—were considered an inferior people, along with the Jews. Many prohibitions kept them segregated from the general population. Carlos tried to integrate them by tendering social and economic opportunities on a level with all other Spaniards. His intentions were good, but his measures failed because he expected the Gypsies to give up their traditional customs, language and dress. Both minority groups remained unassimilated. Long after Carlos's measures Goya continued to paint Gypsies in their traditional costumes.

On Napoleon's orders, the Franco-Spanish fle
engaged the British off Trafalgar. The British won the battle

ough they suffered heavy damage, including the death of their
mmander Nelson—and Spain's days as a sea power were ended.

Wearing hairstyle of a bullfighter (which he may once have been, briefly), young Goya painted himself into bullfight scene.

The Spain of Goya

The last victim of the Spanish Inquisition was burned in Sevilla in the year 1780. That year Francisco José de Goya y Lucientes painted his magnificent Crucifixion and was admitted to the Spanish Academy of Art (Academia Real de Bellas Artes de San Fernando). The painter was 34 years of age. His extraordinary talent and strong personality brought him the commissions that he wanted.

Goya was born in 1746, the year that Felipe V died. He grew up in the peaceful era of Fernando VI, in the tiny village of Fuendetodos, south of Zaragoza. In the year that Carlos III, the reformer king of Spain, succeeded to the throne, young Goya was taken to Zaragoza by his father, who, sympathetic to his son's interest in drawing, apprenticed him to a painter, José Luzán. For the next six years, until he was approximately 20, Goya remained with Luzán in Zaragoza.

It is believed that Goya left school and joined a traveling *cuadrilla* (troupe of bullfighters). With them he journeyed through Spain learning their art and storing up memories. That he must have been intimate with the *corrida* is shown in his work, for in his late 60s he produced his famous sequence of

*Early in his career Goya did this graceful
grouping of a game of blindman's buff as a cartoon for a tapestry.*

Penitentes, *order of flagellants who lashed themselves
into frenzy, escort statue of the Virgin in religious procession.*

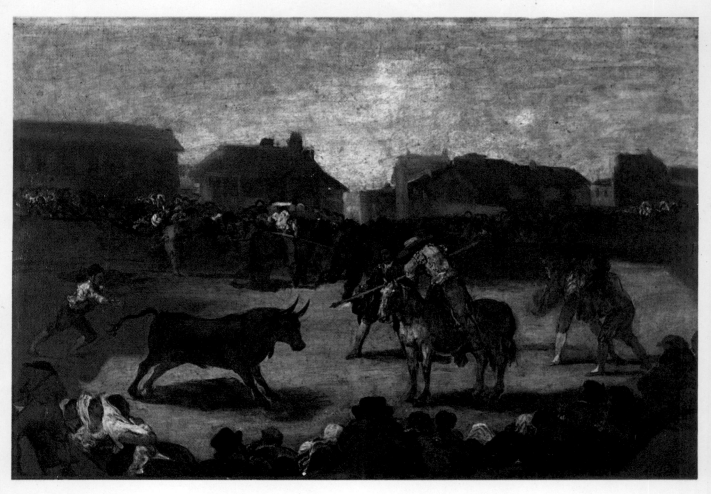

Forbidden to nobility by the king, bullfighting was taken over by commoners like these villagers, later became art and ritual.

etchings known as "La Tauromaquia" ("The Art of Bullfighting").

To see Goya's bullfight pictures is to understand something of the importance the spectacle had achieved in 18th-century Spain. In the preceding centuries it had slowly changed from an exhibition of valor by mounted knights into a grand arena spectacle with ritual and an organized group of participants who played different parts.

It remained for Felipe V to ban the nobility from participating in bullfights. He considered it too dangerous. The result was that between 1700 and 1800 it came into the province of the common people. The *capote* (cape) and the *muleta* (a larger cloth than the one used later) were invented to distract the bull from the man on the ground and to control the beast for the kill. In his etchings Goya shows both Spanish and Moorish matadors in the bullring with members of the *cuadrilla* in attendance. It was the age of the great Pepe-Hillo, who added much to the ritual and even wrote about it. When he was killed in 1801, Goya recorded the event in one of the most famous of all bullfight paintings.

Every detail of the *corrida* is revealed in his paintings and his sequence of documentary etchings. Long, barbed *banderillas* are gracefully placed in the bull's shoulder muscles as he thunders by. Passes, similar to that later called the *verónica,* are made with the cape. A horseman thrusts his long *pica* or pike (like those used by the Spanish soldiers in the 17th century) into the great hump of tossing muscle in the base of the neck. The matador is shown thrusting the sword over the horns to make the kill.

Goya was an avid aficionado of bullfighting. In his canvases the spectators are barely sketched in. All emphasis is on the action in the arena. In paintings and etchings the bull comes alive as a looming lethal symbol of destructive power. Against the powerful dark mass of the charging bull, men are small but brave figures who look death in the face.

The painter saw the bullfight as a Spaniard sees it, without sentimental or moral considerations— as a moving, colorful spectacle. His pictures reflect the intense excitement and graceful movement of the ritual, in which coping with danger becomes both a science and an art.

Fiesta held on last day before Lent shows Goya's famo taste for the grotesque. He later turned it to more savage use

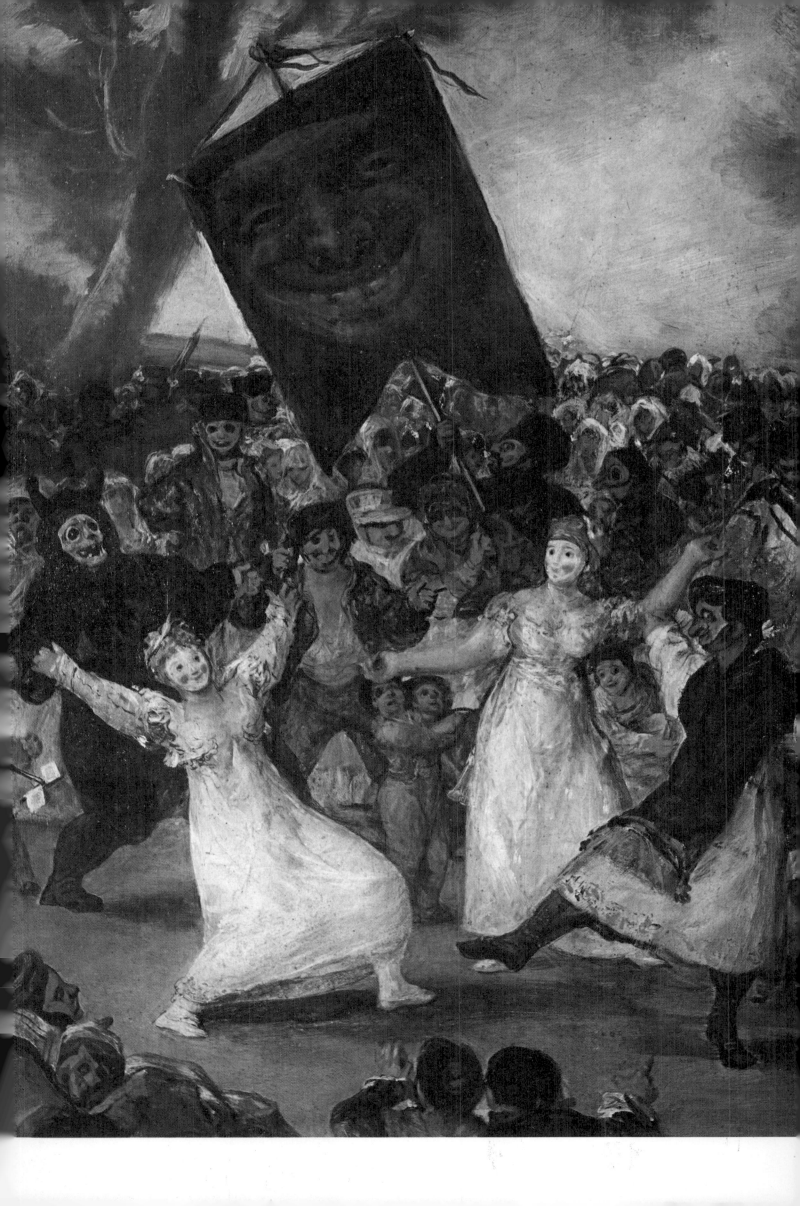

The toreros of his day indulged in unique and dangerous feats inside the arena. In one etching a matador is shown with his feet tied to a chair while he distracts the bull with a hat in his left hand and makes ready to thrust with the sword in his right. In another etching the matador vaults over the animal. Still another stands, with his feet tied, on a table covered with a cape, while the bull charges.

Whether Goya actually was a member of a *cuadrilla* or only a keen observer, no other painter has ever revealed the cult of bullfighting so clearly.

At the age of 25 he was in Italy, painting. We know he won a second prize in a competition at the Parma Academy of Art. The next year he returned to Zaragoza, where he received his first Spanish commissions: "The Triumph of the Virgin" in the cathedral of Nuestra Señora del Pilar and the murals of the Carthusian monastery of Aula Dei. With enough money for a start in the capital he moved on to Madrid. There he married Josefa Bayeu and, through the intercession of her brother Francisco, received a commission to supply cartoons for the royal tapestry factory, a huge enterprise founded by Felipe V but not fully in operation until 1777. His first sketch was the light, French-influenced "Picnic on the Banks of the Manzanares." This pastoral scene with dandies and their ladies playing blindman's buff on the riverside was so well received that he later painted two versions. In the succeeding years, over 50 of his cartoons became large tapestries.

At this time Goya was hardly the most important painter in Spain. Anton Raphael Mengs was court painter and director of the royal tapestry works. Francisco Bayeu received important commissions and Luis Paret was a favorite of Carlos III.

Paret was born the same year as Goya, and like him took his subjects from nature. In many of Paret's paintings the swirl of color and motion foreshadows the impressionist style of painting that was to come many years later. He reflected the French influence in Spain more clearly than any other painter. But his canvases of court life, hunting scenes, masked balls, romerias (pilgrimages) are more charming and decorative than they are revealing of human nature.

Carlos III soon recognized the powerful talent of Goya, who, in his 40th year, became painter to the king. Perceptive portraits of Carlos, his court and members of the nobility flowed steadily from the facile brush of the Aragonese painter. Some of his court canvases of this period were directly in-

Goya in a warm mood painted happy peasants in 1786. Under Carlos III some large holdings were divided up among farmers.

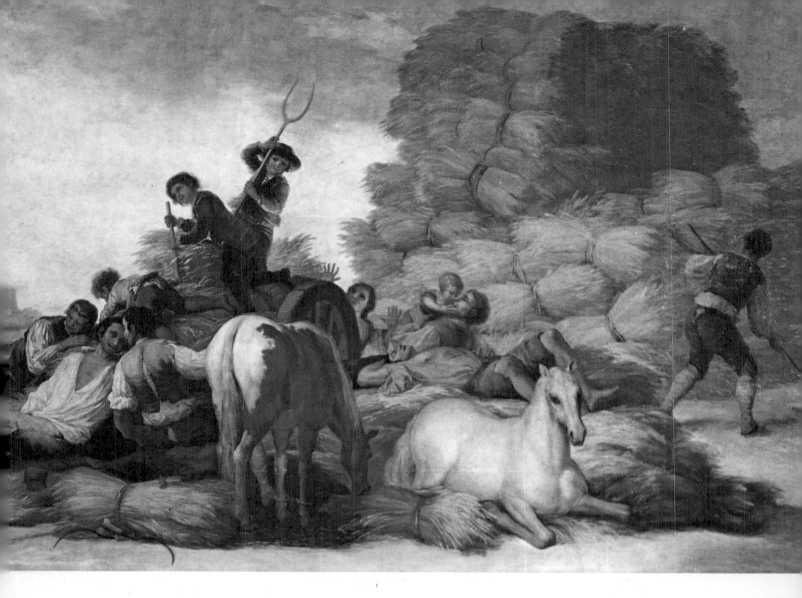

*In picture of a country wedding, Goya cannot
resist a touch of satire at expense of ugly bridegroom in red.*

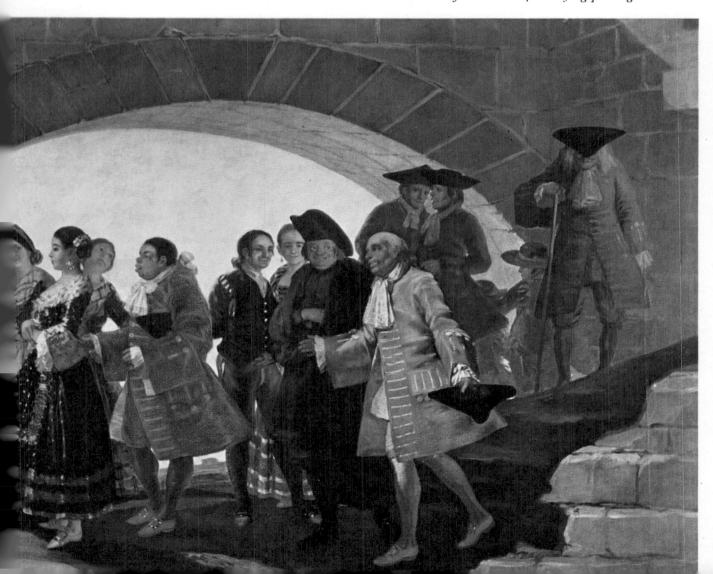

One of Goya's most beautiful models was the Condesa de Chinchón, unhappy wife of statesman Manuel Godoy, the Queen's lover.

The aristocratic and flamboyant Duchess of Alba was s[...] to be Goya's mistress. He painted her in 1795 when she was [...]

fluenced by the earlier court paintings of Velázquez.

At the death of his friend and patron Carlos III, Goya became court painter to Carlos IV. Important commissions were pressed upon him. For two years he was director of the Spanish Art Academy. Money and fame were important to him, but his integrity as an artist always came first. His paintings of the unprincipled Queen María Luisa, her egocentric lover Godoy, and her banal husband Carlos IV show them as they were.

Like Rembrandt, whom he greatly admired, Goya painted even saints with great human realism. As in the case of Velázquez, nature, not mythology, was his teacher. He painted people with all their weaknesses, their faults and their strength, reaching the inner person through the outer flesh. His portraits are not an end in themselves but representations that reveal the arrogance, ego, stupidity, nobility, greed, lust and all the varying degrees of excellence or depravity. There is no compassion in the portraits of Goya. They are earthbound images

of the undying Spaniard. The people themselves [...] important, never the background.

He lived his life as he painted. It was tumultuo[...] vivid, gay, sad, vulgar and tragic. No preter[...] separated him from the world, just as no camoufla[...] concealed his subjects. But, while Goya's people [...] human, they do not surrender to the futility abo[...] them. Like their creator, they fight back agai[...] pain, fear and darkness. They have a quality of co[...] tinuity, of permanence, and a lust for life even to [...] point of walking hand in hand with death.

Goya was not a part of the court although [...] painted for it, nor of the religious establishme[...] although he was a Catholic and did many co[...] missions for the church. He was not part of [...] nobility, nor was he a leader of the common peop[...] He was a man alone. He began to lose his hear[...] at the age of 46 after a serious illness. His deafr[...] seemed to draw him even further within hims[...] Yet he painted more freely than ever.

Most of his later years were spent in a Sp[...]

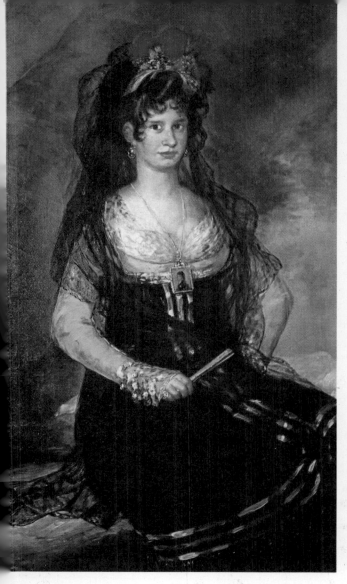

Vivacious Condesa de Fernán Núñez was noted in the court of Carlos IV for jealous fights with her husband.

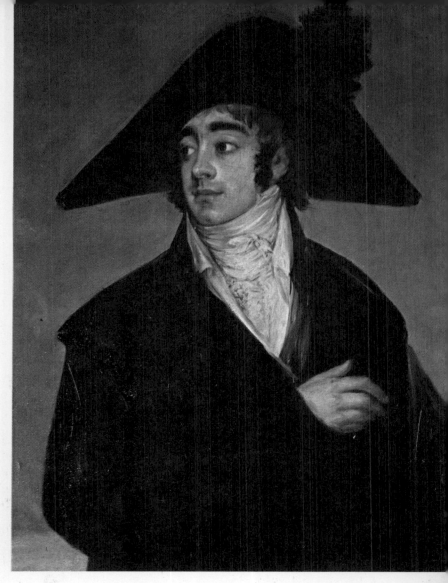

El Conde de Fernán Núñez, a tall, debonair man, was fully deserving of his wife's complaints about his infidelity.

ipped apart by internal dissension. Fernando VII ppointed him court painter, but there was no rapport between the two men. Goya painted the king s the tyrant that he was. As court painter he completed few official portraits. Most of his liberal riends were either dead or in exile. The painter etreated into a world of his own.

After his first serious illness, in 1793, Goya perfected his etching technique and produced the Caprichos." These satirical sketches were visual arables showing with humor, sometimes light but more often grim, the vanities of the time. There are many disquieting notes as though the artist has ooked below the surface to reveal the baser instincts of humanity.

"Desastres de la Guerra" ("Disasters of War") llowed twelve years later. They seem to be etched blood. There are no armies marching, no bugles, glory. Only horror, death nad destruction are vealed by an enraged and compassionate painter ho had witnessed the shameful waste of life.

As Goya grew older, his visions became stronger. Though he painted a few realistic canvases of his friends shortly before his death in France, Goya's realism actually ended with the etchings of the "Tauromaquia." After these came his final etchings, the "Disparates" ("Absurdities") or "Proverbios," which were not completed until his 73rd year. Reason and reality depart. Here is a world of fantasy in which demons, witches, warlocks mingle with human beings and animals. No one has clearly discerned the intention behind these haunting scenes of allegory and symbolism. In a few, the meaning is clear. Like his "black paintings" that followed, their meaning is to be found within the experience of the individual.

At the age of 78, after attempts by some factions to establish a more liberal government had failed, Goya left Spain for Paris, then settled in Bordeaux, where he remained, except for one trip to Madrid, until his death at the age of 82. His life had spanned the reigns of four Spanish kings.

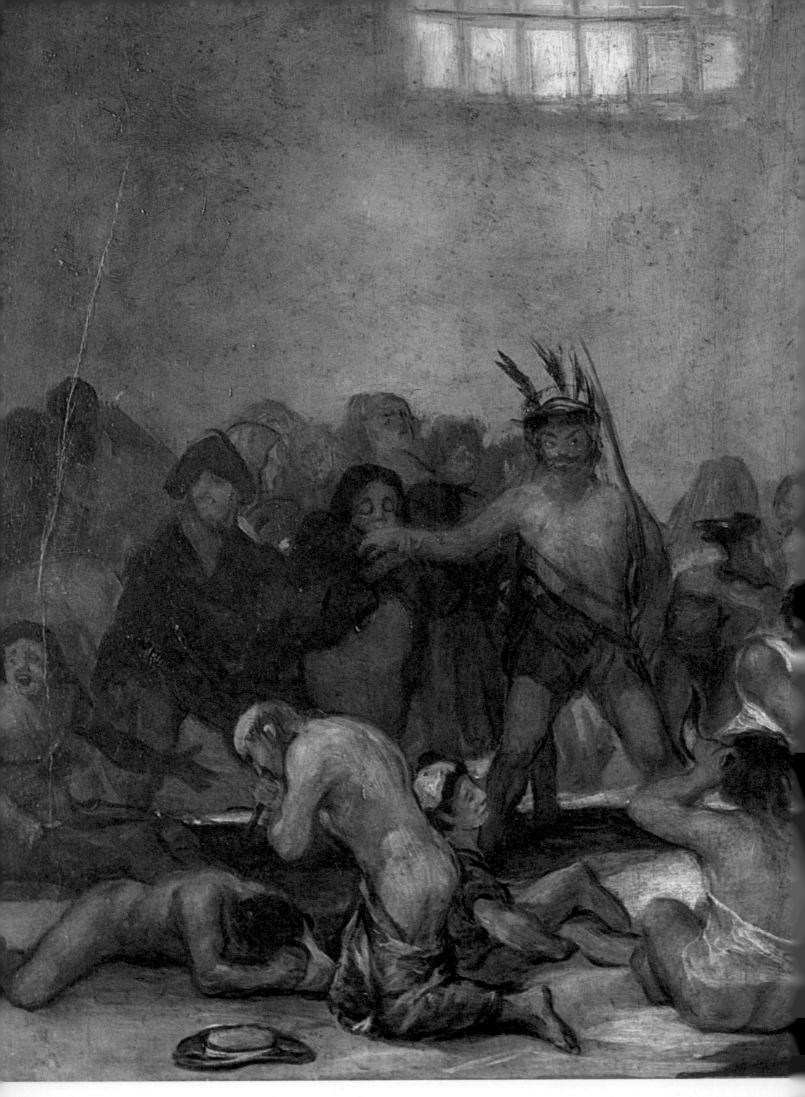

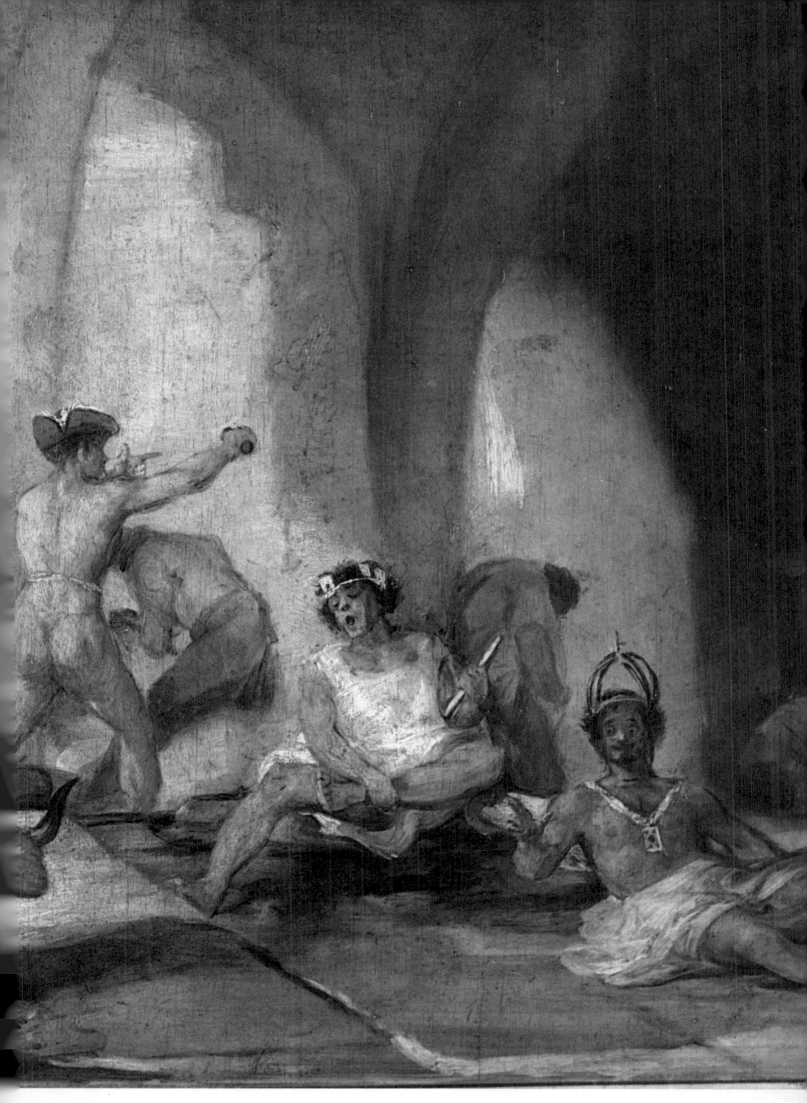

is powerful scene, typical of the barbaric conditions prevalent
he time, is within the Madrid Casa de Locos (Crazy House)

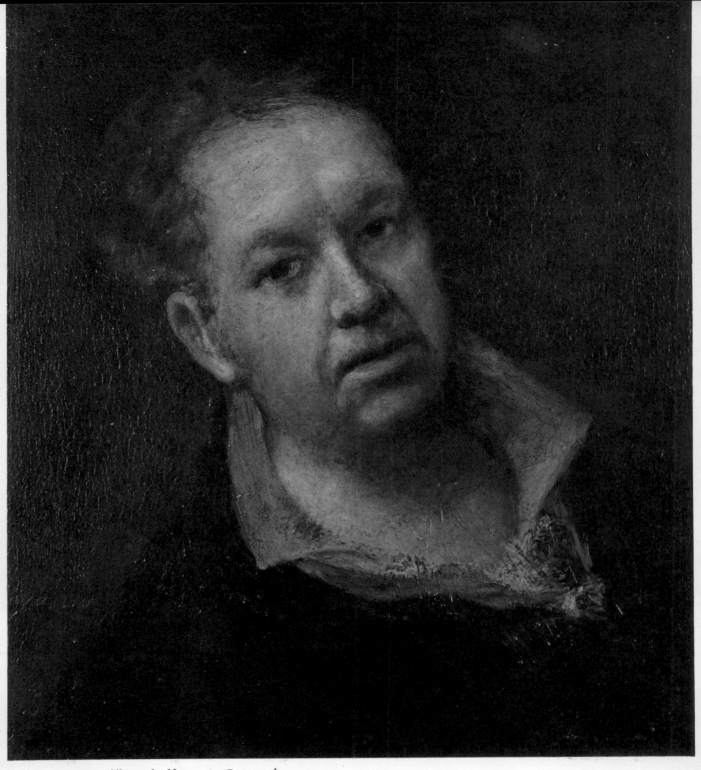

In middle-aged self-portrait, Goya made no attempt
to flatter himself any more than he did others who sat for him.

Goya and Alba—the Artist and the Duchess

"Maja Desnuda" and "Maja Vestida" were done by Goya in the same period that he painted a second portrait of the Duchess of Alba. Goya was 49 when he first painted her. She was 33, a slim, long-haired, delicate but fiery beauty, unconventional, gay, and happily married to Don José Alvarez de Toledo. The three became close friends.

When her husband died in 1795, the Duchess left Madrid for her country estate. After a period of mourning, she invited Goya to visit. There he painted the second full-length portrait. Cayetana posed as a *manola* (woman of the people) in a mantilla, a wide red sash around her extraordinarily narrow waist, and a long white skirt. In neither painting is there a resemblance to the plump, wide-hipped *Majas,* but it was rumored in court that the Duchess was Goya's mistress. Although there is no proof, in the second portrait she wears two rings, on which are clearly painted—Goya and Alba.

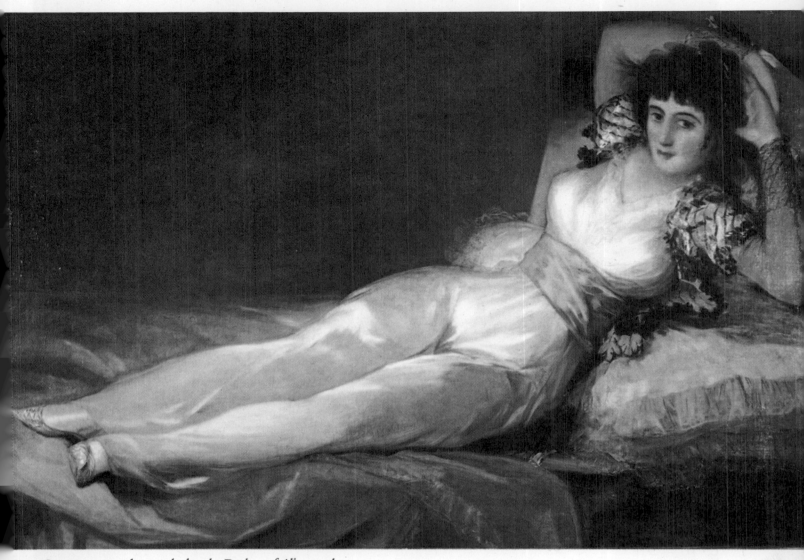

Controversy raged over whether the Duchess of Alba posed
for the "*Maja Vestida*" (*Clothed Maja*). She probably did not.

A similar pose, but less well painted, is the "*Maja Des-
nuda*" (*Nude Maja*). Both pictures were done at about same time.

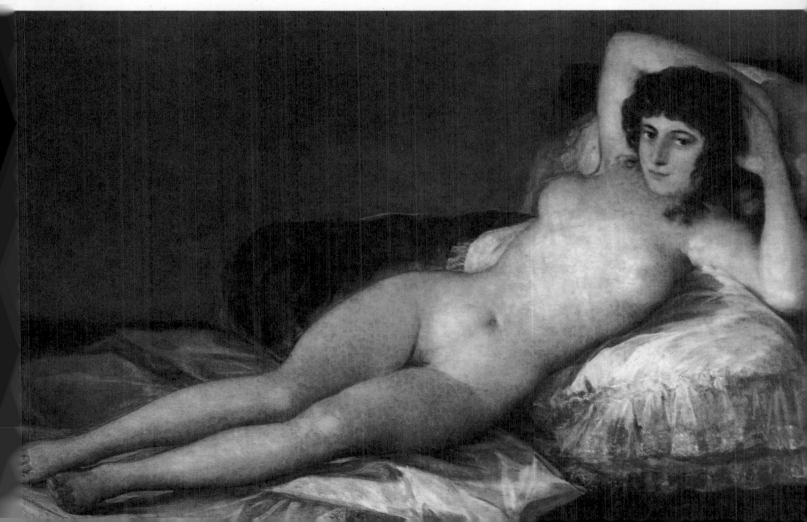

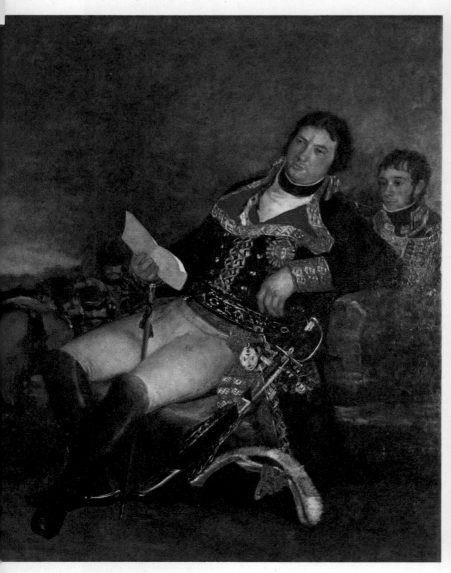

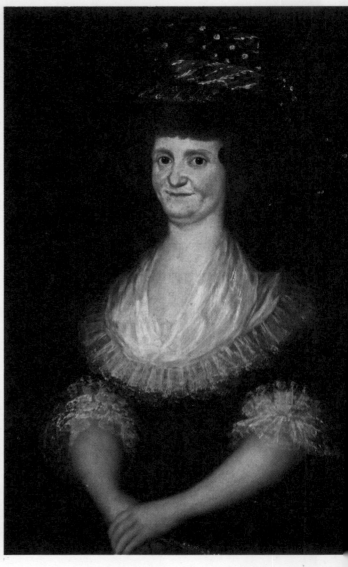

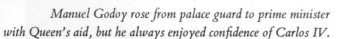

Manuel Godoy rose from palace guard to prime minister with Queen's aid, but he always enjoyed confidence of Carlos IV.

A clever, contriving woman, Queen María Luisa married her cousin Carlos when she was 14, always dominated him

The Palace Trio

Carlos IV was the opposite of his father. He was dull-witted and overweight. Queen María Luisa completely dominated him. She took a lover who became the King's most trusted adviser. Manuel de Godoy was an 18-year-old palace guard when he came under the patronage of the 34-year-old queen. In a few years he was the most powerful man in all of Spain.

As Napoleon rose in power, Godoy and the king came under his influence, even giving permission to the French to march an army through Spain to Portugal. A power conflict between Fernando, the heir, and Godoy followed, giving Napoleon an excuse to dispatch a powerful army to Spain. Godoy wanted to fight. The king refused, and abdicated in favor of his son.

While the French occupied Madrid, Napoleon sat at Bayonne. Carlos, the Queen and Godoy were brought to him. Leading Fernando to believe France would support his succession, he too was induced to come. Confronted with his parents, Fernando was forced to return the throne to his father. Carlos was forced to abdicate again, leaving the Spanish throne in Napoleon's hands.

Carlos, María Luisa and Godoy went together into exile, where María Luisa died at 68. Only Godoy was with her—the king had gone hunting.

As court painter Goya lavished attention on Carlos IV's ribbons and decorations, was honest about his fatuous face

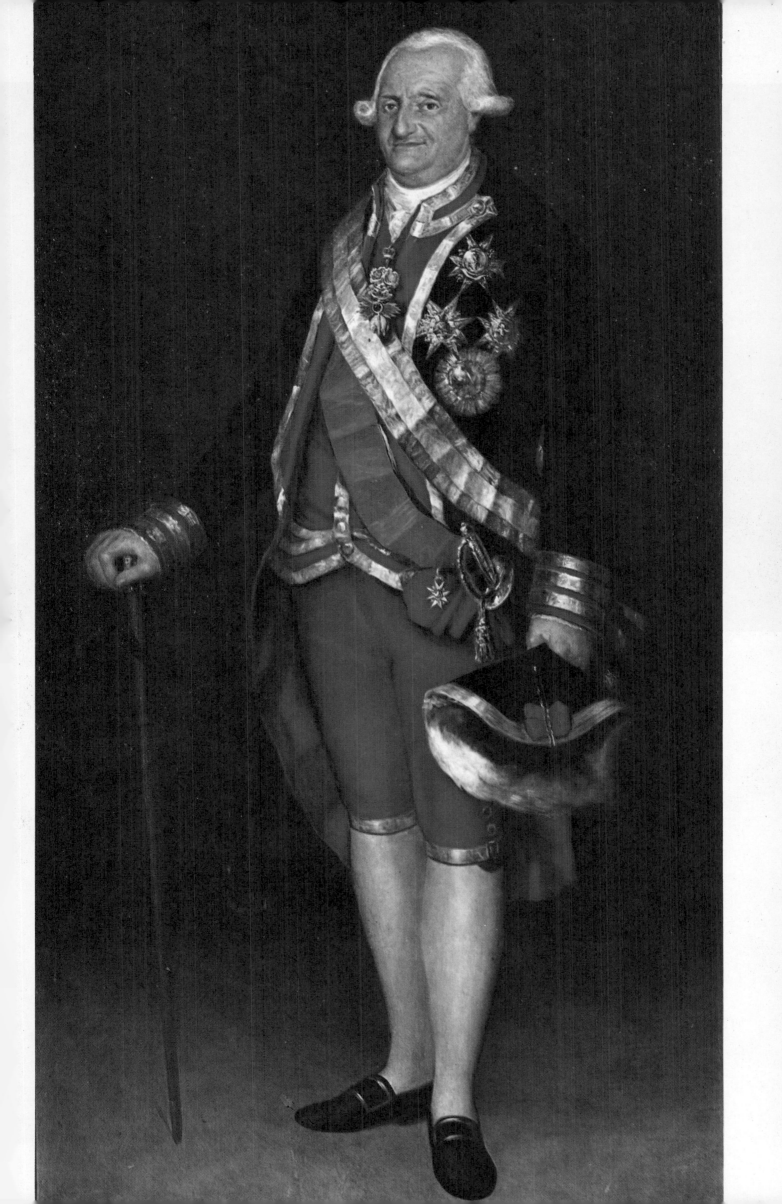

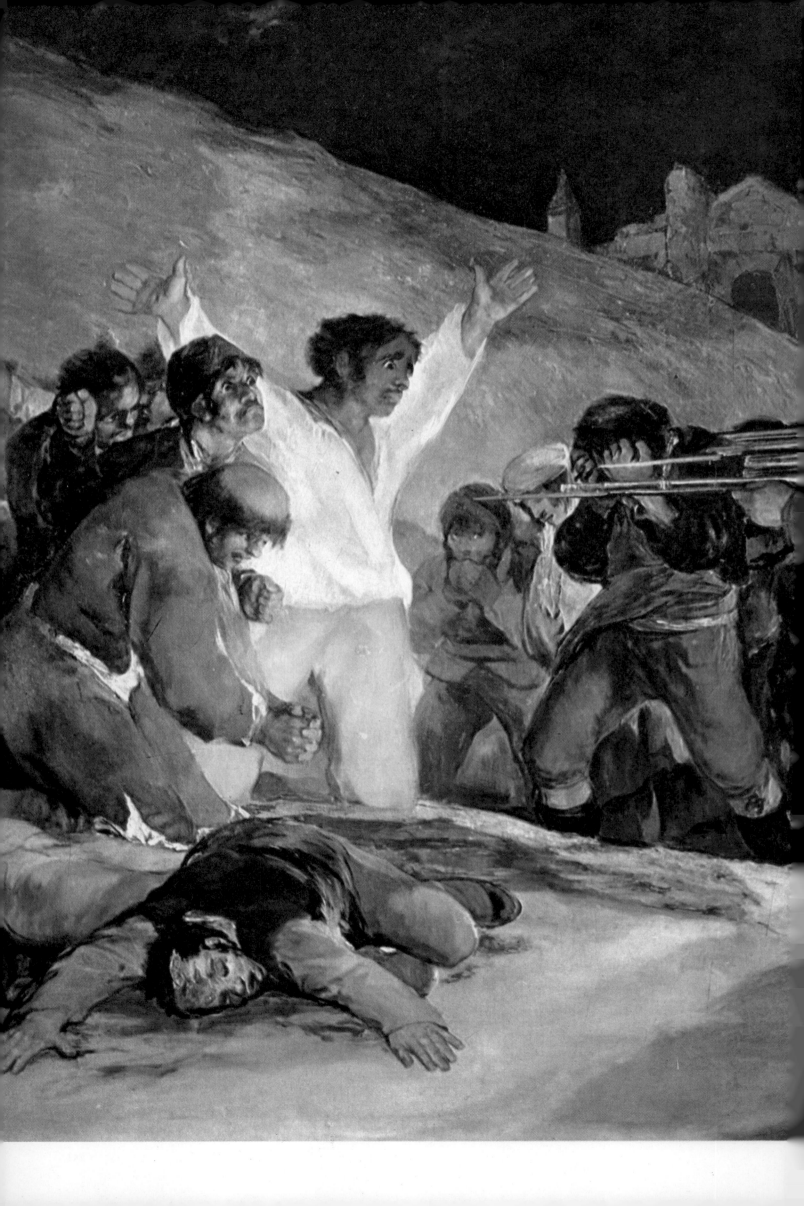

The War
of Independence

Even before Napoleon announced his intention to make Joseph Bonaparte king of Spain, an uprising against the French took place in Madrid on May 2, 1808. The occupied city was quiet as a large crowd gathered before the royal palace. Carlos IV's 13-year-old son, Francisco, and his married sister and her young son were departing that morning for France. As the crowd waited impatiently to see them, rumors spread that Napoleon would not recognize the succession of Fernando, and that the royal family were being lured to France to be murdered. The crowd became more excited and gave credence to the rumors that the young prince was in tears and afraid to leave for France. Soldiers and citizens exchanged insults. As the mob went out of control, the palace guard sent for reinforcements. French soldiers arrived and fired on the demonstrators. The group at the palace was dispersed, but word of the shooting spread throughout the city. Two captains of the Spanish army, Pedro Velarde and Luis Daioz, disobeying their orders, helped organize the townspeople and Spanish soldiers, who fought with guns, knives, shovels and axes. The French drove them from the center of the city, and Velarde and Daioz were killed.

To put down the uprising, the French general, Murat, made a mistake in calling out the Mamelukes, for these Egyptian mercenaries resembled the feared and hated Arabs. The citizenry attacked their

Execution of Spaniards who abortively rebelled against French in 1808 gave Goya the theme for one of his greatest works.

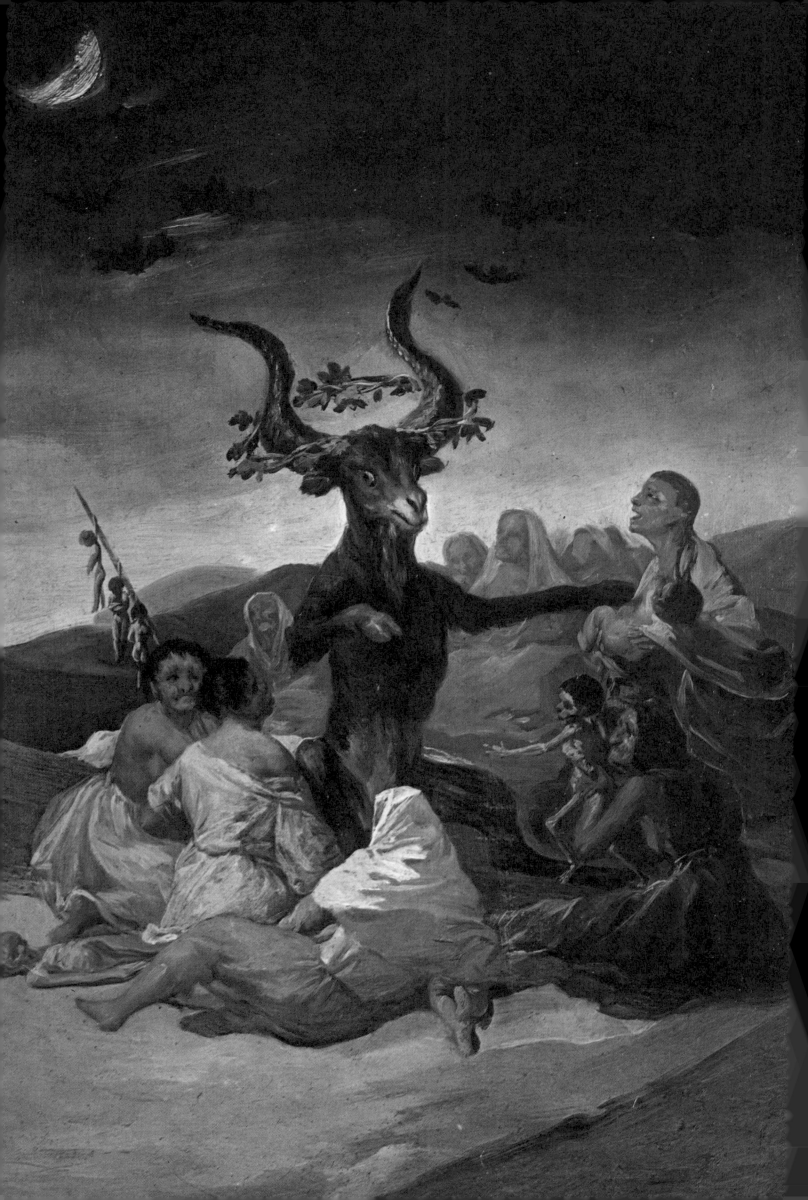

horses and dragged them to the ground, beating many of them to death. Then Murat made an even greater error when he condemned the prisoners to death for their part in the rioting. On the next day, May 3, the death penalty was carried out.

Goya was in Madrid during the rioting and witnessed the fury of the people. In his painting "The Second of May 1808 in Madrid" he details the rage of the citizens. Whether or not he witnessed the events he painted in the "Second of May" canvas, there is little doubt that he saw the events of May 3. According to his servant, Goya viewed the executions from his window. He watched the firing squads through a telescope, with a sketchbook and a gun beside him. On the next evening, he traveled to the hill of the executions, and sketched the dead by moonlight.

As the riots in Madrid were suppressed, guerrilla warfare broke out in the provinces. Within two months the French were forced out of Valencia and their army in Andalucía surrendered at Bailén. The victories of the Spanish guerrilla forces quickly brought Napoleon to Spain, for not only was the Spanish crown of his brother Joseph threatened, but other countries fighting against him were heartened by the successful resistance of the Spaniards.

With the Emperor and a strong army behind him, Joseph Bonaparte was at last installed on the throne of Spain. Still guerrillas in many parts of the nation fought on. The cities of Zaragoza and Gerona held out against the French for many months. Great acts of heroism were performed, but these cities, like the others, were forced to surrender in the end.

The acting rebel government, the Junta Central, was forced by the French army to move from Aranjuez to Cádiz. There it gave way to a Cortes representing the towns and cities of Spain, and the colonies as well. This Cortes adopted the Constitution of 1812, a document that reflected the revolutions of the United States and France. It echoed the most liberal ideas of the time, many of which the people of Spain were not ready to accept. Most revolutionary of the 234 articles were those dealing with sovereignty, vesting it in the people, to whom all rights of legislation were accorded. Laws were to be passed only by the popularly elected Cortes. The king was to remain, but as an executive with limited power whose decrees must be countersigned by ministers responsible to the Cortes. Legal codes were applied equally to all sections of the country and the colonies. All men over 25 were entitled to vote for members of the powerful Cortes. There was to be one representative for every 60,000 people. The Catholic faith was recognized as the state religion, but its power came under the influence of the Cortes. But the French were still in control of much of the country.

A British-Portuguese army, led by the Duke of Wellington, came to the rescue of the Spaniards. Patriots such as Julian Sanchez of León kept the French army under constant pressure. Never could more than half of the French troops be deployed to fight Wellington. The French army was decisively defeated at Victoria, in northern Spain, on June 21, 1813. The victory was as much a triumph for the Spanish guerrilla fighters as for Wellington. Joseph Bonaparte fled from Spain. Wellington fought his way across the Pyrenees and into French territory. Within a year after Napoleon's defeat at Leipzig he realized there was no hope of retaining Spain as part of the French empire. Fernando VII, whom he had held in custody for six years, was released. The War of Independence was over.

While in the custody of the French, Fernando VII had agreed to accept the Constitution of 1812. However, once on Spanish soil, finding that he had the support of the army and the church, he declared it null and void. Some of the provisions of the Constitution were desirable and needed. But the new king was an absolutist by tradition and inclination. Instead of compromising, he embarked on a program of repression and reprisal against all except the most conservative elements. Supporters of the Constitution, or of certain parts of it, rose against the monarchy. The uprising was led by Colonel Rafael del Riego. Discontent with the king's policies, even within the army, was so widespread that he was forced to accept the Constitution. For a time he was virtually a prisoner in his own kingdom.

Fernando appealed to the Holy Alliance for help. An army led by Louis Antoine de Bourbon came to the king's rescue. The show of force was enough to bring Fernando back to a position of absolute power. The Spanish people had not been ready to fight for the principles of the Constitution of 1812. The French army besieged the Cortes at Cádiz, to which city the king had been forced to move. When the Cortes, as a condition of surrender, asked for a general amnesty, Fernando agreed. After his release, the amnesty was not honored. The Constitution was abolished, and the king had the leaders of the Cortes executed.

Peasant superstitions fascinated Goya. Here a ucinatory group of witches gathers around their leader, a goat.

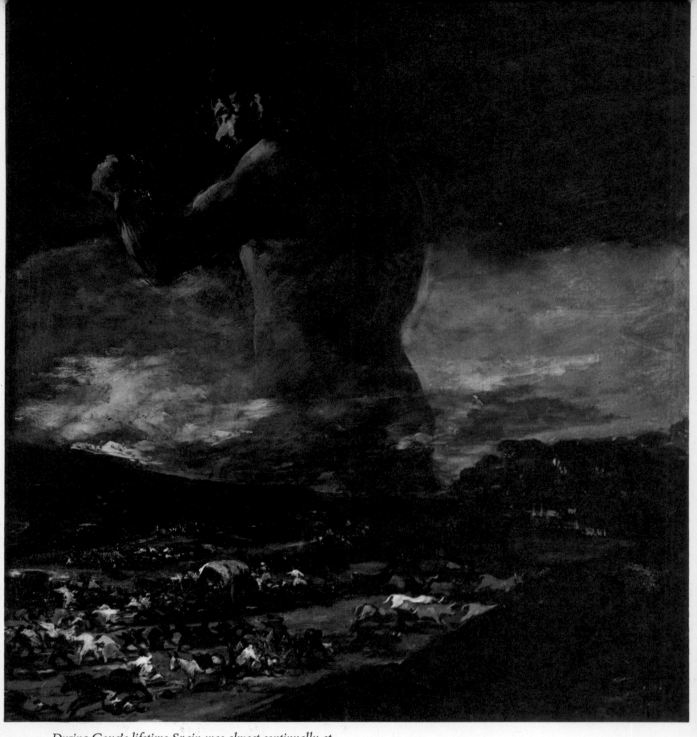

During Goya's lifetime Spain was almost continually at war. To him, war was a giant, brutal and careless, spreading panic.

Between 1808 and 1822 the Spanish colonies in the New World moved gradually toward independence. Great progress in economics, education, trade and social welfare had been made there during the rule of Fernando VI and Carlos III. The countries of South America and Mexico had never been more prosperous. But events were greatly influenced by the successful revolution of the United States against England. The rational philosophies of the 18th century and the ideas expressed in the French Revolution all had an effect. The most immediate factor in hastening their independence was the inability of Spain to govern effectively. While Fernando VII was a prisoner in France, Creole leaders in South America and Mexico formed their own governments. They professed to rule in the name of the king, but their organizations were the beginning of self-government. Those loyal to the Spanish crown tried to subdue the revolutionists.

In the northern colonies of South America the War of Independence was led by Simón Bolívar. In the south, José de San Martín, who crossed the Andes to overcome the royal army in Chile and Peru, and, to occupy Lima, resigned his leadership to Bolívar, who continued the fight until independence was achieved in 1822.

In Mexico the insurgents were led by two priests, Miguel Hidalgo and José Morales. Hidalgo's army

Fernando VII, a cruel reactionary, tolerated Goya as cpainter. But discouraged by king's despotism, Goya left Sp

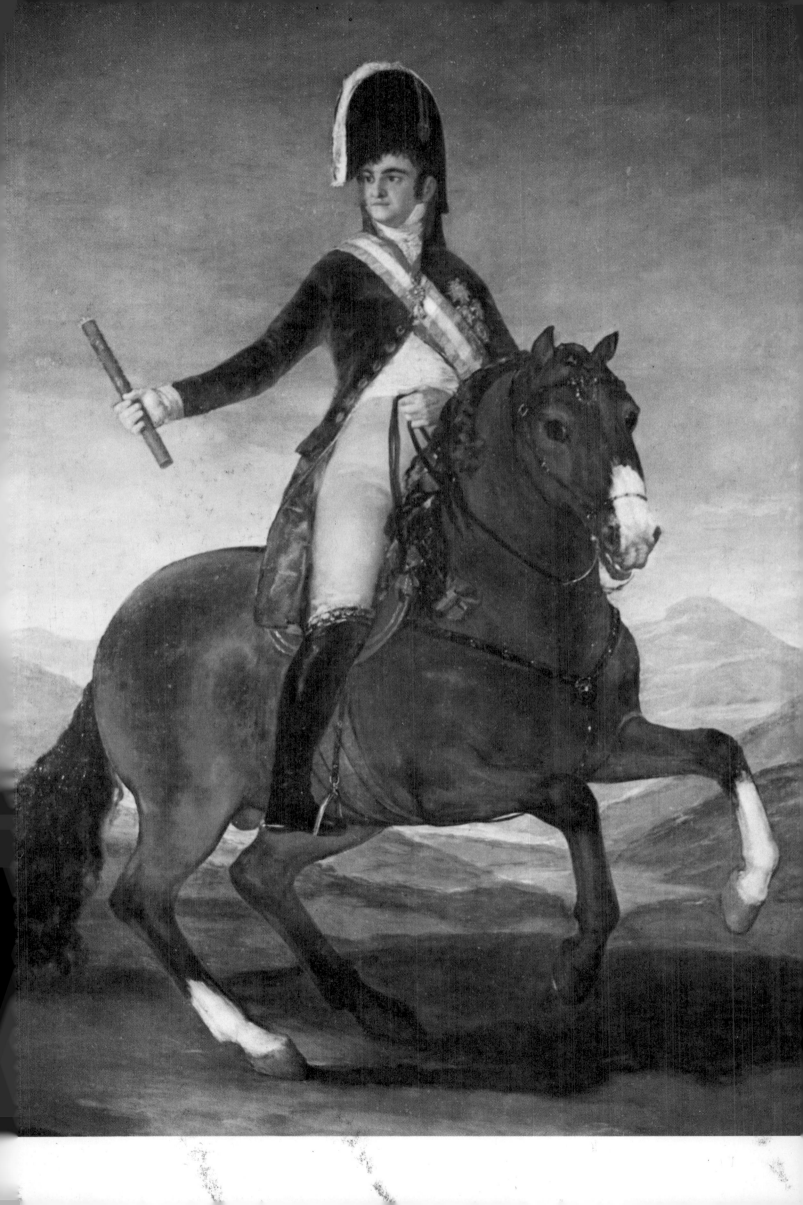

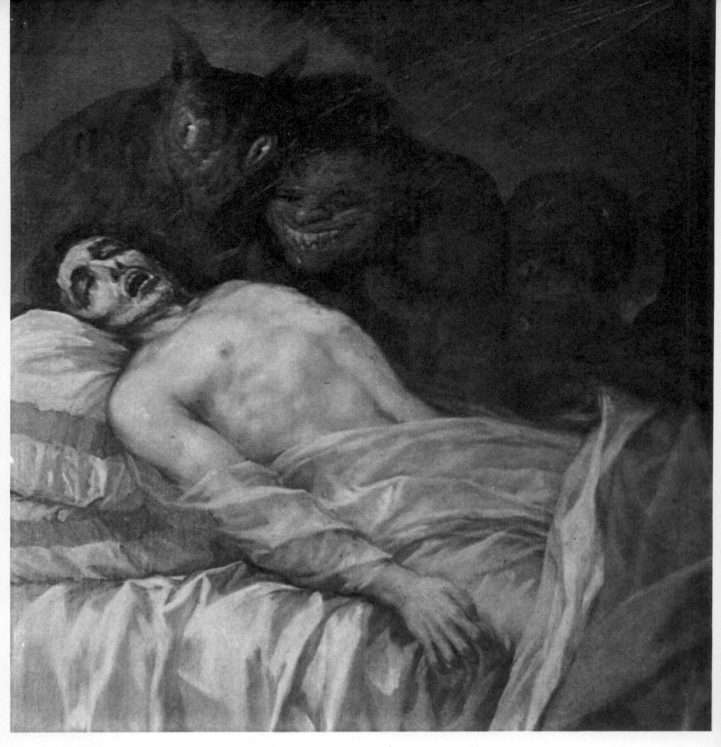

Macabre creatures of death wait to seize soul of a dying man, in detail of larger painting. Goya himself lived to be 82.

almost captured Mexico City. He was defeated and executed. Morales succeeded in assembling a congress, which drafted a constitution. He too was killed by royalist sympathizers, who suppressed the revolution.

When Fernando and Spain came under the control of the Cortes and the army in 1820, Mexican royalists and conservatives combined under Agustín de Iturbide, who was secretly committed to independence. Ostensibly supporting Fernando VII, Iturbide succeeded, on September 16, in proclaiming Mexico's independence.

His brother Don Carlos, who planned to succeed him, believed that Fernando would die without an heir, since he was still childless on the death of his third wife in 1829. But Fernando married María Cristina of Naples, who bore him a daughter, Isabel. Don Carlos had only one hope—the Salic Law forbidding women succession to the throne, adopted in Spain in 1713 to prevent union with France. Prior to that, the ancient law of Castilla and León had given women the right to rule. The Salic Law was invalidated by Carlos IV in 1789, so that Isabel could legally inherit the throne. But the Carlists—followers of Don Carlos—did not recognize the old Spanish law. When Fernando died, his daughter was proclaimed Queen as Isabel II. María Cristina was named regent. The first Carlist war followed.

CONSTITUTIONAL GOVERNMENT

The loss of overseas possessions, combined with internal strife and civil wars, brings on a constitutional monarchy and a first republic. The monarchy is soon restored, but under Alfonso XIII it gives way to a dictatorship and then to a second republic. A late-blooming romanticism in literature and painting accompanies Spain's withdrawal. The "Generation of 1898," a remarkable group of philosophers, educators, musicians, poets and painters, begins a cultural renaissance.

HISTORICAL CHRONOLOGY		ART CHRONOLOGY	
1833	Isabel II proclaimed Queen of Spain. First Carlist war begins.	1845	Painting of Antonio María Esquivel.
1839	Vergara agreement ends Carlist war.	1864	"Last Will of Isabel la Católica," by Eduardo Rosales.
1846–1849	Second Carlist war.	1870	Paintings of Mariano Fortuny.
1860	Spanish victory at Tetuán.	1881	Ricardo Bellver's "The Fallen Angel."
1868	Isabel II dethroned.	1883–1905	Architect Antonio Gaudí's church of
1870	Amadeo of Savoy elected King of Spain.		La Sagrada Familia (Holy Family) at
1873	First republic proclaimed when Amadeo renounces throne.		Barcelona, and his surrealistic Parque Güell, at Barcelona.
1874	In an Army pronunciamiento, Alfonso XII is proclaimed king.	1890	Spanish Dances and Goyescas of Enrique Granados. Albeniz presents his opera
1876	Carlist wars end. Constitution of the Notables makes the Catholic Church the official church in Spain.	1894	Pepita Jiménez. Works of Joaquín Sorolla.
1885	Alfonso XII dies. María Cristina of Hapsburg becomes regent.	1903	Picasso paints in Barcelona.
		1907	Works of Ignacio Zuloaga.
1895	Rebellion in Cuba.	1908	Cataldn Music Palace, by architect
1898	Explosion of battleship Maine. United States declare war on Spain. Spaniards are defeated. Spain recognizes independence of Cuba and Puerto Rico.		Luis Domenech y Montaner.
		1912	Works by Juan Gris.
		1913	Opera La Vida Breve (Life Short), by Manuel de Falla.
		1915	Ballet El Amor Brujo (Love the Sorcerer).
1902	Alfonso XIII becomes king.	1924	Monument to Spanish Nobel Prize winner
1930	Primo de Rivera resigns.		Ramón y Cajal, by Victorio Macho.
1931	Municipal elections are held. Alfonso XIII leaves Spain. The second republic is proclaimed.	1929	Salvador Dalí and Luis Buñuel make a surrealist film, "Le Chien Andalou."

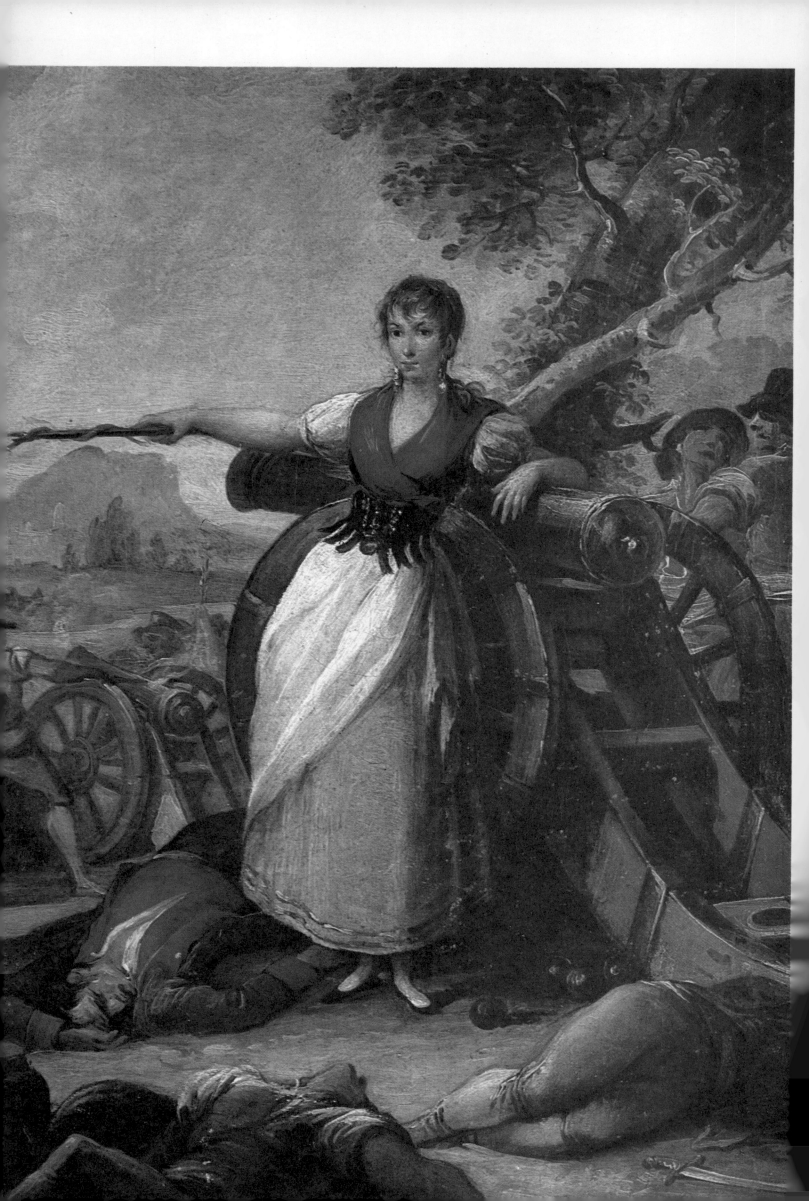

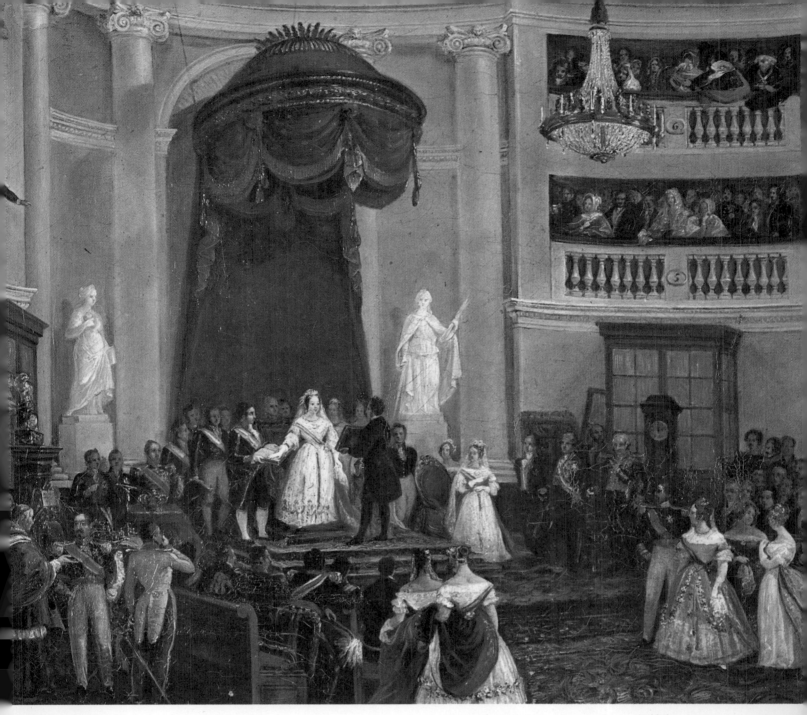

In 1843 Isabel II took an oath to uphold the constitution. Notorious for her immorality, she was deposed in 1868.

The Years of the Generals

t is surprising that Isabel II became ruler of Spain. The forces pitted against her succession were formidable. Yet the matriarchal tradition running deep through Spanish history helped María Cristina, her mother and regent, to defeat the Carlists and gain the crown for her. But a more important factor was the growing liberal element that opposed the traditionalism of her Carlist opponents. María Cristina

An early heroine was Augustina of Aragón, who helped cannon against French during defense of Zaragoza in 1808.

did not favor democratic reform in government; but if the Carlists—who supported Isabel's uncle, Don Carlos, as absolute monarch—were to be defeated, she and Isabel desperately needed the support of the liberals. The first Carlist war was fought not so much on the basis of the legal claim of Don Carlos, but because a passionate, dedicated section of the Spanish people favored a return to a kind of absolute monarchy that they felt would protect their individual freedoms (*fueros*), their regional individuality and their religious conservatism. Nobility within the Carlist movement represented a potent minority, but the war was fought primarily by peasants from those parts of Spain that held sacred the right of the individual to control his immediate

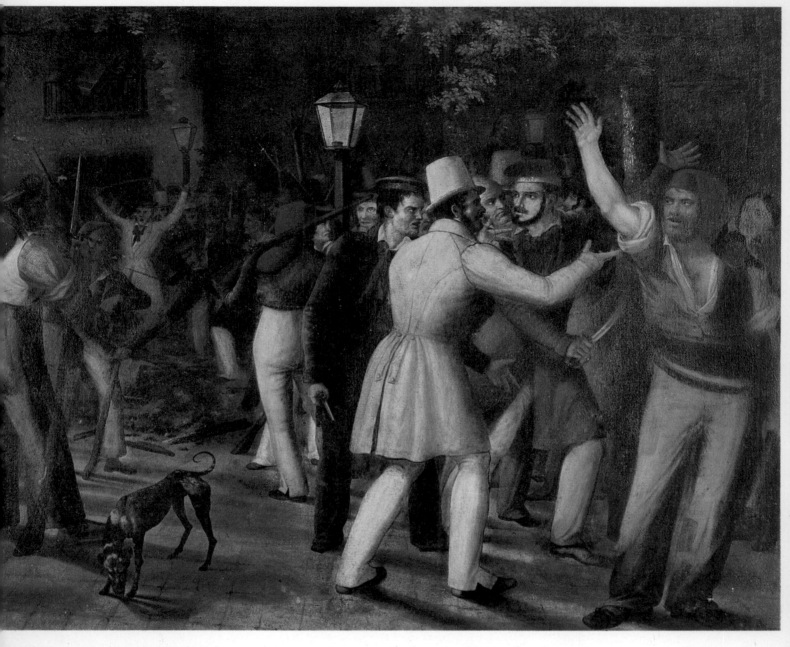

Rioting broke out in Barcelona in 1835 between supporters of Isabel and Carlists who opposed her accession to the throne.

environment. Basques, Catalans and Aragonese fought for the right of self-determination first and for Don Carlos afterward. They fought against a liberal sector which believed that if the country was to progress no separate laws and privileges could be granted to each region; that constitutional and representational government must prevail; that only a Spain united could solve its pressing problems. The principle of unity and limited monarchy won out. The Carlists and their supporters were defeated for the present, but the problem of a workable compromise system of government remained.

Isabel II came to the throne at the age of thirteen. She was as different from her ancestor, Isabel I, as can be imagined. Isabel I had been direct and opinionated; Isabel II was vacillating and had few thoughts of her own. The earlier queen had married a strong man and ruled with him as an equal; Isabel II married a weakling and allowed her government to be directed by three generals. Isabel I had been a woman of strong moral and spiritual integrity; it was generally known throughout Spain that Isabel II's opinions were those of her lovers, her confessors, or her military advisers. It was fortunate for both Spain and Isabel that three able men were available to direct the affairs of the country during the 25 years of the queen's reign.

General Ramón María Narváez brought Isabel to the throne by an army *pronunciamiento* that ended the regency and deposed the prime minister, Baldo-

In 1831, a group of liberals were executed as revolutiona after they had tried to put radical constitution into ef

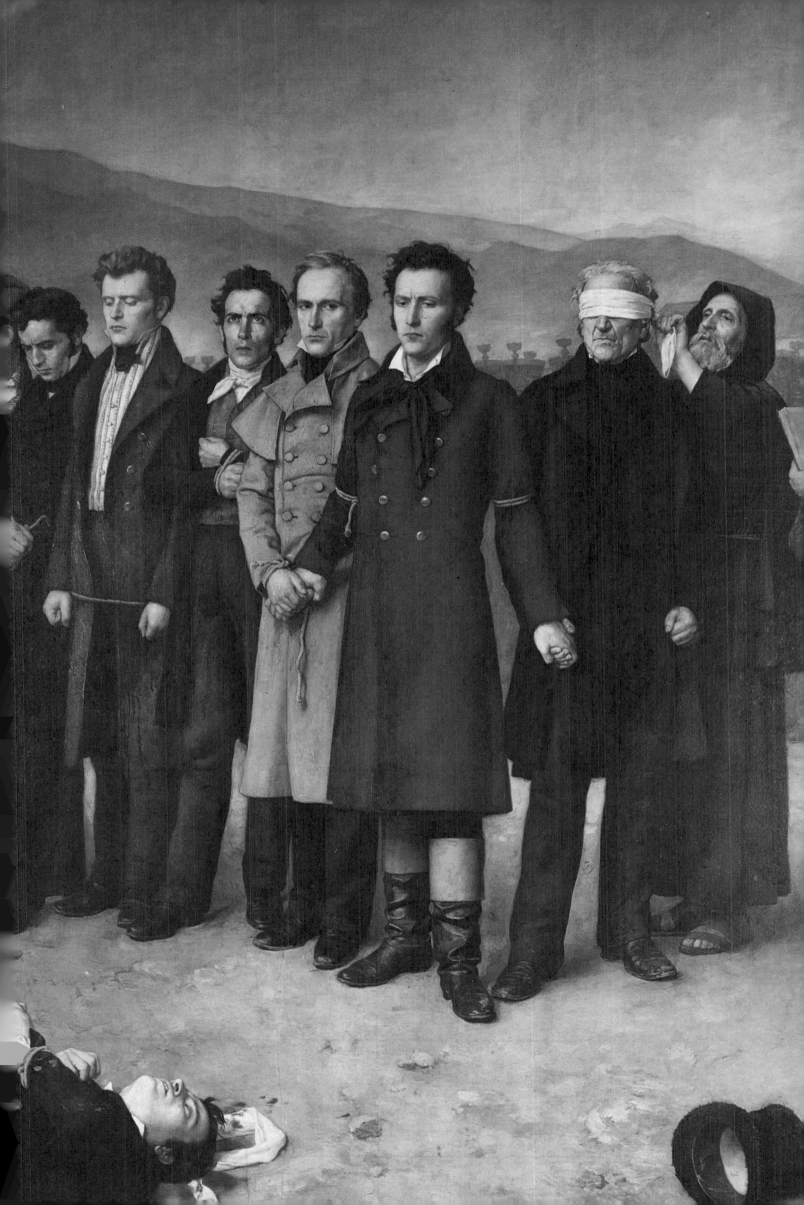

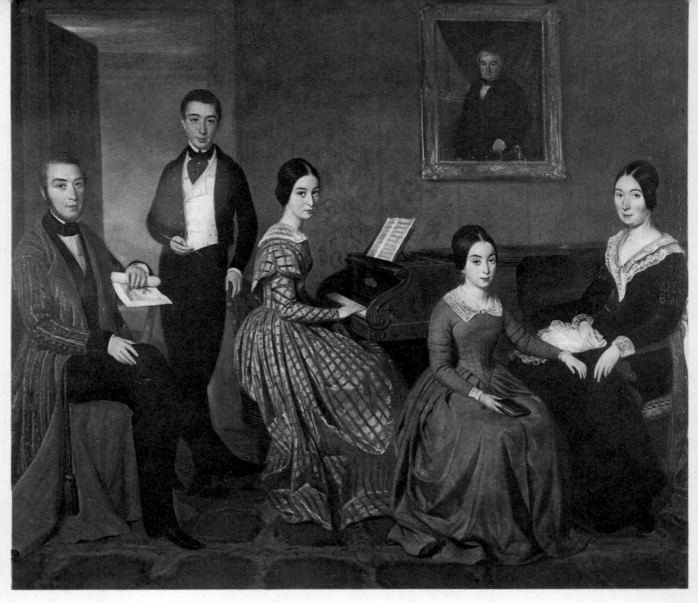

Typical bourgeois family was painted in the 1840s, a happier time, when wars were over and a new constitution in effect.

mero Espartero. Narváez was the leader of the *moderados*, the conservative party. A dependable soldier, with control over the army, he was frequently called upon for help by the queen when the monarchy was threatened. He moved quickly against rebellious elements, maintaining order by exiling or executing his enemies. Never a popular leader, he still served as prime minister five times.

His opponent, General Leopoldo O'Donnell, headed the Union Liberal party. Although a supporter of the crown, he was responsible for considerable constitutional gains. His enthusiastic followers especially respected him for his refusal to sell Cuba to the United States. His popularity increased after his success in the war with Morocco.

Also elevated to political importance by the Moroccan war was General Juan Prim, a skillful diplomat and patriot.

But nobody could cope with the capriciousness, dishonesty and immorality of Isabel II. After Admiral Juan Bautista Topete mutinied with a naval

squadron and part of the army, even General Prim opposed her. At 38 Isabel was exiled to France.

For the next two years the throne that had once been the envy of all Europe went begging. The country was not ready for a republic, and the Cortes voted to continue a constitutional monarchy. Yet a king could not be found. As the honor was turned down by one potential ruler after another, General Prim noted that the search for a democratic king was like looking for an atheist in heaven. After Leopold of Hohenzollern had first accepted and then rejected the crown, it was bestowed upon Amadeo of Savoy, Duke of Aosta. Proclaimed King of Spain by the Cortes in November 1870, he arrived six weeks later to find his supporter, General Prim, dying of wounds inflicted by an assassin. He also found himself attacked from every direction as a foreigner without experience in Spanish politics. Realizing the impossible task of ruling in a country where he had no strong supporters, he abdicated a little more than two years later.

Quite different in style is this photographic rendering of a politician making a speech in a

The academicians now dominated painting. Mythology and early history were represented on huge canvases. The most important artist was Mariano Fortuny, a Catalan. He painted with remarkable technical skill and dramatic realism.

Giant strides were made in Spanish literature. Pérez Galdós, a sensitive and prolific writer, wrote 46 novels on politics as well as social investigation and romance. The most important, *Fortunata y Jacinta,* has been compared to Tolstoy's *War and Peace.* It is a huge novel which reveals much about life in Castilla in the 1880s.

With Amadeo's abdication, in 1873, the Cortes proclaimed Spain's first republic. Constant dissension stifled it from the beginning. There had been little agreement on aims before it was formed, and even less afterward. Four presidents served during the eleven months of its life. None of its cabinets achieved stability. Many regions broke away and governed themselves.

The republic could not have been born at a worse time. It had to face an insurrection in Cuba, monarchist opposition and the Cantonalists (a group which seized the port of Cartagena and the major part of the Spanish navy anchored there). In addition there was a new Carlist revolt. Each day made it increasingly clear that only a strong army could restore order; yet recourse to the army would bring down the republic itself, for one of its most important programs was the end of conscription and the removal of the army from politics. With no other way open, the army at last was summoned and took over the government. Order was restored; but the first republic had died in its infancy.

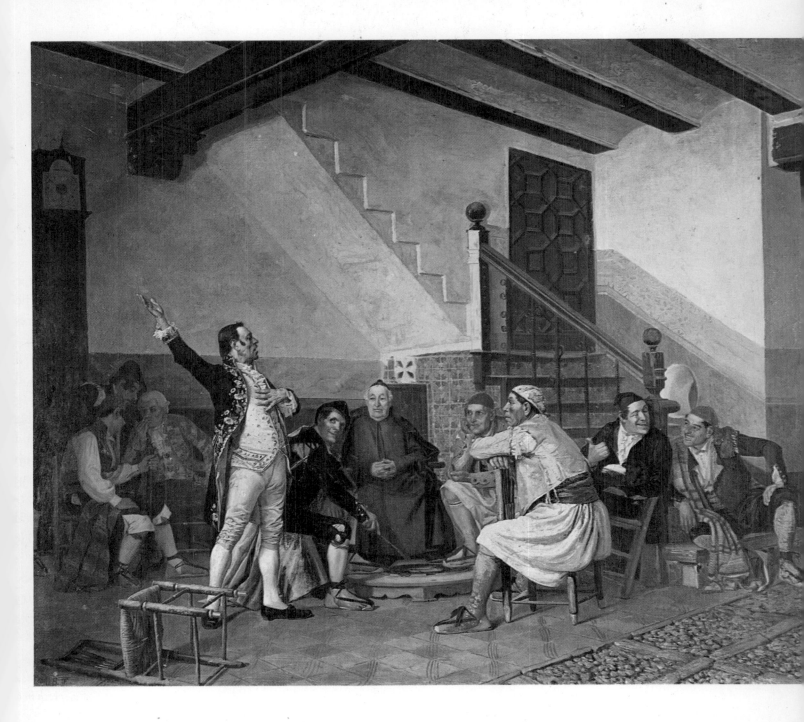

At a soiree held in the artist Esquivel's
studio, 19th-century poet and playwright José Zorrilla, author

Don Juan Tenorio, reads his latest work to a gathering of his
contemporaries. Each is painted so carefully as to be identifiable.

Latter-day resumption of the crusade against the Moslems took place in 1860 when a small expeditionary force under General

O'Donnell (left rear) routed Moroccans at Tetuán. O'Donnell
and other generals were Spain's true rulers during Isabel's reign.

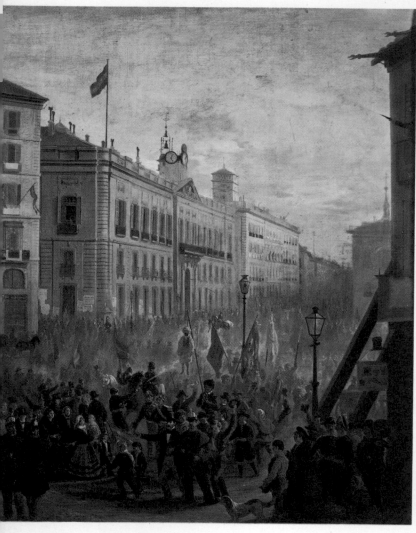

The war in Morocco inspired a mock hanging of a Moslem effigy in Madrid's ancient Puerta del Sol (Gate of the Sun).

New Directions

When Isabel II was exiled, her son Alfonso accompanied her. At the fall of the first republic he was enrolled at the Royal Military College in England. The army, feeling it had a leader in him, summoned Alfonso to the throne. All supported him except the Carlists, who fought for a year but were defeated.

The rebellion in Cuba was put down after 18 months; Spain agreed to reforms and eventual self-government for the island. In the comparative quiet that followed, the Constitution of 1876 was adopted. For the first time, the limited monarchy of Alfonso XII was able to attack the internal problems of the country without the continuous upsets that had plagued the reign of his mother. There was, in

this period, a rapid expansion of industry, commerce and transportation.

The reign of Alfonso XII ended after eleven years, when he died of tuberculosis, leaving his widow, María Cristina of Austria, pregnant. Their only son was born after the king's death.

María Cristina's regency from 1885 to 1902 marks the beginning of contemporary Spain. The queen mother was a woman of dignity and tact. With Antonio Cánovas del Castillo (who had also been Alfonso XII's premier), she faced the greatest colonial difficulties in Spain's history. Defeat of the Spanish garrison in Morocco led to the dispatch of a huge army. Diplomatic moves and the threat of

King Alfonso XII attends the opening of the newly restored chapel in the Royal Palace in 1878. He ruled only eleven years

*Following ancient custom, inhabitants of Madrid look for
Wise Men on night of January 5, the Carnival of the Nativity.*

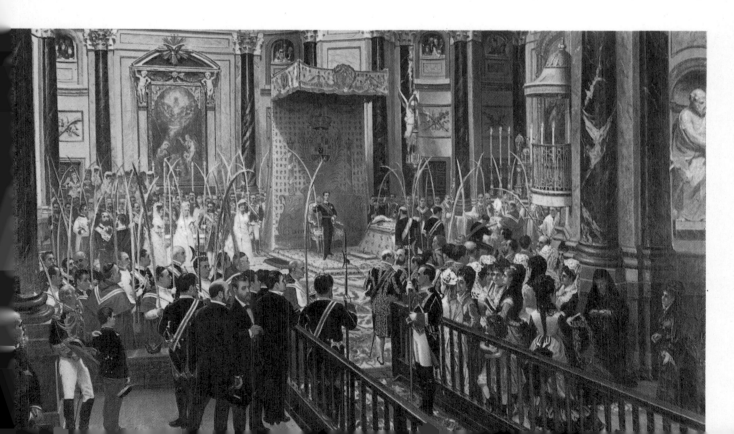

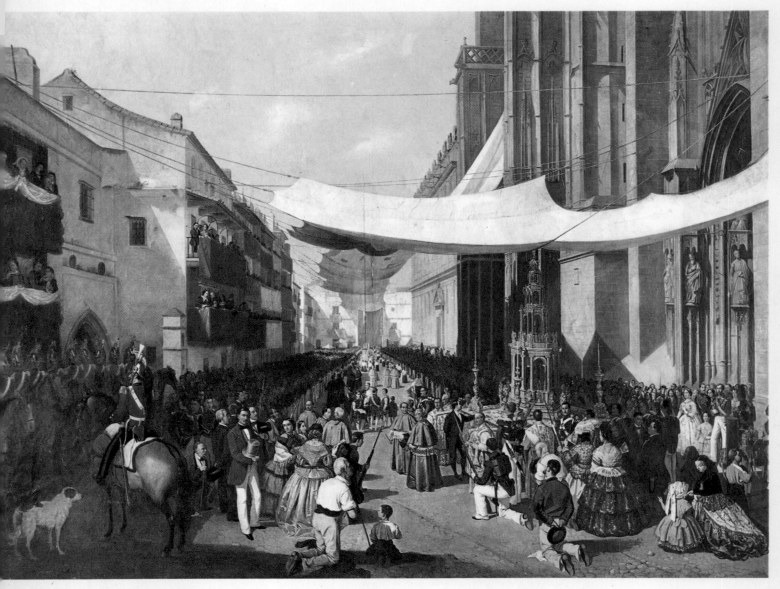

*Feast of Corpus Christi is still major event. Anticlericalism
rose in 19th-century Europe, but faith remained strong in Spain.*

force brought peace in that area. A new uprising
had taken place in Cuba. Creole leaders and revo-
lutionists had United States sympathy and arma-
ments, and negotiations went badly from the start.
The United States would accept only withdrawal
of Spanish troops from Cuba as a preliminary to
peaceful negotiations. Realizing this would mean an
end to her colonial possessions in the New World,
Spain, with typical fatalism, did not concede.

On February 15, 1898, the battleship *Maine* ex-
ploded in the harbor of Havana. The United States
blamed the disaster on the Spaniards. The war that
resulted lasted only three months. The Spanish fleet
was crushed in the Philippines and the Caribbean.
Communication between Spain and the colonies
ceased. Spain had no choice but to ask for peace.

Spanish rule in the Americas was ended. Spain
renounced claims to Cuba and ceded Puerto Rico,
Guam and the Philippines to the United States for
$20,000,000. Such Pacific islands as she still held
were sold to Germany.

Over many generations criticism against Spain
for her actions in the New World has been acute.
Yet her literature, art and architecture became the
basis of civilized culture in much of the Americas.
She brought a far higher civilization than the pio-
neers who were later to push their way across the
northern regions. The other European nations
destroyed large numbers of the native population,
but only the Spaniards educated and integrated the
Indians that remained. Spain gave to her colonies
the very qualities that made them strong enough to
break away from her and yet retain their essential
Spanish heritage.

*At Easter, floats are borne through streets escorted
by members of religious orders wearing peaked hoods and gowns*

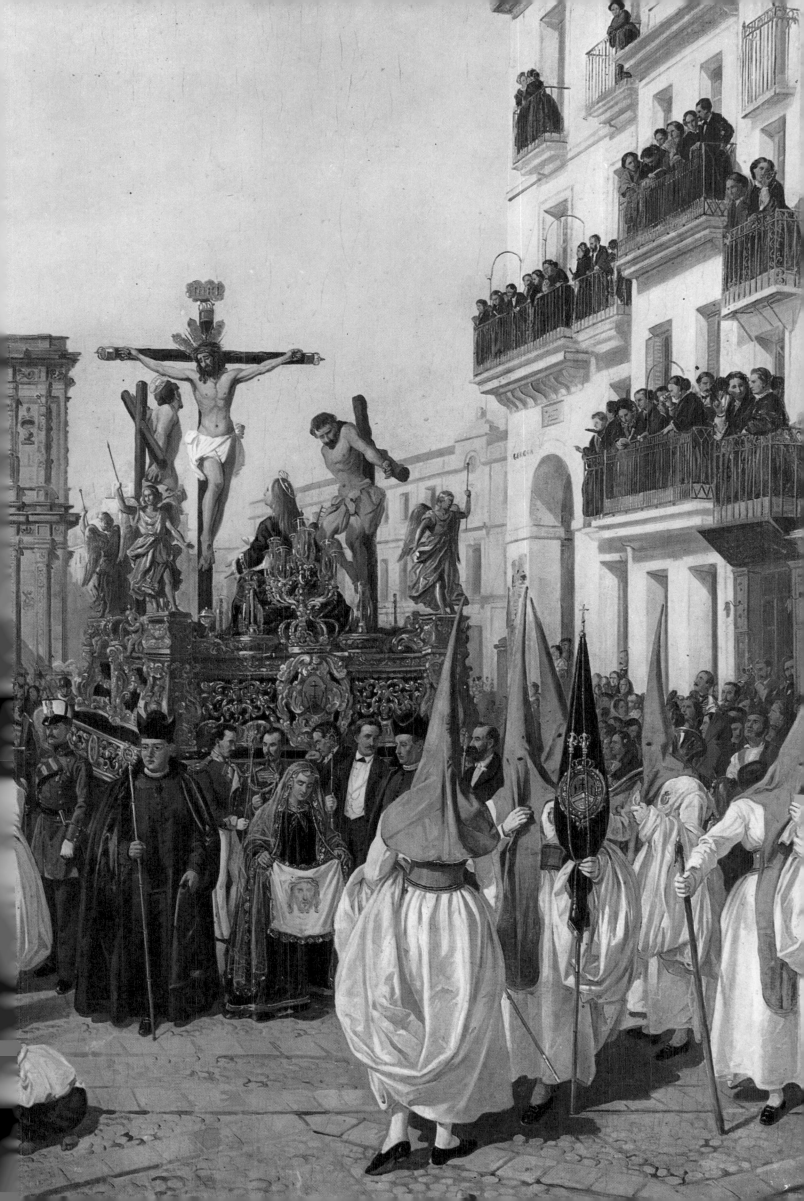

Cataluña was a center of political unrest. In 1895 a revolutionary threw a bomb in Barcelona's exclusive Liceo theater club.

Bomb thrower was executed by garrote as shown in this superrealistic painting by Ramón Casas, a friend of Picasso.

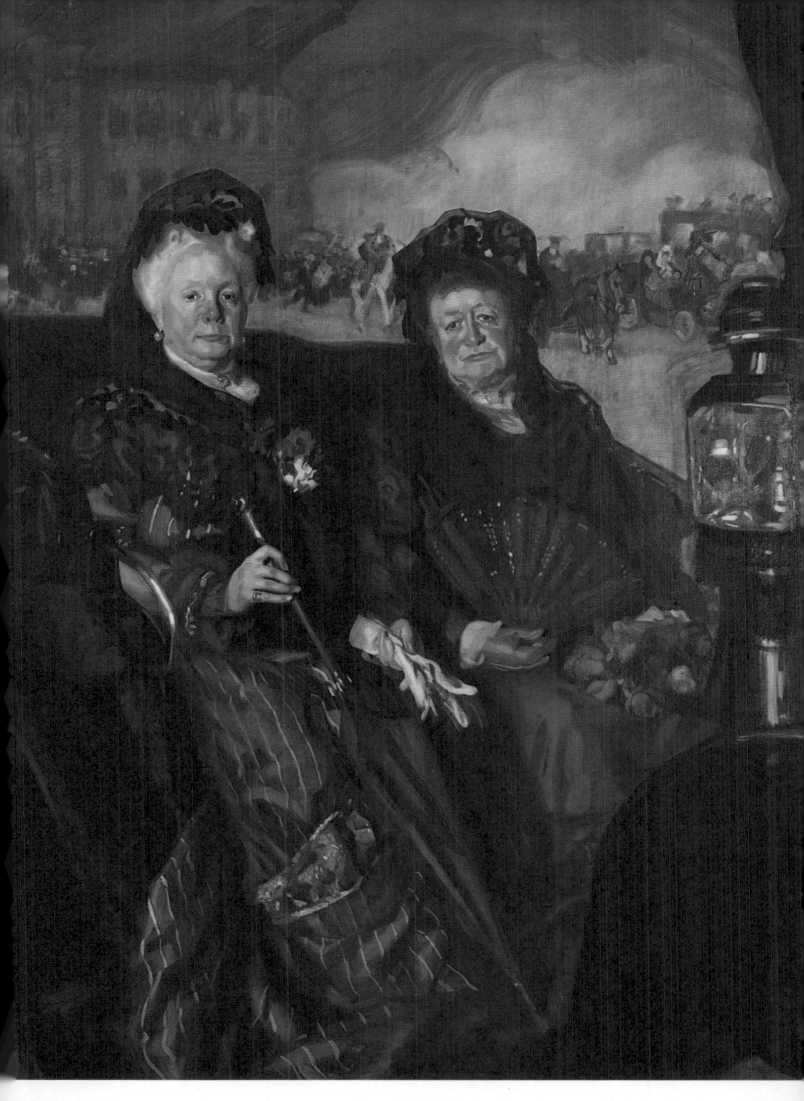

Two ladies of the ancien régime, the Infanta Isabel (aunt of Alfonso XIII) and the Marquesa de Najera, leave the bullfights.

Extreme and widespread pover
partly associated with growing industrialization, caused soc

...nrest and considerable crime. Here, in painting dated 1901, a
...ang of prisoners is marched off to prison by Guardia Civil.

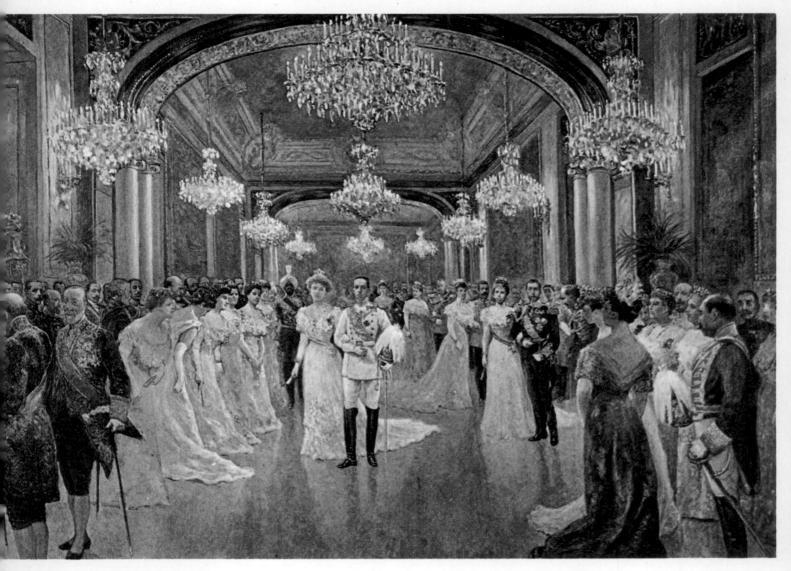

Though assassin tried to kill Alfonso XIII at his own wedding in 1906, king refused bodyguards, was called "muy valiente."

A Cultural Renaissance

The end of María Cristina's regency and the reign of Alfonso XIII signaled the beginning of a great renaissance in Spanish art and literature. A far-reaching movement was initiated in Madrid by Francisco Giner de los Rios and other university professors, who established a free school for advanced study, the Institución Libre de Enseñanza. It was largely from this school that the so-called "generation of

'98" emerged. Its members took on the task of reevaluating Spain and the Spaniards, a task which Ángel Ganivet, who died in that very year of 1898, had already started. His book *Idearium Español* led a number of important writers who came to maturity in the first quarter of the 20th century—Unamuno, Ortega y Gasset, Azorín, Pío Baroja, Valle Inclán, Menéndez Pidal, Maetzu—to ask searching questions: Where had Spain's natural evolution gone wrong? What should she have done about her expansion program in the New World? Could her defeats in Europe have been avoided? Were outside pressures or internal issues responsible for her disasters? Was it a matter of the Spanish personality? Although the members of the new generation rarely agreed either on the questions or the answers, their

probing, their awareness, their creative impulse and technical skills brought Spain to as high an intellectual level as that enjoyed by any country in the world.

Poetry, which had been a wilderness of rhetoric almost since the Golden Age—with the exception of a few isolated sparks like the lyric poet Gustavo Adolfo Bécquer, the Galician poetess Rosalía de Castro, and the Catalan epic poet Jacinto Verdaguer—now burst into a whirlwind of ideas. The trail was blazed by the Nicaraguan Rubén Darío, who introduced the Spanish-speaking world to French symbolism. His breakthrough was followed by Juan Ramón Jiménez, Antonio Machado and, in the late 20s, by a constellation of new poets of whom Federico García Lorca is perhaps the best known.

A parallel explosion occurred in music. A national school was founded by the Catalan composer and musical scholar Felipe Pedrell, who taught a trio of composers: Isaac Albéniz, author of the piano suite *Iberia;* Manuel de Falla, who wrote *El Amor Brujo (Love the Sorcerer),* and raised the Andalusian folksong—the *cante hondo*—to symphonic heights;

and Enrique Granados, a promising young composer who was killed during World War I on a ship torpedoed by the Germans—as he was returning to Spain from the New York opening of his opera *Goyescas.* World-renowned performers, such as the guitarist Tárrega, his successor Andrés Segovia, and the cellist Pablo Casals, round out this bright period.

In painting, the search for new visual means of expression began a revolution which spread from Spain and changed the history of art throughout the world. It was led by a quartet of young artists: Pablo Ruíz y Picasso, born in Málaga and reared in La Coruña and Barcelona; Juan Gris (José Victoriano González), from Madrid; Joan Miró, from Barcelona; and Salvador Dali, who came from Figueras, Cataluña.

The oldest of the four was Picasso. He was five years old when the heir to the throne was born. He was 21 and painting in Barcelona when Alfonso XIII began his rule. In the years between Pablo had lived almost always with brush or pencil in hand. Beginning at the age of seven, he drew pictures of his family and, when he was thirteen, his father—José

Illuminated by the moon and Japanese lanterns, garden party in Madrid's Campos Elíseos presents a romantic scene.

"The Woman Driver" by Ramón Casas, member of Barcelona group that included Picasso, is modern in theme and style.

By 1910 Spanish women were comparatively emancipated. "The Display Case" contrasts fashions, conspicuously omits the mantilla.

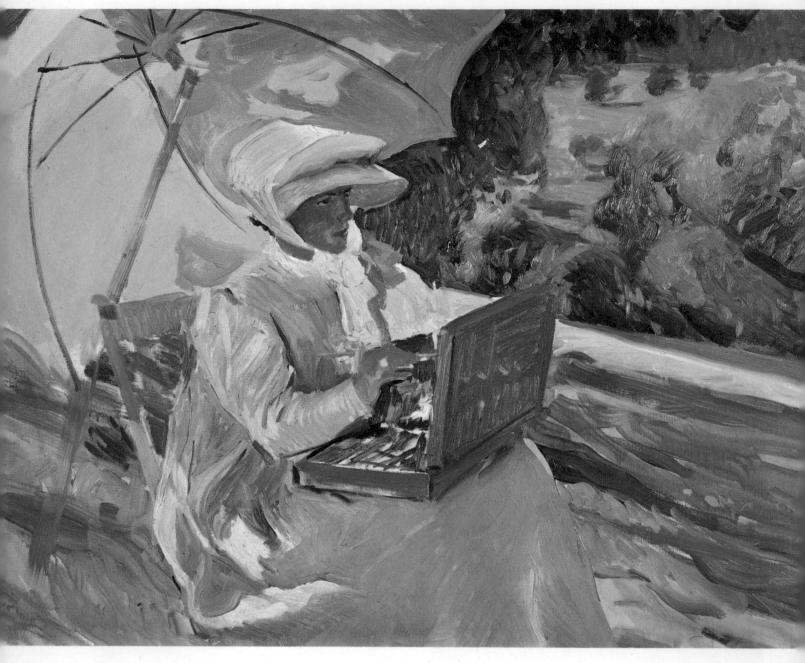

Impressionist painter Joaquín Sorolla was famous for his sunlight effects. Here his daughter sketches in a park.

Ruíz, also an artist—was so impressed by Pablo's talent that he gave up painting and formally presented his oils and brushes to his son. Next came study at the Barcelona Province Art School (La Lonja), where he passed the entrance examinations in a single day (they usually required a month). From Barcelona his studies took him to Madrid and a brief enrollment at the Royal Academy of San Fernando. But there he found the teaching too academic for his restless pen and quick intelligence. He returned to Barcelona within the year. In this cosmopolitan city he found the ideal atmosphere for his visual experiments. The old quarter of Barce-

lona was noted for its exuberance, youthful zest and hospitality to artists and writers. There Picasso met friends like Nonell, the artist who was to influence him by his sensitive impressions of the gypsies; the painter Ramón Casas; the sculptor Julio González; Miguel Utrillo, who was rediscovering and writing about the ancient Romanesque art of Cataluña and praising the modernity of El Greco. There, too, he met his lifelong friend, the poet Jaime Sabartés.

In Picasso's work scarcely an art form is unexplored or untouched by his genius. In Miró there is the color and gaiety of Cataluña. Juan Gris's austere architectural arrangements evoke the pure

Victoria Eugenia, shown in unfinished portra
Sorolla, went into exile with her husband, Alfonso XIII, in

color and line of Zurbarán. Dali looks back to the realism of Roman mosaics and early Christian painters and more recently to the fantastic imagery of Gaudí.

In the Barcelona of Picasso's early years Antonio Gaudí had boldly started to create a series of buildings that were to become the cornerstone of the Art Nouveau movement in architecture. Gaudí went further than any architect before him, and in the process managed to solve a number of difficult structural problems. Based upon his theory that buildings should have a "natural" form, he created a house with a façade in the shape of a sea wave. Another, Casa Milá, resembles a serrated mountainside; it has an undulating roof and the chimneys are huge corkscrews winding toward the sky. Avoiding flat surfaces and straight lines, his structures look as though they might have been made by hand, free-formed from clay. Another of Gaudí's unique works is the Expiatory Church of the Holy Family (Sagrada Familia). In it, and even more so in the famous Parque Güell, the most fantastic park ever created, may be seen the earliest experiments in surrealist art.

At the time that Gaudí was producing his architectural fantasies, Picasso and his friends were frequenting a small café in Barcelona called Els Quatre Gats (The Four Cats). There Picasso drank wine, painted portraits of his friends, and in 1900 held his first exhibition. Picasso returned to Madrid in 1901, where he came under the influence of the most important literary figures of modern Spain. With a friend, Francisco de Asís Soler, he published a magazine called *Arte Joven (Young Art)*. Picasso was art director, Soler the literary editor. When the magazine failed, Picasso moved back to Barcelona. From there he traveled to Paris, but throughout his life he has made frequent trips to Spain and has never ceased to think of himself as a Spaniard.

The political climate of Spain during the reign of Alfonso XIII was conducive to this development of the arts. There were still frequent cabinet changes (33 different governments in all), but less internal and external warfare. Acts of violence persisted. An assassin attempted to kill the king on his wedding day. Throughout his reign other plots against his life occurred. The public admired his courage, for, despite the continuous threats, he traveled around the country freely, ignoring official bodyguards and taking few precautions for his safety.

During World War I, Alfonso managed to keep Spain completely neutral, even though his country lost some 65 ships to German submarines. During the war years and for some time afterward the liberals (or leftists) were primarily intellectuals, members of the merchant middle class, and industrial workers. On the right were the clericals, the bureaucracy and members of the Carlist party. As the industrial power of the country increased, labor organizations grew, and some strikes occurred. A gen-

Considered a living art by Spaniards, bullfighting is still spectacular entertainment. Matador distracts bull from fallen picador.

eral railroad strike was settled when Prime Minister José Canalejas Méndez inducted the strikers into the army. He forced them to continue on their jobs as soldiers, a technique that was to be adopted later by other countries. As the king grew older he began to vacillate between liberal policies and extreme conservatism.

But the country continued to prosper. During the war years gold reserves were quadrupled. After the war, the government was able to take over ownership of the railroads, pay off the national debt and contribute to the establishment of new industries. A large-scale attack was made on illiteracy. New schools and universities were founded.

While the army was the real source of power throughout most of Alfonso's reign, he was occasionally accused of stepping outside the representational framework of his government and indulging in unconstitutional practices. Always adventurous and sometimes reckless, the king decided to back an expedition against the Rif tribesmen, who had been attacking Spanish colonies in Morocco. A trusted

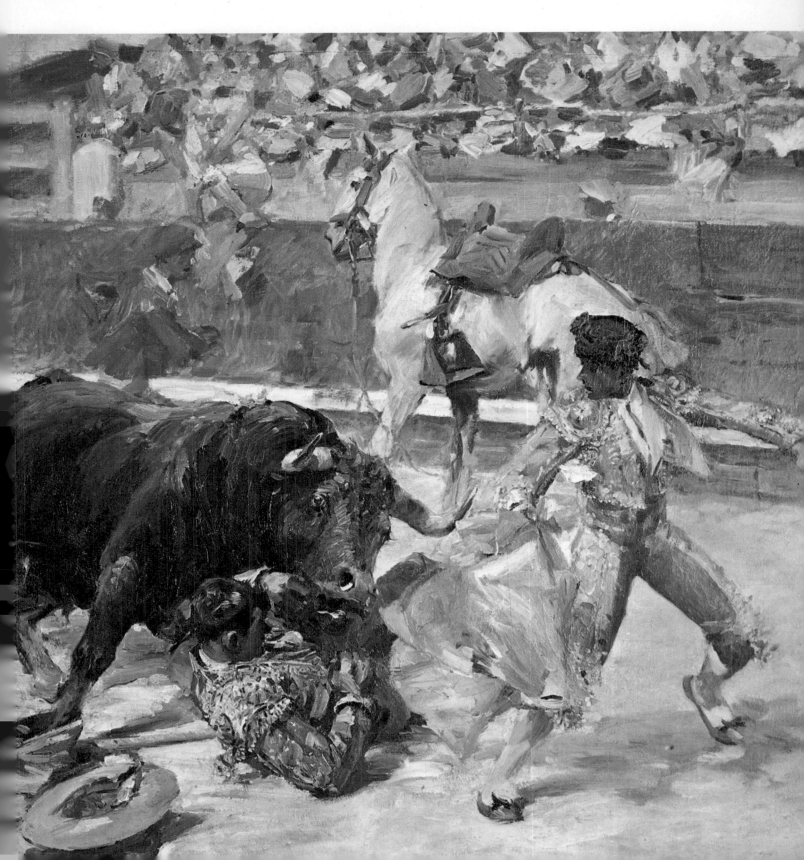

general, Fernández Silvestre, assured him of a glorious victory in Africa. When the expedition turned out to be a complete debacle, with many Spaniards killed and others stranded or imprisoned in Morocco, the general killed himself. Alfonso was left with the responsibility of backing the expedition without having had sufficient authority from either the government or the army.

A military dictatorship resulted when the captain general of Cataluña, Miguel Primo de Rivera, rejected the authority of the government and threatened to jail members of the Cortes. His *pronunciamiento* set up a military directorate with himself as the only minister. When the king refused to convene a new Cortes within three months of the dissolution of the previous one, it was obvious that the dictator was operating with his tacit approval. For the next seven years Primo de Rivera ruled Spain in Alfonso's name. He pacified the Spanish possessions in Morocco by waging swift warfare against the Rif. In Spain, the premier was successful in handling the finance and public works program and in advancing industrial projects, but was completely unable to reconcile the opposing political elements. Three attempts were made to overthrow his regime. As the situation grew more chaotic and the republicans gained more power, his control weakened until even the army deserted him.

When the dictator fled to France, the king made an attempt to bring back a constitutional monarchy, but it was too late. The republican-dominated Cortes demanded the king's abdication. This he refused, but, in an attempt to save the country from a civil war, he agreed to leave Spain.

A train chugs through the Pyrenees in painting in pointiste manner by Regoyos. Railways helped lessen regionalism.

Joan Miró, an early leader in the current renaissance in Spanish art, painted Catalan farm with typical humor in 1922.

Influential member of Barcelona group was Isidre Nonell,
whose character studies of gypsies influenced the young Picasso.

The history of Spain reveals a continuous internal struggle. Social and political considerations based upon the early separation of the country into Celtic and Iberian regions, which led to the formation of independent kingdoms, made united effort difficult. This sketch of some of the major events in Spanish history reveals a Spain often divided against itself. The vitality and cohesiveness of the Spanish nation is in its individuals. Its history is therefore best revealed by the actions of its literary characters—La Celestina, Don Juan, Cervantes' immortal knight Don Quixote and his squire Sancho Panza. And along with the great literature there are the vivid paintings—in a continuous line that mirrors Spanish life, from the cave paintings of Altamira, the rock art of the Spanish Levant, through the visions of Berruguete, El Greco, Velázquez, Zurbarán, Goya and Picasso.

Standing bowed but unyielding as rocks on a seashore, Pica
family group typifies the permanence of the Spanish chara

THE WORKS OF ART

MOSLEM AND
CHRISTIAN SPAIN

58-59 Miniature paintings from the *Cantigas of Alfonso X;* parchment codex with illuminated miniatures and musical scores; El Escorial

60-61 *Attendant playing chess with unseen Queen and servant playing lute (Acompañante jugando ajedrez con la reina y sirvienta tocando el laúd);* from the Book of Chess, Dice and Checkers (*Tratado de Ajedrez, Dados y Tablas);* illustrated parchment; c.1283; El Escorial

62-63 *Moors playing chess (Moros jugando al ajedrez);* Ibid.

65 *Saint Beato of Liébana (San Beato de Liébana);* Apocalyptic Commentaries (Comentarios al Apocalipsis); c.970; Biblioteca Nacional, Madrid

66 *Moors playing chess (Moros jugando al ajedrez);* from the Book of Chess, Dice and Checkers (see page 60-61)

67 *Sancho the Brave (Sancho el Valiente);* manuscript; c.1285; Biblioteca Nacional, Madrid

68 A scene within city walls, possibly Sevilla; *Codex Emilianensis;* illustrated parchment; 10th century; El Escorial

70 King Alfonso II accepting codex from the author; *Libro de Feudos,* an illustrated codex commissioned by the King and written by Raimundo de Caldes between 1162 and 1196; Archivo de la Corona de Aragón, Barcelona

71 Bernardo Aton, Viscount of Bejiers, gives his daughter in marriage to Gaufredo, Count of Rosellón (Bernardo Aton, Vizconde de Bejiers, da a su hija en matrimonio a Gaufredo, Conde de Rosellón); from the *Libro de Feudos* (see page 70)

72-73 *The Hunt (Cacería);* 12th century; Museo del Prado

73 *Musicians (Figuras con instrumentos);* tiles; Mudéjar; 14th century; Museo Arqueológico, Córdoba

74-75 *Book of the Coronations of the Kings of Castilla (Libro de las Coronaciones de los Reyes de España);* parchment with engravings; 14th century; El Escorial

76-77 *Conquest of Majorca by Jaime I of Aragón (La Conquista de Mallorca por*

Jaime I de Aragón); mural; 14th century; Museo de Artes de Cataluña, Barcelona

78 from the *Book of Mineralogy (Lapidario);* ink on parchment; c.16th century; El Escorial

79 from the *Cantigas of Alfonso X* (see page 58-59)

80-81 *Alfonso X with his court (Alfonso X y su corte);* from the Book of Chess, Dice and Checkers (see page 60-61)

82-87 from the *Cantigas of Alfonso X* (see page 58-59)

88 *Men playing dice (Hombres jugando a los dados);* from the Book of Chess, Dice and Checkers (see page 60-61)

89-96 from the *Cantigas of Alfonso X* (see page 58-59)

97 *Virgin of Tobed with Enrique II of Trastamara and his wife and daughters (La Virgen de Tobed con Enrique II de Trastamara y su mujer e hijas);* oil on canvas; Jaime Sena; 1410; coll. of the Sres. Birk, Barcelona

98 *Meeting (Asamblea);* painting on leather ceiling of the Sala de los Reyes; late 14th century; Palacio de la Alhambra, Granada

99 from the *Cantigas of Alfonso X* (see page 58-59)

100-101 *Hunting (Cacería);* painting on leather ceiling of the Sala de los Reyes; late 14th century; Palacio de la Alhambra, Granada

102-103 *Duel (Duelo);* painting on leather ceiling of the Sala de los Reyes; late 14th century; Palacio de la Alhambra, Granada

104 *Santiago fighting the Arabs (Santiago guerrea contra los Árabes;* oil on canvas; Juan de Flandes; c.1500; Museo Lázaro Galdiano, Madrid

THE CATHOLIC
SOVEREIGNS

106 *General Genealogy of the House of Hapsburg (Genealogía General de la Casa de Habsburgo);* codex; Juan Tirols; 16th century; El Escorial

107 *Virgin of the Catholic Sovereigns (La Virgen de los Reyes Católicos);* painting on wood, Anon. (Escuela Hispano-Flamenca); 1490; Museo del Prado

109 *Isabel the Catholic (Isabel la Católica);* oil on wood; B.Bermejo; 1493; Palacio Real, Madrid

110 *Saint Jerónimo (San Jerónimo);* oil on canvas; Segovia School; 1500; Museo Lázaro Galdiano, Madrid

111 *The Annunciation with the first Duke of Alba (La Anunciación con el primer Duque de Alba);* tablet; Anon.; 1470-1500; coll. of the Duke of Alba, Madrid

113 *Auto de fe presided over by Saint Dominic of Guzmán (Auto de fe presidido por Santo Domingo de Guzmán);* oil on canvas; Pedro Berruguete; c.1865; Museo del Prado

114-119 *The Battle of Higueruela (Batalla de Higueruela);* fresco; Anon.; 1431; Hall of Battles, El Escorial

120 *Surrender of Granada to the Catholic Sovereigns (Entrega de la ciudad de Granada a los Reyes Católicos);* altar relief; Felipe Vigarny; 1520; Capilla Real, Granada

121 *Baptism of the Moors (Bautismo de los moriscos);* altar relief; Felipe Vigarny; 1520; Capilla Real, Granada

122-123 *Surrender of Granada to the Catholic Sovereigns (Entrega de la ciudad de Granada a los Reyes Católicos);* altar relief; Felipe Vigarny; 1520; Capilla Real, Granada

125 *Interrogation of the Jew (Interrogatorio del judío);* altarpiece; oil on canvas; Anon.; 1485; Museo de Bellas Artes, Zaragoza

126-127 *Fernando and Isabel;* wood sculptures; Felipe Vigarny; 16th century; Capilla Real, Granada

128 *Cardinal Cisneros entering Oran (Entrada del Cardenal Cisneros en Orán);* mural; Juan de Borgoña; early 16th century; Capilla Mozárabe, Catedral de Toledo

THE NEW WORLD
EXPLORED

130-131 *The New World in the Year 1500 (El Nuevo Mundo en el año 1500);* map; Juan de la Cosa; 1500; Museo Naval, Madrid

132a,b,c *Gold figures (man, woman and helmet) (Figuras de oro – hombre, mujer y casco);* Quimbaya Indians of Colombia; c.1500; Museo de América, Madrid

191 *Landing in the Azores (Desembarco en las Azores);* fresco; Anon.; c.1600; Hall of Battles, El Escorial

192–193 *The Dream of Felipe II (Sueño de Felipe II);* oil on canvas; El Greco: c.1577–1582; El Escorial

194 *Felipe II;* oil on canvas; Juan de la Cruz Pantoja; 1598; Museo del Prado

194–195 *Pantheon of Kings (Panteón de los Reyes);* designed by Juan Bautista Crezenci; mid-17th century; El Escorial

196 *View of Toledo (Vista de Toledo);* oil on canvas; El Greco; c.1570; The Metropolitan Museum of Art, bequest of Mrs. H.O.Havemeyer, 1929; The H.O.Havemeyer Coll.

197 *Felipe III;* oil on canvas; Juan de la Cruz Pantoja; 1606; Museo del Prado

199 *Don Miguel de Cervantes Saavedra;* oil on canvas; Juan de Jaurigni; 1600; Real Academia de la Lengua, Madrid

200 *Felipe IV on Horseback (Felipe IV a Caballo);* oil on canvas; Don Diego Velázquez de Silva; 1636; Museo del Prado

201 *Queen Doña Isabel of France, Wife of Felipe IV (La Reina Doña Isabel de Francia, Mujer de Felipe IV);* oil on canvas; Don Diego Velázquez de Silva; 1636; Museo del Prado

202 *The Attendants, or The Family of Felipe IV (Las Meninas, o La Familia de Felipe IV) (detail showing the artist);* oil on canvas; Don Diego Velázquez de Silva; 1656; Museo del Prado (see page 209 for entire painting)

202–203 *The Surrender of Breda (La Rendición de Breda);* oil on canvas; Don Diego Velázquez de Silva; 1635; Museo del Prado

204 *View of the City of Zaragoza (Vista de la Ciudad de Zaragoza);* oil on canvas; Don Diego Velázquez de Silva and Juan Bautista del Mazo; 1650; Museo del Prado

205 *Defense of Cádiz Against the English (Defensa de Cádiz contra los Ingleses);* oil on canvas; Francisco de Zurbarán; 1634; Museo del Prado

206a *Cardinal-Prince Don Fernando of Austria (Cardenal-Infante Don Fernando de Austria);* oil on canvas; Don Diego Velázquez de Silva; c.17th century; Museo del Prado

206b *Prince Baltasar Carlos (El Príncipe Baltasar Carlos);* oil on canvas; Don Diego Velázquez de Silva; 1635–1636; Museo del Prado

207 *Deer Hunting from a Platform at Aranjuez (La cacería del tabladillo en Aranjuez);* oil on canvas; Juan Bautista Martínez del Mazo; 1665; Museo del Prado

208 *The Virgin Child in Ecstasy (La Virgen Niña en Extasis);* oil on canvas; Francisco de Zurbarán; 1630–1632; The Metropolitan Museum of Art, New York

209 *The Attendants, or The Family of Felipe IV (Las Meninas, o La Familia de Felipe IV);* oil on canvas; Don Diego Velázquez de Silva; 1656; Museo del Prado

210 *Saint Hugo in the Refectory (San Hugo en el Refectorio);* oil on canvas; Francisco de Zurbarán; 1625; Museo Provincial de Bellas Artes de Sevilla

211 *Vision of Saint Alonso Rodríguez (Visión de San Alonso Rodríguez)* (detail); oil on canvas; Francisco de Zurbarán; c.1630; Academia de Bellas Artes de San Fernando, Madrid

212 *Cavalry Battle (Choque de Caballería);* oil on canvas; Philip Wouverman; c.1640; Museo del Prado

213 *Siege of Aire-sur-la-Lys (Asedio de Aire-sur-la-Lys);* oil on canvas; Peeter Snayers; 1653; Museo del Prado

214–215 *Dream of Death (El Sueño de la Muerte);* oil on canvas; Antonio Pereda; 1640; Academia de Bellas Artes de San Fernando, Madrid

216 *Carlos II;* oil on canvas; Claudio Coello; 1642; Museo del Prado

THE HOUSE OF BOURBON

218–219 *Felipe V and María Luisa of Savoy (Felipe V y María Luisa de Saboya);* oil on canvas; Felipe de Silva; c. mid-18th century; El Escorial

220 *View of the Battle of Gibraltar (Vista de la batalla de Gibraltar);* oil on canvas; Anon.; c.1704; Museo Naval, Madrid

221 *Model of a hydraulic machine (Modelo de máquina hidráulica);* invented by Burlet Fores; 1791; Museo Naval, Madrid

222 *Spanish fan (Abanico español);* 18th century; Museo Lázaro Galdiano, Madrid

223 *Allegorical Vision of the Coronation of Fernando VI (Alegoría de la Coronación de Fernando VI);* oil on canvas; Anon.; 18th century; Museo de Bellas Artes, Sevilla

224–225 *Masquerade Ball (Baile en máscara);* oil on canvas; Luis Paret; c.1770; Museo del Prado

226 *The Shop (La tienda);* oil on canvas; Luis Paret; 1772; Museo Lázaro Galdiano, Madrid

227 *Ascent of a Montgolfier Balloon in Madrid (Ascensión de un globo Montgolfier en Madrid);* oil on canvas; Antonio Carnicero; 1792; Museo del Prado

228 *Market in the Plaza of Cebada (Feria en la Plaza de la Cebada);* oil on canvas; Manuel de la Cruz; c.1800; Museo Municipal, Madrid

229 *Madrid's Main Plaza (Plaza Mayor de Madrid);* oil on canvas; Anon.; c.1780; Museo Municipal, Madrid

230–231 *Naval Engagement off the Coast of Provence (Batalla naval distante de Costa de Provenza);* oil on canvas; Moraleda; 1783; Museo Naval, Madrid

232 *The Hunt (Montería);* oil on canvas; Charles-Francois de la Traverse; late 18th century; Museo del Prado

233 *Duck Hunt (Caza de patos);* oil on canvas; Luis Paret; 1772; Museo Lázaro Galdiano, Madrid

234–235 *Battle of Trafalgar (Combate de Trafalgar);* oil on canvas; Anon.; 1805; Museo Naval, Madrid

236 *The Young Bulls (La novillada)* (detail); oil on canvas; Francisco de Goya; 1779–1780; Museo del Prado

237a *Blindman's Buff (La gallina ciega);* oil on canvas; Francisco de Goya; 1791; Museo del Prado

237b *Procession of the Flagellants, or Penitents (Procesión de flagelantes);* oil on canvas; Francisco de Goya; 1793; Academia de Bellas Artes de San Fernando, Madrid

238 *Bullfight in a Village (Toros en un pueblo);* oil on canvas; Francisco de Goya; 1793; Academia de Bellas Artes de San Fernando, Madrid

239 Burial of the Sardine (El entierno de la sardina); oil on canvas; Francisco de Goya; 1793; Academia de Bellas Artes de San Fernando, Madrid

240–241a The Threshing Floor (La era); oil on canvas; Francisco de Goya; 1786; Museo del Prado

240–241b The Wedding (La boda); oil on canvas; Francisco de Goya; 1791–1792; Museo del Prado

242a The Countess of Chinchón (La Condesa de Chinchón); oil on canvas; Francisco de Goya; 1808; coll. of the Duke of Sueca, Madrid

242b The Duchess of Alba (La Duquesa de Alba); oil on canvas; Francisco de Goya; 1795; coll. of the Duke of Alba, Madrid

243a The Countess of Fernán-Núñez (La Condesa de Fernán-Núñez); oil on canvas; Francisco de Goya; 1803; coll. of Duchess of Fernán-Núñez, Madrid

243b The Count of Fernán-Núñez (El Conde de Fernán-Núñez); oil on canvas; Francisco de Goya; 1803; coll. of Duchess of Fernán-Núñez, Madrid

244–245 The Madhouse (El manicomio, o casa de los locos); oil on canvas; Francisco de Goya; 1793; Academia de Bellas Artes de San Fernando, Madrid

246 Self-Portrait (Autorretrato); oil on canvas; Francisco de Goya; 1815; Academia de Bellas Artes de San Fernando, Madrid

247a Clothed Maja (Maja vestida); oil on canvas; Francisco de Goya; 1797–1798; Museo del Prado

247b Nude Maja (Maja desnuda); oil on canvas; Francisco de Goya; 1797–1798; Museo del Prado

248a Manuel Godoy; oil on canvas; Francisco de Goya; c.1800; Academia de Bellas Artes de San Fernando, Madrid

248b Queen María Luisa of Parma (La Reina María Luisa de Parma); oil on canvas; Francisco de Goya; 1799; Museo del Prado

249 Carlos IV; oil on canvas; Francisco de Goya; 1798; Museo del Prado

250–251 May 3, 1808, in Madrid: the Firing Squad (El 3 de Mayo de 1808 en Madrid: Los Fusilamientos); oil on canvas; Francisco de Goya; 1814; Museo del Prado

252 The Witches' Sabbath (Aquelarre); oil on canvas; Francisco de Goya; 1795–1798; Museo Lázaro Galdiano, Madrid

254 The Colossus, or The Panic (El coloso, o El pánico); oil on canvas; Francisco de Goya; 1808; Museo del Prado

255 Fernando VII; oil on canvas; Francisco de Goya; 1813; Academia de Bellas Artes de San Fernando, Madrid

256 Saint Francis of Borja and a Dying Man (San Francisco de Borja y El Moribundo) (detail); oil on canvas; Anon.; 1788; coll. of the Marquesa de Santa Cruz, Madrid

258 Agustina of Aragón (Agustina de Aragón); oil on canvas; Anon.; c.1820; Museo Lázaro Galdiano, Madrid

259 Queen Isabel II swears to uphold Constitution before Senate, 1843 (Jura de la Constitución por la Reina Isabel II en el Senado, 1843); oil on canvas; Anon.; c.1850; Museo Municipal, Madrid

260 Riot of the Ramblas (Motin de la Rambla); oil on canvas; Juan Arrau; 1835; Museo Histórico de la Ciudad de Barcelona

261 The Execution of General Torrijos and His Companions (Fusilamiento del General Torrijos y sus compañeros); oil on canvas; Antonio Gisbert; 1865; Museo Nacional de Arte Moderno, Madrid

262 The Flaquer Family (La familia Flaquer); oil on canvas; Joaquín Espalter; 1840; Museo Romántico, Madrid

263 The Speech (El discurso); oil on canvas; Bernardo Ferrandis; late 19th century; Museo de Bellas Artes, Granada

264–265 Contemporary Poets (Los poetas contemporáneos); oil on canvas; Antonio Esquivel; 1846; Museo Nacional de Arte Moderno, Madrid

266–267 The Battle of Tetuán (La batalla de Tetuán); oil on canvas; Mariano Fortuny; 1863; Museo de Arte Moderno, Barcelona

268 Demonstration at the Puerta del Sol over the African War (Una manifestación en la Puerta del Sol con Motivo de la Guerra de Africa); oil on canvas; Martín de Atienza; c.1886; Museo Romántico, Madrid

268–269 Carnival (Carnaval madrileño); oil on canvas; Manuel Castellano; late 19th century; Museo Municipal de Madrid

269 The Restored Chapel (La capilla restaurada); oil on canvas; F. Ronze; 1878; Palacio Real, Madrid

270 The Procession of the Corpus Christi in Seville (La procesión del Corpus Christi en Sevilla); oil on canvas; Manuel Cabral; 1858; Museo Moderno de Madrid

271 Good Friday Procession in Seville (Procesión del Viernes Santo en Sevilla); oil on canvas; Manuel Cabral; 1862; Palacio Real, Madrid

272a Interior of the Liceo Theater After the Explosion of a Bomb, November 7, 1893 (Interior del Teatro del Liceo después de la explosión de una bomba, Noviembre 7, 1893); pen and ink sketch; Salvador Rosas; Museo de la Historia de la Ciudad, Barcelona

272b The Infamous Garrote (El garrote vil); oil on canvas; Ramón Casas; 1895; Museo Moderno, Madrid

273 The Infanta Isabel and the Marquesa of Nájera leaving a Bullfight at the Old Plaza Madrileña (La Infanta Isabel y la Marquesa de Nájera salen de una corrida de toros en la vieja plaza madrileña); oil on canvas; J.M.López Mezquita; c.1900; Museo Municipal de Madrid

274–275 Cordon of Prisoners (Cuerda de presos); oil on canvas; J.M.López Mezquita; Museo Moderno, Madrid

276 The Wedding of Alfonso XIII (La boda de Alfonso XIII); oil on canvas; Juan Comba; c.1906; Palacio Real, Madrid

277 Garden Party at Campos Elíseos (Velada en los Campos Elíseos); oil on canvas; Ramón Botella; 1862; Museo Municipal de Madrid

278 Woman Driving (Mujer conduciendo); oil on canvas; Ramón Casas; 1909; Círculo del Liceo, Barcelona

279 The Display Case (La vitrina); oil on canvas; Juan Gutiérrez Solana; 1910; Museo Nacional de Arte Contemporáneo, Madrid

280 María Painting at El Pardo (María pintando en el Pardo); oil on canvas; Joaquín Sorolla; 1907; coll. of Pons-Sorolla, Madrid

281 Victoria Eugenia of Battenberg (Victoria Eugenia de Battenberg); oil on canvas;

Joaquín Sorolla; 1907; coll. of
Pons-Sorolla, Madrid

282–283 *The Fall of the Picador (La caída del
 picador);* oil on canvas; Roberto
 Domingo; c. 20th century; Museo de
 Bellas Artes, Granada

284 *The Train (El tren);* oil on canvas;
 Dario de Regoyos; early 20th

century; Museo de Arte Moderno,
Barcelona

285 *The Farm (La granja);* oil on canvas;
 Joan Miró; 1928; coll. of Mrs. Mary
 Hemingway, New York City

286 *The Gypsy (La gitana);* oil on canvas;
 Isidre Nonell; early 20th century;
 Museo de Arte Moderno, Barcelona

287 *The Tragedy (La tragedia);*
 oil on canvas;
 Pablo Picasso; 1903;
 The National Gallery of Art,
 Washington, D.C.

288 *Don Quixote and Sancho Panza
 (Don Quijote y Sancho Panza);*
 brush drawing; Pablo Picasso;
 1954

BIBLIOGRAPHY

RAFAEL ALTAMIRA,
A History of Spain,
D. Van Nostrand Company, New York,
1949

MANUEL BALLESTEROS,
España en los Mares,
Madrid, 1943

GERALD BRENAN,
The Face of Spain,
Cambridge University Press, London,
1960

GERALD BRENAN,
The Literature of the Spanish People,
Meridian Books, New York, 1953

AMÉRICO CASTRO,
The Structure of Spanish History,
Princeton University Press,
Princeton, New Jersey, 1954

CHARLES E. CHAPMAN,
A History of Spain,
Macmillan, New York, 1961

GILBERT CHASE,
The Music of Spain,
Dover Publications, Inc., New York, 1959

SHELDON CHENEY
The Story of Modern Art,
Viking Press, New York, 1945

SIR GEORGE CLARK et al.,
The New Cambridge Modern History,
vols. 1 and 2,
Cambridge University Press,
London, 1958–1965

JOHN A. CROW,
Spain: The Root and the Flower,
Harper and Row, New York, 1963

NINA EPTON,
Love and the Spanish,
Cassell and Company, London, 1961

AUGUSTÍN BLÁNQUEZ FRAILE,
Historia de España,
Editorial Ramón Sopena, Barcelona, 1936

JOSÉ GUDIOL,
The Arts of Spain,
Chanticleer Press Edition, Doubleday,
New York, 1964

Spain,
Hachette World Guides,
79 Blvd. St-Germain, Paris, 1961

H. W. JANSON,
History of Art,
Prentice Hall, Inc., and Harry N. Abrams,
New York, 1963

HENRY CHARLES LEA,
A History of the Inquisition of Spain,
4 vols.,
New York, 1906–1908

Histoire d'Espagne,
Libraire Arthemé Fayard, Paris, 1959

EMILIO GONZÁLEZ LÓPEZ,
Historia de la Civilización Española,
Las Américas Publishing Company,
New York, 1959

SALVADOR DE MADARIAGA,
Guía del Lector del Quijote,
Editorial Hermes, Mexico, 1953

JUAN DE MARIANA,
*Historia General de España
(The General History of Spain),*
tr. from the Sp. ed. of 1669 or 1670,
ed. by Capt. John Stevens,
London, 1699
(Orig. ed. in Latin, Toledo, 1592;
first Sp. ed., Toledo, 1601)

SIR WILLIAM STIRLING MAXWELL,
Stories of Spanish Artists Until Goya,
Tudor Publishing Company,
New York, 1938

ROGER BIGELOW MERRIMAN,
*The Rise of the Spanish Empire in the Old World
and in the New,* 4 vols.,
Macmillan, New York, 1918–1934

JAMES MORRIS,
The Presence of Spain,
Harcourt, Brace and World, New York, 1964

ABRAHAM A. NEUMANN,
*The Jews in Spain: Their Social, Political and
Cultural Life during the Middle Ages,* 2 vols.,
Jewish Publication Society,
Philadelphia, 1942

JOSÉ ORTEGA Y GASSET,
Papeles Sobre Velázquez y Goya,
Revista de Occidente, Madrid, 1950

MARCELINO MENÉNDEZ PELAYO,
Historia de los Heterodoxos Españoles, 8 vols.,
Madrid, 1946–1948

RAMÓN D. PERES,
*Historia de la Literatura Española
e Hispanoamericana,*
Editorial Ramón Sopena, Barcelona, 1949

V. S. PRITCHETT,
The Spanish Temper,
Harper and Row, New York, 1954

J. F. RAFOLS,
Historia del Arte,
Editorial Ramón Sopena, Barcelona, 1949

JOSÉ AMADOR DE LOS RÍOS,
*Historia Social, Política y Religiosa de los Judíos
en España y Portugal,* 3 vols.,
Madrid, 1875–1876

F. J. SÁNCHEZ CANTÓN (INTRO.),
Catálogo, Museo del Prado,
Madrid, 1963

HENRY D. SEDGWICK,
Spain—A Short History,
Little, Brown and Company, Boston, 1926

SACHEVERELL SITWELL,
Spain,
B. T. Batsford, Ltd., London, 1961

El Greco,
Skira, Distributed by the World Publishing
Company, Cleveland, 1961

RHEA MARCH SMITH,
Spain, A Modern History,
University of Michigan Press,
Ann Arbor, 1965

J. B. TREND
The Civilization of Spain,
Oxford University Press, Fairlawn,
New Jersey, 1944

FERNANDO ARRANZ VELARDE,
Compendio de Historia Maritima de España,
Barcelona, 1940

CHAPTER I

MARTIN ALMAGNO BASCH,
Manuel de Historia Universal, Tomo I,
Prehistoria,
Espasa-Calpe, S. A., Madrid, 1960

HENRI BREUIL *et al.,*
The Art of the Stone Age, tr. Ann E. Keep,
Crown, New York, 1961

J. B. BURRI *et al.,* EDS.,
The Cambridge Ancient History,
vols. 1 and 2,
London and New York, 1923–27

HAWKES AND WOOLLEY,
Prehistory and the Beginnings of Civilization,
History of Mankind 1,
Harper and Row, New York, 1963

H. R. HAYS,
In the Beginnings,
G. P. Putnam and Sons, New York, 1963

RAMÓN MENÉNDEZ PIDAL *(dirigida por),*
Historia de España,
Espasa-Calpe, S. A., Madrid, 1963

CHAPTER II

J. B. BURRI *et al.,* EDS.,
The Cambridge Ancient History,
vols. 1 and 2,
London and New York, 1923–27

HEINZ KÄHLER,
The Art of Rome and Her Empire,
Crown, New York, 1963

RAMÓN MENÉNDEZ PIDAL *(dirigida por),*
Historia de España, España Protohistorica,
España Prerromana, España Romana,
Espasa-Calpe, S. A., Madrid, 1963

T. G. E. POWELL,
The Celts, Ancient Peoples and Places,
Frederick A. Praeger, New York, 1958

C. H. V. SUTHERLAND,
The Romans in Spain,
London, 1939

CHAPTER III

JUAN AINAUD (INTRO.),
Spanish Frescos of the Romanesque Period,
Mentor-UNESCO, New York, 1962

REINHART PIETER ANNE DOZY,
Spanish Islam: A History of the Moslems
in Spain,
tr. and ed. by F. Griffin Stokes, London,
1913

ENRIQUE ORIA HERRERA,
Historia de la Reconquista de España,
Madrid, 1943

AHMED IBN MOHAMMED AL MAKKART,
The History of the Mohammedan Dynasties
in Spain,
extracted and tr. (from mss. copies in the
British Museum), ed. by Pascual de Gayangos,
2 vols., London, 1840–43

ROGER BIGELOW MERRIMAN,
The Rise of the Spanish Empire in the Old World
and the New, 4 vols.,
rev. ed., Oxford University Press,
New York and London, 1950

J. ROMANO MURUBE,
Alcázar de Sevilla,
Editorial Patrimonio Nacional, Madrid,
1963

ANGEL GONZÁLEZ PALENCIA,
Historia de la España Musulmana,
Barcelona, 1935

RAMÓN MENÉNDEZ PIDAL,
La España del Cid, 2 vols.,
Madrid, 1929

G. GOMEZ DE LA SERNA,
Toledo,
Editorial Noquer, S. A., Madrid, 1963

J. VICENS VIVES,
Juan II de Aragón (1398–1479),
Barcelona, 1953

CHAPTER IV

PHILIP GOSS,
History of Piracy,
Tudor Publishing Co., New York, 1932

HENRY CHARLES LEA,
The Moriscos of Spain: Their Conversion
and Expulsion,
Macmillan, New York, 1901

JEAN HIPPOLYTE MARIÉJOL,
The Spain of Ferdinand and Isabella,
trans. and ed. by Benjamin Keen,
Rutgers University Press,
New Brunswick, New Jersey, 1961

WILLIAM H. PRESCOTT,
History of the Reign of Ferdinand and Isabella
the Catholic,
C. Harvey Gardiner and George Allen and
Unwin, London, 1962

WILLIAM H. PRESCOTT,
History of the Reign of Ferdinand and Isabella
the Catholic, 2 vols.,
Lippincott, New York, 1838

ANDRÉS GIMÉNEZ SOLER,
Fernando el Católico,
Barcelona, 1941

WALTER STARKIE,
Grand Inquisitor: Being an Account of Cardinal
Ximenes de Cisneros and His Times,
London, 1940

ARNOLD TOYNBEE,
A Historian's Approach to Religion,
Oxford University Press,
London and New York, 1956

CHAPTER V

GERMÁN ARCINIEGAS,
Amerigo and the New World:
The Life and Times of Amerigo Vespucci,
Alfred A. Knopf, New York, 1955

VICTOR W. VON HAGEN,
Realm of the Incas,
New American Library, New York, 1963

VICTOR W. VON HAGEN,
The Aztec Man and Tribe,
New American Library, New York, 1962

LEWIS HANKE,
Bartolomé de las Casas, Historian,
University of Florida Press, Gainesville,
1952

LEWIS HANKE,
The Spanish Struggle for Justice in the Conquest
of America,
Crown, New York, 1948

C. H. HARING,
The Spanish Empire in America,
2nd ed., Cambridge University Press,
London, 1952

HUBERT HERRING,
A History of Latin America from the Beginnings
to the Present,
Alfred A. Knopf, New York, 1955

PAUL HORGAN,
Conquistadors in North American History,
Farrar Strauss and Co., New York, 1963

BENJAMIN KEEN, ED.,
Readings in Latin American Civilization,
1492 to the Present,
1955

BENJAMIN KEEN, TR. AND ED.,
The Life of the Admiral Christopher Columbus
by His Son Ferdinand,
Houghton Mifflin, New York, 1959

F. A. MacNUTT,
De Orbe Novo, The Eight Decades
of Peter Martyr d'Anghera, 2 vols.,
1912

J. L. MECHAM,
Church and State in Latin America,
University of North Carolina Press,
Chapel Hill, 1934

R. B. MERRIMAN,
The Rise of the Spanish Empire in the Old World
and the New, 4 vols.,
Macmillan, New York, 1918–34

SAMUEL ELIOT MORISON,
Admiral of the Ocean Sea: A Life of Christopher
Columbus, 2 vols.,
Atlantic Monthly Press, New York, 1942

GONZALO FERNÁNDEZ DE OVIEDO Y VALDÉS,
Historia General y Natural de las Indias Islas
y Tierra-Firme del Mar Oceano,
Editorial Guarania, Madrid, 1944–45

C. M. PARR,
So Noble a Captain: The Life and Times
of Ferdinand Magellan,
Crowell Collier, New York, 1953

F. J. POHL,
Amerigo Vespucci, Pilot Major,
Columbia University Press, New York,
1944

WILLIAM H. PRESCOTT,
History of the Conquest of Mexico and History
of the Conquest of Peru,
Random House, Modern Library,
New York, 1957

J. F. RIPPY,
Latin America, A Modern History,
University of Michigan Press,
Ann Arbor, 1958

L. B. SIMPSON,
The Encomienda in New Spain,
rev. ed., University of California,
Berkeley, 1950

R. A. SKELTON,
Explorers' Maps: Chapters in the Cartographic
Record of Geographical Discovery,
Routledge and Kegan Paul, London,
1958

STERLING A. STOUDEMIRE, TR. AND ED.,
Natural History of the West Indies, Oviedo y
Valdés, University of North Carolina
Press, Chapel Hill, 1959

H. R. WAGNER,
The Rise of Hernán Cortés,
University of California Press, Berkeley, 1944

CHAPTER VI

CHARLES R. BOXER,
The Dutch Seaborne Empire, 1600–1800,
Alfred A. Knopf, New York, 1965

JOHN J. BURKE, TR. AND ED.,
Saint Teresa of Jesus of the Order of Our Lady
of Carmel,
Paulist Press, New York, 1911

LUIS COLOMA,
The Story of Don John of Austria,
tr. and ed. by Lady Moreton,
London and New York, 1912

R. TREVOR DAVIES,
The Golden Century of Spain, 1501–1621,
Macmillan, New York, 1954

PHILIP GOSSE,
History of Piracy,
Tudor Publishing Company,
New York, 1932

LEWIS HANKE,
Bartolomé de las Casas, Historian,
University of Florida Press, Gainesville, 1952

LEWIS HANKE,
The Spanish Struggle for Justice in the Conquest
of America,
Crown Publishers, New York, 1948

C. H. HARING,
The Spanish Empire in America,
2nd ed., Cambridge University Press,
London, 1952

C. H. HARING,
Trade and Navigation Between Spain and
the Indies in the Time of the Hapsburgs,
Harvard University Press,
Cambridge, Massachusetts, 1918

MARTIN ANDREW SHARP HUME,
Philip II of Spain,
Macmillan, New York, 1911

ROBERT A. KANN,
The Hapsburg Empire,
Frederick A. Praeger, New York, 1957

JOHN LYNCH,
Spain Under the Hapsburgs, vol. I,
Oxford University Press, New York, 1964

J. L. MECHAM,
Church and State in Latin America,
University of North Carolina Press,
Chapel Hill, 1934

J. H. PARRY,
The Spanish Theory of Empire in the
Sixteenth Century,
Macmillan, New York, 1940

WILLIAM H. PRESCOTT,
History of the Reign of Philip the Second, 3 vols.,
Lippincott, Philadelphia, 1916

L. REA,
The Armada,
London, 1933

ARNOLD TOYNBEE,
Study of History,
Oxford University Press, London,
1934–35

CHAPTER VII

ALBERT FREDERICK CALVERT,
Goya, An Account of His Life and Works,
Helburn, London and New York, 1908

JULIÁN CORTÉS CAVANILLAS,
Alfonso XIII, el Rey Romántico,
Madrid, 1943

EDMUND B. D'AUVERGNE,
Godoy: The Queen's Favorite,
Appleton, Boston, 1913

D. E. POHREN,
The Art of Flamenco,
Lopez Romero, Madrid, 1962

HUGH STOKES,
Francisco Goya: A Study of the Work and
Personality of the Eighteenth-Century Spanish
Painter and Satirist,
Putnam, New York, 1914

CHAPTER VIII

HENRY BUTLER CLARKE,
Modern Spain, 1815–1898,
Macmillan, New York, 1906

FRANK ELGAR AND ROBERT MAILLARD,
Picasso,
Frederick A. Praeger, New York, 1956

MARTIN ANDREW SHARP HUME,
Modern Spain, 1788–1898,
Macmillan, New York, 1900

PIERRE DE LUZ,
Isabel II, Reine d'Espagne,
Paris, 1935

JOSÉ ORTEGA Y GASSET,
Revolt of the Masses,
W. W. Norton and Co., New York, 1930

University of North Carolina Press,
Chapel Hill, 1934